D1395614

WINCHESTER

BACK TO THE FUTURISTS

Manchester University Press

Back to the Futurists

The avant-garde and its legacy

Edited by
Elza Adamowicz and Simona Storchi

Manchester University Press
Manchester and New York
distributed in the United States exclusively
by Palgrave Macmillan

Published by Manchester University Press
Oxford Road, Manchester M13 9NR, UK
and Room 400, 175 Fifth Avenue, New York, NY 10010, USA
www.manchesteruniversitypress.co.uk

Distributed in the United States exclusively by
Palgrave Macmillan, 175 Fifth Avenue, New York,
NY 10010, USA

Distributed in Canada exclusively by
UBC Press, University of British Columbia, 2029 West Mall,
Vancouver, BC, Canada V6T 1Z2

British Library Cataloguing-in-Publication Data
A catalogue record for this book is available from the British Library

Library of Congress Cataloging-in-Publication Data applied for

ISBN 978 07190 9053 0 hardback

First published 2013

Typeset
by Carnegie Book Production, Lancaster
Printed in Great Britain
by TJ International Ltd, Padstow

Contents

List of figures

Notes on contributors

Elza Adamowicz is Professor of French Literature and Visual Culture at Queen Mary University of London. She has published extensively on Dada and Surrealism, the European avant-garde and the livre d'artiste. Her publications include *Surrealist Collage in Text and Image. Dissecting the Exquisite Corpse* (1998; 2004), *Ceci n'est pas un tableau. Les écrits surréalistes sur l'art* (2005), *Surrealism: Crossings/Frontiers* (edition) (2006), *Un chien andalou* (2010), and *Dada and Beyond*, 2 vols (2011 and 2012), co-edited with Eric Robertson.

Pierpaolo Antonello is Reader in Italian at the University of Cambridge and Fellow of St John's College. He specialises in contemporary Italian literature, culture and intellectual history, and has written extensively on the relationship between literature and science. His books include: *Science and Literature in Italian Culture: From Dante to Calvino* (2004), co-edited with Simon Gilson; *Il ménage a quattro. Scienza, filosofia e tecnica nella letteratura italiana del Novecento* (2005); *Imagining Terrorism: The Rhetoric and Representation of Political Violence in Italy, 1969–2009* (2009), co-edited with Alan O'Leary; *Postmodern impegno: Ethics and Commitment in Contemporary Italian Culture* (2009), co-edited with Florian Mussgnug; *Contro il materialismo. Le 'due culture' in Italia: bilancio di un secolo* (2012).

Günter Berghaus was Reader in Theatre History and Performance Studies and is now a Senior Research Fellow at the University of Bristol. He has directed numerous plays and devised experimental productions. He has organised conferences on European theatre and Futurism. He has held research awards from the Polish Academy of Sciences, the German Research Foundation, the Italian Ministry of Culture, the British Academy and the Brazilian Ministry of Education. He has been Guest Professor at the State University of Rio de Janeiro and at Brown University, Providence, RI. He has published some twenty books on theatre anthropology, theatre history and politics, including: *Theatre and Film in Exile* (1989), *The Genesis of Futurism* (1995), *Fascism and Theatre* (1996), *Futurism*

and Politics (1996), *Italian Futurist Theatre* (1998), *On Ritual* (1998), *International Futurism in the Arts and Literature* (2000), *Avant-Garde Performance: Live Events and Electronic Technologies* (2005), *Theatre, Performance and the Historical Avant-garde* (2005), *F. T. Marinetti: Selected Writings* (2006), *Futurism and the Technological Imagination* (2009). His current project is a bibliographic handbook, *International Futurism*, 1945–2009.

Delphine Bière is a Lecturer in the History of Art at the Université Lille III and a researcher at the IRHIS. She is the author *Le réseau artistique de Robert Delaunay entre 1909 et 1939* (2006). She has published articles on artistic relations in the first half of the twentieth century and on avant-garde reviews. She is currently researching on the work of Wols.

Jonathan Black completed a PhD in the History of Art at University College London on 'Constructions of Masculinity and the Image of the British Soldier in the First World War art of: C. R. W. Nevinson; Eric Kennington and Charles Sargeant Jagger c.1915–1925' (2003). In 2004 he curated the exhibition *Blasting the Future: Vorticism in Britain* at the Estorick Collection of Modern Italian Art, London, and the Whitworth Art Gallery, University of Manchester. Publications include: *Form, Feeling and Calculation: The Complete Paintings and Drawings of Edward Wadsworth* (2005), *Dora Gordine, Sculptor, Artist, Designer* (2008), as well as essays on the wartime prints of C. R. W. Nevinson, Wadsworth and 'Dazzle' camouflage, and the friendship between Henri Gaudier-Brzeska and Edward Wadsworth. He is currently Senior Research Fellow in History of Art at Kingston University.

Willard Bohn is Distinguished Professor Emeritus of French and Comparative Literature at Illinois State University. He has published extensively on Futurism, Dada and Surrealism, Guillaume Apollinaire, Giorgio de Chirico and modern visual poetry. He has authored 130 articles and fourteen books, including *The Aesthetics of Visual Poetry, 1914–1928* (1986/1993), *Apollinaire and the Faceless Man* (1991), *Apollinaire and the International Avant-Garde* (1997), *Modern Visual Poetry* (2000), *The Rise of Surrealism* (2001), *The Other Futurism: Futurist Activity in Venice, Padua, and Verona* (2004), *Italian Futurist Poetry* (2005), *Apollinaire on the Edge* (2010), and *Reading Visual Poetry* (2011).

Sascha Bru is Professor of Literary Theory at Leuven University, Belgium. His work focuses mainly on the fate of literature during the late nineteenth century and the first half of the twentieth, as this period marks both the heyday and the gradual decline of literature as a highly valued cultural and social medium. He is the author of *Democracy, Law and the Modernist Avant-Gardes: Writing in the State of Exception* (Edinburgh University Press, 2009). He has edited various volumes, including *The Invention of Politics in the European Avant-Gardes, 1906–1940* (2006), *Europa! Europa? The Avant-Garde, Modernism and the Fate of a Continent*

(2009), and *The Critical and Cultural History of Modernist Magazines*, Vol. III: Europe, 1890–1940 (2012).

Selena Daly is an Irish Research Council Post-Doctoral Fellow in the School of History and Archives at University College Dublin. She is co-editor of *The European Avant-Garde: Text and Image* (2012). She has published articles on Futurism in *Rivista di Studi Italiani* and *Otto/Novecento*.

Carolina Fernández Castrillo is Associate Professor of Visual Media and Digital Research at the Open University of Madrid. She holds a PhD in Audiovisual Communication (Universidad Complutense de Madrid) and a PhD in Communication Science (La Sapienza University of Rome), entitled 'Futurism as "Poliexpressive" Reconstruction of the Universe: From Cinema to *Postmedia* Condition'. She has published a number of essays on Futurism and digital culture.

Jennifer Griffiths completed her PhD in the History of Art at Bryn Mawr College on 'Futurist Aeropainting: Extended Women and the Kingdom of the Machine' (2012), which examined the art of women Futurists during the period of Fascist rule in Italy. She is currently teaching at the American University of Rome.

Marja Härmänmaa is a Senior Lecturer in Italian at the University of Helsinki. Her research is mainly focused on Futurism, D'Annunzio and the cultural life in Fascist Italy. She has published *Un patriota che sfidò la decadenza: F. T. Marinetti e l'idea dell'uomo nuovo fascista* (2000) and has co-edited several books about early twentieth-century European culture. She is currently working on Gabriele D'Annunzio.

Dafydd Jones lectures in modern art history and theory at Cardiff School of Art. He was previously visiting researcher to the International Dada Archive and Research Centre at the University of Iowa, and has participated in research projects, including the Avant-Garde Project at the Universities of Edinburgh and Glasgow (2000–7) and the landmark series *Crisis and the Arts: The History of Dada* (1996–2005). He edited the volume *Dada Culture* (2006) and is currently completing a critical reading of Dada in Zurich for publication in 2014.

Debra Kelly is Professor of French and Francophone Literary and Cultural Studies at the University of Westminster, London. Her research interests focus on text and image studies, war and culture studies, the relationship between literature and cultural memory and Franco-British cultural relations. Her publications include *Pierre Albert-Birot. A Poetics in Movement, A Poetics of Movement* (1997) and *Autobiography and Independence. Selfhood and Creativity in North African Postcolonial Writing in French* (2005). She is the Director of the Group for War and Culture Studies, an international network of researchers, and has edited and co-edited volumes of essays in this field, including *France at War in the Twentieth Century: Propaganda, Myth and Metaphor* (2000) and *Remembering and*

Representing the Experience of War in Twentieth Century France (2000). She is an editor of the *Journal of War and Culture Studies*. She is currently co-ordinating a collective project on the History of the French in London from the Huguenots to the present day, and is a co-editor of the collective volume *The French in London from the 18th Century to the Present Day: Liberty, Equality, Opportunity* (2013).

Matthew McLendon completed his PhD at the Courtauld Institute of Art, University of London, on the manifestos of the Italian Futurists. He was Interim Curator of Adult Learning at Tate Britain. He is currently Associate Curator, Modern and Contemporary Art, at The John and Mable Ringling Museum of Art in Sarasota, Florida, under the aegis of Florida State University. At the Ringling he has overseen the permanent installation of *Joseph's Coat*, the largest Skyspace to date by artist James Turrell. He has also curated numerous exhibitions including *Beyond Bling: Voices of Hip-Hop in Art*, *Zimoun: Sculpting Sound* and *Sanford Biggers: Codex*. He is on faculty at Florida State University, where he teaches graduate seminars in contemporary art and museum practice, and is adjunct faculty at New College of Florida, the State Honors College.

Elisa Sai completed her PhD thesis on the subject of representation and concept of space in interwar Italian Futurism. She was a member of the teaching staff at Bristol University. She has given papers at several international conferences in the US, France, Italy and UK.

Paola Sica is Associate Professor of Italian Studies at Connecticut College (USA). She is an affiliated member in the departments of Gender and Women's Studies and Film Studies. Her publications include *Modernist Forms of Rejuvenation: Eugenio Montale and T. S. Eliot* (2003) and articles and translations on twentieth-century literature and culture in journals including *Italica, Modern Language Notes, Annali d'Italianistica, Quaderni del Novecento, Journal of Anglo-Italian Studies, Rivista di Studi Italiani, Italian Quarterly, Yale Italian Poetry* and *Italian Poetry Review*. She is writing a book on the women writers and artists of *L'Italia Futurista*.

Simona Storchi is a Lecturer in Italian at Leicester University. Her work focuses on twentieth-century Italian literature and cultural history, with a particular interest in the early twentieth century. Her publications include *Valori Plastici 1918–1922. Le inquietudini del nuovo classico* (2006), *Beyond the Piazza: Public and Private Spaces in Modern Italian Culture* (ed., 2013) and *Da Calvino agli ipertesti. Prospettive della postmodernità nella letteratura italiana* (2002), co-edited with Laura Rorato. She has published several articles on early twentieth-century Italian literature and culture, and on Fascism and culture. She co-curated the exhibition *Against Mussolini. Art and the Fall of a Dictator* at the Estorick Gallery, London (2010).

Maria Elena Versari is Assistant Professor of Modern European Art and Architecture at the University of North Florida. She has held the positions of Lynette S. Autrey Visiting Professor in the Humanities Research Center at Rice University and Visiting Scholar at the Getty Research Institute. She completed her PhD in 2006 on the international relations of Futurism in the 1920s. She is the author of *Constantin Brancusi* (2005) and *Wassily Kandinsky e l'astrattismo* (2007; French translation 2008). She has written articles on Italian Futurism, Cubism, Fascist aesthetics and architecture, and the international avant-garde. She has edited a new publication of Ruggero Vasari's Futurist dramas *The Anguish of the Machines* and *Raun* (Palermo, 2009), and is preparing a collection of essays on the politics of iconoclasm and conservation in relation to totalitarian architecture in the twentieth century. She is currently working on a book manuscript titled *The Foreign Policy of the Avant-Garde: International Networks, National Politics and the Development of European Art in the 1920s*, and pursuing research for a book on avant-garde historiography.

John J. White is Emeritus Professor of German and Comparative Literature and Visiting Senior Research Fellow at King's College London. He has published extensively on modern fiction, German drama, experimental writing, literary semiotics and Italian and Russian Futurism. He is the author of *Mythology in the Modern Novel: A Study of Prefigurative Techniques* (1971), *Literary Futurism: Aspects of the First Avant-Garde* (1990), *Bertolt Brecht's Dramatic Theory* (2004), *Brecht's 'Leben des Galilei'* (1996), and (with I. A. White) *Bertolt Brecht's 'Furcht und Elend des Dritten Reiche': A German Exile Drama in the Struggle against Fascism* (2010).

Introduction

Elza Adamowicz and Simona Storchi

In 1909 the Italian poet Filippo Tommaso Marinetti's *Founding Manifesto of Futurism* was published on the front page of *Le Figaro*. Between 1909 and 1912 the Futurists published over thirty manifestos, celebrating speed and danger, glorifying war and technology, and advocating political and artistic revolution. In Italy, France, England and Russia, this avant-garde movement was active in the field of painting and sculpture, theatre, photography and politics.

After decades of neglect, essentially for ideological reasons, Futurism has become a major object of critical attention both in Europe and in North America, as evidenced by the large number of publications and exhibitions in the field, particularly during the last decade. Scholarly publications exploit a range of methodological approaches, including gender studies, literary theory, intellectual history and word-and-image studies. Anthologies of Futurist texts, published in new translations, have expanded the range of documents available in English (W. Bohn, ed., *Italian Futurist Poetry*, 2005; G. Berghaus, ed., *Critical Writings: F. T. Marinetti*, 2006; L. Rainey, C. Poggi and L. Wittman, eds, *Futurism: An Anthology*, 2009). The significance of Futurism has been reassessed, notably by M. Perloff (*The Futurist Moment*, 2004); G. Berghaus (ed., *Futurism and the Technological Imagination*, 2009), and G. Buelens, H. Hendrix and M. Jansen (eds, *The History of Futurism. The Precursors, Protagonists, and Legacies*, 2012). Recent scholarly publications of the key figures of the movement include biographies of Marinetti (G. B. Guerri, *Filippo Tommaso Marinetti. Invenzioni, avventure e passioni di un rivoluzionario*, 2009) and Umberto Boccioni (G. Agnese, *Boccioni da vicino. Pensieri e passioni del grande futurista*, 2008), as well as new editions of the work of Giacomo Balla (*Scritti futuristi*, ed. G. Lista, 2010) and Marinetti (*Teatro*, ed. J. Schnapp, 2004). Recent studies have also revealed the important role of women in the movement (F. Zoccoli, *Benedetta Cappa*

Marinetti. L'incantesimo della luce, 2000; S. Contarini, *La femme futuriste (mythes, modèles et représentations de la femme dans la théorie et la littérature futuristes)*, 2006; M. Bentivoglio and F. Zoccoli, *Le futuriste italiane nelle arti visive*, 2008; V. Mosco and S. Rogari, *Le amazzoni del futurismo*, 2009). Following Günter Berghaus's study *Futurism and Politics* (1996), the politics of the movement has been the object of a number of studies, situating Futurism within the broader European avant-garde context (E. Gentile, *The Struggle for Modernity: Nationalism, Futurism, and Fascism*, 2003; S. Bru and G. Martens, *The Invention of Politics in the European Avant-Garde*, 2006; W. Adamson, *Embattled Avant-Gardes: Modernism's Resistance to Commodity Culture in Europe*, 2007; S. Bru, *Democracy, Law, and the Modernist Avant-Gardes: Writing in the State of Exception*, 2009; E. Gentile, *La nostra sfida alle stelle. Futuristi in politica*, 2009; F. Perfetti, *Futurismo e politica*, 2009). Recent publications have also offered new readings of the Futurists' position in relation to modernity, arguing that, far from enthusiastically embracing technological progress, their position was complex and ambivalent (L. Somigli, *Legitimizing the Artist. Manifesto Writing and European Modernism 1885–1915*, 2003; G. Berghaus, ed., *Futurism and the Technological Imagination*, 2009; C. Poggi, *Inventing Futurism. The Art and Politics of Artificial Optimism*, 2009). Scholarly research has focused on lesser-known aspects of the movement, such as Futurism and the esoteric (S. Cigliana, *Futurismo esoterico. Contributi per una storia dell'irrazionalismo italiano tra Otto e Novecento*, 2002); and Futurism in regional centres (W. Bohn, *The Other Futurism. Futurist Activity in Venice, Padua and Verona*, 2004; A. Castronuovo, *Avanguardia Balneare. Figure e vicende del Futurismo a Rimini*, 2009; V. Cappelli, ed., *Calabria futurista. 1909–1943*, 2009; M. Gazzotti and A. Villari, eds, *Futurismo dada. Da Marinetti a Tzara. Mantova e l'Europa nel segno dell'avanguardia*, 2010; C. Giuliani, ed., *Futurismi a Ravenna*, 2010). Finally, studies linking historical Futurism with contemporary developments in art and design include: Futurism and sport (M. Mancin, ed., *Futurism & Sport Design*, 2006); Futurism, cinema and performance art (G. Davico Bonino, ed., *Teatro futurista sintetico. Manifesti teatrali del futurismo*, 2009; G. Lista, *Il cinema futurista*, 2010); Futurist photography (G. Lista, *Futurism and Photography*, 2001); fashion and Futurism (L. F. Garavaglia, *Il futurismo e la moda*, 2009); and Futurism and multimedia art (G. Celant and G. Maraniello, *Vertigo: A Century of Multimedia Art, from Futurism to the Web*, 2008). The recent surge in scholarly interest in Futurism on a global level has resulted in the launch of the *International Yearbook of Futurism Studies*, edited by Günter Berghaus for de Gruyter.

Recent interest in Futurism is also evidenced by the large number of exhibitions in the field. Since it opened in 1998 the Estorick Collection

of Modern Italian Art in London has hosted a number of exhibitions on Futurism, including artists such as Balla, Severini, Depero, Carrà, Russolo and Boccioni, as well as aeropainting, Vorticism, and Russian Futurism. The recent Futurism exhibition, held first in Paris at the Centre Pompidou (15 October 2008–26 January 2009), then reconfigured in Rome at the Scuderie del Quirinale (20 February–24 May 2009) and London's Tate Modern (12 June–20 September 2009), focused on the confrontation between Futurist and Paris avant-garde artists, as well as Futurism in Britain (Vorticism) and Russia (Cubo-Futurism). It was accompanied by an extensive catalogue with contributions by curators D. Ottinger, E. Coen and M. Gale, as well as G. Lista and J.-C. Marcade. The centenary of the first Futurist manifesto was celebrated by a number of other exhibitions in Italy, among which it is worth mentioning the exhibition held at the MART (Museo d'Arte Moderna e Contemporanea) in Rovereto entitled *Futurismo 100. Illuminazioni. Avanguardie a confronto: Italia, Germania, Russia* (17 January–7 June 2007), with a catalogue edited by Ester Coen (2009) which focused on the relationship between Futurism and early twentieth-century European avant-gardes; the Milanese exhibition *Futurismo 1909–2009. Velocità + arte + azione* (5 February–7 June 2009), hosting a wide range of Futurist exhibits, from paintings and sculptures to examples of stage sets, architecture, decorative art, advertising and fashion, accompanied by a catalogue edited by G. Lista and A. Masoero; the Venetian exhibition *Futurismo. L'avanguardia delle avanguardie* (12 June–4 October 2009), with a catalogue by C. Salaris; the exhibition *Futurismo Manifesto 100 X 100. 100 anni per 100 manifesti* (Rome, 21 February–17 May 2009; Naples, 3 September–3 November 2009), with a catalogue edited by A. B. Oliva, focusing on the manifestos; the Milanese exhibition *F. T Marinetti = Futurismo* (12 February–June 2009), accompanied by a catalogue edited by L. Sansone (2009).[1]

A series of special journal issues devoted to Futurism has also marked the centenary of the *Founding Manifesto of Futurism*. Of note are the special issue of *Annali d'Italianistica* (vol. 27, 2009) entitled *A Century of Futurism 1909–2009*, edited by F. Luisetti and L. Somigli; *Future Imperfect – Italian Futurism between Tradition and Modernity*, a special issue of *The European Legacy*, 14:7, edited by M. Härmänmaa and P. Antonello; and an issue of *L'Illuminista*, 25, entitled *Futurismo e letteratura* (2009).

In the 2011 volume of the *International Yearbook of Futurism Studies* Günter Berghaus highlights the importance acquired by Futurism Studies in the past twenty years, particularly since the 2009 centenary. As he points out, more than 300 exhibitions, over fifty international conferences and a vast number of theatre and musical performances, radio and TV broadcasts have given Futurism an unprecedented prominence in the cultural calendar (Berghaus 2011: XI). Yet, he observes, Futurism studies

are still strongly compartimentalised, not only in terms of artistic media but also, and especially, along national borders. He argues that the debate on Futurism should become globalised and less centred on Italy: 'Futurism had a world-wide impact and generated many international Futurisms, despite the fact that their agendas only partially overlapped with Marinetti's aesthetic and political programme' (Berghaus 2011: XI). This argument is partly echoed by Geert Buelens, Harald Hendrix and Monica Jansen's claim that 'there is no such thing as Futurism' and that any definition of Futurism should take into account its diverse goals and results in space and time (2012: 1). The need to look more comprehensively at the fortunes of Futurism outside Italy has been stressed by Giorgio Di Genova (2011: 9). The extent of the intersections between Italian Futurism and the international avant-garde is one of the main features of Berghaus's *Yearbook*, and features prominently in the catalogue for the Tate 2009 exhibition *Futurism* (see Ottinger 2009 and Gale 2009).

The innovative character of Futurism is still widely acknowledged. As Federico Luisetti and Luca Somigli point out, 'the Futurist movement marked a crucial rupture within European literature and art … it called into question all aspects of literary and artistic production, from the sacrality and eternalness of the work of art to the privileged role of the artist and the passivity of the reader and the spectator' (2009: 14). Pierpaolo Antonello and Marja Härmänmaa, as well as Günter Berghaus, remind us that Futurism was the '-ism' of the future, dedicated to the glorification of modernity in all its phenomena: from the metropolis and city life to the advancement of science and technology; from the excitement and beauty of speed and machines to the new means of communication. Futurism embraced twentieth-century technology as a key element of its aesthetics (Antonello and Härmänmaa 2009: 778; Berghaus 2009a: 19–27). Yet Futurism is still considered an enigmatic and uncanny movement, as well as a 'curiously misunderstood' one, as Marjorie Perloff has recently put it (2012: 9): because of the cultural context from which it sprang, its praise of modernisation and technology was marred with ambiguities and contradictions (Antonello and Härmänmaa 2009: 778). Its eschewal of mainstream literary communication and stylistic practices, its cult of war, Marinetti's sexism and his alliance with Fascism 'have not helped to disseminate or even garner sympathy for the artistic methods of this pioneering avant-garde movement' (Luisetti and Somigli 2009: 14). The founding father himself of Futurism, Filippo Tommaso Marinetti, is still considered an enigma: his all-embracing work is at times discomforting – especially in its glorification of war – and his writing blurs the boundaries between literature and politics (Bru 2009: 41). Politics features pre-eminently in all recent reassessment of Futurist work: after his seminal

book *Futurism and Politics* (1996), Marinetti and Futurism's political trajectory have recently been re-examined by Berghaus, both through the formation of the Futurist political party (2006) and in the light of Marinetti's ideology of war and violence (2009b). Sascha Bru has also reassessed Marinetti's relationship with politics up until 1922, the year of Fascism's rise to power and of Marinetti's novel *Gli indomabili*, which he reads as a political allegory (2009: 41–86). One of the preferred Futurist textual practices, the manifesto, has been described by Luca Somigli as 'a textual space ambiguously poised between the aesthetic and the political, between the work of art and propaganda, between practice and theory' (2003: 4). Bru reminds us of the intrinsically political character of the avant-garde: not only at the level of making practical decisions concerning patronage, policy and education but also through its response to mass culture, which challenged the avant-garde to acquire visibility and create its own space in the public arena. Bru demonstrates how the avant-garde artist was part of a class of intellectual labourers that had been forming since the late nineteenth century, who engaged from time to time with political debates and produced ways to perceive and discuss social and other issues (Bru 2006: 15–16). Marinetti's politics has been read by Walter Adamson as 'a new and unique mode of fusing cultural activity with political action'. By manipulating press and publicity in an effort to marshal 'symbolic capital' on an international scale, Marinetti aimed not merely to advance himself or his movement but to confront a crisis of civilisation and 'to contribute to its resolution by competing for influence in the public sphere with traditional elites whose capital was economic and political' (2007: 77). More recently Adamson has suggested that we should see Futurism as 'an integrated social movement which moves from a mythic phase in which Futurism functions as a harbinger of an alternative form of capitalist mass culture into a utopian phase in which it transmutes into an alternative party politics coupled with a supportive aesthetics' (2012: 309).

Emilio Gentile has re-examined Futurism's involvement in politics as linked to its project for an 'anthropological revolution', which would create the new man of a modernity identified with the triumph of machine and technology. Futurism's politics, according to Gentile, was a manifes-tation of 'modernist nationalism', that is a cultural position characterised by an enthusiasm for modernity bound up with a nationalistic ideology. Futurism's obsession with industrial and technological modernity and the imperialist outlook resulted in a rejection of democracy, a warmon-gering attitude and an aesthetics of speed, technology and the machine (Gentile 2009: 4–16). Modernist nationalism is seen by Gentile as one of the cultural roots of Fascism (Gentile 1996: 32–45). However, while Gentile argues that Marinetti and his followers subordinated themselves to

Mussolini and Fascism after 1920, and accepted to renounce their status as an autonomous social and political movement, abandoning the stances of modernist nationalism (Gentile 2009: 129–30), Adamson maintains that they continued to pursue a Futurist cultural politics well into the 1920s and 1930s (2012: 310).

In his reassessment of the well-known Futurist obsession with the machine, Berghaus identifies a sense of unease transpiring from Futurist texts, stemming precisely from the machine they exalt. According to Berghaus, 'the Futurist machine had a Janus face, one side divine and positive, the other obscure and frightening, and too painful to admit to the conscious mind. The experience of chaos and alienation led to the incorporation of the external threat into the internal world and a transformation of the enemy into a friendly object' (Berghaus 2009a: 27). The machine aesthetics would function as a means of controlling and imposing order on anxiety-producing energies, of exorcising the dark side of modernity. Interestingly, Berghaus stresses Futurism's multifaceted character and its heterogenous response to machine aesthetics: the technophilia and *macchinolatria* which characterised the first phase of the movement were gradually countered by dissenting or critical voices from within Futurism itself. As Italy became more technologically advanced, idealised images of the Mechanical Age became mitigated with more contradictory, complex and faceted attitudes Futurists developed towards technology: as Berghaus puts it, 'a basically positive attitude towards the Machine Age went hand in hand with an increasing awareness of the flipside of the coin. *Macchinolatria* was tempered by machine angst' (2009a: 31).

A nuanced interpretation of Futurism's *meccanolatria*, which also takes into account Marinetti's relationship with nature, has been put forward by Marja Härmänmaa, who argues that Futurism's glorification of technology was predicated on the one hand on the abandonment of the 'myth of Pan' – symbolising the cult of nature and a cyclical concept of time – to pursue that of Prometheus and Ulysses – representing civilising power and heroic force. The replacement of the natural landscape with a landscape of steel and concrete represented the human ability to tame a nature seen as hostile, an enemy to conquer and dominate (Härmänmaa 2009). According to Roger Griffin, developing at the beginning of the twentieth century – a time when the West had entered a point of 'high modernity' and hence high anomie – Futurism promoted technolatry as the product of three main cultural attitudes: firstly, a revitalising attitude according to which the root cause of contemporary decadence is the loss of a unifying, energising *nomos* resulting in a fixation with past achievements to conceal the moribund state of present culture. Secondly the Futurist attempt to combine aesthetics with technophilia was the result of the desire to 'precipitate society's total

palingenesis through an art capturing the essence of modern dynamism' (Griffin 2009: 92). Art would have the role of shocking a declining culture into a healthier, more powerful condition. In this context, and as distinct from other forms of Modernism, technology was seen not as the source of society's decadence but as its salvation, on condition that human creativity overcame technology's tendency to enslave and robotise. Futurism did not want to combat the 'storm of progress' by taking refuge from it, but by 'harnessing its energy in the shaping of a technocratic future' (2009: 92). Thirdly, Griffin argues, Futurism's variant of Modernism represents an example of 'mazeway resynthesis', which operated by 'hybridizing elements of old and new values into a temporalized Utopia in which the membranes that separate art, philosophy, culture, society, and politics in times of stability had become porous' (2009: 92). Griffin identifies the main flaws of the Futurist project in its utopian nature (which eventually turned dystopian), in the selective amnesia of collective memory and tradition entailed by Futurism's rejection of the past and in its celebration of ruthless violence directed against demonised Others as integral to its project of regeneration (2009: 93).

Nonetheless, despite its inconsistencies, its successes and failures, both in culture and politics, Marinetti's (and Futurism's) greatest significance, according to Adamson

> lay rather in his prescient intuition … that the future of modern art and culture lay in some creative fusion of artistic talent and imagination with the popular energies and forms of expression bound up with the dynamism of modern urban life. Modern art and culture, [Marinetti] understood, could hope to preserve itself as a tradition or professional practice independent of the world of newspapers, films, cameras, telephones, railroads, and machine technologies more generally, but would have to take full advantage of what modern, industrial, technological, and commercial institutions and practices had created – and would continue to create at an ever-increasing speed. Art would have to abandon its pretension to be 'Art with a capital A', attune itself to the intensified visuality and clipped syntax of modern life, and make itself anew. (Adamson 2007: 108–9)

As Antonello and Härmänmaa conclude, 'despite the many theoretical inconsistencies, artistic shortcomings, political contradictions and faux pas, it has become evident that Futurism holds a significant position in the cultural history of the twentieth century' (2009: 781). Futurist experimentation anticipated many of the ideas that would later be developed by leading twentieth-century artists. For better or worse, as Didier Ottinger reiterates, Futurism was the first of the twentieth-century avant-garde movements (2009: 20). The Futurists' vision and their drive to extend their

reach to all artistic and social domains became a foundational experience for many art forms, from poetry to music, from theatre to painting, leaving an indelible mark on modern culture (Antonello and Härmänmaa 2009: 781; Adamson 2007: 109). Finally, Adamson argues that the most important legacy of Futurism is its trajectory which he sees as a 'natural' trajectory for avant-gardism in general, for 'the problem for avant-gardes after World War II and for those seeking to operate in contemporary, liberal-democratic cultures is how to be "critical" without either falling off into an unrealizable stance as an "opposition" or "betraying" themselves by becoming fully "integrated" movements whose messages simply "circulate" without any disconcerting, practical effect' (2012: 314–15).

The majority of these chapters were originally given as papers at an international conference, 'Back to the Futurists: avant-gardes 1909–2009', co-organised by the University of Swansea, Royal Holloway University of London and Queen Mary University of London, with the collaboration of the Estorick Collection of Modern Italian Art, and hosted by Queen Mary in July 2009. The chapters, written by international specialists as well as by younger researchers in the field, reassess the activities and legacies of Futurism.

Summary of chapters

The first three chapters reassess Futurist manifestos. Matthew McLendon links Marinetti's techniques of self and group promotion in his Manifestos with practices in the expanding realm of commercial advertising. The theory of crowd psychology (Gustave Le Bon, Giuseppe Prezzolini, Walter Dill Scott), it is argued, facilitates an understanding of the Futurists' portrayal of their own audience or crowd. Jennifer Griffiths's 'Heroes/Heroines of Futurist Culture: *Oltreuomo/oltredonne*' explores the question of how Futurist manifestos address notions of genius and gender and in particular how Futurist women addressed these issues in their texts and art. She argues that the concept of *ultradonna* allowed a philosophical entrance point for women artists to become active participants within Futurism despite its anti-feminist declamations. Finally Pierpaolo Antonello reconstructs the historical, cultural and ideological background of Marinetti's *Manifesto del tattilismo* (1921) as one of the key texts which inaugurated the second wave of Futurism. He maps the scientific and philosophical references on which Marinetti's text is grounded and situates the Manifesto within the wider context of the mainly French anti-ocular discourse as historically reconstructed by Martin Jay in his *Downcast eyes*. Marinetti's text is considered in the light of the general 'critique of separation' espoused by the European avant-garde movements.

Dafydd Jones opens the next group of chapters, on Futurism and the contemporary avant-gardes, with a chapter exploring Futurism's complex relationship with Dada. In spite of the Dadaists' rejection of any cultural precedent, Jones argues that the Zurich Dadaists adopted cultural stances heavily indebted to the terms of critical engagement and cultural visibility initiated within the Futurist circle, in particular in their manifestos and in their strategic use of cabaret as political action. The relations between Futurism and Dada are also explored by Maria Elena Versari in an analysis of the avant-garde's examination of its internal strategies of identity and canonisation. She re-assesses Huelsenbeck's and Hausmann's accounts of the originality of Dada's aesthetic and theoretical positions by arguing that they shaped their own theoretical and aesthetic stances in relation to the foundational role played by Futurism in establishing the codes of the avant-garde. Developing further the links between Futurism and contemporary avant-gardes, Debra Kelly analyses the importance of Futurism for the French poet and painter Pierre Albert-Birot. She argues that his meeting with Severini in 1915 was the catalyst for his advent to modernism. Futurist painting, poetry and theatre design inform the early issues of Albert-Birot's avant-garde review *SIC*. However, far from being a Futurist publication, *SIC* is critical of the movement.

The following four chapters explore some of the dialogues and conflicts within Futurism. Delphine Bière charts the details of the argument on simultaneity between Boccioni and Delaunay, showng how their differing interpretations of Chevreul's ideas on simultaneous contrasts, as well as Bergson's ideas on simultaneity, informed quite divergent aesthetics and pictorial practice. Convergence and divergence are also the subject of Elza Adamowicz's analysis of critical readings of Léger's *La noce*. The painting is considered as the site of a battle between Cubist and Futurist aesthetics; as a place where the two movements intersect and dialogue; and as a pictorial space of convergence between Léger's practice and the broader avant-garde. The dialogue between Occultism and Futurism is the subject of Paola Sica's exploration of the theme of night in the works of the Florentine Futurists. Finally, Jonathan Black examines the reasons why Wyndham Lewis and his colleagues, who had enthusiastically embraced Futurism in 1913, rejected it in early 1914, questioning its revolutionary credentials and its failure to integrate avant-garde abstraction.

In 'Futurist performance', Günter Berghaus reassesses Futurist theatre as the most effective medium for polemics and propaganda in an evolving mass society. He shows how the Futurists, through the *serate*, Futurist Variety Theatre, and Theatre of Essential Brevity, used theatre as a weapon in the battle for a renewal of Italian public life. For Marinetti and the Futurists, theatre constituted a natural progression from politics: perfor-

mances were a demonstration of the Futurist concept of *art-action*, a form of art that had the power to invade society and provoke active responses from the spectators, rather than serving as an object of consumption. Berghaus also stresses the importance of theatre for the Futurists as an effective propaganda medium in an age increasingly dominated by mass society. More than any other artistic form, the *serate* (Futurist performances) challenged the autonomous position of art in bourgeois society. The performative element in the work of art was therefore conceived of as key in the reclaiming of the integration of art and life-praxis.

Performance is also the subject of Selena Daly's analysis of Marinetti's 1905 play *Le Roi Bombance* as a precursor to his 1932 *La cucina futurista*, which, more than a book of recipes, should be considered as a piece of performance art, in which food is separated from its nutrional function and the act of eating is related to notions of creativity and identity.

The next two chapters examine Futurist poetics. John White considers a series of unique examples of innovative expressivity in Italian Futurists' free-word poems and *dipinti paroliberi*. He chooses examples which were a product of the political phase of literary Futurism at a time when eye-catching propaganda content – politics 'expressively' mediated – was a central concern. As a consequence, these texts demand a bolder – at times heuristic – new reading strategy than was usually required in the case of horizontal-linear words-in-freedom. The poems are analysed in terms of their contribution to the political campaigns that were a feature of Futurist activity in the second decade of the twentieth century. Willard Bohn examines a later group of poems, Futurist aeropoetry, which celebrates the triumph of modern aviation. His meticulous textual analyses focus on the Futurists' experimentation with aerial aesthetics in their hybrid verbal-visual poems.

Sascha Bru, re-evaluating the politics of Futurist poetics, argues that Gramsci's philosophy of language coincides with Futurist language experimentation. He focuses in particular on Marinetti's manifestos and his allegorical novel *Gli indomabili* (1922) and argues that Gramsci may have taken an interest in Futurism because he realised the political potential of Futurism's linguistic experimentation. According to Bru, Futurism's use of language may have resonated with Gramsci's reflections on the need to construe a counter-hegemonic language with which a wide variety of social groups could identify and which could collectively attain a single cultural climate. Indeed, Gramsci probably saw Futurism as a significant counter-hegemonic voice. It is Bru's argument that Marinetti's poetics to an extent formalised tactics which were also found in Gramsci's writings, tactics according to which traditional meanings of words in political representations could be eased off from their signifiers and replaced with new connotations.

Marja Härmänmaa's discussion of war in Marinetti's texts and worldview explores the ideological reasons for his glorification of war and the rhetorical means used to exalt war and represent the enemy. She argues that the glorification of violence and war in Marinetti's work is not for its own sake, but rather as propaganda for the formation of a 'heroic citizen'. Techno-logical war was also at the centre of the Futurist modernolatry, and Futurist aesthetics and stylistic innovations were born and developed in relation to the notion of 'aesthetic war'.

In her chapter on interdisciplinarity and intermediality, Carolina Fernández Castrillo explores cinema's contribution as a *metamedium* to an understanding of the interconnections between old and new art forms, in order to create a common language suitable to the new times. Adopting a 'cinemacentrist' perspective, Castrillo's chapter focuses on the relationships established between art, literature and theatre with the new medium to achieve a 'total spectacle'. It reviews the main Futurist manifestos, articles and manuscripts in the light of theories developed by Mario Verdone, Michael Kirby or Giovanni Lista. It argues that the Futurist movement contributed to a blurring of disciplinary borders in Europe at the beginning of the last century

Finally, Elisa Sai's chapter, on Futurism's legacies, opens with Marinetti's words: 'A very beautiful day after tomorrow', addressed to his daughter at the end of his life. These words were adopted by the artist Luca Buvoli for the title of his project presented at the Venice Biennale of 2007, a vibrant multimedia work which incorporates Futurist themes. Buvoli explores the concepts of power, velocity and flight, recalling Futurism's enthusiasm for aviation while simultaneously encouraging the spectator to engage with the deconstruction of Futurist myths. Buvoli's work intends to be a re-contextualisation of Futurism, which, in Buvoli's words, 'questions the authoritarian and threatening side of our fascination with the future, velocity and power'.

Notes

All translations are authors' own, unless otherwise stated.
1 Several of these exhibitions are reviewed in Di Genova (2011) and Michaelides (2011).

References

Adamson, W. (2007). *Embattled Avant-Gardes. Modernism's Resistance Against Commodity Culture in Europe* (Berkeley and Los Angeles: University of California Press).

Adamson, W. (2012). 'The End of an Avant-Garde? Filippo Tommaso Marinetti and Futurism in World War 1 and Its Aftermath', in G. Buelens, H. Hendrix and M. Jansen (eds), *The History of Futurism. The Precursors, Protagonists, and Legacies* (Lanham: Lexington), pp. 299–318.

Antonello, P. and M. Härmänmaa (2009). 'Introduction: Future Imperfet – Italian Futurism between Tradition and Modernity', in M. Härmänmaa and P. Antonello (eds), *Future Imperfect: Italian Futurism between Tradition and Modernity, The European Legacy*, 14:7, 777–84.

Berghaus, G. (2006). 'The Futurist Political Party', in S. Bru and G. Martens (eds), *The Invention of Politics in the European Avant-Garde* (Amsterdam: Rodopi, 2006), pp. 153–82.

Berghaus, G. (2009a). 'Futurism and the Technological Imagination Poised between Machine Cult and Machine Angst', in G. Berghaus (ed.), *Futurism and the Technological Imagination* (Amsterdam: Rodopi), pp. 1–39.

Berghaus, G. (2009b). 'Violence, War, Revolution: Marinetti's Concept of a Futurist Cleanser for the World', in F. Luisetti and L. Somigli (eds), *A Century of Futurism 1909–2009, Annali d'Italianistica*, 27, 23–43.

Berghaus, G. (2011). 'Editorial: Aims and Functions of the International Yearbook of Futurism Studies', in G. Berghaus (ed.), *International Yearbook of Futurism Studies*, vol. 1 (Berlin: de Gruyter), pp. IX–XIII.

Bru, S. (2006). 'The Phantom League. The Centennial Debate on the Avant-Garde and Politics', in S. Bru and G. Martens (eds), *The Invention of Politics in the European Avant-Garde* (Amsterdam: Rodopi, 2006), pp. 9–31.

Bru, S. (2009). *Democracy, Law, and the Modernist Avant-Gardes. Writing in the State of Exception* (Edinburgh: Edinburgh University Press).

Buelens, G., H. Hendrix and M. Jansen (2012). 'Futurisms. An Introduction', in G. Buelens, H. Hendrix and M. Jansen (eds), *The History of Futurism. The Precursors, Protagonists, and Legacies* (Lanham: Lexington), pp. 1–7.

Bürger, P. (1984). *Theory of the Avant-garde*, trans. M. Shaw (Minneapolis: University of Minnesota Press).

Di Genova, G. (2011). 'The Centenary of Futurism: Lame Duck or Political Revisionism?', in G. Berghaus (ed.), *International Yearbook of Futurism Studies*, vol. 1 (Berlin: de Gruyter), pp. 3–19.

Gale, M. (2009). 'A Short Flight: Between Futurism and Vorticism', in D. Ottinger (ed.), *Futurism* (London: Tate Publishing), pp. 66–75.

Gentile, E. (1996). *Le origini dell'ideologia fascista 1918–1925* (Bologna: Il Mulino).

Gentile, E. (2009). *La nostra sfida alle stelle. Futuristi in politica* (Rome and Bari: Laterza).

Griffin R. (2009). 'The Multiplication of Man: Futurism's Technolatry Viewed through the Lens of Modernism', in G. Berghaus (ed.), *Futurism and the Technological Imagination* (Amsterdam: Rodopi), pp. 77–99.

Härmänmaa, M. (2009). 'Futurism and Nature: The Death of the Great Pan?', in G. Berghaus (ed.), *Futurism and the Technological Imagination* (Amsterdam: Rodopi), pp. 337–60.

Lista, G. (2009). 'The Italian Sources of Futurism', in D. Ottinger (ed.), *Futurism* (London: Tate Publishing), pp. 42–51.

Luisetti, F. and L. Somigli (2009). 'A Century of Futurism: Introduction', in F. Luisetti and L. Somigli (eds), *A Century of Futurism 1909–2009, Annali d'Italianistica*, 27, 13–21.

Michaelides, C. (2011). 'FUTURISM 2009. Critical Reflections on the Centenary Year', in G. Berghaus (ed.), *International Yearbook of Futurism Studies*, vol. 1 (Berlin: de Gruyter), pp. 20–31.

Ottinger, D. (2009). 'Cubism + Futurism = Cubofuturism', in D. Ottinger (ed.), *Futurism* (London: Tate Publishing), pp. 20–41.

Perloff, M. (2012). 'The Audacity of Hope. The Foundational Futurist Manifestos', in G. Buelens, H. Hendrix and M. Jansen (eds), *The History of Futurism. The Precursors, Protagonists, and Legacies* (Lanham: Lexington Books), pp. 9–30.

Somigli, L. (2003). *Legitimizing the Artist. Manifesto Writing and European Modernism, 1855–1915* (Toronto: University of Toronto Press).

Engaging the crowd: the Futurist manifesto as avant-garde advertisement

Matthew McLendon

In April 1912 Umberto Boccioni, writing to Carlo Carrà from Berlin and the travelling Futurist exhibition, expressed his concerns about the lack of publicity surrounding the event. He complained: 'I fear that there is not the tremendous interest of Paris and London, because the publicity has been badly organised. Marinetti should be here, it is necessary. I am neither a journalist nor a writer, nor do I have his name, or the experience of publishing' (Gambillo and Fiori 1958: 239). Boccioni's anxiety and his insistence that 'Marinetti should be here' demonstrates the Futurists' consciousness of the importance of publicity to their movement. Marinetti was the one with the 'name', and it was he who had the 'experience of publishing'. Without Marinetti the Futurist publicity machine – of which the manifesto was the primary component – obviously did not run smoothly.

Filippo Tommaso Marinetti was undoubtedly the primary momentum behind Futurism, though some may argue that his tight-fisted control over all aspects of the movement did more harm than good in the end; he is often depicted as a type of one-man public relations firm. Underlying this acceptance of Marinetti's gift for public relations is a kind of awe that inspires an uncritical acceptance of his powers of persuasion. There has been no attempt to compare Marinetti's practices of self and group promotion with those practices in the expanding realm of commercial advertising.[1] While there may be no direct evidence that Marinetti systematically studied the emerging techniques of publicity, it can be argued that there is circumstantial evidence that he did have some knowledge and understanding of the latest ideas in advertising – ideas that were firmly rooted in the emerging science of psychology. Yet it is not my intention to set up a cause and effect relationship between Marinetti and advertising theory. Rather, I shall argue that Marinetti's practice, especially as maker and instigator of

manifestos, was remarkably in tune with the latest developments in both advertising practice and theory.

Futurism has long been noted for its vigorous engagement with the mass culture of its day, and almost every study concerned with the movement references its use of early twentieth-century European ephemera in its art, both visual and literary. To demonstrate this, an examination of Futurist publications in light of popular theories of 'the crowd' and of 'suggestive advertising' will highlight the similarities in practice.

The crucial difference between the established advertising practices of the nineteenth century and the new techniques emerging at the beginning of the twentieth century is the concept of suggestion. It is no longer enough for an advertisement simply to state the specifications of the product; the new advertisement must convince the consumer – through suggestion – that the product is a necessity. As advertising is pitched at the largest audience possible, its affinity with a theory of the mind of the crowd is obvious. The theories employed by the proponents of suggestive advertising in both America and France share a view of the audience that is strikingly similar to the theory of the crowd put forth by the French psychologist Gustave Le Bon. By studying key points in Le Bon's text of 1895, *Psychologie des foules*, and then comparing these ideas with works by the American psychologist and proponent of suggestive advertising, Walter Dill Scott, as well as a little-known text by the young Giuseppe Prezzolini, a clear affinity between Futurist practice and the latest advertising theory emerges.

Gustave Le Bon was not the first to develop a theory of 'crowd psychology' though today he remains one of the best-known forefathers of what is now called social psychology.[2] In 1895 when he first published *Psychologie des foules*, recent moments in history seemed to be at the forefront of his mind – the not too distant memory of the Revolution (in particular the Reign of Terror that ensued), the rise and fall of Napoleon, and the Commune. The importance of these events cannot be overstated when considering Le Bon's theories. How did these moments happen and how could they be prevented from happening again? In the new modern age, the age of mass-production and literacy in this era of the domination of the broadsheet and the emerging 'proletariat', how could the 'right people' shape the opinions of the majority? Moreover, how could the propensity to riot be curtailed? These questions, for Le Bon and his followers, seemed best answered through the new understanding of the mind and its limitations.

While it can be argued that the Futurists were more often interested in inciting riot than in suppressing it, it is the control of the masses that Le Bon's theories promise, and this is where the interest to advertisers lay. For Le Bon, the crowd exhibits 'impulsiveness, irritability, incapacity to reason, the absence of judgement and of the critical spirit, the exaggeration of

the sentiments', characteristics that 'are almost always observed in beings belonging to inferior forms of evolution – in women, savages, and children, for instance' (1982: 40). Le Bon first gives this statement:

> A crowd thinks in images, and the image itself immediately calls up a series of other images, having no logical connection with the first … a crowd scarcely distinguishes between the subjective and the objective. It accepts as real the image evoked in its mind, though they most often have only a very distant relation with the observed fact. (Le Bon 1982: 45–6)

This passage introduces two crucial concepts in understanding the overall technique of crowd control. The first is that the collective mind of the crowd, free from rationality, reacts most strongly to images, not concrete ideas. The second concept is that the crowd is always swayed by the subjective, which it cannot distinguish from the objective or 'observed fact'. With the 'exaggeration in its feelings', Le Bon continues, 'a crowd is only impressed by excessive sentiments. An orator wishing to move a crowd must make an abusive use of violent affirmations' (Le Bon 1982: 57). Are such 'violent affirmations' what Marinetti in a letter to Henry Maassen meant when he instructed the young poet that above all the manifesto had to be constructed with 'violence and precision' (Lista 1973: 18–19)?

When later Le Bon explains that 'appeals to the sentiments of glory, honour, religion, and patriotism are particularly likely to influence the individual forming part of the crowd, and often to the extent of obtaining from him the sacrifice of his life' (Le Bon 1982: 57), he foreshadows Marinetti's irredentist and nationalist writings. In light of Le Bon's theories, I contend there is far more than mere patriotism at work in Marinetti's overtly political writings. While he certainly wants to 'reconstruct the universe', the fact that he interlaces most of his Futurist writings with broad emotional patriotic sentiment betrays a desire and an understanding that, if not directly influenced by Le Bon, is at least in consonance with his theories of audience or crowd appeal.

Of the many factors affecting the behaviour of the crowd that Le Bon posits (e.g. race, traditions, time, political and social institutions, education), he spends a great deal of time stressing the importance of images, words and formulas, and illusions. These 'immediate factors', as he terms them, have the most consonance with Futurist practice. It is Marinetti's reliance and insistence on these methods in the construction of Futurist manifestos that demonstrates how in line his actions are with this discourse. Le Bon writes:

> When studying the imagination of crowds we saw that it is particularly open to the impressions produced by images. These images do not always lie ready to hand, but it is possible to evoke them by the judicious employment of words and formulas … a pyramid far loftier than that of old Cheops could be raised

merely with the bones of men who have been victims of the power of words and formulas. (Le Bon 1982: 95–6)

Le Bon places great importance on the construction of images in the mind of the crowd through the use of oratory. The attractiveness of such a method to the poet Marinetti needs hardly to be pointed out. However, it is in what follows the use of images that the true understanding of how crowd psychology, advertising and Futurism are intrinsically linked: the illusion. The illusion, or *lie* as Giuseppe Prezzolini later calls it, is what I believe we today would term a narrative (Prezzolini 1991: 30). Le Bon instructs that in order to control the crowd the leader must give it a 'story' or 'illusion' in which its conviction can rest. This kind of narrative is in almost every Futurist text, beginning with the first manifesto, and can be found to one degree or another in every popular movement.

Le Bon's treatise on the crowd introduces a number of concepts that were just beginning to be explored by psychologists in the late nineteenth century. Leaving nineteenth-century Europe and now focusing on early twentieth-century American thought, an understanding can develop as to what importance these revolutionary ideas in psychology would have in advertising; advertising that would change not only the marketing of commodities in the capitalist markets of Europe but also the marketing and selling of the new Italian avant-garde. For when the methods prescribed by the American Walter Dill Scott are studied in detail, their relevance to Futurist practice is illuminated.

Dr Walter Dill Scott was the Director of the Psychological Research Laboratories at Northwestern University in Chicago. In his two books, *The Theory and Practice of Advertising: A Simple Exposition of the Principles of Psychology in their Relation to Successful Advertising* (1903) and *The Psychology of Advertising* (1908), Scott presents his own research into the workings of the mind and instructs the businessman how that research is best applied to the commercial pursuit of advertising.[3] These ideas are then elaborated on, in France, by Octave-Jacques Gérin and Camille Espinadel in their book *La publicité suggestive* (1911), providing a bridge between American and European practice.

Scott stresses the importance of attention, association and suggestion in the advertisement. According to him, in order for the advertiser to attract the attention of the consumer, he must employ intensity of emotion, simplicity of message and repetition – three key tools to be used by Le Bon's leader of the crowd. Here it is seen that the 'audience' of the advertiser is in fact the 'crowd' of Le Bon and so Scott's audience is portrayed in the same simplistic, primitive terms. The audience must be led to the right decision (to buy the product), just as the crowd must be led to the correct action (support of the leader).

When comparing the methods of suggestive advertising with Futurist manifestos, a key aspect of Scott's theory is the concept that 'the power of any object to attract our attention depends on the intensity of the sensation aroused'. To illustrate this point he references another American researcher:

> Professor Harlow Gale has made some experiments to determine what the attention value of different colors is. He has found that red is the color having the greatest attention value, green the second, and black the third ... Large and heavy types not only occupy a large amount of space ... they affect the eye and give a strong sensation. (Scott 1907: 14)

Anyone who has seen even a few Futurist publications immediately recognises their application of these ideas. The manifestos almost invariably begin with the title in very large, simple, black type. The Futurist manifestos were of course not the only publications employing large, attention-grabbing type. This was commonplace by the turn of the twentieth century, as can be seen in an advertisement for *Olio Sasso* found in *Corriere della Sera* (5 July 1914). This advertisement bears a striking resemblance to a number of Futurist manifestos in the large, bold type and use of short, bullet-point-type text.

Just as Le Bon instructs the leader to appeal to 'the sentiments of glory, honour, and patriotism' in the crowd, so too does Scott state that 'in the ideal advertisement the emotions and sensibilities of the possible customers must be appealed to'. He goes further in advising that while emotions such as curiosity, sympathy, pride and ambition 'have been awakened by the skilful advertiser', the advertiser must not forget that joys *and* sorrows are both usable (Scott 1907: 29–30). As stated above, I interpret Marinetti's overt patriotism as far more than a simple love of his country. By appealing to such strong sentiments – sentiments made even stronger by the hint of war – Marinetti ensured his message was more palatable to the largest possible audience.

Before considering the work of the Italian Giuseppe Prezzolini, a discussion of Scott's understanding of the term 'suggestion' is necessary. The theory of suggestion presented by Scott in the first of his two books discussed here, *The Theory and Practice of Advertising*, is simplistic by today's standards and is not as complex as that offered by Le Bon. Scott's 'law of suggestion' simply states: 'Every idea of a function tends to call that function into activity, and will do so, unless hindered by a competing idea of physical impediment' (Scott 1907: 47). Therefore, according to Scott, if a person thinks of bending a finger it will bend, and if a person thinks of pulling his or her own nose, the action will take place until reason is restored. Yet actions are not the only things that can be 'suggested'; ideas, too, are invoked through suggestion. The words and images used in the advertisement must suggest the 'idea' of the product advertised.

It is in his later book, *The Psychology of Advertising*, that Scott expands his explanation of suggestion and ties it in with his concept of the will. He differentiates between two methods of suggestion. The first is the suggestion of ideas through the actions of others. This method of suggestion is seen by Scott as the most effective. The second method of suggestion is ideas that are suggested by the words of our companions. It is this method that he sees as pertaining to advertising: 'Advertisements that are seen frequently are difficult to distinguish in their force from ideas which are secured from the words of our friends. Advertising thus becomes a great social illusion' (Scott 1909: 84). To be effective at suggesting ideas, advertisements must be frequently repeated; this has been established before. Of more interest is the second part of this sentence, for it is here that Scott introduces the idea of 'illusion'. The advertisement that is oft repeated becomes indistinguishable from the recommendations of friends – it becomes a substitute in the mind for a testimonial. The illusion then becomes fact through the repetition of the suggestion. This entrance into the 'social illusion' is acquired through the narrative action of advertisements. Repeated often enough, the advertisement (or manifesto) becomes indistinguishable from fact – the images and emotions have swayed the crowd.

Finally, the works of the American Walter Dill Scott must be established as important in a discussion of European advertising practices. As alluded to above, Scott's theories were well known in Europe. The editions of his works cited here are those published in London soon after their initial publication in the United States. More important, however, is the fact that Scott wrote the introduction to Gérin and Espinadel's text, *La publicité suggestive*, mentioned above. Its authors were instrumental in the debates between orthodox advertising practices and the new, psychologically informed advertising of the early twentieth century. Scott's theories are thus shown to have currency in France which, since the middle of the nineteenth century, led the way in continental advertising. It was to France that the advertising men of Italy looked, and knowing of Marinetti's love of all things French – more specifically Parisian – Scott's notoriety in France increases the likelihood that Marinetti would have encountered his theories of 'suggestive advertising' even if at a remove.[4]

The last work to be discussed briefly before examining examples of Futurist practice is Giuseppe Prezzolini's *L'arte di persuadere* (1907), written when Prezzolini was just twenty-five years old. Prezzolini's work owes much to Le Bon, indeed parts are direct paraphrases of Le Bon's work on the crowd. The same techniques of simplicity of message, repetition and the use of image over fact all figure heavily in his argument. Yet, the concept I wish to focus on here is *la bugia* – the lie. Prezzolini's idea of the lie is at the heart of his argument – it *is* the art of persuasion, it is the keystone:

'The better, more practical, more normal examples of the art of persuasion find themselves in lies ... there are infinite professions in which the lie is socially useful and considered an insignificant necessity of the occupation' (Prezzolini 1991: 30).

Prezzolini then goes on to list diplomats, doctors and priests as such occupations. Next, he offers a distinctly intuitive understanding of popularity and what makes one, in his words, an 'eminently social' man:

> The eminently social man is he that never speaks the raw and naked truth to the people, in doing so, softening and distorting he renders himself dear to all and is at peace with everyone. Molière affirmed the social value of the lie painting for us the Misanthrope as one who is terrible and truthful, who lamely spoke the lame verses of the poets and mocked the stupid words of women, even if he was a friend of the poet or enamoured by some woman. And so, more than one who hates, his Misanthrope is hated by men. (Prezzolini 1991: 31)

Prezzolini begins by instructing his reader that in order to be popular, in order to be a leader, he must shy away from 'the raw and naked truth'. Prezzolini's advice seems calculating and callous, even cynical. His leader will lead not with truth but with deception. Yet, this 'lie' shares similarities with the advice of both Le Bon and Scott:

> There is for example, a fundamental point of the theory of lies that many are ignorant of, that is to say; to form a lie that has the greatest probability of being accepted, it is necessary to observe the same rules the scientist follows forming scientific theories; the lie and scientific theory respond to the same intellectual needs ...
>
> *a) economy*, namely simplicity and easiness of understanding and of organization being a tool of every theory
>
> *b) biological coherence*, that is to say, scarcity of close contradictions
>
> *c)* agreement *with the facts*, that is, in balancing a) to b) one chooses the theory that reconciles itself with the greatest number of explainable facts that obtain a certain degree of security by being difficult to deny in the future. (Prezzolini 1991: 32)

In the above passage, Prezzolini seems to be taking his lead directly from Le Bon. Le Bon published his work in 1895, Prezzolini in 1907. The overall message is that the lie must be simple because the people (crowd) are not able to digest complexities or subtleties of thought. Prezzolini is echoing the latest 'scientific' hypotheses and can therefore be read as a bridge between Italy and France. He continues:

> The lie is not, therefore, the main port of entrance of science, and a study of the lie is not an introduction to the art of persuasion. But rather it is an introduction to the art of invention; the poet is a liar that delights, the scientist

a liar who makes useful things; the poet and the scientist are creators as is the liar ... industrial-scientific and poetic inventions find among themselves the close ancestor of the childlike lie. (Prezzolini 1991: 35)

Prezzolini does not see the lie as vicious; on the contrary, to him the lie is a mark of innovation or creation and is the foundation for persuasion. Prezzolini's lie can, I think, be given a parallel reading with Le Bon and Scott as a type of narrative that each proposes – though they do not necessarily use that term. Both Le Bon and Scott refer to the necessity of images, whether they are of a nationalistic and patriotic type in the case of Le Bon or in the form of sensations of desire associated with a product as espoused by Scott. These images form a narrative idea in the mind of the audience. If done well and repeated often, the audience will come to believe they have held this idea all the time. Scott uses the example of an advertisement repeated so often that the consumer assumes he or she has heard of the product from a friend. Le Bon calls the lie the *illusion*. It is worth quoting Le Bon's thoughts on this issue:

The masses have never thirsted after truth. They turn aside from evidence that is not to their taste, preferring to deify error, if error seduces them. Whoever can supply them with illusions is easily their master; whoever attempts to destroy their illusions is always their victim. (Le Bon 1982: 105)

Le Bon, Scott and Prezzolini all offer similar advice: speak to the crowd in simple images, do not go against their beliefs rather work with them, and repeat your message (narrative) again and again until the crowd believe it to be an independent thought. It is this lie or narrative structure that is to be one of the Futurists' greatest tools of influence.

With this discussion of suggestion and the tools of both the leader and advertiser in mind, there is no better place to begin a discussion of Futurist writings than with the Founding Manifesto of 1909. This is, arguably, the most familiar and most written about Futurist text. Most commonly, in English as well as Italian, the first manifesto is referred to as *Fondazione e Manifesto del Futurismo*.[5] What is interesting about this title is that it breaks the first Futurist publication into two distinct parts. The first part is 'the founding' the second part 'the manifesto'. What sets apart this first manifesto is that it is prefaced with a lengthy narrative. Like most good stories, this one seems not to be overly encumbered with facts. Yet, that Marinetti chooses to preface his movement's inaugural manifesto with a narrative is most telling. Marinetti and his friends, having just been lazing about under filigreed mosque lamps in a state of ennui are off literally to change the world. This beginning narrative, championing the industrial age, is familiar enough not to need repeating here. Yet its importance, especially when viewed in the context of Le Bon and Prezzolini, is essential

to a further understanding of why Futurism as a movement was so successful in having itself noticed.

Marinetti's narrative illusion is fundamental in giving his public a tangible understanding of what his new movement was to mean to them. By prefacing the manifesto with this story, the reader is invited into this private world of intimate friends and is brought along on the violent path to epiphany. The reader becomes one of the 'friends' in the narrative. A familiarity with the movement is established as well as a mythology which insists that Futurism was a movement founded by many – not by one man, as we now know it to have been. Marinetti understands that the crowd think in images and are not overly concerned with fact. Remembering Le Bon's admonition that a 'pyramid far loftier than that of old Cheops could be raised merely with the bones of men who have been victims of the power of words and formulas' (Le Bon 1982: 117), it is clear that, whether or not he had actually read Le Bon, Marinetti has chosen to lay the foundation of his pyramid very much as Le Bon had advocated, using the power of words and images.

Quite apart from theory, this use of narrative, in fact, has a direct parallel in the practice of commercial advertising. At the turn of the twentieth century a series of advertisements ran in French and Italian newspapers for *Pilules (Pillole) Pink*. One could say these advertisements were in fact ubiquitous. Such was their instant recognisability that Marinetti himself was referred to as the 'Poeta Pink' in the press during his pre-Futurist days. Already before the onslaught of Futurism Marinetti was seen as an ad-man whose actions to popularise his literary magazine were interpreted as analogous to a commercial advertising campaign.

The *Pillole Pink* advertisements are all similarly structured. A picture of a woman, appearing weak or grief-stricken, is followed by a lengthy text. This text (narrative) serves to explain what causes the woman's suffering. Invariably, this dilemma affects thousands like her. A woman is seated before her window looking out. Across the road a wedding procession is leaving the church; the woman is literally watching life go by. The text asks us: 'Why do so many young women find themselves not married?', and quickly answers: 'It is often due to bad health that suitors are absent'. The illustration and text provide the reader with a plot in the same way that Marinetti's introduction to the Founding Manifesto does. The reader or consumer can empathise and place himself or herself into the story.

The *Pillole Pink* campaign demonstrates a number of techniques advised by Scott. The overall style is repeated for the sake of recognition, but there are subtle changes. As both the illustration and the text change, the story also changes week to week, prompting the reader to 'tune in' for this week's instalment. The suggestion comes from within the narrative. Are you weak,

depressed, jaundiced, etc. like the poor lady here? If so, the pink pill will take away all of your troubles. How little the methods of advertising have changed from 1914 to today.

Turning now to the publicity techniques employed by the Futurists for their *serate*, we see an even more complex and audacious use of advertising both before and after the event. What may be deemed the first fully fledged Futurist *serata* took place at the Politeama Rossetti in Trieste on 12 January 1910 (Berghaus 1998: 86). Soon after that night, Marinetti published the *Rapporto sulla vittoria del Futurismo a Trieste* (Caruso 1990: 6). This report took the form of a booklet beginning with a narrative telling of a train journey into the future. Günter Berghaus (1998: 90) has pointed out that this train journey closely parallels the automobile journey that begins the Founding Manifesto. What is most striking about the Rapporto is that a number of newspaper reviews are included in a section titled 'Le fanfare della stampa'. These reviews offer vivid descriptions of the event and its reception. Most importantly to this discussion, these newspaper articles, chosen by Marinetti to publicise his success in Trieste, reference the onslaught of publicity unleashed on the city beforehand. Writing in the *Indipendente*, Arturo Bellotti speaks candidly about the Futurists' use of advertising:

> It must be that the violence of publicity [was] to rouse the sleepers. And the duke of the Futurists, the prince of these warriors knows it well, and it seems to some a misuse of the violence of advertising. Although in short the advertising nowadays is not equal to nor can it be similar to that used 50 or 100 years ago. Everything is susceptible to change, and by now it would be foolish to still believe it's not ... here's to the triumph of modesty. (Caruso 1990: [6], 39)

This is a contemporary view of the Futurists' use of 'violent' advertising. It is brash, some would say a misuse, and certainly not the modest notices of fifty years ago. Yet, again this shows that by the early days of the Futurist movement Marinetti – the warrior prince – was known to 'know it [advertising] well'.

Before concluding, we will now look at one manifesto taken from a group of manifestos. These manifestos are important in this discussion not so much for what is said but for how it is presented. This group of five manifestos dating from March 1913 to March 1914 illustrates a coherence in presentation and structure as well as an overt attempt at advertising. *Il Teatro di Varietà* dated 29 September 1913 can be taken as representative of this group.[6] The title and subtitle form a masthead analogous to the masthead of a newspaper. The manifesto is four magazine-sized pages, front and back. Main points and Futurist words are printed in boldface.

This manifesto, like the others in this group, has a discernible style with only slight variations. Anyone picking it up can immediately recognise it as a Futurist publication.

However, what is most important about *Il Teatro di Varietà* are two small boxes that appear in the masthead section. The left box advertises *Lacerba Giornale Futurista*, giving both the address of its office and the price. The right box advertises the Galleria Permanente Futurista on the Via Tritone, Rome. Here the true intention of the Futurist manifesto is clearly illustrated. It is above all an advertisement, and within the larger advertisement smaller ads can appear which bear no relation other than being Futurist enterprises. These small box ads have a direct correlation to advertisements in newspapers and journals. Typically at this time the back page of a newspaper would be devoted to larger, more complex advertisements. However, smaller ads would appear elsewhere in the paper. It is this latter form of advertisement that the Futurists have 'copied' for the masthead of their manifesto.

The masthead of *Il Teatro di Varietà* includes another form of publicity as well. Under the subtitle 'Futurist Manifesto', the reader is told that this particular manifesto was also published 21 November 1913 in the *Daily Mail* in London. By including this citation, Marinetti gives further evidence for the international pedigree of his movement whilst at the same time blurring the distinction between polemic and advertisement. *Il Teatro di Varietà*, published in a broadsheet filled with advertisements employing modern techniques of persuasion, and here published in pamphlet form, blends the disparate forms of advertisement into one.

The above argument leads to me to conclude that there was a strong correlation between the emerging fields of psychology, advertising, and the Italian avant-garde. Yet perhaps the most conclusive evidence for this comes from the Futurists themselves. In 1927 Fortunato Depero published one of the masterpieces of Futurist self-promotion, the book *Depero Futurista*, which contained a highly stylised retort to those who felt Futurism blurred the lines between high and low art to the detriment of the avant-garde project. The text forms the head of an arrow so that both visually and textually the point is made. The title in boldface, lowercase type reads simply, 'necessità di auto-rèclame'. Depero writes plainly:

> Self-promotion is not [a] vain, useless, or an exaggerated expression of megalomania, but rather an indispensable NECESSITY for rapidly making known to the public the correct ideas and creations …
>
> Only for our producers of genius, of beauty, of art, is publicity considered such abnormal, ambitious mania and impudent immodesty. (Depero 1927: 5)

Depero has clearly stated the Futurists' opinion. Though it comes some

years after the main period with which this study is concerned, there is no reason to think the Futurists thought any differently concerning advertising before this date. Again, advertising was not a tool that could or could not be used; for the Futurists it was a necessity.

Notes

1 This is certainly true of English-language studies. While the relationship between advertising and Futurism has been explored in a number of texts, this discussion has always followed the lines of a similar discussion within the context of Cubism. Historians have looked at the actual advertisements that are often included in works either through collage or illustration. While this proves useful in problematising the relationship between the avant-garde and the consumer world as well as the distinctions of high and low art, it remains fundamentally superficial. What I hope to gain here is a more complex theoretical understanding of the techniques of self-promotion used by the Futurists in light of the contemporary theory on the advertisement of consumer goods.

2 Susanna Barrows (1981) traces Le Bon's theories back through Taine, Zola, Espinas, Sighele, etc.

3 My interest in the theories of Walter Dill Scott and the relation of these theories to Europe comes out of a reading of Simon Dell's excellent PhD thesis. Simon James Dell, 'The Personality of Choice Subjectivity and Commodity Culture France c.1918–1935' (Courtauld Institute of Art, 1995). Dell remarks: 'Scott's work … has been taken as the birth of scientific ("psychological") publicity … Scott's work was first cited in France in 1904, in the first brief article on the conjunction of psychology and publicity: Anon. "La Psychologie de la publicité" pp. 2–3 in La Publicité (No. 8, March 1904)' (Dell: 58, note 10).

4 Gérin and Espinadel were indeed known in Italy. Their work is cited by Lancellotti (1912), who also discusses many of the same techniques as his French counterparts.

5 This title does indeed have precedents in the Futurist publications themselves. An Italian version published in pamphlet form by the Direzione del Movimento Futurista in Milan in 1909 was so named. For a facsimile see Caruso (1990: 3). A curious nomenclature surrounds this first manifesto. Sometimes it is referred to simply as the first manifesto of Futurism. When it appeared on the front page of *Le Figaro* it was simply titled *Le Futurisme* – although in the brief introductory paragraph it was referred to as the 'manifeste des *Futuristes*'.

6 The other manifestos of this group are *L'arte dei rumori*; *Controdolore*; *Pesi, misure, e prezzi del genio artistico*; and *Lo splendore geometrico e meccanico e la sensibilità numerica*.

References

Barrows, S. (1981). *Distorting Mirrors: Visions of the Crowd in Late Nineteenth-century France* (New Haven: Yale University Press).

Berghaus, G. (1998). *Italian Futurist Theatre 1909–1944* (Oxford: Clarendon Press).

Caruso, L. (ed.) (1990). *Manifesti, proclami, interventi e documenti teorici del futurismo 1909–1944* (Florence: SPES).

Depero, F. (1927). *Depero Futurista* (Milan: Edizione della Dinamo).

Gambillo, M. D. and T. Fiori (eds) (1958). *Archivi del Futurismo* vol. I (Rome: Istituto Grafico Tiberino di Luigi De Luca).

Gérin, O.-J. and C. Espinadel (1911). *La publicité suggestive. Théorie et technique* (Paris: Dunod et Pinat).

Lancellotti, A. (1912). *Storia aneddotica della réclame* (Milan: Dott. Riccardo Quintieri).

Le Bon, G. (1982). *The Crowd: A Study of the Popular Mind* [*La psychologie des foules* 1895], trans. unknown (Atlanta: Cherokee Publishing Company).

Lista, G. (1973). *Futurisme: manifestes, documents, proclamation* (Lausanne: L'Age d'Homme).

Prezzolini, G. (1991). *L'arte di persuadere* [1907], introd. A. A. Rosa (Naples: Liguori Editore).

Scott, W. D. (1907). *The Theory and Practice of Advertising: A Simple Exposition of the Principles of Psychology in Their Relation to Successful Advertising* [1903] (London: Sir Isaac Pitman and Son, Ltd).

Scott, W. D. (1909). *The Psychology of Advertising* [1908] (London: Sir Isaac Pitman and Son, Ltd).

Heroes/heroines of Futurist culture: oltreuomo/oltredonna

Jennifer Griffiths

Futurism was born in an atmosphere of Hegelian idealism and Bergsonian pragmatism when philosophers and thinkers were refuting notions of objective removal from political or social affairs and insisting instead upon the importance of engagement. Like Giovanni Gentile's 'Actual Idealism', Marinetti's Futurism declared any philosopher, writer or artist isolated from life to be culturally bankrupt. Futurism's assertion about the primacy of the artist and his art followed the traditions of Schopenhauer, Wagner and Nietzsche. In this spirit Futurism placed the artist at the centre of socio-political affairs. The artist formed part of a unique creative elite, whose talents should be used in the service of education and national achievement. The birth of the creative genius follows the infamous death of God. In particular Futurism made use of Nietzsche's conception of the *Übermensch*, best translated as 'overman'. The theorising of an extraordinary human being of the future would become a fundamental element in the ideas of F. T. Marinetti at the heart of the Futurist project. His ideal of the *superuomo* would have tremendous influence on the personage of the Futurist artist, who was acclaimed by the Futurists as a *man* of action, a *man* whose superior intellect would be actively engaged therefore in the creation of his world, but always assumed to be a man.

The insistence of a socio-political role for the artist had implications for women who were being excluded from active public life in Italy, particularly in the postwar periods. Yet, strangely enough, women writers and artists of the Futurist movement existed and succeeded alongside their male contemporaries. How does the concept of the *superuomo*, such a significant part of the Futurist discourse, relate to the participation of women within this masculinist ambit? In the following pages I would like to examine the relationship between the concepts of *Übermensch* and *superuomo* to insist upon the unique character of Marinetti's concept and ask how

the principle of a *superuomo* contributed to the gender discourse within Futurist art.

The back cover of the 2003 Mondadori edition of *Mafarka il futurista* describes the book as being 'di netta derivazione nietzschiana'. The frequency of the declaration that Marinetti's work is so 'clearly derived' from Nietzsche deserves scrutiny. The terms *Übermensch*, *oltreuomo* or *superuomo* are scattered in studies on Futurism. In popular literature the terms are often used interchangeably. While scholars in other fields such as philosophy and comparative literature have examined distinctions between the concepts, art historians often perpetuate an uncomplicated parallelism between them. Little clarification is made for the reader of art history about the philosophical underpinnings of these ideas. Similarities between Nietzsche and Marinetti are frequently drawn, but the distinct nature of Marinetti's concept is obscured. So how Nietzschean is Marinetti's oft-noted 'Nietzschean cult of the superman' (Poggi 2009: 35)?

Let us first examine the nature of Nietzsche's concept. The concept of *Übermensch* was distorted in the rhetoric of German National Socialism. Nietzsche died in 1900 leaving his ideas prey to exploitation by his sister, who edited some of his work to align his philosophy with Nazi ideals. In her introduction to *Thus Spoke Zarathustra* Elisabeth Förster-Nietzsche explains her brother's conception of an elite human being defined by terrific healthiness. She writes: 'a new table of valuations must be placed over mankind – namely, that of the strong, mighty, and magnificent man, overflowing with life and elevated to his zenith – the Superman, who is now put before us with overpowering passion as the aim of our life, hope, and will' (Förster-Nietzsche 1917: xi). Her analysis focuses on the physical character of the *Übermensch*. Yet the statement may well reflect her views rather than those of her brother. Förster-Nietzsche's support of the Third Reich and her brother's contrasting personal objections to both anti-semitism and German nationalism should be duly noted while assessing our current understanding of *Übermensch*. Our postwar understanding of the *Übermensch* has been distorted by political history and tangled up with Marinetti's *superuomo* in the aftermath. There is a distinct character to the *Übermensch*. Nietzsche's historic association with the right-wing political agenda of European politics was the result of ideological manipulation, but also resulted from the intentionally ambiguous nature of his *Übermensch*. As early as 1911 Alfred Richard Orage (1911: 71) wrote in his biography of Nietzsche: 'The truth is, Nietzsche himself found it impossible really to describe the Superman'. F. C. Copleston (1942: 231) wrote in 1942 that it is 'absurd' to look for a definition of the *Übermensch* in Nietzsche since the concept represents 'man-surpassed' who 'is not yet but is to be.' Nietzsche scholar Keith Ansell-Pearson (1992: 317) has instead written

that the *Übermensch* demands an understanding of 'how to become what we are' and a courageous acceptance of life as its own justification. His clarification of the term *Übermensch* states: 'In *Ecce Homo* Nietzsche writes that the notion of the *Übermensch* is not in any way to be conceived along Darwinian lines or as representing a transcendental ideal of man. The *Übermensch* is thus not an ideal that is posited in terms of an infinite future beyond the reach of mere mortals; it is not a "super" or "above" (über) in this sense' (1992: 316). Translations of the term *Übermensch* have always been slippery precisely because of the multiple meanings that can be attributed to the German *über*. Ansell-Pearson (1992: 317) explains that within the term *Übermensch* itself exists Nietzsche's play with the nuanced meaning of *über* to relate the very struggle for change within the self. He writes that Nietzsche's call for self-overcoming and transformation 'is a question of giving birth, of child-bearing'. Thus the concept of *Übermensch* is uncertain and elusive, but suggests itself as a term through which one might negotiate states of becoming and change. This description, as we will see, is a far cry from the Futurist *superuomo*.

A closer look at the *Übermensch* offers a clearer lens through which to see the parallel, but distinct, Futurist *superuomo*. Nietzsche and Marinetti shared the same dream for a transformation of society, but Nietzsche's mandate for mental transcendence is in direct contrast to Marinetti's longing for physical transcendence. In other words the physical body played a lesser role in Nietzsche's philosophy. The *Übermensch* is born in the mind, but the *superuomo* is born in the flesh. The Nietzschean and Marinettean supermen thus take distinct sides in the argument of Cartesian dualism. The persistent Nietzschean references within Futurist art analysis imply that distinctions between the Nietzschean and Futurist supermen must be minor, yet I would argue that, given the historical importance of a gendered mind/body discourse, this departure, far from being negligible, is crucial to any discussion of gender and Futurism. The materiality of the Futurist *superuomo* anchors Futurism within a classical Aristotelian gender discourse that seeks to appropriate creative force for men and minimise the creative role of women. While Marinetti took great inspiration from Nietzsche, his superman is not cut from the same cloth. Before continuing to explore this major difference between the *Übermensch* and *superuomo* concepts as it relates to Futurist women, let me remark upon an interesting correspondence.

Destruction and regeneration

Both Nietzsche and Marinetti failed to escape past tradition or present condition to create something totally new. Marinetti openly disassociated his

superuomo from the *Übermensch*, strongly desiring to create an authentically
Italian movement that was independent of foreign roots. Marinetti's main
criticism of Nietzsche related to the latter's praise for ancient Greek culture.
In *Contro i professori* of 1910 Marinetti decried Nietzsche's *Übermensch*
as Greek. He says: 'We are opposed to this Greek Superman, begat from
the dust of libraries, and against him we set the Man who is extended by
his own labors, the enemy of books, friend of personal experience, pupil
of the Machine' (Marinetti 2006: 81). Yet Nietzsche's praise for Greece
was in fact inspired by what he perceived as the independence of Greek
thinking; it was a reminder that the highest forms of culture are created
independently. Nietzsche was in no way advocating a return to Greek
culture. As Copleston (1942: 232–3) wrote, Nietzsche's philosophy was
designed to be 'an instrument of creation', a call not to know the present
or past 'but to create the future'. However Marinetti's manifesto adamantly
decries both Greece and Nietzsche, emphasising the creative autonomy of
the Futurist 'extended man' who is 'cultivator of his own will' (Marinetti
2006: 82; Marinetti 1983: 307). It is in this rebuff that Marinetti actually
reveals his closest alignment with Nietzsche who called on man to be the
creator of his own world and never to turn to the past for inspiration.
This example is crucial in revealing how both Nietzsche and Marinetti
advocated the evolution of mankind via the organic formula of death and
rebirth/destruction and creation. Creation was the objective for both, but
they intended the new to rise like a phoenix from the ashes of the old.
Therefore Marinetti believed that the *superuomo* could be born only from
the ashes of the *Übermensch*. It is in Marinetti's attempt to expunge from
his *superuomo* the antecedent and foreign *Übermensch* that we truly discern
its most powerful presence.

The formula of destruction and regeneration, which underlies the Futurist
project, can be read in the manifestos and has been continually observed in
the writings on Futurism. Marinetti's manifestos advocate the formula with
ferocious zeal, as famously evidenced in point 10 of the 1909 manifesto
with its call to demolish museums, libraries and academies. The creation of
Marinetti's mythical *superuomo* through a process of destruction followed
by regeneration or rebirth is in fact the central theme of Marinetti's novel
Mafarka il futurista (1909). *Mafarka* is a novel about male partheno-
genesis, narrating a fantasy wherein a *superuomo* is born to a male father
without contamination by the female corpus. Gazurmah, Mafarka el-Bar's
mechanical son and the embodiment of Marinetti's *superuomo*, is born
with Mafarka's self-sacrifice. Mafarka sculpts his progeny from wood and
is commanded by the ghost of his dead mother to give his creation the kiss
of life. After passing his anima to his son, the same son throws him against
the rocks. Only with the destruction of his father can Gazurmah burst into

life. Mafarka the superman gives birth to Gazurmah, the super-superman of the next generation. Marinetti's concept of the *superuomo*, thoroughly explored in this novel, represents the zenith of a dream for pure, unfettered masculinity. It has been noted by Cinzia Sartini-Blum (1996a: 31) that this formula of destruction and rebirth is predicated on gender divisions. She writes: 'the futurist epistemological and aesthetic model [is cast] into a gendered situation, which sets up an aggressive, virile subject against a feminised reality that must be conquered or destroyed'. Ann Bowler (1991: 771) has also discussed the same theme, stating that in Futurist theory 'it is ... the female body that forms the landscape of decay and disorder that afflicts Italian culture'. The goal of violent Futurist rhetoric is the rebirth or regeneration of masculinity, perceived to be under threat of extinction from the feminine. In Marinetti's tale violent and heroic death is gendered male and embodied in characters such as Mafarka-el-Bar; while woman, specifically Coloubbi (Mafarka's former lover), comes to represent the death of disease or decay. Marinetti casts the feminine as carrier of contagion and disease, thus Marinetti's project of masculine empowerment via the birth of a superman necessitates the excision of woman. Woman as mater/material must be removed from the act of (pro)creation, where once she took pride of place. Healthy regeneration becomes a male prerogative. As Barbara Spackman (1996: 55) has eloquently summed up, the novel eliminates woman 'as matrice, mater, empty receptacle but also as "vulva", as object of sexual desire'. Spackman's remark highlights the unequivocal nature of Marinetti's procreative fantasy. Woman, marked by lack and tainted by decay, can take no part in the ideal human creation: the ultimate *super-uomo*, Gazurmah. He can attain a pure masculine pedigree only without a mother. Again, such physical prescriptions and descriptions for the creation of Marinetti's *superuomo* are foreign to the Nietzschean ideal.

Nietzsche shared the common nineteenth-century bourgeois attitude of his fellows and cannot be called a feminist. However, Nietzsche does cast woman in a central role within his formula of creation and evolution. In Ansell-Pearson's estimation, 'Nietzsche uses the idea of "woman" as a metaphor for life understood as eternal pregnancy and fecundity. It is woman who thus embodies, who bears and carries, the overman as life's perpetual desire for self-overcoming' (Ansell-Pearson 1992: 327). From this perspective Nietzsche views women in the Aristotelian role of material embodiment. Yet his philosophy condemned Cartesian dualism, instead celebrating both physical and mental aspects of the human condition. Nietzsche refuses to condemn the material to triviality as Aristotle did; he refuses to accept the superiority of mind over body that became fundamental in Christianity. Thus Nietzsche's philosophy has radical implications for women and gender. Ansell-Pearson (1992: 327) writes that

one can see 'in Nietzsche's writings a celebration of the "feminine" and of woman conceived as sensuality, the multi-faceted body, and passion, an affirmation which stands in marked contrast to the masculinist tradition of Western philosophy'. In fact these radical implications were taken up within the early Futurist work of Valentine de Saint-Point as discussed by Günter Berghaus (1993: 27) and Siobhan Conaty (2002: 70). The friction between Nietzsche's and Marinetti's ideas may have continued to fuel the creative fires of later women Futurists.

It is not difficult to see the origins of *Mafarka*, Marinetti's story of male (pro)creation, in the mythical birth of Minerva from the head of Zeus or classic tales such as Pygmalion or Pinocchio. In this sense Marinetti's imagination seems powerfully activated by classical traditions. All three tales recount miraculous acts of divine creativity by men, a plot derived from Aristotelian principles that are deeply embedded in the Western consciousness. In his *De generatione animalium*, *De partibus animalium* and *Historia animalium*, Aristotle sets out his theory of causation, which speculates four causes involved in the process of procreation (efficient, formal, material and telic). Aristotle attributed only what he viewed as the least important of these causes, the material cause, to the female. He further extended the implications of this theory to assert global distinctions about feminine passivity and male activity. Aristotle's theories of embryology formed a basis for asserting the superiority of male formative powers in the process of procreation; in short Aristotle attempted to appropriate the creative elements of procreation for men.[1] Aristotelian ideas lie at the heart of Marinetti's tale of Gazurmah's divine creation just as they sit within a masculine Western tradition. His theories were adopted by medieval scientists, quoted in Renaissance debates, and infuse early modern and modern gender ideals.[2] Nietzsche and Marinetti both build on the philosophical precedent of Aristotle, but, while Nietzsche differs from Aristotle in his celebration of the material, Marinetti, like Aristotle, trivialises material cause and in fact seeks to liberate male creative force from the constraints or limits of the material, which is always equated with woman. Thus, even while the roots of the *Übermensch* and *superuomo* can be traced to a common source, they diverge on the matter of materiality.

Immanence and transcendence

Submission to the limits of physical or material reality is the task that Nietzsche (2009: 28–34) sets for his overman, as described in the tale of *Thus Spoke Zarathustra* (1883–85). The overman's will is a mental ideal. In contrast Marinetti's *superuomo* represents a search for the physical ideal of man who will not submit to the earth but rise above and beyond it. This

is an important point of departure for it returns Marinetti to the ancient mind/body division that Nietzsche desperately sought to disqualify. For Nietzsche the desire for physical transcendence distracts from the living of life. Nietzsche's overman does not believe it is possible and does not seek to break free from the physical realities of the body, but he seeks to master them. Marinetti, however, envisioned the *superuomo* as a man-machine hybrid representing the possibility of transcending the limits of frail human flesh by physical transformation. His conception of the new breed of man shares Nietzsche's energy, intuition, and will to power, but ultimately stems from the mythical and seeks empowerment from technology, which may be born of man, but is attributed Godlike powers. While Nietzsche sought to obliterate the idol, Marinetti was erecting a new one. Christine Poggi (2009: 233) has observed that the Futurist reverence for the machine closely resembled religious idolatry: 'Fetishised in works of art and literature, the machine displaced both the idealised woman and the religious icon, triumphing over these now superseded divinities with its cold, hard, and metallic forms'. Such a philosophy falls back once more on the hope for physical transcendence. Ansell-Pearson (1992: 317) explains that 'the paradox of Zarathustra's vision of the overman is that we seek in it the monumental or fantastic when its meaning lies in how to become what we are'. Marinetti's *superuomo* represents precisely this search for the fantastical. He is a figure that refuses to accept immanence and searches for transcendence through fusion with the machine and physical domination of his environment. Mafarka declares to his unborn mechanical son, 'Here you are invincible', and later 'Yes! You are immortal' (Marinetti 2003: 208, 209). His superhuman son has shed the limitations of the body to become invincible and immortal. Rather, the strength and heroism of the *Übermensch* is in his knowledge and acceptance of inexorable human immanence.

Evidently Marinetti's concept of *superuomo* is far more akin to the traditional superhero, augmented as he is by technology and born outside normal reproductive circumstances. Gazurmah's superhuman fusion with technology has given him the ability to literally fly beyond the earthly or material realm. Gazurmah, when seen to represent Marinetti's *superuomo*, points to an important Futurist fantasy of escape from nature, escape from the body and escape from the imperfection of the material world, represented by and embodied in woman. In his literary construction, Marinetti's superman is not a biological creation but a mechanical and technological one, born out of the mind and soul of his creator. In adopting this strategy Marinetti returns Futurism to the bosom of Western cultural tradition grounded in Aristotle's theories of procreation with their masculinist assertion that the female always provides the material, the male fashions it (Jacobs 1994: 80). Marinetti relies on the philosophical and

theological divisions of mind and body that attribute mind to masculine and body to feminine and in so doing demote the creative potential of the feminine. Maryanne Cline Horowitz (1976: 197) has observed that in Aristotle the creative aspects of procreation 'are attributed exclusively to man', likened to the craftsman whose 'soul contributes the form and model of the creation'. This set of Aristotelian ideas and metaphors deems the act of creative genius a male privilege and makes the female creative spirit or woman artist a paradox. Aristotle claims that 'definition and form' are male creative forces, which make him 'better and more divine in nature'; this set of ideas was adopted by Renaissance humanists Benedetto Varchi and Giorgio Vasari among others (Jacobs 1994: 80). The adoption and dissemination of Aristotle's ideas in the Renaissance and the importance of these ideas in the exclusion of women from the artistic process has been explored in the work of feminist art historians (Jacobs 1994, 1997; Garrard 1992: 69–70). Fredrika Jacobs (1994: 81) has written that, under the conditions of Aristotelian logic, the Renaissance 'woman artist is an oxymoron'. This epistemological foundation, which excludes women from the realm of high culture and art, became so entrenched in Western discourse as to be accepted as a natural truth. It is the same logic that has been repeatedly aimed against women artists from the Italian Renaissance to French Impressionism or later American Abstract Expressionism.

Futurism clearly constructed the very same philosophical barriers against women artists. Like Aristotle or the Renaissance humanists, Marinetti denies creative forces to the mater/material and appropriates creativity entirely to the masculine mind. In this interpretation Mafarka might be understood to represent the superman artist of Futurism whose creative powers elevate him to heroic status while giving birth to the next generation of supermen. Marinetti's *superuomo* artist is insistently masculine, but Nietzsche's *Übermensch* had the capacity to be interpreted in a different light by women artists. Marinetti may have intended to completely reinvent a superman figure for his movement, taking little from Nietzsche's original concept, but women of the Futurist movement seem to have understood the positive implications of taking their heroic cues more closely from Nietzsche. As Günter Berghaus observes, Nietzsche's influence on Valentine de Saint-Point was the subject of a study by Henri Le Bret in 1923 in which the author examines the influence of the *Übermensch* on Saint-Point's artistic 'road to self-realization' (Berghaus 1993: 38). Thus the difference between the *Übermensch* and *superuomo* was vital to the participation of a woman Futurist like Saint-Point and perhaps vital to others who followed in her footsteps.

The history of Modernism is a story of supermen rather than superwomen, even if the occasional heroic artist turned out to be a woman and some

of these women have gained considerable attention over the last fifty years. However, the recent Paris–Rome–London exhibition of 2009 failed to include even one Italian woman artist. Scholars have largely taken Marinetti's 'scorn for women' in the *Founding and Manifesto* of 1909 at face value. It is perhaps for this reason that even feminist scholars have been sceptical about how to approach the activities of the unconventional women, like Valentine de Saint-Point, who participated in the harsh rhetoric of the movement. Yet the fact remains that many women artists negotiated a role for themselves within the hostile environment of Futurism. If, as Cinzia Sartini-Blum (1996b: 88) elaborates, '[w]oman is programmatically spurned as the arch-enemy of Futurism's heroic program', and femininity 'is associated with all that man has to eschew, subjugate, or contain in order to create form, meaning, and identity', then these women's artistic activities constitute an even more impressive success. Their hard-won victories should not continue to be undone by silence. The success of a woman Futurist like Benedetta Cappa Marinetti, collaborator and wife of the founder, belies the lonely figure of the self-made and self-procreating *superuomo*. Barbara (Olga Biglieri) and other aeropainters translated the Futurist man/machine into a woman/machine, appropriating both technological capabilities and the phallic gaze from above. The careers of these women are a testament to the existence of a *superdonna* in the most literal sense of the word 'superare'. Women Futurists, by the very act of writing and painting, refused to yield creative genius to any boy's club. It is no minimal achievement to assert a Futurist (female) subject. As Whitney Chadwick (2001: 9) has observed: 'in taking up brush or pen, chisel or camera, women assert a claim to the representation of women (as opposed to Woman) that Western culture long ago ceded to male genius and patriarchal perspectives'. The combined facts of their sex and their creative production exploded Marinetti's dream of an immaculate conception by man.

The differences between the superman philosophies of Nietzsche and Marinetti, far from being incidental, relate directly to women Futurists' understanding of the artist. The new man of creative genius, whether 'über' or 'super', sought to redefine the limits of the self and overcome the boundaries and definitions prescribed by human history, but challenging the boundaries of male subjecthood necessarily invited women to do the same. Marinetti's *superuomo* begged comparison with Nietzsche, whose celebration of the Dionysian spirit and formula for self-overcoming offered revolutionary promises for women. The concepts of *Übermensch* and *superuomo* differ most markedly in their relationship to the mind/body polemic and it is precisely within the margins of these two concepts that women found a space for their creative energy. Nietzsche's revolutionary contribution to philosophy was to explode the Ideal with the

Real. Marinetti held tightly to that Ideal and particularly to the Ideal of masculinity. The *superuomo* represented the founder's best attempt to reconsolidate the masculine ideal creative subject. In his Futurist vision, Italy's artists and poets were masculine heroes for a new superhuman age that would rise above the limitations of the body. Evidently Marinetti tried to take for Futurism only that which he wanted from Nietzsche and leave the rest, but I believe that task was proved impossible thanks to the efforts of Futurist women who refused to let it go.

Notes

1　For a fuller analysis of Aristotle's antifeminism and its influence see Horowitz (1976).
2　For a clear summation of these arguments in relation to women artists of the Renaissance see Jacobs (1994).

References

Ansell-Pearson, K. (1992). 'Who Is the Ubermensch? Time, Truth and Woman in Nietzsche', *Journal of the History of Ideas*, 53:2, 309–31.
Berghaus, G. (1993). 'Dance and the Futurist Woman: The Work of Valentine de Saint-Point (1875–1953)', *Dance Research: The Journal of the Society for Dance Research*, 11:2, 27–42.
Bowler, A. (1991). 'Politics as Art: Italian Futurism and Fascism', *Theory and Society*, 20:6, 763–94.
Chadwick, W. (2001). 'How Do I Look', in *Mirror, Mirror: Self-portraits by Women Artists* (London: National Portrait Gallery), pp. 8–21.
Conati, S. (2002). 'Italian Futurism: Gender, Culture and Power' (UMI Dissertations).
Copleston, F.C. (1942). 'Friedrich Nietzsche', *Philosophy*, 17:67, 231–44.
Förster-Nietzsche, E. (1917). Introd. to F. Nietzsche, *Thus Spake Zarathustra: A Book for All and None*, trans. T. Common (New York: Dover Publications).
Garrard, M. (1992). 'Leonardo: Female Portraits, Female Nature', in N. Broude and M. D. Garrard (eds), *The Expanding Discourse: Feminism and Art History* (New York: Westview Press), pp. 59–86.
Horowitz, M. C. (1976). 'Aristotle and Women', *Journal of the History of Biology*, 9:2, 183–213.
Jacobs, F. (1994). 'Woman's Capacity to Create: The Unusual Case of Sofonisba Anguissola', *Renaissance Quarterly*, 47:1, 74–101.
Jacobs, F. (1997). *Defining the Renaissance Virtuosa* (New York: Cambridge University Press).
Marinetti, F. T. (1983). *Teoria e invenzione futurista*, ed. L. de Maria (Milan: Mondadori).

Marinetti, F. T. (2003). *Mafarka il futurista* [1910] (Milan: Mondadori).

Marinetti, F. T. (2006). *Critical Writings*, ed. G. Berghaus, trans. D. Thompson (New York: Farrar, Straus and Giroux).

Nietzsche, F. (2009). *Thus Spake Zarathustra: A Book for All and None*, trans. T. Common (New York: Dover Publications).

Orage, A. R. (1911). *Friedrich Nietzsche: The Dionysian Spirit of the Age* (Chicago: A. C. McClurg & Company).

Poggi, C. (2009). *Inventing Futurism* (Princeton: Princeton University Press).

Sartini-Blum, C. (1996a). *The Other Modernism: F. T. Marinetti's Futurist Fiction of Power* (Berkeley: University of California Press).

Sartini-Blum, C. (1996b). 'The Futurist Re-fashioning of the Universe', *Futurism and the Avant-Garde, South Central Review*, 13:2–3, 82–104.

Spackman, B. (1996). *Fascist Virilities* (Minneapolis: University of Minnesota Press).

3

'Out of touch': F. T. Marinetti's *Il tattilismo* and the Futurist critique of separation

Pierpaolo Antonello

On the evening of 11 January 1921, at the Théâtre de l'Œuvre in Paris, Filippo Tommaso Marinetti, the founding father of Futurism, presented what he claimed to be a new form of art: Tactilism, or the Art of Touch. He read aloud *Il tattilismo. Manifesto futurista* that he had allegedly conceived the summer before while bathing in Antignano, on the Tuscan coast near Livorno, and that he had penned for the occasion. He also presented a tactile board or *tavola tattile*, titled *Sudan-Paris*, the first concrete example of a work of art that should be experienced not through visual contemplation or analysis but by touch, through the direct tactile perception of the art object in its material constitution. In Marinetti's words:

> These tactile boards have arrangements of tactile values that allow hands to wander over them, following colored trails and producing a succession of suggestive sensations, whose rhythm, in turn languid, cadenced, or tumultuous, is regulated by exact directions. (Marinetti 1968: 163)

Because he was returning to the international stage as a diva, an aged celebrity, after the silent years he spent during the war and its immediate aftermath, the event was widely reported by both the national and international press which, quite predictably, concentrated on the brawl or 'cagnara' [dog barking] that ensued that evening from the presence of twenty Dada artists, up in arms to defend their territory from the Futurist intrusion, as reported in the press.[1] They started shouting 'to go to Limbo (or to Hell) with Verlaine' while they distributed leaflets where they stated that Futurism was dead: 'Le futurisme est mort. De quoi? De DADA'. Particularly vociferous was Picabia who claimed that tactilism was his invention, since his *sculpture à toucher* had already been exhibited in New York in 1916. As a matter of fact, it was a special occasion for the Dadaists, because they managed to set apart their internal rivalries, particularly between Picabia and Tzara,

and coalesce against the common Italian enemy (Sanouillet 1965: 237). Marinetti's portrayal of the artists seated in the front rows is quite sardonic:

> Although quite used to discord and quarreling among themselves the French futurists dadaists expressionists cubists and surrealists seem compactly seated in the first rows ready to attack and among them Tzara Picabia Patrascu Codreanu Léger Salmon Picasso ... get quite agitated, they fizz and effeminately wag their tails and arses, wiggling their hypercritical ultradelicate hips. (Marinetti 1969: 264–5)

Marinetti's later account of that evening, albeit obviously biased, is not that far from a fair report of what happened. The *New York Times* reporter, for instance, stressed in his article the similarities (and consequent brotherly rivalry) between the two opposing camps:

> The Dadaists and Futurists who have been brothers and enemies ever since the inception of the former, have come to open war ... They ... have taken the offensive in the war and, apparently jealous of their place as the very newest of all new movements, they have banded together to declare as utter foolishness 'tactilism', the latest form of art discovered by the Futurist leader Marinetti. Tactilism, in the opinion of the Dadaists, is 'just rot' and in true Futurist fashion, for they are descendants in the direct line, they scoff at all allegiance to their former leaders and poured scorn on Signor Marinetti when he tried to expound his great discovery before them. ('Tactilism Greeted by Dadaist Hoots', *The New York Times*, 17 January 1921)

As a matter of fact, in his own report of the event Marinetti mentions the presence, among the audience, of Rachilde, nom de plume of Marguerite Vallette-Eymery, a French decadent writer of the period, who, from the gallery, voiced her sympathy for Marinetti, shouting he should not worry because the Dadaists were all his children. The vociferous Dada protest and brawl was in fact a Futurist gesture par excellence, exemplified by Marinetti and friends in their famous *serate futuriste*. It also embodied what Marinetti forecast in the Founding Manifesto of Futurism: 'When we are forty, other younger and stronger men will probably throw us in the wastebasket like useless manuscripts – we want it to happen!' (1968: 12). The only catch was that Marinetti, then forty-five, was not particularly willing to retire, hence his tongue-in-cheek answer to Rachilde at the Théâtre de l'Œuvre: yes, they may be my children, but 'not all pregnancies end well' (1969: 267).

'Retour à l'ordre'

The *Manifesto of Tactilism* belongs to a transitional period in Marinetti's activity, after the euphoric early years of Futurism and the demise of the

movement during the First World War. The most active, gifted, and talented members of the movement, like Umberto Boccioni or Antonio Sant'Elia, died during the war, Russolo and Marinetti were seriously wounded, while Carrà was so traumatised by the event that he defected altogether from the group and retired. As Stephen Kern has commented, Marinetti, in *War the Only Hygiene of the World* (1915), 'rhapsodised about his hopes for the fulfilment of the Futurists' goals through the war ... Ironically the war cut them off from the future – it destroyed their movement by realizing their ideals' (Kern 1983: 299). Moreover, the particular 'trench warfare' that was fought in the First World War produced an erosion of 'officially sponsored conceptions of the soldierly self as an agent of aggression', which was part of Futurist rhetoric and vocabulary:

> Long-range artillery, machine guns, trenches, barbed wire, and gas immobilised men for long period of times in cramped quarters under circumstances of great stress. The normal response to mortal danger is active aggression, but the front-line soldiers were forced to be passive. Their humiliating circumstances produced a kind of 'defensive personality' that became a distinctive characteristic of war neurosis ... The men had to resign themselves to their fate and internalise normal outward manifestations of aggression as well as libido. (Kern 1983: 297)

As a matter of fact, the *Manifesto of Tactilism* is quite explicit in acknowledging these circumstances:

> The unrefined and elemental majority of men came out of the Great War concerned only to conquer greater material well-being. The minority, composed of artists and thinkers, sensitive and refined, displays instead the symptoms of a deep and mysterious ill that is probably a consequence of the great tragic exertion that the war imposed on humanity. (Marinetti 1968: 160)

In the period between 1918 and 1920, Marinetti was also trying to find his feet both existentially and politically and to make sense of the confused political and social situation of the period, with the tentative constitution of the Futurist Party first in 1918, and with the early gestational collaboration with Benito Mussolini in the foundation of the Fascist Party the following year. The latter experienced a setback in the 1919 general elections, and Marinetti eventually defected in May 1920 at the party general congress, both as a result of the conservative and reactionary swing of the movement that he had expected to be more radical, anarchic and revolutionary (Marinetti 1987: 305, 392), and because of the clashes between two big egos such as himself and Mussolini, who defined Marinetti as 'this extravagant buffoon who wants to make politics and whom nobody in Italy, not even I, takes seriously' (Rossi 1958: 393). In fact, although Marinetti

was certainly an inspiration for Mussolini's rhetoric and his programme of the aesthetization of politics, institutionalised politics was not something really congenial to Marinetti's temperament. As Günter Berghaus (1996: 117–18) has remarked, Marinetti, unlike Mussolini, was far from being 'a realist or pragmatic politician':

> His concept of the 'Italian Revolution' was based on instinct, creativity, fantasy. Politics for him was an art form, not an opportunist wrangle between diplomats and *realpolitiker*, the 'so-called politicians who feed on common-places and bookish ideologies'. As he noted in his introduction to *Futurismo e fascismo*, his preferred definition of his movement was: 'Futurists are the mystics of action'.[2]

Failing to make his mark in the political arena, Marinetti turned to the more congenial art scene – although he probably sensed a form of exhaustion in the first thrust of Futurism not only because of the disillusionment of the First World War and the moral and cultural implosion of many fellow artists and citizens but also because of the very nature of avant-gardist proposals and gestures which are instantaneous and ephemeral, yet become trite and ineffectual when repeated too many times. The values of modernity and modernism extolled in the early 1910s in the first manifestos, were becoming common knowledge in the 1920s. On the other hand, however, the First World War left a deep chasm in everybody's consciousness. As Paul Fussell wrote in *The Great War and Modern Memory*, 'the image of strict division clearly dominates the Great War conception of Time Before and Time After, especially when the mind dwells on the contrast between the pre-war idyll and the wartime nastiness' (Fussell 1975: 80). Eventually 'images of the former life became more fixed and idealised the more distant they were' (Kern 1983: 292).

It is probably with this invigorating nostalgia for his heroic early period that Marinetti tried to revamp himself by playing the same card, repeating a radical gesture similar to that of the 1909 founding Manifesto, in order to regain visibility within the international art scene, through what he thought was a radical new proposal, a new form of art, tactilism.

On this score, it is not surprising to see how the *Manifesto of Tactilism* opens with a peremptory statement: 'Punto e a capo [Full stop, new paragraph]', signalling a new beginning for Marinetti, the need for a new foundation, in order to revitalise the movement which made Marinetti's fame and fortune worldwide (Mango 2001: 19–20). Further evidence for this is the fact that Marinetti uses a variety of images and rhetorical mannerisms that resonate with the *Founding Manifesto*. For instance, he opens up with the image of himself naked in the silky water of the Tyrrhenian sea, which parallels the originary immersion in the 'Maternal

ditch, almost full of muddy water' (Marinetti 1971: 40) of the *Founding Manifesto*, that he 'gulped down' to nourish his genius:

> I was naked in the silky water that was being torn by rocks, by foaming scissors, knives, and razors, among beds of iodine-soaked algae. I was naked in a sea of flexible steel that breathed with a virile, fecund breath. I was drinking from a sea-chalice brimming with genius as far as the rim. (Marinetti 1971: 110)

In Marinetti self-mythologisation, the sea had an important symbolic value because it was inscribed in his surname (Mari-netti = 'clean, pure seas'). This personal reference resonates more strongly also because, contrary to the *Founding Manifesto*, the *Manifesto of Tactilism* was written and presented by Marinetti as the product of an individual mind: the pronoun 'we' is replaced by 'I'. This is no longer the logic of an avant-garde group but an experimental project proposed by a single artist. Nonetheless, the structure of the *Manifesto of Tactilism* mimics the 1909 manifesto, again signalling the parallelism between the two. It opens with a narrative prologue or overture; then it moves to a programmatic and normative central part; it is finally sealed by a rhetorical gesture, which aims at consensus and proselytism.

Highly symbolical also was the venue in which the text was presented: the Théâtre de L'Œuvre in Paris, very much in the same way the first manifesto was published in France on the front page of *Le Figaro*. The official date of publication of *Il tattilismo* is also symbolically charged: 11 January 1921; it was reprinted a year later in the journal *Il Futurismo* (11 January 1922). Marinetti's numerological obsession is a well-known fact, and also in this case the symbolism of the number 1 was most likely intended to signal a new beginning (Mango 2001: 11).

What is left of Tactilism?

If the evening at the Théâtre de l'Œuvre in Paris, together with many other *soirées* organised in Italy and Europe to present the new manifesto, could be considered quite a success in terms of actual artistic production, tactilism needs a more general critical assessment, which is not particularly easy to do, because, besides *Sudan-Paris*, no other tactile board was saved, and very few Futurists of the second wave were drawn into this new art form. On one Futurist *soirée* at the Galleria Centrale in Milan (27 February 1921), Marinetti offered the public some samples of his *tavole tattili*. An anonymous reporter mentions the works titled *Africa* and *Simultaneità tattile*, as well as the aforementioned *Sudan-Paris* ('Conferenza tumultuosa sul tattilismo', *Testa di Ferro*, 27 February 1921). However, no other record of these boards exists. In the 1924 *Tattilismo*, we also find the description of

several *tavole tattili*, although it remains unclear whether or not they were ever made.[3]

The problem was that these tactile boards were quite fragile, and many were destroyed during the many *serate* organised by Marinetti. In *Il teatro della sorpresa* (1921), which was penned by Marinetti with Francesco Cangiullo, the latter describes the paroxysm and avid curiosity which pervaded the audience during these presentations. Cangiullo was particularly surprised by the kind of reception they received, as he was expecting, as always happened in the past, the boos and the vegetable ammunition that the audience of Futurist *serate* were more than ready to throw at the performers:

> It is easy to imagine the avid curiosity with which the audience was pulling these boards … from Marinetti's and my hands, when, during the intermissions, he in the stalls and me in the galleries, let people touch the most recent word of Futurism … To mention one episode, a frantic woman from Trieste pulled the board titled *Sudan-Paris* with such vigour that she broke it into two pieces, with Paris left in my hands and Sudan in hers. (Cangiullo and Marinetti 1968: 150–1)[4]

As a matter of fact, the *tavole tattili* were produced and assembled in series by Marinetti's legendary housekeepers and servants, the Angelini sisters, Nina and Marietta, whose duty was to glue or sew on cardboard, in Cangiullo's words, 'the most extravagant assemblage of matter' in a way that seems to anticipate Andy Warhol's The Factory:

> First of all let's remember what Marinetti's 'tactile boards' are, or better, what they were, because after the soirée in Trieste they no longer existed: mostly rectangular pieces of cardboard, fifty or sixty centimetres long, on which Nina and Marietta, under the artistic direction of the author, would glue felt, sand papers, tin foil, sponges, pumice stones, powder-puffs, and other objects or ingredients, according to the sensation they wanted to create. (Cangiullo and Marinetti 1968: 150)[5]

The fact that the tactile boards were meant to be destroyed fits quite well with the Futurist idea about the ephemerality of the work of art, the immediacy of the experience of artistic production – not wanting to create marble monuments that would last forever. Nonetheless, we can try to assess the only surviving *tavola tattile*, *Sudan-Paris*.

As is often the case with Marinetti, the proposal for radical experimentation expounded by the *Manifesto of Tactilism* eventually remained underexplored from a formal standpoint. *Sudan-Paris* is described by Marinetti in the following manner:

> *Sudan-Paris* contains, in the part representing *Sudan*, rough, greasy, coarse, prickly, burning tactile values (spongy material, sponge, sandpaper, wool, brush,

wire brush); in the part representing *The Sea*, there are slippery, metallic, fresh tactile values (silver-coated paper); in the part representing *Paris*, there are soft, delicate, caressing tactile values, hot and cold at the same time (silk, velvet, feathers, down). (Marinetti 1968: 163)

It is evident that the *tavola tattile* was still structured around the traditional frame of painting, resembling more Enrico Prampolini's polymateric art, developed since 1915, than anything genuinely radical or experimental (Fossati 1977: 103). Moreover, the use of colours in this tactile board contradicts what the manifesto itself proclaimed: 'This still-embryonic tactile art is cleanly distinct from the plastic arts. It has nothing in common with painting or sculpture. As much as possible one must avoid variety of colours in the tactile tables, which would lend itself to plastic impressions' (Marinetti 1971: 111).

Also, quite surprisingly for somebody who invented the so-called 'words-in-freedom' – and against the notion of simultaneity extolled by Marinetti and his fellow Futurists in early manifestos – *Sudan-Paris* is structured with a very obvious vertical, topological linear narrative (with the sole inversion of the two geographic poles). On this score, Umberto Artioli (1975: 13) has pointed out the intrinsic discontinuity of tactilism and of tactile experience, which cannot perceive aesthetic or natural forms in their totality, as with sight; there is an intrinsic temporality in the haptic perception of an object, which resembles the act of reading a text or listening to a tune, rather than the holistic visual appreciation of a painting or a sculpture.

Despite the fact that Marinetti claimed the idea of tactilism came to him while he was swimming at Antignano, he used solely solid material for his tactile experimentations, avoiding, for instance, liquids. He also worked mainly with surfaces, and he never took into consideration volume, weight or temperature. Taking a further conservative step back from the radicalism of tactilism, Marinetti channelled his innovation into literary *sintesi tattili*, which were simply poems describing haptic sensations.[6]

Nonetheless, the *Manifesto of Tactilism* genuinely aimed to fill a gap in the aesthetic consideration of the haptic in its attempt to compensate for the lack of a principle of order in the experience of tactile sensations. Testimony to that is an essay by Frances W. Herring published in 1949, in which she discusses 'the reasons for our comparative failure to create and enjoy tactile art forms', and she mentions the possibility of crafting a tactile aesthetics and the necessity, for this purpose,

> to invent and name units which correspond to our perspective abilities to distinguish such quantities, and to arrange them on a scale in order of size (a cardinal dimension) … We can distinguish degrees of lightness and heaviness – a weight dimension; we can distinguish degrees of softness to hardness – a

solidity dimension; degrees of warmth to coldness – a temperature dimension; degrees of smoothness to roughness – a texture dimension. Other scales, less frequently used are theoretically possible: pliability to rigidity; friability to strength, etc. (Herring 1949: 209)

Thirty years earlier, Marinetti was already moving in that direction, when he tried to formulate a list of categories for tactile sensations: 'educational scales of touch' or 'scales of tactile values' that would allow the construction of the aesthetic judgement based on touch:

I created the first educational scale of touch, which at the same time is a scale of tactile values for Tactilism, or the Art of Touch.

First scale, flat, with four categories of different touches

First category: certain, abstract, cold touch.
 Sandpaper,
 Emery paper.

Second category: colorless, persuasive, reasoning touch.
 Smooth silk,
 Shot silk.

Third category: exciting, lukewarm, nostalgic.
 Velvet,
 Wool from the Pyrenees,
 Plain Wool,
 Silk-wool crepe.

Fourth category: Almost irritating, warm, willful.
 Grainy silk
 Plaited silk
 Spongy material
 …

(Marinetti 1971: 110)

War, science, new perceptions

In spite of this typical Marinettian ambivalence between genuine and original experimentation and actual artistic shortcomings,[7] the *Manifesto of Tactilism* resonates strongly with the cultural and ideological climate of the period. First of all, it is in tune with that cultural tendency explored by social and cultural historians like Paul Fussell, Stephen Kern or Kenneth Silver, who see in the First World War experience the matrix for a revolution of perception. Trench warfare in particular was crucial to reshaping the whole spectrum of individual perceptions and foci of attention:

The invisibility of the enemy and the necessity of hiding in the earth, the layered intricacy of the defensive system, the era shattering roar of the barrage, and the fatigue caused by the day and night shifts, combined to shatter those stable structures that can customarily be used to sequentialise experience. (Kern 1983: 291)

The extensive use of camouflage techniques also 'broke up the conventional visual borders between object and background' (Kern 1983: 304), forcing the soldier to rely on different forms of perception. Fussell (1975: 327) also recalls: '[M]ilitary training is very largely training in alertness and a special kind of noticing … When a man imagines that every moment is his next to last, he observes and treasures up sensory details purely for their own sake.' Accordingly, Marinetti recalls in his *Manifesto of Tactilism* that he actually started to develop his tactile ability 'in the underground darkness of a trench in Gorizia' (Marinetti 1968: 165):

> One night during the winter of 1917 I was crawling on hands and knees down to my pallet in the darkness of an artillery battery dugout. Hard as I tried not to, I kept hitting bayonets, mess tins, and the heads of sleeping soldiers. I lay down, but I didn't sleep, obsessed with the tactile sensations that I'd felt and classified. For the first time that night I thought of a tactile art. (Marinetti 1971: 109)

However, in general epistemological terms, the prewar period was already marked by a strong interest in the senses and their mutual interaction and integration. The positivist climate of the late nineteenth and early twentieth centuries in Europe corresponded to a period in which paradigms of tentative integration of the senses gradually emerged, trying to overcome the disjunctive logic of Cartesian dualism, typical of modern philosophy, which posited the centrality of sight as the epitome of the rational and the mental, against the backdrop of the other senses confined to the baseness of the corporeal.

In his seminal book *Downcast Eyes: The Denigration of Vision in Twentieth-Century French Thought*, Martin Jay thoroughly illustrated the emergence of a general anti-ocular discourse in French philosophy at the turn of the century, characterised by a sustained theorization against the scopic, intellectualised outlook imposed by modernity, in its various philosophical and ideological declensions, from Henri Bergson's critique of the spatialisation of time to Georges Bataille's celebration of the acephalic body, and Maurice Merleau-Ponty's diminished faith in a new ontology of vision (Jay 1993: 16).

Marinetti's manifesto could easily be situated within this general epistemological tendency. As a matter of fact, various Futurist texts of the 1910s already explicitly addressed the problem of the multifaceted nature of

sensorial experience and the need for integration. Carlo Carrà's manifesto *The Painting of Sounds, Noises and Smells* (1913) proposed a synaesthetic approach to pictorial representation, and explicitly questioned the power of vision.[8] In particular, Carrà's text refers to widespread discussion, within European poetic and artistic movements at that time, on 'synaesthesia', meaning the poetic description of a sense impression in terms of another sense, as in 'a loud perfume' or 'an icy voice', which sprang from a wave of scientific studies on the neurological base of the particular phenomenon of allegedly 'pathological' perception.

In his study on tactilism Lorenzo Mango also recalls the 'complessi plastici [three-dimentional constructions]' described by Giacomo Balla and Fortunato Depero in their manifesto *Futurist Reconstruction of the Universe* (1915). Although they were supposed to be bright, colourful, dynamic, transparent, and noisy three-dimensional sculptures, aimed at mixing auditory and visual stimuli, they did not allow for haptic appreciation in spite of the fact that some were made with materials similar to the ones Marinetti referred to in his manifesto – fabrics, tin foil, silk, etc. (Mango 2001: 9–10).

Although Marinetti had an ambivalent, or rather opportunistic, relationship to scientific knowledge, the *Manifesto of Tactilism* is clearly in debt to the positivist climate of the early twentieth century.[9] He was certainly aware of the discussion about synaesthesia in symbolist poetry, which was also part of a more general interest in 'pathological' perceptive phenomena at that time. Marinetti probably also borrowed from Jules Romains's *La vision extra-rétinienne et le sens paroptique* (1920), published the year before Marinetti's *Manifesto of Tactilism*, in which Romains argued, among other things, that '*any region* of the periphery of the body … *is capable of securing by itself* a certain degree of extra-retinal vision. … *Vision is difficult, hesitating, and imperfect when only one region is exposed*' (Romains 1924: 68–9; italics in the original). Furthermore, in the *Manifesto of Tactilism* itself, Marinetti explicitly mentions research carried out by Charles Henry, director of the Laboratoire de Physiologie des Sensations (1968: 184). Henry, a physicist by formation, developed a doctrine of psychophysiological aesthetics, calling attention to phenomena like synesthesia, and studying the interrelatedness of sensorial experiences, whether they be visual, auditory or tactile. In particular, he elaborated on the notion of the so-called 'physiological white', which is the synthesis of the chromatics of all senses simultaneously perceived and experienced (Argüelles 1972: 122–3).

A similar understanding is present in the opening section of Marinetti's longer version of the *Manifesto of Tactilism*, published in 1924, which in fact questions any arbitrary distinction between the senses:

The five senses, as they are commonly studied and defined, are more or less arbitrary localizations of that confused cluster of intertwined senses which constitutes the typical forces of the human machine. I believe that all these forces can be better observed on the epidermic thresholds of our body. For this reason I name Tactilism the cluster of all of these still uncharted senses. (Marinetti 1968: 179)

Hence, moving from coeval scientific research, Marinetti (1968: 178) understood that 'sight, smell, hearing, touch, and taste are modifications of a single keen sense: touch, divided in different ways and localised in different spots', which is a common assumption in the scientific field: the skin is in fact the oldest and the most sensitive of our organs, our first medium of communication; and touch is the sense which differentiated into the others, it is 'the mother of the senses' (Montagu 1986: 3).

Following this basic understanding, Marinetti purposely shifted the pivot of our cognitive activity from the traditionally 'noblest' of the senses, sight, to touch, which is more fundamental in evolutionary terms, while cognition should now be channelled through the skin: 'Thus, the need to transform the handshake, the kiss, and coupling into continuous transmissions of thought' (Marinetti 1968: 161).

The apex of Futurism

In the *Manifesto of Tactilism* Marinetti not only theorised about the art of touch but also explored the possibility of new sensorial domains tied to the haptic, and its relation with orientation, proprioception, and spatialisation. The motor-muscular and proprioceptive sensibility – that is, the unconscious perception of movement and spatial orientation arising from stimuli within the body itself, which has been properly defined as the 'sixth sense' – is here stretched and readapted by Marinetti to account for different human abilities, such as athletes' physical skills; acrobats' 'absurd' equilibrium; the expertise or tacit knowledge required to drive a mechanical vehicle; the sensation of extreme exhaustion and fatigue; the sensibility to musical rhythm, to speed, etc. (Marinetti 1968: 179–81).

This general emphasis on the haptic in its various cognitive and bodily manifestations should not be considered simply one of the many experimental eccentricities extolled by Marinetti, for it has a wider theoretical relevance for the understanding of Futurism and its scope and activity, as it resonates and is germane with a crucial aspect of their whole enterprise (and of the avant-garde in general). Francesco Cangiullo (1968: 22), on this score, claimed that tactilism was 'the apex' of Futurism. But what did he mean by that?

Besides poetry, Marinetti's largest production consisted in theatrical

plays of many types, and Cangiullo was Marinetti's artistic partner in various theatrical projects in the 1920s. The post-First World War period was no exception, and in 1924, together with Cangiullo, Marinetti penned the manifesto *After the synthetic theatre and the theatre of surprise, we invent the anti-psychological abstract theatre of pure elements and the tactile theatre* (Marinetti 2004: 735–40)

Marinetti saw in the theatre one of the possible domains where tactilism could intervene to radically alter the cognitive and perceptive experience of the spectator. His theatrical production of the period was in fact not script based in its classical form, but it was a theatre of multi-sensorial and performative action. The rationality of the mind and of propositional knowledge of text-based theatre was replaced by physical performativity, by the bodily involvement of actors and spectators in both the production and fruition of the work of art. This was already addressed in the early years of Futurist activity, particularly by emphasizing the frantic activism of the *fisico-follia* [body madness], extolled by Marinetti both in his writing and in his famous *serate futuriste*, which were a form of carnivalisation of the artistic experience, where performers and the public could exchange roles. This was also at the base of Marinetti's interest in popular forms of entertainment such as the musical, the *café-chantant*, the circus, fairground spectacles, *bals musettes*, or the variety theatre which, according to Marinetti, is the only theatrical form to seek 'the audience's collaboration. It doesn't remain static like a stupid voyeur, but joins noisily in the action, the singing, accompanying the orchestra, communicating with the actors in surprising actions and bizarre dialogues' (Marinetti 1968: 83). The 1921 manifesto *Il teatro della sorpresa* is derived from a similar source of inspiration. As Noëmie Blumenkranz (1982: 105) summarises it:

> The brevity and condensation with which the authors of synthetic theatre constrain themselves, force them to search for a new theatrical language where all possible material could be 'legally' used: light, body, movements, dance, mime, text, voice ... The unexpected element of the staged situation induces the audience to react spontaneously, and the actors to improvise their roles according to the spectators' reactions, which, according to Marinetti, were often quite original.

Performance is obviously linked to the senses, for the body becomes a key site for immediate experience. Performances are totalising acts both in their use of different means of expression and of a variety of sensorial effects, which always require the physical presence and reciprocal involvement of artists and spectators (against any scopic 'museification' of the work of art). The culmination of this interest is exemplified by the so-called 'total theatre' theorised in the 1933 manifesto *Il teatro totale futurista*, which is

a detailed description of a gigantic theatrical machine that 'foresaw the introduction of cinema, radio and television to the theatrical means of communication in a truly multi-media spectacle' (Berghaus 2007: 113).[10] However, its aim was to provide a totalising sensorial experience that went beyond the visual and the acoustic. The seats and tables of the theatre were to be fitted with tactile and odoriferous moving belts, an idea borrowed from the *Manifesto of Tactilism*:

> We shall have theatres specifically designed for Tactilism. The audience will place their hands on long, tactile conveyor belts which will produce tactile sensations that have different rhythms. One will also be able to mount these panels on turntables and operate them with the accompaniment of music and lights. (Marinetti 1968: 164)

Touch could then be seen as the more radical moment of this performative involvement of the spectator. In their deep anthropological and cognitive sense, tactilism and theatre belong to the same 'domain' in which hapticity and touch would be the 'genetic' cognitive principle which regulates this experience or, in other words, touch could be conceptualised as the synecdoche for the bodily presence as a prerequisite for any authentic form of communication among people, which was the goal both of Futurist theatre and of the *Manifesto of Tactilism*: 'to achieve tactile harmonies and to contribute indirectly toward the perfection of spiritual communication between human beings, through the epidermis' (Marinetti 1968: 161).

Critique of separation

As a matter of fact, in its original formulation tactilism aimed to move beyond the artistic realm to involve the whole human experience. In the 1921 Manifesto, Marinetti envisaged not only tactile boards or tactile theatres, but also tactile furniture, tactile rooms, tactile dresses, tactile streets. As a genuine avant-gardist invention, tactilism was designed to become an instrument to implement a total revolution of perception, reconfiguring all social and living experiences of the human being, in order to obliterate the modern (and modernist) separation between art and life praxis. This brings to mind Peter Bürger's fundamental *Theory of the Avant-garde* (1974). According to the German critic, the aim on the part of the European avant-garde at the beginning of the twentieth century was to overcome the *autonomy* which the arts acquired during modernity in relation to life praxis (Bürger 1974: 35–54). Modern art is seen by Bürger as the culmination of a historical development which saw an increasing level of autonomy of the aesthetic realm with respect to both its production and its fruition. For Bürger modern art has become more and more individualised

in relation both to production and fruition, depotentiating all the collective mechanisms of socialisation which were the foundations of traditional art, eventually becoming an instance of the self-staging and self-representation of bourgeois individualism. The main goal of the historical avant-garde was therefore to move against this separation.

Bürger never considers Futurism in his analysis, confining it to a footnote (1984: 109). This exclusion clearly has an ideological rather than a philosophical motivation, possibly because of Marinetti's later involvement with Fascism. However, one has to 'Give to Caesar what is Caesar's', and, in the context of European avant-garde movements, Italian Futurism had a privileged position, for it acted as a sort of blueprint or template for all subsequent avant-gardist movements, and, because the original polemical nature of Futurist activities was in fact triggered by the radical critique of any form of separation in artistic, social and political life, very much in the sense discussed by Bürger.

Both with his theatrical theorisation and with tactilism in particular, Marinetti seemed to be looking for a radical 'fusional model' of artistic experience, not in the sense of the embodied spectatorship much theorised by recent film critics through a Lacanian or Deleuzian lens, but in the sense of the 'group-in-fusion' proposed by Jean-Paul Sartre, as a strategical form of praxis that would overcome passivity and alienation, resulting in political and revolutionary acts (Craib 1976: 173–94).

From a theoretical standpoint this resonates with what Martin Jay discusses about French thought and its prolonged denigration of vision, which was based not only on philosophical premises but on political dialectics, as a form of critique of the scopophilic bourgeois capitalist culture dominant in Western society. According to Peter Bürger, the avant-garde was in fact proposing the negation of the autonomy of the arts from life praxis, but also a more general 'critique of separation', of social separation: the former is indeed a consequence of the latter. This was also theoretically formulated, in the most straightforward fashion, by one of the latest twentieth-century avant-gardist movements, the Internationale situationiste – more ideologically homogeneous with Bürger's biased theoretical pigeonholing of Futurism. Raoul Vaneigem, one of the key members of the group, in a chapter of *The Revolution of Everyday Life* (1967) titled 'Separation', situates the whole history of humanity within a Hegelian framework. He sees it as an institutionalised, coercive history of progressive separation and social atomisation, fostered in modern times by bourgeois individualism:

> People live separated from one another, separated from what they are in others, separated from themselves. The history of humanity is the history of one

basic separation which precipitates and determines all the others: the social distinction between masters and slaves. (Vaneigem 1994: 117)

Guy Debord was to translate the notion of separation in his Marxist critique of the so-called *Spectacle* as the defining feature of our contemporary late-capitalist era. The first chapter of *The Society of the Spectacle* (1967) is indeed titled 'Separation Perfected', in which Debord states: 'The phenomenon of separation is part and parcel of the unity of the world, of a global social praxis that has split up into reality on the one hand and image on the other' (Debord 1994: 13). And more specifically:

> Since the spectacle's job is to cause a world that is no longer directly perceptible to be *seen* via different specialised mediations, it is inevitable that it should elevate the human sense of sight to the special place once occupied by touch; the most abstract of the senses, and the most easily deceived, sight is the most readily adaptable to present-day society's generalised abstraction. (Debord 1994: 17)[11]

On the basis of these theoretical premises one could easily understand the conceptual conundrum expressed by Millicent Marcus about the very scanty production of Futurist cinema:

> [C]inema offered proof of the Futurists' argument for a breakdown of the barrier between the industrial and the aesthetics, between technology and art. The Futurist ideals of *compenetrazione* (compenetration) and *simultaneità* (simultaneity) also found congenial expression in the cinema; ... cinema should emerge [then] as the uncontested medium of choice for adherents to this particular avant-garde. Instead, we find a remarkable paucity of Futurist films: a few abstract short subjects ..., three feature films ... filmed by Bragaglia ... and the only 'official film' of the mouvement, *Vita futurista* (*Futurist life*, 1916). (Marcus 1996: 63–4)

Marinetti surely sensed the power of seduction of cinema for the modern masses, but at the same time he lacked the expertise and the symbolic grammar to master this new art, hence he felt safer, so to speak, with more classical art forms such as poetry or theatre. However, in his anxiety not to be left behind, he had to radicalise to the extreme the experimental fabric of the latter.

However, there is also a deeper theoretical reason which vindicates Marinetti's option in the light of the overall avant-gardist enterprise and its political aims. Cinema produces only the illusions of closeness and proximity with represented reality, while it acts very much like traditional classic theatre: it confines the spectators to their autonomous, totally passive experience in their isolated seats. This argument has further ramifications for contemporary cultural theory and the whole discussion about embodied

spectatorship and the role of the haptic in cinema viewing. For instance, in the much praised *Atlas of Emotion*, Giuliana Bruno explores in particular the relationship between architecture and cinema, 'the haptic nature of cinema [which] involves an architectural itinerary, related to motion and texture rather than flatness ... [H]aptic [is] the measure of our tactile apprehension of space, an apprehension that is an effect of our movement in space' (2002: 250).

Bruno constructs an avant-gardist genealogy in order to validate her point, mentioning both Marinetti's *Manifesto of Tactilism* and the notion of psychogeography as elaborated and expressed by the Situationists. However, the Situationists proposed the anarchic experience of urban flâneurism and psychogeography as an antidote to the kind of separation that was implemented and diffused by the society of the spectacle. As a matter of fact, in his film *Critique de la separation* (1961), Debord whole-heartedly criticises cinema as the ultimate form of spectacle, whose aim 'is to present a false and isolated coherence as a substitute for activity and communication which *are* actually absent'.[12]

In a similar avant-gardist manner, and for the same 'political' reasons, Marinetti always favoured theatre over cinema, although a totally revolutionised genre of theatre, a theatre of total bodily involvement of the spectator, who had to be physically as well as emotionally *touched* by the event. This was at the very core of the revolutionary enterprise established by the avant-garde, Futurist or other: to stay in touch with both art and life. That is why tactilism is the perfect metonym or genetic seed of Futurist art, and it explains Cangiullo's claim that tactilism was the 'apex' of all Futurist activity.

Notes

1 See 'Cagnara tra futuristi e dadaisti in una conferenza di Marinetti', *Giornale di Sicilia* (15 January 1921).

2 Berghaus is quoting Marinetti's 'Vecchie idee a braccetto, da separare', *L'Ardito* (March 1919) (Marinetti 1968: 427).

3 See for instance: *Ritratto fisico-psico-tattile di Marinetti; Tavola tattile di paesaggio arido; Tavola tattile astratta della conseguente nostalgia di morbidezze-calore; Tavola tattile astratta di volontà dinamica aggressiva* (Marinetti 1968: 182–4).

4 For an account of that evening, see Antonucci (1975: 64).

5 See also Mango (2001: 55).

6 See for instance 'Navigazione tattile' in Marinetti (1925: 279–80).

7 On this score Luciano De Maria writes: 'the wider the gap between theoretical enunciation and actual practice (in the sense that this practice is

still at the potential and hypothetical level), the more intense the degree of what we might call a creative or artistic utopia, and the more effective and interesting the manifestos from a literary standpoint' (Marinetti 1968: liii).

8 Enrico Prampolini developed a similar theory in *La cromofonia: Il colore dei suoni* [*Cromophony: The Colour of Sounds*], *Gazzetta Ferrarese* (26 August 1913); reprinted in P. Bucarelli and M. Calvesi (eds), *Enrico Prampolini*, exhibition catalogue, Galleria nazionale d'arte moderna (Rome: DeLuca, 1961): 31–4.

9 This is evident in the 1924 *Tattilismo*. On the one hand, he resorted to coeval scientific knowledge to substantiate his point: 'We are aware of the hypotheses of material essence. This provisional hypothesis considers matter to be a harmony of electronic systems, and through it we have come to deny the distinction between matter and spirit.' On the other hand, he claims that his manifesto, apparently inspired by scientific advances, nonetheless goes beyond hard sciences, outdoing their methods: 'With tactilism we propose to penetrate deeper and outside normal scientific method into the true essence of matter' (Marinetti 1971: 112).

10 It also borrows from Prampolini's *teatro magnetico* (Mango 2001: 62).

11 Martin Jay (1993: 416–34) situates the experience of the Situationists in the general 'anti-ocular discourse' of French twentieth-century culture.

12 Guy Debord, *Critique of Separation*, Film Soundtrack: www.bopsecrets.org/SI/debord.films/separation.htm. Accessed 10 November 2010.

References

Antonucci, G. (1975). *Cronache del teatro futurista* (Rome: Abete).

Argüelles, J. A. (1972). *Charles Henry and the Formation of a Psychophysical Æsthetic* (Chicago: University of Chicago Press).

Artioli, U. (1975). *La scena e la dynamis* (Bologna: Patron).

Berghaus, G. (1996). *Futurism and Politics: Between Anarchist Rebellion and Fascist Reaction, 1909–1944* (Providence, RI, and Oxford: Berghahn Books).

Berghaus, G. (2007). 'F. T. Marinetti's Concept of a Theater Enhanced by Audio-visual Media'. *Forum Modernes Theater*, 22:2, 105–16.

Bettini, F. (1977). 'Analisi testuale del primo manifesto futurista', in F. Bettini et al., *Marinetti futurista* (Naples: Guida), pp. 75–94.

Blumenkranz, N. (1982). 'Le théâtre de Marinetti: La subversion de l'espace et du temps', in J.-C. Marcadé (ed.), *Présence de F. T. Marinetti. Actes du colloque international tenu à l'UNESCO* (Paris: L'Age d'homme), pp. 93–109.

Bruno, G. (2002). *Atlas of Emotions: Journeys in Art, Architecture, and Film* (New York: Verso).

Bürger, P. (1984). *Theory of the Avant-garde*, trans. M. Shaw (Minneapolis: Minnesota University Press).

Cangiullo, F. and F. T. Marinetti (1968). *Il teatro della sorpresa* (Livorno: Belforte).

Craib, I. (1976). *Existentialism and Sociology: A Study of Jean-Paul Sartre* (Cambridge: Cambridge University Press).

Debord, G. (1994). *The Society of the Spectacle* [1967], trans. D. Nicholson-Smith (New York: Zone).

Fossati, P. (1977). *La realtà attrezzata* (Turin: Einaudi).

Fussell, P. (1975). *The Great War and Modern Memory* (Oxford: Oxford University Press).

Herring, F. W. (1949). 'Touch: The Neglected Sense', *Journal of Aesthetics and Art Criticism*, 7:3, 199–215.

Jay, M. (1993). *Downcast Eyes: The Denigration of Vision in Twentieth-century French Thought* (Berkeley: University of California Press).

Kern, S. (1983). *The Culture of Time and Space, 1880–1918* (Cambridge, MA: Harvard University Press).

Mango, L. (2001). *Alla scoperta di nuovi sensi. Il tattilismo futurista* (Naples: La città del sole).

Marcus, M. (1996). 'Anton Giulio Bragaglia's Thaïs, or, the Death of the Diva + the Rise of the Scenoplastica = the Birth of Futurist Cinema', *South Central Review*, 13:2–3, 63–81.

Marinetti, F. T. (1968). *Teoria e invenzione futurista*, ed. L. De Maria (Milan: Mondadori).

Marinetti, F. T. (1969). 'Le tavole tattili costruite da Benedetta sulla spiaggia di Antignano', in L. De Maria (ed.), *La grande Milano tradizionale e futurista. Una sensibilità italiana nata in Egitto* (Milan: Mondadori), pp. 263–7.

Marinetti, F. T. (1971). *Selected Writings*, ed. and introd. R. W. Flint., trans. R. W. Flint and A. A. Coppotelli (New York: Farrar, Straus and Giroux).

Marinetti, F. T. (1987). *Taccuini (1915–1921)* (Bologna: Il Mulino).

Marinetti, F. T. (2004). *Teatro*, vol. 2, ed. J. Schnapp (Milan: Mondadori).

Montagu, A. (1986). *Touching: The Human Significance of the Skin* (New York: Harper & Row).

Romains, J. (1924). *Eyeless Sight: A Study of Extra-retinal Vision and the Paroptic Sense* [1920], trans. C. K. Ogden (London and New York: Putnam).

Rossi, C. (1958). *Ventitre vicende mussoliniane* (Milan: Ceschina).

Sanouillet, M. (1965). *Dada à Paris* (Paris: Pauvert).

Vaneigem, R. (1994). *The Revolution of Everyday Life* [1967], trans. D. Nicholson-Smith (London: Rebel Press / Left Bank Books).

4

La bomba-romanzo esplosivo, or Dada's burning heart

Dafydd Jones

The received wisdom that Futurism was 'the actual seedbed of Dada art' is often enough repeated (Winter 1996: 141). Beyond the political, however, the complex problematic nature of the relation between Futurism and Dada is far less frequently addressed, and Dada's aesthetic negotiation of anti-nationalist politics, for instance, is largely ignored. We know that in rejecting all cultural precedents the Dadaists implicitly rejected Futurism; and they declared their rejection explicitly, sloganising under Paris Dada that 'The Futurist is dead. What killed it? Dada' (Pierre 2005: 252). To name and shame, it was Dada drummer Richard Huelsenbeck who famously denounced Filippo Marinetti's worldview and Futurism's goals despite being, notably, among the most enthusiastic Dada exponents of Futurist sound art, embracing as he did the concepts of simultaneity and of bruitism, even if he well recognised how bruitism was taken over by the Dadaists without their having 'any idea of its underlying philosophy' (Füllner 1996: 97–8). It is perhaps by its remarkable prescience that Roman Jakobson's essay on Dada, written in 1921, draws critical distinction, noting there the Futurists' impassioned cry 'long live the future' in opposition to the Cabaret Voltaire players' no less impassioned 'down with the future' (Jakobson 1987: 38). Chronologically, Futurism comes before Dada, but the two formations overlap. Strictly speaking, Futurism even outlives Dada through the convolutions of Italian Dada and the emergence from the latter of the problematic case of Giulio Evola, for example (Schnapp 2005) – historical fact, ultimately, that compromises the preferred linear passaging of easy art history. Properly to consider the relationship between the two movements may demand recourse to the less distinct position that was put into words by Hans Richter (1965: 33), as he described Dada's failure to digest Futurism, simply swallowing it whole, 'bones, feathers and all'. We might summarise

this as Dada's indigestion, with Futurism constantly repeating on Dada: Dada's heartburn, if not its burning heart. Almost everywhere we look in Dada, Futurism repeats in stances indebted to the terms of cultural engagement and visibility initiated by the Italians; the manifesto form in particular, that which announced Futurism to the world in 1909 – and in which the later Dadaist Walter Serner invested such venom during the Zurich Dada phase, having previously already denounced Futurism in essays that dismissed some of the movement's painters from the realm of art – finds itself at the centre of the expanse of cultural-linguistic activities in which the international Dada brigade participated.

Those who would one day become Dadaists discovered Futurism by varied means. This chapter will first track the exposure of Futurism to its German constituency before considering in particular how early Dada experimentation in 1916 negotiated the relation to its Italian antecedent. From first condemnation, the Berlin anarchist periodical *Die Aktion* would eventually embrace the Futurist cause as its publisher, Franz Pfemfert, gravitated towards the poet Theodor Däubler, who had been a participant in the Futurist evening demonstrations of Milan and Florence alongside Marinetti, Giovanni Papini, Ardengo Soffici and Umberto Boccioni – Austrian-born Däubler being the only poet who wrote in German to have participated in the *serate*. Two special issues of *Die Aktion* were devoted to Futurism in 1915–16 (one reviewing Däubler's achievements, the other edited by Däubler out of Papini's *Lacerba*), and it published frequent translations by Else Hadwiger of Futurist poetry. Among the most devoted readers of *Die Aktion* – one of 'our periodicals' – of course, was the future founder of the Cabaret Voltaire, Hugo Ball (1996: 6). Ball had met Pfemfert in 1913 and was a contributor to his periodical. At the same time, the always Futurist-friendly *Der Sturm*, published in Berlin by former Florentine art student and Germany's cultural impresario, Herwarth Walden, promoted the work of the Italian artists and writers in the name of the new creative revolution that was at pains to distance itself from German Expressionism, distributing its versions of the Futurist manifestos to a German-speaking audience. It was during the war years, for instance, that poet Johannes R. Becher, during what is described as his 'developing period', came into collaborative contact with the *Sturm* enthusiasts. Peter Demetz (1994: 179) tells us how this wild young man, who would one day become the GDR's first Communist Minister of Culture, 'was more thoroughly attracted to the Italian Futurists than any other German poet of the war generation, and enthusiastically seized on Futurist rhetoric … in the most effective Leninist poems ever written in the German tongue'. Becher appropriated much of the Futurist techniques of words-in-freedom – particularly

Marinetti's 'analogies', which he condensed as incendiary devices – to produce work that Peter Davies (2002: 892) describes as 'the most comprehensive German reception of the formal and stylistic preoccupations of Futurism'. *Der Sturm* had been modelled initially on Giuseppe Prezzolini's *La Voce*, the latter founded in 1909 as a debating forum in response to 'the new forms of human coexistence' of its time (Prezzolini 1909); and it was *Der Sturm*, indeed, that duly proved to be the Futurists' most vigorous mouthpiece outside Italy from March 1912 onwards, with its manifesto translations given suitably frequent public airings. In April 1912, for instance, Marinetti's *Technical manifesto of Futurist Literature*, subsequently to be published in *Der Sturm* (133, October 1912, 194–5) as *Die futuristische Literatur – Technisches Manifest*, was read out by expressionist poet Ferdinand Hardekopf at the Weisser Hirsch hotel in Munich, as an encore to the Cabaret Grüner Teufel – the green devil cabaret starring none other than Emmy Hennings, occasional liaison of Becher,[1] and future co-founder of the Cabaret Voltaire – and this, it is said, was the very evening that 'for (and with) Hennings, Futurism was launched in the Munich bohemia' (van den Berg 1996: 73), inciting its listeners to the liberation of vocabulary and syntax.

The assault on typography

By whatever means the liberation was to be achieved, before anything else it would be necessary to disturb the transparency of language in its habitual functioning. Performative declamation would duly manifest itself as dynamic and synoptic for the Futurists, and mapping the same would take place according to a revolutionary typographical philosophy that aggressively turned on the simplicity and transparency of an existing print culture that was subordinate always to the conveyance of meaning – a print culture for which 'the first lady of typography', Beatrice Warde, much admired as she was in another country by Eric Gill in the 1920s, would in subsequent decades find a metaphor in the perfect wine goblet made of 'crystal-clear glass, thin as a bubble, and as transparent … calculated to *reveal* rather than to hide the beautiful thing which it was meant to *contain*', *sans* or otherwise (Warde 2000: 91). What the Futurist typographic revolution had already targeted was, in Marinetti's words,

> the so-called typographical harmony of the page, which is contrary to the flux and reflux, the leaps and bursts of style that run through the page. On the same page, therefore, we will use *three or four colours of ink*, or even twenty different typefaces if necessary. For example: italics for a series of similar or swift sensations, boldface for the violent onomatopoeias, and so on. (Apollonio 1973: 104–5)

To embrace flux and reflux, ebb and flow, swell and spend, on the page first meant looking *at* the text instead of looking *through* it, so that the style and verbal surface became more immediately constitutive of meaning than any 'content' or 'substance' that lay beneath or independently of that surface. This did not do away with content, clearly, but critically it set up an oscillation, or more recently a 'toggling' as rhetoric scholar Richard Lanham describes it, between surface and substance, drawing as Lanham does for demonstration on pop artist Roy Lichtenstein's magnified microdot newsprint patterns of the early 1960s, which are described as presenting 'a self-conscious and opaque design motif, something we are forced to look AT and not THROUGH' (Lanham 1993: 43). Similarly the work of British pop artist Eduardo Paolozzi can be considered as he brings serialised order to bear upon the disparity of 'cut out sheets for planes and tanks, building instructions for Lego-kits, the works of a clockwork robot, stickers for Mickey Mouse, Donald Duck and their synthetic companions' (Schmied 1976: 23–4). In such graphic works, Paolozzi exercises first of all the principle of 'computerising' material into informational and potentially interchangeable units, which enter into the circulation of signs on the picture plane 'in relation to similar objective details, these then become abstract, and in the repetition of geometrical elements they can combine and often lead to associative legibility' (Schmied 1976: 24). This regularity emerges most distinctly in examples of Paolozzi's *Moonstrips Empire News* screenprints, where columns of text generate formal cohesion and point towards such associative legibility.[2] Surfaces are made emphatic, texts dissolve in their own texture; and so, declared the Futurists in 1916, the book, indeed, as printed codex, that most 'wholly passéist means of preserving and communicating thought, has for a long time been fated to disappear like … the pacifist ideal' (Apollonio 1973: 207). Their sights were trained, in glorious anti-pacifism, on typographical convention.

 What came next was the intervention itself, and resulting from it the oscillation between surface and substance or suggested depth: the physical and the aesthetic planes together became coextensive and co-ordinate in a particular sense. Marinetti's *Zang Tumb Tumb* – published in 1914, having already been declaimed in parts within Berlin avant-garde circles during the preceding year – is perhaps the first virtuoso rendering of words-in-freedom, stressing and straining its rhythms and onomatopoeias through revolutionary typography; *Vive la France* of 1915 suspends the linearity of the book; and by the time Europe was emerging from the war that ended in 1918, the Futurist orchestrator's grandiose tumult had mustered its destructive potential as the explosive incendiary novel, *la bomba-romanzo esplosivo*, performed the book's auto-deconstruction, with the explosion 'at its centre literally shattering typographical convention into distended

fragments' (Lanham 1993: 33). The approach to the assault on typography had been set out in 1912 with the *Technical Manifesto of Futurist Literature*, where Marinetti took heed of what the aeroplane propeller had to tell him above 'the mighty Milanese smokestacks' – to 'free words, releasing them from the prison of the Latin period' (2002: 77) – as he grafted the rousing rhetoric of transcendence 'onto the technology of flight' (Schnapp 1994: 169). The random placement of nouns, infinitives standing in for indicatives, the abolition of adjectives, of adverbs and – most triumphantly – of punctuation, which was replaced by the dynamism of musical or mathematical signs, would all together combine in the undoing of the 'abstract code' of syntax, emphatically to negate the past and to affirm the Futurist universe. Syntax, Marinetti wrote, 'was a kind of interpreter and monotonous cicerone' (Apollonio 1973: 80), routinely exercised through simplified typography devoid of colour, assembled through a 'strict order of left to right then down one line; no type changes; no interaction; no revision' (Lanham 1993: 34); modulation is then achieved as '[t]ype is altered and arranged according to classical models of balance and equilibrium, convention requiring capitals and minuscules, occasional italics to supply emphasis and differentiation, white space to define borders, margins, and interruptions on the page' (Cohen 1979: 73–4). Marinetti argued how

> [w]e must remove this intermediary [the monotonous cicerone] so that literature may enter directly into the universe and become one with it … Liberation of words, soaring wings of the imagination, analogical synthesis of the earth embraced in a single glance, all drawn together in essential words. (Marinetti 2002: 80)

Without heed for communication or for beauty, Marinetti's declared interest in creativity that is free of all inhibition, released from rational control and constraint, was reiterated and expanded upon one year later in the manifesto *Destruction of Syntax*. The intoxication of intense life, he wrote, would stir the lyric voice of the individual who

> will begin by brutally destroying the syntax of his speech. He wastes no time in building sentences. Punctuation and the right adjectives will mean nothing to him. He will despise subtleties and nuances of language. Breathlessly he will assault your nerves with visual, auditory, olfactory sensations, just as they come to him … Fistfuls of essential words in no conventional order. Sole preoccupation of the narrator, to render every vibration of his being. (Apollonio 1973: 98)

The rendering visual of the words-in-freedom, making us look at them before we look through them, practically takes us beyond awareness simply

of the breathless, vitalist emotion that is declared in the writings – the soaring imagination, the embrace of the earth and of life's intoxication. Hence the move into revolutionary typography deliberately exposes the act of simplification represented by ordinary printed text, and the action makes us 'self-conscious about a register of expressivity that as literate people we have abjured' (Lanham 1993: 33). Marinetti, it is argued,

> attacks the entire literate conception of humankind – the central self, a nondramatic society just out there waiting for us to observe it – and the purposive idea of language that rests upon it. He would urge us to notice that all this reality-apparatus is as conventional as the typography we are trained *not* to notice. (Lanham 1993: 34)

What we should recognise, however, is that for all its aggression, nowhere in his writing does Marinetti imagine, let alone declare, for Futurism a deliberate and explicitly stated oppositional role in such an engagement with and deconstruction of reality-apparatus. We read, just as the readers of *Le Figaro* did in 1909, of the flight from mythology and the mystic ideal (which, I suggest, is as close as Marinetti ever comes to looking directly at what has socially and culturally been abjured); but ultimately what we are left with is the enduring romantic image of the future man standing on the summit of the world, hurling defiance at the stars.

Text and chaos, surface and substance

The position of criticality in the midst of all this intoxication is, therefore, at stake. The emerging aesthetic of the words-in-freedom provides us, very early on in Futurism, with the recognisable relation between the aesthetic and the ideological: the aesthetic, we know, 'reflects' its enveloping ideology. But it is at the same time an ideological act, one that participates in the resolution of social conflict and historical contradiction – one that in Marxist thought, therefore, functions in the promotion and perpetuation of false consciousness. Yet, despite the proliferation of aesthetic activity under precisely the same conditions that made possible the age of technology that was now being embraced by the Futurists, any thought of securing annulment or remedy for social conflict and historical contradiction was similarly misguided or, simply and inevitably, absent. Annulment; remedy; resolution; reconciliation; even synthesis – whichever term we use, there follows from it a conflation of the aesthetic and the ideological, a collapsing of that distance where criticality might reside, a conflation that evacuates the work of art of any critical potential with regard to the aesthetic 'as not much more than a realm where consent to bourgeois class rule is guaranteed' (Foster 1985: 158). If Futurism assumed a revolutionary

stance, it nonetheless perpetuated this conflation of surface and substance, and in this we may recognise the later contention among the Dadaists as they struggled with their own relation to Futurism. On 30 June 1915, Ball recorded his at least theoretical resistance to 'the idea of revolution as art for art's sake' and his greater desire to know where he was heading rather than what he was leaving behind: 'If I found that life had to be conserved in order to survive, then I would be conservative' (Ball 1996: 22). One of the poems he would later recite as part of the Cabaret Voltaire's initially conventional fare was first published in *Die Aktion* – Erich Mühsam's *Revolutionary Song* – and, beneath the limelight, it signalled Ball's clear aversion in the face of posturing radical revolutionaries:

> There was once a young revolutionary.
> ...
> His walk a revolutionary walk
> His yell: 'I am a revolutionary!'
> His cap: a revolutionary's cap
> pulled down over his left ear,
> By God, he thought he was terrifying.
>
> (Howard and Lewer 1996: 59)

Being loud and declamatory simply for the sake of it was not an option for Ball and, within a fortnight of his end-of-June diary entry, the productive possibilities of Futurist activity began, I think, to register:

> Marinetti sends me *Parole in Libertà* by himself, Cangiullo, Buzzi, and Govoni. They are just letters of the alphabet on a page; you can roll up such a poem like a map. The syntax has come apart. The letters are scattered and assembled again in a rough-and-ready way. There is no language any more ... it has to be invented all over again. (Richter 1995: 25)

This, for Ball, came at a critical juncture in the development of his political philosophy. By this time, in mid-1915, committed to pacifism and having rejected anarchist utopianism, his correspondence with Marinetti came about from his attraction to fantasy in language, an attraction consistent at that time with his growing interest in mysticism. His resistance to the content of Futurist art, however, is recognisable in his first real encounter with the movement's painters at an exhibition in Dresden in 1913, which made a marked impression on him; yet, though his was a negative response to the content, he judged that the work redeemed itself by the truthfulness of its 'heightened representation of the modern and mechanistic world' (Ball 1996: xviii).

Ball wrote what he described as his 'enthusiastic article' on this Futurist exhibition for *Revolution* – yet one more of the instrumental publications

of the prewar years in Germany – describing what he saw in paintings by Boccioni, Carlo Carrà, Gino Severini and Luigi Russolo (1996: 6).[3] The idea of publishing *Revolution* had been discussed by Ball, Huelsenbeck and writer Hans Leybold in 1912, and the first issue appeared in late 1913, edited by Ball and Leybold as an attempt to provide an alternative to Pfemfert's *Die Aktion*, in vociferous support of revolution 'that was more aesthetic than political' (Ball 1996: xvii). Ball's increasing alienation at this time from Pfemfert's commitment to political solutions to the cultural crisis in Germany became more pronounced during Zurich Dada, with Ball's pursuit of 'a radically different course … searching for answers in aesthetics and metaphysics' (Allen 1985: 11, n. 46). The prophetic slogan for *Revolution* came courtesy of the poet whose work Ball would eventually recite at the Cabaret Voltaire – Mühsam's heroic declaration, 'Lässt uns chaotisch sein!' [Let us be chaotic!] – and, with that as its motive impulse, *Revolution* was perhaps inevitably short-lived. In a life 'full of quixotic reversals, sudden leaps, and steep emotional ascents and descents' (Rabinbach 2000: 69), before we arrive at nascent Dada, the years 1912–15 are hugely important for Ball in terms of the personal and collaborative relationships that he enters into and in terms of the critical intellectual repositioning that he undergoes.

The most important and most personal relationship to emerge from this intense period, of course, was the one with Emmy Hennings, whom he met in the autumn of 1913 at the Café Simplicissimus in Munich, to remain with her throughout his most productive years and until his death in 1927: 'It is impossible to measure the influence this frail girl had on Hugo Ball. Hugo was so strongly influenced by Emmy that one cannot love his writings unless one fully and deeply understands her influence', Richard Huelsenbeck would later write (Rugh 1982: 10). Already in Munich, in 1912, Ball had met Huelsenbeck, with whom he collaborated on *Revolution* and subsequently in the promotion of their shared anti-war views at evening performances such as 'the commemoration of the fallen poets' at the Berlin Architektenhaus in 1915, an event of remembrance that was followed up with the Expressionistenabend at the city's Harmoni-umsaal (at which Hennings and Becher, interestingly enough, were also present). This last occasion was reported locally as being 'basically a protest against Germany in favour of Marinetti' (Ball 1996: 17), where the self-proclaimed 'negationists' railed against *Kultur* and 'the kind of courage it takes to get shot for the idea of a nation which is at best a cartel of pelt merchants and profiteers in leather, at worst a cultural association of psychopaths' (Huelsenbeck 1981: 23). Both events came after Ball's own exposure to the conditions of subsistence at the Belgian front in late 1914 – where, by the time of Ball's civilian visit, Leybold had already committed

suicide during a period of hospitalisation at Itzenhoe after having been fatally wounded on active service. Ball's unsentimental and unpatriotic obituary to Leybold at the Architektenhaus posed palpable discomfort for the audience present, and in life, theirs had been a relation of unexpected convolution: the two men shared a sexual liaison, for instance, with one Finny Morstadt, who bore Leybold's child but with whom Ball appears to have had sexual intercourse around the period of the child's conception – and this, it was suggested, only 'in order to help his friend Leybold evade liability for support'. This slight was recorded in his diaries by Mühsam who, at this particular juncture, held Ball in extremely low regard and fully intended to 'force Mr Hugo Ball ... to pay for alimony' (van den Berg 1996: 72). Such intimacy is as may be, but the impact of the appalling reality that Ball had now seen with his own eyes at the Belgian front, scenes 'fearful, shocking and tragic beyond anything the theatre could produce' (Melzer 1994: 25–6), did indeed banish his theatrical aspirations to a very remote place, and impressed upon him the moral bankruptcy of art and art-making that did not rise to the challenge of its own political conscience.

The dilemma was a stubborn one for Ball. The first summer of Dada was marked by the continuing struggle as he questioned himself (15 June 1916): 'I do not know if we will go beyond Wilde and Baudelaire in spite of all our efforts; or if we will not just remain romantics' (Ball 1996: 66). The problem had not gone away for him in the preceding months, the time during which he had developed his own sound poetry within the enabling environment of Dada cabaret and performance. What complicated matters, I think, was the residual romanticism of the Futurist words-in-freedom, a romanticism of the expressive-intuitive individual that Ball himself was prone to, but which might compromise the political potential he invested in Dada as 'an opportunity for true perception and criticism of the times we live in' (Ball 1996: 58). There was, of course, no conflict with Marinetti's preparedness to abandon traditional ideas of beauty in favour of the creation of 'ugly' art, but the Italian's casual letting go of communication was a problem. To declare that 'it is not necessary to be understood', as Marinetti did (Tisdall and Bozzolla 1993: 95), posed the triumph of free intuition over rational logic in the Futurists' return to the senses; but, for Ball, it was of fundamental importance that the Futurists' and subsequently the Dadaists' 'disintegration right in the innermost process of creation' be understood as more than motor impulse or re-action. It was, precisely, a pro-action, the interruption of synthesis and order as affect (and affect as opposed to concept, the latter being that which gives order to our thinking). Rather than a letting go, this affect obtained renewed engagement with language:

It is imperative to write invulnerable sentences. Sentences that withstand all irony. The better the sentence, the higher the rank. In eliminating vulnerable syntax or association one preserves the sum of the things that constitute the style and the pride of the writer – taste, cadence, rhythm, and melody. (Ball 1996: 25)

What this amounted to was the renunciation of conceptual thought by means of the retention of the expressive surface of language, and simultaneously the abolition of resident meaning – not, however, in order to transform language into some 'significant form' but in order to direct attention at language: '[t]he only attention permitted was *at* attention; looking *through* was abolished' (Lanham 2006: 66). Still, the retention of recognisable or familiar word-forms preserves something that we can look through, and ultimately there is a logic that will lead us to Ball's sound poetry, where even the freed words of the Futurists are abolished.

Symmetries and rhythms

Within a month of the Cabaret Voltaire opening its doors in 1916, Ball was recording his thoughts on the public presentation of poetic works: 'Reciting aloud', he wrote on 2 March, 'has become the touchstone of the quality of a poem for me' (Ball 1996: 54). He had long been alert to the potential of exploiting rhythm and cadence in performance, and his 'fantastic novel' *Tenderenda* (1914–20) gave opportunity to explore devices of linguistic and vocal possibilities in response to his recognition of the way in which the dramatist might purposely move into song for dramatic effect, observing in his diary (11 April 1915) how '[t]he words of the song do not matter; the laws of rhythm are more important' (Ball 1996: 16). This does clearly link to the Futurist linguistic programme in terms of cleansing language and reducing it to its essentials, and occurs in the context of *Wortkunst* theory as practised among the *Sturm* Expressionist circle in Berlin; but it is not to empty Ball's developing sound patterns of meaning. Among the poems without words, for example, *Karawane* presents the listening audience with far from random, arbitrary or even chaotic sounds. Rather, the poem's evocative and rhythmic sequences pose 'new' sign systems (conventional language being the sign system par excellence), with the deliberate intention of putting in place foundations 'for signs that would not be any more signs, but the object, thereby overcoming the necessary falsification [of language], the lies produced by the cultural arbitrary sign system' (Kuenzli 1979: 67). The euphony of *Karawane* generates new signs and sound patterns that resist functioning as metaphors; signs and patterns that therefore resist operating as part of the currency of 'lies' produced by and circulating within culturally sanctioned but arbitrary sign systems –

'the language that journalism has abused and corrupted' (Ball 1996: 71); signs and patterns that resist functioning in a 'second-hand' manner as our medium for engaging the world. But they position themselves nonetheless as sounds that can touch 'lightly on a hundred ideas ... without naming them' (Ball 1996: 68), coming close to metaphor but not being metaphor; the poem is manifestly, therefore, not purely self-referential.[4] Herein, for Ball, lay the 'alchemy' and transformative potential of the word as he renounced all 'words (to say nothing of sentences) that are not newly invented for our own use' (Ball 1996: 71). To be precise, of course, it is clear from Ball's approach that it does not divest itself of the romantic ideal of an original, adamic language (logos) that resides innocently in a pre-logical and pre-cultural state:

> The primeval strata, untouched and unreached by logic and by the social apparatus, emerge in the unconsciously infantile and in madness, when the barriers are down; that is a world with its own laws and its own form. (Ball 1996: 75)

But as a romantic ideal this, critically, would not get in the way of, but would rather enable, the political potential that was central to Ball's activities; and it provides a departure accordingly from the romanticism that he perceived in Marinetti's approach, for instance, along with all of the attendant complications.

Ball comes to the poems without words (the 'Verse ohne Worte') and to the sound poems (the 'Lautgedichte') from an intriguing place. When he writes of 'alchemy', he signals for us how religious ideas and mysticism guide an approach that is indebted, in no small measure, to the contribution of Wassily Kandinsky. Ball met Kandindsky in 1912, the same year he met Huelsenbeck, and he was receptive to the older and established artist's observations on the literature of the future and on the way in which sounds impress upon the soul, which 'experiences a non-objective vibration that is more complex ... more "supersensible" ... than the effect on the soul produced by a bell' (Kandinsky 1982: 147). Ball knew also of the coherence *but* unintelligibility of the so-called 'lost language of the soul' that was transcribed from speech in hypnotic states and published by the poet Justines Kerner in 1829, for example. Through Kandinsky, Ball encountered the suspended configurations in the poetry of some of the Russian Futurists, the work of the phoneticists Aleksei Kruchenykh and Velimir Khlebnikov with its transrational experimentation in *zaum* that was designed 'to obtain freedom from meaning' (Melzer 1994: 41, nn. 81, 82); and the works of Germany's Christian Morgenstern, who died in 1914, were read out by Ball to the motley cabaret audiences:

Kroklokwafzi? Sememi!
Seiokrontro – prafriplo:
Bifzi, bafzi; hulalemi:
quasti basti bo …
Lalu, lalu lalu lalu la!

(Morgenstern 1963: 13)

Out of such phonetic, rhythmic configurations were generated these seductive and 'wonderfully plaintive words' that Ball located in 'ancient magical texts' (1996: 66–7); words like the priest-magician's powerful 'abracadabra' (the supposed ancient Aramaic meaning of which reinforces the power of words: 'I will create, as I say'; we might search for our own homonymic resonance in 'abre [el] cadáver', 'open the body', and the whole intricate interconnectivity to which the body laid bare is exposed). So, Ball wrote, '[w]e have loaded the word with strengths and energies that helped us to rediscover the evangelical concept of the "word" (logos) as a magical complex image' (Ball 1996: 68) – and supreme among these words is 'dada', which, as Jakobson reminds us, is

a meaningless little word thrown into circulation in Europe, a little word with which one can juggle à l'aise, thinking up meanings, adjoining suffixes, coining complex words which create the illusion that they refer to objects: dadasopher, dadapit. (Jakobson 1987: 37)

Perhaps the signal event to have taken place at the Cabaret Voltaire (the name which had, by mid-1916, yielded to the Dada-Soirée) is the only one for which there exists a widely reproduced, albeit staged, photographic record – Ball's performing of his sound poetry in June–July 1916, just before his first break with Dada. The photograph shows us Ball rigged in the painted cardboard cylinders, the huge collar, the 'wings', the famous witchdoctor's hat, and flanked by the music stands for his manuscripts, all of which he describes in detail in his triumphant diary entry of 23 June 1916 that followed the performance (Ball 1996: 70–1). In truth, perhaps, how different might we argue Ball to be from the man that Jakobson described in 1921, the improviser who, having 'received the gift of a clarity of vision which laid everything bare, ends his life as a fool in a cap scrawling transrational verses' (1987: 38)? Ball, in his fool's cap, began at that June *soirée* 'slowly and solemnly' to vocalise his cycle of word-like configurations:

gadji beri bimba
glandridi lauli lonni cadori
gadjama bim beri glassala
glandridi glassala tuffm i zimbrabim
blassa glassasa tuffm izimbrabim …

Here was what Ball had already charged himself with doing – his self-appointed task was to adopt 'symmetries and rhythms instead of principles', working out his aesthetic negotiation of the political terrain through opposition of 'world systems and acts of state by transforming them into a phrase' (Ball 1996: 56). The power and 'magic' of the spoken word became tangible in the sound poetry that ultimately resisted the visual renderings of the Futurist poems or, elsewhere in the context of Dada, the visual renderings of Raoul Hausmann's optophones. (It is a salient point that the typesetting of *Karawane* with which we are today so familiar comes from the 1920 *Dada Almanach*, edited by Huelsenbeck; the layout of 1920 was, crucially, never authorised by Ball himself whose stress fell always on the performance of his poems. Still, in delightful symmetry, the eighteen typefaces of the *Almanach* version practically match the twenty typefaces in italic and boldface so heartily recommended by Marinetti in his 1913 *Destruction of Syntax* manifesto.) By that resistance to visual rendering, and with the arrest of attention on its texture and plasticity, the formation of language becomes, 'magically' we might say, the object that we can no longer look, or now listen, through. What was pursued from the outset was the idea of a culturally redemptive 'new' art, precisely the function that Ball designed for his sound poetry as he privileged above the nonsense of others 'my own stuff, my own rhythm, and vowels and consonants too, matching the rhythm and all my own' (1996: 221). To attempt to imagine how Ball might have visualised his 'Lautgedichte' will, ultimately, yield very little when we recognise his priority of positioning a sense of authenticity or 'truth', therefore, as an aesthetic norm. His reading initially of the *parole in libertà* acknowledges what was distinct in the Futurist innovation:

> They [the Futurists] took the word out of the sentence frame (the world image) that had been thoughtlessly and automatically assigned to it, nourished the emaciated big-city vocables with light and air, and gave them back their warmth, emotion, and their original untroubled freedom. (Ball 1996: 68)

What had been the Dada burp, Futurism repeating on Dada, Dada's burning heart, became the sound poetry that Ball elaborated upon in order to apply in the break-up of the structures and inhibitors of his own world; so did his recovery and reclamation of the contingence of humanity that signally departed Futurism's imbroglio and at times crude celebration of technology, a move at once constructive and constitutive:

> We [the Dadaists] went a step further. We tried to give the isolated vocables the fullness of an oath, the glow of a star. And curiously enough, the magically inspired vocables conceived and gave birth to a *new* sentence that was not limited and confined by any conventional meaning ... this sentence made it

possible to hear the innately playful, but hidden, irrational character of the listener. (Ball 1996: 68)

Ball extends no appeal to the reader, then, and fully resists the imposition of text on the 'vocables'. The new and eruptive sentence is for the listener, it finds its integrity in process and operates consequently as a socio-political phenomenon. When language and life fall apart, the necessary disintegration of all that appeared stable and permanent makes way for *something else*, and we hear again and anew what was hidden and what is now freed from inhibition.

Notes

1 Hennings's conquest of the 'Munich bohemia' was manifold: unmodified gendered commentary on her 'extensive love life' is noted in a variety of sources. In 1911, she had been arrested for street-walking, and registered as a prostitute; it is most likely that she was sent out soliciting by Ferdinand Hardekopf, her permanent lover at the time, for what Erich Mühsam described as reasons of 'snobism'. Mühsam later reflected in his diary how '[t]he poor girl gets too little sleep. Everybody wants to sleep with her, and, since she is so accommodating, she never gets any rest ... I am really worried about Emmy. I am afraid she is seriously ill and yet is singing and screwing like the devil.' See van den Berg (1996: 77, 74).

2 Eduardo Paolozzi, *Moonstrips Empire News*, 100 screenprinted sheets and a text by Christopher Finch, published by Editions Alecto in 1967.

3 Russolo's name, of course, would echo three years on in the performance and, subsequently (in 1920), in the fourth line of Ball's 'Karawane'; Russolo's art of noise was well known to the Zurich Dadaists and his compositions performed in acknowledgement of the Italian's newly developed *intonarumori*, generating "*Le bruit*", noise with imitative effect ... a chaos of typewriters, kettledrums, rattles and pot-covers', as Huelsenbeck (1981: 25) recalled 'a terrifying vision of a world in agony, a vision which expressed the artist's own "ecstatic sickness"' (Melzer 1994: 26).

4 Richard Sheppard (1979: 94) invokes the line 'elomen elomen lefitalominai' from Ball's 'Wolken' of 1916, for example, as rhythmically if not consonantly reminiscent of Christ's words on the Cross, 'Eli, eli, lama sabachthani'.

References

Allen, R. F. (1985). 'Zurich Dada, 1916–1919: The Proto-phase of the Movement', in S. C. Foster (ed.), *Dada/Dimensions* (Ann Arbor, MI: UMI Research Press), pp. 1–22.

Apollonio, U. (ed.) (1973). *Futurist Manifestos* (London: Thames and Hudson).

Ball, H. (1996). *Flight Out of Time: A Dada Diary*, trans. A. Raimes (Berkeley, Los Angeles and London: University of California Press).

Cohen, A. (1979). 'The Typographic Revolution: Antecedents and Legacy of Dada Graphic Design', in S. C. Foster and R. E. Kuenzli (eds), *Dada Spectrum: The Dialectics of Revolt* (Madison, WI: Coda Press Inc.), pp. 71–89.

Davies, Peter (2002). 'Becher's Version of Majakovskij's "150 000 000"', *Modern Language Review*, 97, 892–908.

Demetz, P. (1994). 'The Futurist Johannes R. Becher', trans. W. Werthern, *Modernism/Modernity*, 1:3, 179–94.

Dickerman, L. and M. S. Witkovsky (eds) (2005). *The Dada Seminars* (Washington: The National Gallery of Art).

Foster, H. (1985). *Recodings: Art, Spectacle, Cultural Politics* (Seattle, WA: Bay Press).

Füllner, K. (1996). 'Richard Huelsenbeck: "Bang! Bang! Bangbangbang" The Dada Drummer in Zurich', in B. Pichon and K. Riha (eds), *Dada Zurich: A Clown's Game from Nothing* (New York: G. K. Hall & Co.), pp. 89–103.

Howard, M. and D. Lewer (1996). *A New Order: An Evening at the Cabaret Voltaire* (Manchester: Manchester Metropolitan University).

Huelsenbeck, R. (1981). 'En avant Dada: A History of Dadaism' [1920], in R. Motherwell (ed.), *The Dada Painters and Poets: An Anthology* (Cambridge, MA, and London: Belknap Press of Harvard University Press), pp. 21–47.

Jakobson, R. (1987). *Language in Literature*, eds K. Pomorska and S. Rudy (Cambridge, MA, and London: Belknap Press of Harvard University Press).

Kandinsky, W. (1982). 'On the Spiritual in Art' [1912], in K. C. Lindsay and P. Vergo (eds), *Kandinsky: Complete Writings on Art*, vol. 1 (London: Faber and Faber), pp. 114–219.

Kuenzli, R. E. (1979). 'The Semiotics of Dada Poetry', in S. C. Foster and R. E. Kuenzli (eds), *Dada Spectrum: The Dialectics of Revolt* (Madison, WI: Coda Press Inc.), pp. 51–70.

Lanham, R. A. (1993). *The Electronic Word: Democracy, Technology and the Arts* (Chicago and London: University of Chicago Press).

Lanham, R. A. (2006). *The Economics of Attention: Style and Substance in the Age of Information* (Chicago and London: University of Chicago Press).

Marinetti, F. T. (2002). *Selected Poems and Related Prose*, trans. E. R. Napier and B. R. Studholme (New Haven and London: Yale University Press).

Melzer, A. (1994). *Dada and Surrealist Performance* (Baltimore and London: Johns Hopkins University Press).

Morgenstern, C. (1963). *The Gallows Songs: Christian Morgenstern's* Galgenlieder, trans. M. Knight (Berkeley, Los Angeles and London: University of California Press).

Pichon, B. and K. Riha (eds) (1996). *Dada Zurich: A Clown's Game from Nothing* (New York: G. K. Hall & Co.).

Pierre, A. (2005). 'The "confrontation of modern values": A Moral History of

Dada in Paris', in L. Dickerman and M. S. Witkovsky (eds), *The Dada Seminars* (Washington: National Gallery of Art), pp. 241–67.

Prezzolini, G. (1909). 'Al lettore', *La Voce*, 1:9, 33.

Rabinbach, A. (2000). *In the Shadow of Catastrophe: German Intellectuals between Apocalypse and Enlightenment* (Berkeley and Los Angeles: University of California Press).

Richter, H. (1965). *Dada: Art and Anti-art*, trans. D. Britt (London: Thames and Hudson).

Rugh, T. F. (1982). 'Emmy Hennings and Zurich Dada', *Dada/Surrealism*, 10–11, 5–28.

Schmied, W. (1976). 'Bunk, Bash, Pop – the Graphics of Eduardo Paolozzi', trans. P. Bostock, in F. Whitford et al., *Eduardo Paolozzi: Sculpture, Drawings, Collages and Graphics* (Stamford: Arts Council of Great Britain), pp. 21–5.

Schnapp, J. T. (1994). 'Propeller Talk', *Modernism/Modernity*, 1:3, 153–78.

Schnapp, J. T. (2005). 'Bad Dada (Evola)', in L. Dickerman and M. S. Witkovsky (eds), *The Dada Seminars* (Washington: National Gallery of Art), pp. 31–55.

Sheppard, R. (1979). 'Dada and Mysticism: Influences and Affinities', in S. C. Foster and R. E. Kuenzli (eds), *Dada Spectrum: The Dialectics of Revolt* (Madison, WI: Coda Press Inc.), pp. 91–113.

Tisdall, C. and A. Bozzolla (1993). *Futurism* (London: Thames and Hudson).

Van den Berg, H. (1996). 'The Star of the Cabaret Voltaire: The Other Life of Emmy Hennings', in B. Pichon and K. Riha (eds), *Dada Zurich: A Clown's Game from Nothing* (New York: G. K. Hall & Co.), pp. 69–88.

Warde, B. (2000). 'The Crystal Goblet', in G. Swanson (ed.), *Graphic Design & Reading: Explorations of an Uneasy Relationship* (New York: Allworth Press), pp. 91–4.

Winter, G. (1996). 'Zurich Dada and the Visual Arts', in B. Pichon and K. Riha (eds), *Dada Zurich: A Clown's Game from Nothing* (New York: G. K. Hall & Co.), pp. 138–52.

5

Futurist canons and the development of avant-garde historiography (Futurism– Expressionism–Dadaism)

Maria Elena Versari

In 1921, Marc Bloch published an essay entitled 'Reflections of an historian on the fake news under the war', in which he justified his interest in that somewhat unusual subject: 'Our ancestors did not quibble over these sorts of things, they rejected error, when they recognised it as such, and they were not concerned about its repercussions. That's why the information they left us doesn't allow us to satisfy our curiosity, which is of no interest to them' (Bloch 1999: 14).[1] What I propose to examine in this chapter are the traces of a wide array of interpretations and misinterpretations that Futurism triggered in Germany, and the effect they had on defining a new model of avant-garde practice.

Herwath Walden, propagandist and antagonist of the Futurists in Berlin

When the Futurists first appeared in Germany in 1912, the majority of their works were acquired by the banker Wolfgang Borchardt through the intercession of Herwarth Walden. With this acquisition, Walden became de facto the sole handler of the Futurist trademark in Germany, the Netherlands and Northern and Central Europe. He established a limited liability society, the Gesellschaft zur Förderung moderner Kunst, which between 1912 and 1914 arranged a European tour of Borchardt's collection. Futurist works travelled to several European cities, including Hamburg, Amsterdam, The Hague, Munich, Vienna, Budapest and Karlsruhe. For these exhibitions, he created a standard catalogue entitled *Die Futuristen*, which, interestingly, contains no original Futurist texts besides a truncated version of Marinetti's 1909 Manifesto.[2] We will return to the importance of this catalogue, but, for the moment, let's focus our attention on the first Futurist show in Berlin.

At the beginning of 1912, Walden was embarking on a new project. He had just inaugurated the Der Sturm Gallery, under the insignia of his journal, which at that time was only two years old. To the self-proclaimed avant-garde impresario, his involvement with the Futurists' show, the second exhibition of any kind in his gallery, was crucial for the long-lasting success of his new cultural and commercial enterprise.

At that point in time, a Futurist show entailed not only an exhibition of paintings but an all-encompassing 'Futurist' event, like those that Marinetti had originally staged in Paris (with the help of Felix Fénéon) and later in London. Berlin became the third major European capital to host it. The insertion of Walden's gallery within the circuit of the already clamorous touring Futurist exhibition helped to launch it as a prominent, international site for the avant-garde.

In April 1912, Umberto Boccioni was the first to arrive in Germany. Disappointed by the poor ticket sales for the exhibition, he described himself, in a letter to Carlo Carrà (12 April 1912), as 'lonely, sad, and in the most elegant and rich hotel in Berlin'. In the same letter, he listed three reasons for these circumstances: 'The revenue (from the ticket sales) has been very low, compared to what I saw in Paris and London. The reasons for this: the horrible weather, the environment that is hardly enthusiastic about artistic manifestations, and the fact that the show is organised by a journalist, that is, by a colleague and an enemy of all the other journalists, and therefore an enemy of the only instrument suitable for the public *réclame* necessary in situations like ours' (Coen 2009: 159).

Summoned by Boccioni, Marinetti eventually came to Berlin in order to launch a massive publicity campaign for the exhibition. As Nell Walden recollects in the biography she wrote of her husband, this involved the Italians, along with her and her husband, driving noisily through Berlin's silent streets, throwing out leaflets and screaming 'Evviva il Futurismo!' (Coen 2009: 467). One of these items was probably the poster that reproduces Marinetti's *Manifesto of Futurism*, printed by Walden to advertise the exhibition as well as Marinetti's conference taking place on 22 April (Figure 5.1).

Marinetti's publicity stunt aside, the Berlin show emerged as a new paradigm for the staging of the Futurists' presence abroad. Their identity was now strictly framed by the double conduit of visibility offered by Walden through his gallery and his journal. It is in *Der Sturm* that the German translations of the manifestos were first published: in March 1912 the *Manifesto of the Futurist Painters*, which acts almost as an introduction to the show that was soon to follow; Marinetti's own founding manifesto of 1909; Boccioni's *Appeal of the Exhibitors to the Public*; and later, Valentine de Saint Point's *Manifesto of the Futurist*

Ausstellung der Zeitschrift „DER STURM"
Herausgeber: HERWARTH WALDEN

Gemälde der Futuristen

Tiergartenstrasse 34a / Geöffnet von 10-6 Uhr / Eintritt 1 Mark

Manifest des Futurismus / von F. T. Marinetti

1 Wir wollen die Liebe zur Gefahr singen, die gewohnheitsmässige Energie und die Tollkühnheit.

2 Die Hauptelemente unserer Poesie werden der Mut, die Kühnheit und die Empörung sein.

3 Wie die Literatur bisher die nachdenkliche Unbeweglichkeit, die Ekstase, den Schlummer gepriesen hat, so wollen wir die aggressive Bewegung, die fiebrige Schlaflosigkeit, den gymnastischen Schritt, den gefahrvollen Sprung, die Ohrfeige und den Faustschlag preisen.

4 Wir erklären, dass der Glanz der Welt sich um eine neue Schönheit bereichert hat: um die Schönheit der Schnelligkeit. Ein Rennautomobil, dessen Wagenkasten mit grossen Röhren bepackt sind, die Schlangen mit explosivem Atem gleichen, ein heulendes Automobil, das auf Kartätschen zu laufen scheint, ist schöner als die „Sieg bei Samothrake."

5 Wir wollen den Mann preisen, der am Lenkrad sitzt, dessen gedachte Achse die auf den Umkreis ihrer Planetenbahn geschleuderte Erde durchbohrt.

6 Der Dichter muss sich mit Wärme ausgeben, mit glanzvoller Verschwendung, um den begeisterten Eifer der Uranfänglichen zu vergrössern.

7 Nur im Kampf ist Schönheit. Kein Meisterwerk ohne aggressives Moment. Die Dichtung muss ein heftiger Ansturm gegen unbekannte Kräfte sein, um sie aufzufordern sich vor den Menschen zu legen.

8 Wir sind auf dem äussersten Vorgebirge der Jahrhunderte! . . . Wozu hinter uns blicken, da wir gerade die geheimnisvollen Tore des Unmöglichen brechen? Zeit und Raum sind gestern dahinaufgegangen. Wir haben schon im Absoluten, denn wir haben schon die ewige, allgegenwärtige Schnelligkeit geschaffen.

9 Wir wollen den Krieg preisen — diese einzige Hygiene der Welt — den Militarismus, den Patriotismus, die zerstörende Geste der Anarchisten, die schönen Gedanken, die töten, und die Verachtung des Weibes.

10 Wir wollen die Museen, die Bibliotheken zerstören, den Moralismus bekämpfen, den Feminismus und alle opportunistischen und Nützlichkeit bezweckenden Feigheiten.

11 Wir werden die arbeitbewegten Mengen, das Vergnügen, die Empörung singen, die vielfarbigen, die vielfönigen Brandungen der Revolutionen in den modernen Hauptstädten; die nächtliche Vibration der Arsenale und Zimmerplätze unter ihren heftigen, elektrischen Monden; die gefrässigen Bahnhöfe voller raucheder Schlangen; die durch ihre Rauchfäden an die Wolken gehängten Fabriken; die gymnastisch hüpfenden Brücken über den Messerschmiede der somdurchflimmernden Flüsse; die abenteuerlichen Dampfer, die den Horizont wittern; die breitbrüstigen Lokomotiven, die auf den Schie-

nen stampfen wie riesige, mit langen Röhren gerüstete Stahlrosse und den gleitenden Flug der Aeroplane, deren Schraube knattert wie eine im Winde wehende Flagge und die klatscht wie eine beifallstobende Menge.

In Italien veröffentlichen wir dieses feurige, gewaltige Manifest, durch das wir heute den Futurismus schaffen, weil wir Italien von seinem Krebs von Professoren, Archäologen, Ciceronen und Antiquaren befreien wollen.

Italien ist lange genug der grosse Markt der Trödler gewesen. Wir wollen es von den unzähligen Museen befreien, die es wie unzählige Kirchhöfe bedecken.

Museen, Kirchhöfe! . . . Wirklich identisch sind sie im finsteren Beruhren ihrer Körper, die einander nicht kennen. Oeffentliche Schlafstellen, wo man auf ewig verhassten und unbekannten Wesen gegenüber schläft. Reziprokes Ungestüm der Maler, die sich mit Linien- und Farbenschlägen gegenseitig in demselben Museum töten.

Man besuche sie jedes Jahr, wie man alljährlich die Gräber seiner Lieben besucht . . . Einverstanden! . . . Man lege meinetwegen jährlich der „Gioconda" Blumen zu Füssen die verstehen es! . . . Aber täglich unsere Tätigkeit, unseren zerbrechlichen Mut und unsere Unruhe in die Museen spazieren führen, das lassen wir nicht zu! . . . Will man sich denn vergiften? Will man verwesen?

Was kann man gut an einem alten Bilde finden, wenn nicht die mühseligen Verrenkungen des Künstlers, der sich bemüht, die undurchdringbaren Tore zu durchdringen, nur weil er wünscht seinen Traum auszudrücken?

Ein altes Bild bewundern heisst unsere Empfindsamkeit auf eine Totenurne verschwenden, statt sie nach vorn zu schleudern mit heftigen Stössen, die schöpfen und tatkräftig sind. Will man denn so seine besten Kräfte durch die Bewunderung des Vergangenen verschwenden, um gänzlich erschöpft, geschwächt zu sein?

In Wirklichkeit ist der tägliche Besuch der Museen, der Bibliotheken, der Akademien (dieser Friedhöfe verlorener Anstrengungen, dieser Golgatha gekreuzigter Träume, dieser Register gebrochener Schwungen) für den Künstler dasselbe, was verlängerte Vormundschaft für intelligente, an ihrem Talent berauschte Jünglinge ist.

Für Talkranke, Invaliden und Gefangene, meinetwegen. Es ist vielleicht ein Balsam für ihre Wunden, die bewunderungswürdige Vergangenheit, da ihnen die Zukunft versagt ist . . . Aber wir wollen so etwas nicht, wir jungen, starken, lebendigen Futuristen!

Lasst sie doch kommen, die guten Brandstifter mit den karbolduftenden Fingern! . . . Da sind sie! Da sind sie! . . . Steckt doch die Bibliotheken in Brand! Leitet die Kanäle ab, um die Museen

zu überschwemmen! Ha! Lasst sie dahintreiben, die glorreichen Bilder! Nehmt Spitzhacken und Hämmer! Untergrabt die Grundmauern der hochehrwürdigen Städte!

Die Aeltesten von uns sind dreissig Jahre alt; wir können also wenigstens zehn Jahre unsere Pflicht tun. Sind wir vierzig Jahre, so mögen Jüngere und Tüpfere uns in den Papierkorb werfen wie unnütze Manuskripte! Von weither werden sie uns entgegenkommen, tanzend nach dem leichten Rhythmus ihrer ersten Gedichte. Mit ihren hakenförmigen Fingern werden sie in die Luft kritzeln und vor den Türen der Akademien den guten Geruch unserer verwesenden Geister einatmen, die schon den Katakomben der Bibliotheken versprochen sind.

Aber wir werden nicht da sein. Sie werden uns in einer Winternacht mitten auf dem Lande vor einem düsteren Hangar finden bei unseren bebenden Aeroplanen, und wir werden uns gerade über dem Feuer unserer Bücher von heute die Hände wärmen und hoch wird die Flamme aus ihnen unter dem Fluge ihrer Bilder herausschlagen.

Sie werden uns umringen, keuchend vor Angst und Aerger, und verzweifelt durch unseren stolzen unermüdlichen Mut; sie werden sich auf uns stürzen mit ebenso viel Hass, wie ihr Herz trunken von Liebe und Bewunderung für uns sein wird. Und die starke, heilige Ungerechtigkeit wird aus ihren Augen strahlen. Denn Kunst kann nur Gewalt, Grausamkeit sein.

Die Aeltesten von uns sind dreissig Jahre alt, und doch haben wir schon Schätze vergeudet. Schätze von Kraft, Liebe, Mut und strengem Willen, eilig, in Delirium, ohne zu rechnen, im Handumdrehen, zum Atemverlieren.

Blickt uns an! Wir sind nicht ausser Atem . . . Unser Herz ist nicht im mindesten erschöpft! Denn Feuer, Hass, Schnelligkeit ernährt es! . . . Das setzt euch in Erstaunen? Ja, weil ihr euch nicht einmal erinnert gelebt zu haben. Auf dem Gipfel der Welt stehend schleudern wir noch einmal unsere Herausforderung den Sternen zu!

Eure Einwürfe? Genug, genug! Versteh ich sie. Wir wissen sehr gut, was unsere schöne falsche Intelligenz uns bestätigt. — Wir sind nur, sagt sie, der Inbegriff und die Verlängerung unserer Ahnen. — Vielleicht! Meinetwegen! . . . Was tuts? Aber wir wollen nicht begreifen. Wiederholt ja nicht diese infamen Worte! Kopf hoch! Das ist besser!

Auf dem Gipfel der Welt stehend schleudern wir noch einmal unsere Herausforderung den Sternen zu!

Autorisierte Uebersetzung von Jean-Jacques

F. T. MARINETTI hält in der Ausstellung DER STURM / Tiergartenstr. 34a
am Montag, den 22. April 1912 / 5½ Uhr / eine CONFÉRENCE über

FUTURISMUS

besonders über futuristische Malerei und die ausgestellten Gemälde

Die Wochenschrift DER STURM / Einzelbezug 20 Pfg. / ist überall erhältlich
Verlag DER STURM / Berlin W / Potsdamer Strasse 18

5.1 Poster advertising the Futurist exhibition and a conference by Marinetti at the Galerie Der Sturm, April 1912 (32 cm x 47 cm). Private collection.

Woman; Marinetti's own various manifestos on literature and Boccioni's text *Futurist Simultaneity*.[3]

The catalogue of this first German show, originally published by the Der Sturm Publishing House (Verlag Der Sturm) in 1912, is a copy of the one produced for the previous London Sackville Gallery exhibition, which had taken place in March. It bears the title *Zweite Ausstellung: Die Futuristen* (*Second Exhibition: The Futurists*) and contains a shortened version of Marinetti's *Manifesto of Futurism* and two texts signed by Boccioni, Carrà, Russolo, Balla and Severini: *The Exhibitors to the Public* and the *Technical Manifesto of Futurist Painting*. The latter appears, like in the previous Paris and London catalogues, under the title of *Manifesto of the Futurist Painters*. Moreover, as was the case in London, the visitor to the Berlin show could find in the catalogue, below the title of each work, a short explanation in German. Around the time of the first exhibition, Walden was pressured into reprinting and further distributing this catalogue, which contained reproductions of eight Futurist paintings. Copies available in public and private collections testify to at least five reimpressions. It's however a later, more heavily reworked version of it, conceived for the travelling show of the Borchardt acquisition, that offers some hints about Walden's attitude toward the Futurists and their aesthetics. This latter catalogue (we can call it 'The Borchardt catalogue') is simply titled *Die Futuristen* (*The Futurists*) and appeared in two slightly different versions: first, under the aegis of the journal *Der Sturm* (Walden 1912b) and, later, under the aegis of the journal together with the Gesellschaft zur Förderung moderner Kunst m. b. H (Walden 1912c).[4] It is clear that printing and selling this item was for Walden a publicity stunt in itself. He capitalised on the growing demand for Futurist documentation in the cities that hosted his touring Borchardt show. The Futurists' own words, however, progressively disappeared from the catalogues that were propagating their art in Germany and Central Europe. As already noted, the Borchardt catalogue contained only Marinetti's shortened version of the *Manifesto of Futurism*. Moreover, of the thirty-five works listed in the first catalogue, it listed only the twenty-four acquired by Borchardt. The catalogue's illustrations, instead, were those that had already been selected by the Futurists for their Paris and London catalogues. All the paintings were indicated as 'belonging to a private collection and not for sale' (Walden 1912b: n.p.) while the back cover linked the identity of Expressionism and Futurism with Walden's enterprise, advertising: 'Permanent exhibitions. Der Sturm Journal: Works of the Expressionists and Futurists' (Walden 1912b: back cover). It is therefore evident that the success of the Borchardt touring exhibition and its catalogue, in the absence of the Futurists' own texts, highlights the importance of the few descriptions originally conceived for the London catalogue and reproduced in German.

20 Die Straße mit den Balkonen
 Eindruck des sich bewegenden Lichts, ein Thema in einer
 Melodie musikalischer Farben.

21 Mailänder Bahnhof
 Impression eines Eisenbahndamms.

RUSSOLO

22 Revolution
 Der Zusammenstoß zweier Mächte. Das revolutionäre
 Element der Enthusiasten und roten Lyriker gegen die Macht
 der Schläfheit und des starren Festhaltens an der Tradition.
 Die Engel sind die schwingenden Wellen der früheren Macht.
 Die Perspektive des Hauses ist zerstört, wie ein Faustkämpfer
 zweimal gebeugt, der einen Schlag in den Wind empfängt.

23 Die Erinnerung einer Nacht
 Eine phantastische Impression, nicht durch Linien, son-
 dern durch Farbe hervorgebracht.

24 Zug in voller Fahrt
 Synthese der Lichtreflexe, die ein Expreßzug mit sechzig
 Meilen stündlicher Geschwindigkeit hervorbringt.

25 Ein Drei-Köpfe
 Studie der Durchsichtigkeit des Körpers wenn Licht
 darauf fällt.

26 Tinas Haar
 Studie der Lichteffekte auf einem Frauenantlitz.

27 Porträt des Künstlers
 Interpretation des Gemütszustandes des Künstlers.

SEVERINI

28 Der „Pan-Pan" Tanz in Monico
 Eindruck des Lärms einer Musikkapelle, die champagner-
 trunkene Menge, der perverse Tanz der Artistin, das Ge-

26

Luigi Russolo: Revolution

27

5.2 Pages devoted to Luigi Russolo in the catalogue *Der Sturm, Zweite Ausstellung: Die Futuristen. Umberto Boccioni, Carlo D. Carrà, Luigi Russolo, Gino Severini* (Berlin, Königin Augusta-Strasse 51, 12 April–21 May 1912).

Formal and ideological content are summarized in these descriptions. For Luigi Russolo's *Revolution*, for instance, the original English text, inserted in the catalogue, reads:

> The collision of two forces, that of the revolutionary element made up of enthusiasm and red lyricism against the force of inertia and reactionary resistance of tradition. The angles are the vibratory waves of the former force in motion. The perspective of the houses is destroyed just as a boxer is bent double by receiving a blow in the wind. (Walden 1912c: 15)

But in the German translation, 'the revolutionary element made up of enthusiasm and red lyricism' becomes 'the revolutionary element of the enthusiasts and of the red poets' [Das Revolutionäre Element der Enthusiasten und roten Lyriker] (Walden 1912a: 26 and Walden 1912c: 15), drawing attention to the political reference of the painting.

Walden himself explicitly pointed to these captions as the interpretative tool for understanding Futurism, thus presenting his own catalogue, on sale for 60 Pfennigs, as the main reference for his public (Walden

1914: 6). While the Borchardt works on display were 'not for sale', in fact, the exhibition itself would give way to the creation of collectible, and marketable, ephemera: the illustrated catalogue as well as a series of postcards (20 Pfennings), comprising Futurist and Expressionist artworks (Walden 1914: 8).

At the beginning of 1914, Walden conceived an addendum to the catalogue he drafted for the 'Die Futuristen' exhibition held in Leipzig at the Galerie Del Vecchio. In it, he published an *Introduction* to the show, stating:

> The new movement in the plastic arts has imposed itself quite simultaneously in all lands of culture [Kulturländern]. The German group is called 'Expressionist', the French 'Cubist', the Italian 'Futurist'. All these movements constitute a single tendency, even if they differ from one another. They do not try to render a more or less exact optical impression, but rather the expression of their artistic personality ... The Futurists do not want to photograph an isolated phenomenon in a particular state; they search for the whole complex of sensations; they want to express the isolated phenomenon in different stages without considering Space and Time. (Walden 1914: 6)

Walden's anti-materialistic reading of Futurist aesthetics was indebted to Kandinsky's theoretical texts, *Über die Formfrage* (1912) and *Malerei als reine Kunst* (1913). In the letters he wrote to Walden at the time, Kandinsky outlined his doubts over the Futurists' choices of composition (see Coen 2009: 181–2). But this was not a matter that concerned Walden: what he was interested in doing was creating a new system for understanding modern art, an alternative to the codes of Impressionist aesthetics, then under scrutiny in the Berlin art scene (see Ewers-Schultz 1996). And in order to do so, he established an interpretative model, based not on a shared stylistic identity but on a collective, aesthetic and spiritual theory of modern art. Besides Walden's own aesthetic influences and interpretation, what I would like to stress here is the nonchalance with which he went beyond the obvious discrepancies distinguishing Cubism, Futurism and Expressionism in order to create a theoretical model that united them. For the German public, this model of connection and correspondence replaced the original manifestos and the Futurists' own conferences and performances. The introduction published for the Leipzig catalogue became in fact the core of a conference titled *What the Futurists Want and Envision. A Few Explanatory Words of Clarification*, which Walden gave during the itinerant exhibition of the Borchardt collection (Walden 1914: 5).

It is through this process of manipulating aesthetic principles that *Der Sturm* superimposed its own image on to the Italian movement. From being the main 'Futurist organ in the German language', as Peter Demetz (1990:

18) has called it, it came to embrace its status as a 'Corporate identity for the international avant-garde', to use Barbara Alms's terms (Alms 2000).[5] I would like to add just one more element of reflection to our analysis. Walden's portrayal of Futurism was pivotal to the promotion of an aesthetic and aestheticised reading of the movement, but it was also somehow responsible for freezing in time the perception of Futurism in Germany to the date of Borchardt's acquisition in 1912.

Futurism in the critical battlefield over Expressionism

In Germany, however, another way of understanding Futurism was slowly developing in those very years, countering the codes of interpretation established by Walden. Reviewing the Berlin show, the critic Alfred Döblin (1912: 42) stated: 'The basic refutation offered by Futurism resides in this. They need time. Every painting is a story, a tale, a drama: you cannot read it in two minutes. We need more time to read a Futurist painting than we do those of the Pointillistes and Impressionists. Paintings [like the Futurists'] require interpretation. It is a task. For an entrance fee of one mark people get not sixty works of art, but sixty tasks'. Döblin used the Futurists as a polemical example to counter what he saw as the Expressionists' merely formal exercises: 'Futurism is a great step. It represents an act of liberation. It's not a tendency, but a movement. Better: it is the movement of the artists going forward'. He added: 'Our artists make experiments, they study the laws of colour, of lines, of planes. They are quite candidly attending to this task – it's laughable – while the house is on fire. I'm not a friend of big words, but as for Futurism I endorse it with a clear Yes'.

Attempting to escape from the mindset of naturalism, Döblin could not see, as Walden was doing, the Expressionists' formal investigations as a spiritual response against Impressionism. By stressing the Futurist 'task', what he indicated was a new 'interpretative task', capable of reconfiguring the relationship between painting and public. For Döblin, the Futurists inserted a hiatus, an extraneous, psychological element inside the Impressionists' direct referential relation between vision and emotion. This moment of pause allowed for a new type of interpretation. It is for this reason that, the following year, he would react with virulence to Marinetti's technique of the *parole in libertà* or 'words-in-freedom', in an article, 'Futuristische Worttechnik', published in *Der Sturm* (Döblin 1913), which is now generally known for the powerful statement with which it ends: 'Ecce Müll' [Ecce Rubbish]. Marinetti's use of words as the minimal elements of reference to reality, which Döblin compared to the sad procession of many 'shorn poodles', undermined the German critic's plea for a new, indirect and anti-naturalistic model of interpretation. Döblin wanted a new system

of viewing that did not simply reproduce reality but inserted a hierarchy of meaning within it. Walden himself referred to this new vision, but for him it was only a guarantee of the internal, formal autonomy of a work of art. Both Walden and Döblin refused the complete objectivisation of the author's role within the (visual or linguistic) 'matter', a practice that for the latter was analogous to an act of 'brutality against Art' (Schmidt-Bergman 1991: 166–7).

No matter how distant from the gallerist's aesthetic interests, then, Döblin's criticism seemed to fulfil the need, shared by many, for new categories of interpretation. When five years later Walden defined the *Kunstwende*, the new wave of modernity in art, he echoed ideas already found in Döblin's criticism and elsewhere. Far from presenting all the modern trends which derived from Impressionism as being on the same level, he now created sub-categories. In his newly conceived aim of defining a temporal progression from Impressionism to Abstraction, from Objectivity to Non-Objectivity, Walden positioned Futurism at midpoint. The Futurists, he wrote, 'have an objective vision. They shape the optic effect into a unity of image'. He argued that the Expressionists, on the other hand, considered reality as an element, not as the inner sense, the guiding principle in the [painting's] composition' (Walden 1918: 103–4).

This historiographical model of the development of modern artistic trends, from and against Impressionism, had already been used by Paul Fechter, art critic from the Berlin journal *Vossische Zeitung*, who in 1914 had published the first monograph devoted to the German modern art scene, *Der Expressionismus*, updated and reissued in 1919 and 1920. His analysis offered an additional step in the codification of Futurism within Expressionism. According to him, the Italian movement attempted to reconcile the creative principle, proper to man, with the external form which this principle assumed in the work of art: 'The distance between human experience and its form must be reduced to a minimum, so [for Futurism] the artistic form in itself will be felt as an obstacle. The aesthetic value of the form and of the material and the debate on what the work needs and how to use it have contributed to this protest [against the traditional means of composition]' (Fechter 1914: 42). Fechter thus sees Futurism 'in deliberate contrast to the abstraction of Cubism, in that it shifts attention [from the value of composition] back to the instinctive and the immediate' (Fechter 1914: 43). Interestingly, this attention to subjective emotion pushed Fechter to liken Futurism to the novelty of Freud's theory, and accused both of remaining at the surface of emotional phenomena. Like Freud's method for the interpretation of images, Futurism, according to Fechter, did not reach the stratified levels of experience, but lingered on the representation of the superficial emotional experience, the 'simultaneity of states of mind'.

Significantly, he added, 'it is noteworthy that the Futurists attempt to represent the metropolis; the disorder and confusion generated by [such a] multiplicity offer automatically, through the image of chaos [*Bildwirrwarr*], a meaningful image [*Sinnbild*]' (Fechter 1914: 44).

The automatic 'meaningful image' of the Futurist metropolitan chaos

Crucially, however, this automatism was activated by the reference to art's content and this fact established an additional connection between Futurist pictorial style and thematic choices. The meaning of the artwork can be obtained automatically, without the use of formal intercession and re-elaboration, by representing chaos itself. The thematic choice of a visually chaotic subject becomes the inner guarantee of a chaotic state of mind. We are thus faced with the return of the problem, outlined by Döblin, of the radical aesthetic realism of the *words in freedom*. But while Döblin considered it a huge error, Fechter saw it instead as a crafty way to establish a modern kind of symbolism. This idea of a possible automatism in the connection between pictorial and emotional vision eliminates the use of abstraction as a necessary step in the 'purification' of the visual-emotional element, as suggested by Döblin and Walden. Some art, like that of the Futurists, was therefore particularly apt to realise a specific psychological effect, namely that of the representation of chaos. But this presented a serious problem to Fechter. In his book, he had striven to highlight Futurism's incoherence, as opposed to Expressionism's coherence, in terms of the stylistic development of the arts reacting against Impressionism. For him, Futurism was still too rooted in the psychological quandaries of an irrational, unmediated merger between vision and form. It was too rooted in Impressionism. But some subjects seemed particularly suitable to be treated visually in this way. And, moreover, some subjects, some visions taken from reality, possessed the capacity to be meaningful 'automatically', without the intercession of the values of abstract composition. To paraphrase Döblin's dismay for the mere use of reality, we could say now, after 'Ecce Müll', 'Ecce Chaos'.

Hence, Futurism created the perfect visual, 'automatic' icon of the chaos proper to modernity. But the author's historiographical progression from Impressionism to Futurism to (eventually) Expressionism, now had to face an unexpected incongruence. The overabundance of emotive elements in the artwork, which Fechter saw as a symptom of Futurism's inferiority to Expressionism, became the basis for representing the most contemporary of phenomena – metropolitan chaos.

At this point in his analysis, Fechter started to reconsider Futurism's stylistic characteristics from the point of view of this modern *Zeitgeist*. He

states: 'We can find in Futurist pictures the worrisome unease created by these [new] technical forces, their invisible irruption upon humanity'. Moreover, binding modernity with what he saw as a contemporary humanistic catastrophe, he adds, Futurism, 'more than Cubism and Expressionism, has given voice to the foreseeable spiritual situation in Europe, which is slipping into the catastrophe of war and revolution' (Fechter 1919: 52).

We are faced here with a paradox: the evolutionary model of argumentation used by art critics becomes more and more rooted in a philosophical reading of modern art. In 1914, concurrently with the first edition of Fechter's essay, Ludwig Meidner published his famous plea entitled *Instructions for painting the big city*, in which he referred directly to the Futurists and their manifestos, even at times paraphrasing them. His discourse mixed Futurism with a certain catastrophism. 'A street isn't made up of tonal values but it's a bombardment of whizzing rows of windows, of screeching lights between vehicles of all kinds and a thousand jumping spheres, scraps of human beings, advertising signs, and shapeless colours' (Meidner 1995: 102).

Meidner's *Apocalyptic landscapes* of these years (Der Sturm exhibited a first group of them at the end of 1912) presented the recurrent leitmotiv of the comet, which Carol Eliel has identified as a Nietzschean reference (Eliel: 18–19). In *Thus spake Zarathustra*, this 'pillar of fire' signals the impending destruction of the metropolis and its mediocre and decadent values. Visually, however, Meidner's coloured streaking bursts reveal the influence of the Futurist canvases shown at Walden's. In Boccioni's *Forces of a Street*, which had entered the Borchardt collection with the title *Die Macht der Strasse*, the Italian artist had offered a visual rendering of the energetic structure of the universe, defined by the line-forces, 'the bundle of lines corresponding to all the conflicting forces' of the painting (Boccioni 1912: 17) (Figure 5.3). The representation of these conflicting forces became, for the Expressionists, the epiphany of an energetic 'event', capable of destabilising the structure of reality. More specifically, it came to suggest the emotionally unstable, visual reality of the built environment proper to the modern city (Figure 5.4).

This contamination between a landscape seen in Futurist terms and the Expressionist taste for chaos was in fact not a simple translation of the Futurists' favourite iconographies into a German context. It was a more complex ideological transformation which, as we saw in Fechter, progressively bound the identity of Italian Futurism with the semantic field, or in Freud's terms, the figures of representation of the chaos and instability proper to modernity.[6] As Timothy Benson has suggested, the roots of this interpretation are embedded in the Expressionists' own celebration of what, in his influential book published in 1908, *The Beauty of the Metropolis*,

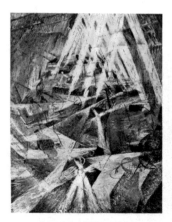

5.3 Pages devoted to Futurism from Paul Fechter's 1914 book
Der Expressionismus.

architect August Endell had already called the 'beauty of the city as nature' (Benson 2001: 24). Thus, the Futurist exhibitions played a significant role in the early and mid-1910s, when Meidner, together with other Expressionists, 'became more interested in the contrast between the artificial and the natural', and their works started to 'further convey the transitoriness of Endell's "street as living being", where the movement of vehicles and masses of people produced "mere appearances", "autonomous organizations", not of "inner connections" but of outward forms' (Benson 2001: 25, 27). Moreover, as the case of Döblin has shown, Futurism at this stage offered a set of references that contributed greatly to the debates surrounding the issue of representation, binding theories of painting and poetry. In a circular set of influences, the reworking of Futurist models by August Stramm and the Sturm Wortkunst, as well as the literary references to a metropolitan apocalypse offered by Meidner's associate Jacob van Hoddis and by Georg Heym, added a new layer of meaning to the contemporary perception, the critical assessments and the historiography of Futurism itself.

There is another factor that played a significant role in the codification of the image of Futurist art as a visual rendition of chaos. It is the influence played on German artists and writers by the anarchist culture of the late nineteenth century, and more specifically by the intellectual reflection on anarchism, which had not failed to influence modern Italian culture or

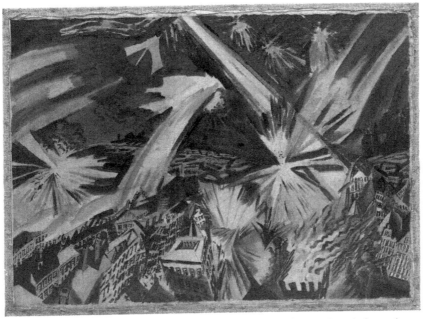

5.4 Ludwig Meidner (1884–1966), *Apocalyptic Landscape* (*Apokalyptische Stadt*), 1913. Oil on canvas, 81.3 cm x 115.5 cm, LWL-Landesmuseum für Kunst und Kulturgeschichte (Westfälisches Landesmuseum).

Futurism itself. Around the middle of the decade, however, this association assumed a decidedly negative aspect in Germany.

With the outbreak of the war, the fulfilment of the foreseen apocalypse brought about increasing expectations for a spiritual renaissance and a recomposition of individuals into a new totalising organism. This utopian drive became a kind of alter ego for the vicissitudes of the debate on Expressionism proper. Moreover, the debate on the possible outcomes of Expressionism became a metaphor of Germany's existential situation. Formalist, ideological and spiritual arguments merged, establishing a properly messianic image of Expressionism, seen as the force destined to find a response to the actual crisis. But again, this crisis had been, according to Fechter, faithfully portrayed mainly by Italian Futurism.

What we should stress is how in those years Fechter's codification, that is, the connection he established between Futurism, chaos and crisis, became not only a topos accepted by critics of art and literature but a conceptual node around which several intellectuals and philosophers articulated their reasoning. Georg Simmel, for instance, had already tackled the issue of modernity in 1903 with his seminal text on the psychology of the urban

individual, *The Metropolis and Mental Life*. In his 1916 essay *Crisis of Culture*, he described the impasse of contemporary culture, only capable of producing, in his words, 'a mere chaos of atomised formal elements' [*nur ein Chaos atomisierter Formstücke*], adding:

> Futurism has advanced to this extreme consequence of our situation in the arts: a passionate desire for the expression of life, for which traditional forms are inadequate, but for which no new forms have been devised, and which therefore seeks pure expression in a negation of form, or in forms that are almost provocatively abstruse – a violation of the very nature of creativity in order to escape its other inherent paradox. Nowhere, perhaps, do we see more forcefully than in some of the manifestations of futurism that once again the forms that life created as dwelling-places have become its prisons. (Simmel 2000: 94)

In this framework, Expressionism was deemed to offer an ideal response to the crisis, as outlined by Hermann Bahr's essay of 1916. In his view, Expressionism had become a new Romanticism, where, paraphrasing Goethe, painting represented what man could and should see, not what he actually does see. Again, even for Bahr (1916: 90), '[a]rt too cries into the deep darkness, it cries for help, it cries for the spirit. That is Expressionism'. Expressionism was an impending answer, always about to happen, an undefined and confused promise. This eschatological perspective widened the distance between the image of Expressionism and the actual, contemporary production of German artists. The space opened by this distance was taken by Futurism, interpreted as a historical and critical category that precedes and acts as a prelude to Expressionism.

But there is another element of Futurism that seems to offer an alternative exit strategy, not formal but this time explicitly political, to the German cultural impasse. The pacifist and revolutionary journal *Die Aktion*, directed by Franz Pfemfert, often took a position against *Der Sturm*, defending instead the model of the politicised artist (see Drygulski Wright 1983). In 1913 Oskar Kanehl, a writer and critic associated with Pfemfert, engaged in a diatribe with Walden, trying to lessen the role of the Italian Futurists in the battle for modern art. But his dismissal of the Italians as a group turned into a somewhat unexpected manifesto. He wrote that any artist who has a new and unfamiliar style, not yet understood by his contemporaries, is a Futurist (Kanehl 1913: 814).[7] A year before in the same journal, Ludwig Rubiner had published his own manifesto, 'The poet takes a stance in politics', which reads: 'Who are we? We are the people of the metropolis. We are silhouettes pushed out in the air as arrows among the centuries' (Rubiner 1917: 20; see Bernini 1995). Again, as both Fechter and Meidner would later do, he described the style and content of new painting with a reference to Boccioni's form-forces: 'The good poet doesn't

make verses devoted to radio stations, to cars, but to the lines of forces that stream around these objects in space'. He outlines his ideal for the new intellectual in the following terms: 'He speaks of the catastrophes that he himself taught us to see' (Rubiner 1917: 31). The visionary eschatology of Expressionism, depicted by Bahr, who, as we saw, wanted a 'painting that would represent what man could and should see, not what he actually sees', was turned back by Rubiner to the preferred content, so to speak, of Futurist art: catastrophe.

The Futurist Peril of the Dadaist Aktiv Typ

When in 1918 Thomas Mann wrote his *Reflections of an Unpolitical Man*, he tried to counter the kind of political activism of the intellectuals reunited around *Die Aktion*. Addressing the 'progressive' artists, he talked overtly about Italian Futurism, making extensive use of an essay written some years before by Hans Pfitzner. Entitled *Futuristengefahr* [Futurist Peril], Pfitzner's text went against Ferruccio Busoni's theory of music and accused him and his more visible, polemical compatriots, the Futurists, of professing a 'progressive' vision of history and the historical development of art.[8] Following this hint, the Italian Futurists represented, for Mann, the embodiment of an ideology of history that reflected a 'progressive' agenda. The final step on this path, from Futurism onwards, was, according to him, Expressionism. But contrary to Futurism, Expressionism 'abandons resolutely any acknowledgement of reality and institutes instead the sovereign, explosive, relentlessly creative rule of the spirit' (Mann 1920: 583). Mann, for his part, called instead for an art that struck a balance between moral and aesthetic elements, an art that was timeless, eluding the concept of evolution.

Significantly, not only the model of activism sustained by *Die Aktion* but also Mann's criticism of it had important repercussions, some years later, on the development of Berlin Dada. The Futurists' association between art and life informs the concept of the 'Aktive Typ', as Richard Huelsenbeck (1951: 28) calls it, 'the completely active type who only lives through action'. It is this concrete model of activism that the Berlin Dadaists propose in order to counteract the merely spiritual activism propagated by the main progressive association of German artists of the late 1910s, the Novembergruppe. Although we cannot enter into the debate between Berlin Dada and the Novembergruppe here, I would like to stress at least one issue in relation to it: the Dadaists' goal in this debate was to fight an idealistic vision of Expressionism. In their view, the Expressionists were guilty of having become self-referential in their promotion of a utopian, but substantially inconsequential, model of the artist in society. As Huelsenbeck states in

'Dadaism in life and art' (a text written in 1918 and better known as 'The Dadaist Manifesto'):

> The best and more extraordinary artists are the ones that every hour, with their bloody hands and hearts, put together the pieces of their bodies from the chaos of the waterfall of life, tied to the mindset of their times.
>
> Did Expressionism satisfy our expectations for such an art that might engage our most vital interests?
> No! No! No!
> Did the Expressionists fulfil our expectations for an art that brands the essence of life in our flesh with a red-hot iron?
> No! No! No! (Huelsenbeck 1980: 36–7)

This passage reveals familiar elements: in it Huelsenbeck combines the model of the Futurists' *arte-vita* with the catastrophic and traumatic imagery which, paradoxically, had also defined the reception of Futurism in Germany. His critique is first and foremost a historiographical reassessment that calls into question the codes that had defined Expressionism.

Undomesticated noise and Futurism's historical role of disruption

Huelsenbeck dispelled the climate of expectation, the eschatological projection that had sustained and justified Expressionism. By doing so, he closed the temporal dichotomy between the present of modernity and the mere unfulfilled projection of, to use Mann's terms, a progressive vision of history. When he tackled more specifically the formal choices of the artists, he stated that the Expressionists, 'under the false pretense to propagate the spirit, with the intent to battle Naturalism, have ended up re-discovering a series of abstract, pathetic gestures, which in turn presuppose a life without content, comfortable and motionless', a kind of life, in other words, as Huelsenbeck puts it, proper to 'people who value their armchair more than the noise of the street' (Huelsenbeck 1980: 37).

Huelsenbeck used two references, taken from Futurism, to distance himself from Expressionistic idealism: the aforementioned concept of *arte-vita* and bruitism. In many passages of his writings, he nonetheless stresses his distance from the Futurists, revealing his 'tactical use' of these references: 'This is the clear dividing line that separates Dadaism from all tendencies that consider life aesthetically; first of all Futurism – which lately some idiots have misconstrued as a new kind of Impressionist realization'. Again, referring to Dada, he wrote that 'it has propagated the BRUITIST music of the Futurists in all Europe but doesn't want to generalise its purely Italian specificities' (Huelsenbeck 1980: 37–8).[9]

However, in a discourse conceptually set up by references to a series of

sociological elements tied to the Italian movement (violence, anti-bourgeois attitude, metropolitan life), Huelsenbeck could not easily rely on these caveats and mild accusations of aestheticism in order to overcome the issue of Dada's not only formal but also ideological and historical indebtedness to Futurism. In other terms, he tried to push Futurism back into the realm of a 'purely Italian specificity', in order for Dada to take its place as the more modern and therefore viable embodiment of contemporaneity. But, given the pre-existing codification of Futurism within the debate on Expressionism in Germany, these efforts of historicisation could not simply rely on the same accusation of aestheticism that the Dadaists used against the Expressionists. It is therefore understandable that, beyond their overt opposition to Expressionism, which was philosophical as well as stylistic, the Dadaists sought to ensure that their own activities were perceived by critics and the public as different from those of the Futurists. Help in this enterprise came in May 1919 from the art critic of the *Freie Zeitung*, Udo Rusker. Reviewing the First Dada Exhibition at the Graphische Kabinett Neumann, he wrote:

> Dadaism, as a form of combat, as polemics, is the protest by the artist against the cultural ideal of the philistine, who sees in universal schooling the extreme achievement of civilization … Dadaism is the artist's strategy to transmit some of his inner trouble to the bourgeois … [The bourgeois] is shocked because he's left with nothing to hold on to, not even a word, because Dada doesn't mean anything. From what we see Dada is not a tendency: it's the proof of a sentiment of autonomy, of diffidence against society, a protest against all flocks. (quoted in Huelsenbeck 1980: 41–2)

In other words, for Rusker, Dada was a protest against the 'domestication' of humanity. Paradoxically, his text was largely and overtly influenced by Thomas Mann's criticism of the Futurist-Expressionist 'civil literati' and their goal of a progressive *Zivilization*, and helped clarify Dada's stance against dated models of activism. But when the analysis shifted to a closer reading of the stylistic and artistic distance between the newcomer Dada and the Expressionists, as outlined instead by Adolf Behne's review of the same show, the issue of Futurism's historical positioning quickly reappeared. For Behne, Dada's criticism of the Expressionists is appropriate only when the latter become 'the Expressionists (with a capital E)' [*die Expressionisten – 'Expressionisten' werden*], or, more specifically, 'when they finally become themselves historicised, typified, "characteristic" … It would really be grotesque if Expressionism, too, one nice day became an Academy and refused "immature youngsters". Nobody can really believe that Expressionism is the final right move, once and for all, in the history of art' (Behne 1919: 722).

So, how might one exit from the expressionist *academy* of art? According to Behne, 'we need to launch arrows against Expressionism, just as ten years ago the Futurists shot their arrows against Impressionism. The Dadaists render this important service of constantly tormenting Expressionism' (Behne 1919: 723). This historiographical classification, and the identification of Dada with a revived Futurism, was sustained more clearly by a stylistic necessity and an anti-intellectualist stance. Behne stated it overtly: 'What impedes us most of all? Formal education [*Bildung*]! What is the most urgent mission of the future? The destruction of formal education [*Zestörung der Bildung*]' (Behne 1919: 725).[10] Following this line of thought, Behne tied Huelsenbeck's critique of Expressionism (its alleged aloofness and remoteness from modern life) to the need for a new formal model, capable of overturning the new academy of pure abstraction of lines and colours. Futurist 'materialism', which had been stigmatised early on as a residual mark of Impressionism, thus offered the possibility of reuniting the psychology of the modern experience and its historical iconology, emotion and ideology, or, as we have already seen, its vision and chaos.

In his memoir *En avant dada*, published in 1920 (Figure 5.5), Huelsenbeck, revising the somewhat limiting reference to Futurism expressed in 1918, states:

> In contrast to the cubists or for that matter the German expressionists, the futurists regarded themselves as pure activists. While all 'abstract artists' maintained the position that a table is not the wood and nails it is made of but the idea of all tables, and forgot that a table could be used to put things on, the futurists wanted to immerse themselves in the 'angularity' of things – for them the table signified a utensil for living, and so did everything else. Along with tables there were houses, frying-pans, urinals, women, etc. Marinetti and his group love[d] war as the highest expression of the conflict of things, as a spontaneous eruption of possibilities, as movement, as a simultaneous poem, as a symphony of cries, shots, commands, embodying an attempted solution of the problem of life in motion ... While number, and consequently melody, are symbols presupposing a faculty for abstraction, noise is a direct call to action ... bruitism is life itself ... bruitism is a view of life, which, strange as it may seem at first, compels man to make an ultimate decision. There are only bruitists, and others. (Huelsenbeck 1951: 25–6)

So, re-charting the co-ordinates of the avant-garde, Huelsenbeck seemed finally not only to adhere to but to actually go beyond Behne's suggestion. Futurism could not be dismissed as the oldest (and unfulfilled) element of a dialectical opposition on the path of progressive history, as was the case with Expressionism. Through Bruitism, Dadaism attempted to englobe and assimilate Futurism not as an external temporal reference but as an internal practice and mindset.

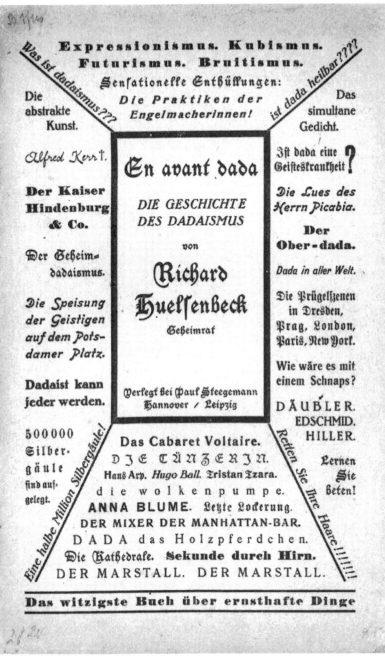

5.5 Cover of Richard Huelsenbeck's 1920 book *En Avant Dada: Die Geschichte des Dadaismus.*

From Döblin's 'Ecce Rubbish' to Georg Simmel's 'passionate desire for the expression of life' which 'seeks pure expression in a negation of form', the interpretation of Futurism and its relation with reality seemed to offer the Dadaists an alternative model of artistic practice to that of the 'civil literati' lamented by Mann. As Huelsenbeck (1951: 26) stated, bruitism puts humanity in front of a definitive fracture. There are only the bruitists, and the others. But the awareness of this fracture and its assimilation was made possible now precisely because the codes of the Italian movement's identity had already been turned into functional thresholds for the historiographical debate on Dada's main dialogical enemy, Expressionism.

Notes

1 I would like to thank Tim Benson, Barbara Bernini, Giacomo Coronelli, Cristina Cuevas-Wolf and Marja Härmänmaa for their help and suggestions.
2 For a discussion of the dates of the various exhibitions, see Pacini (1977: 23–6).
3 See the list of Futurist manifestos published by Walden before the First World War: U. Boccioni et al., 'Das Manifest der Futuristen', *Der Sturm*, 2:103 (March 1912), 822–4; F. T. Marinetti, 'Das Manifest des Futurismus', *Der Sturm*, 3:104 (April 1912), 828–9; U. Boccioni, 'Die Aussteller an das Publikum', *Der Sturm*, 3:104 (April 1912), 3–4; V. de Saint-Point, 'Manifest der futuristischen Frau', *Der Sturm*, 3:108 (May 1912), 26–7; F. T. Marinetti, 'Tod dem Mondschein', *Der Sturm*, 3:111–12) (Summer 1912), 50–1, 75–8; F. T. Marinetti, 'Das technische Manifest der futuristischen Literatur, *Der Sturm*, 3:135 (October 1912), 194–5; F. T. Marinetti, 'Supplement zum technischen Manifest der futuristischen Literatur'. Antwort auf die Kritiker', *Der Sturm*, 3,150–1 (March 1913), 279–80; U. Boccioni, 'Simultanéité futuriste', *Der Sturm*, 4:190–1 (December 1913), 151.
4 In the unpaged back matter of this last version we find the advertisement of items for sale at the gallery: the complete collection of the first year run of the journal *Der Sturm* (nos 1 to 56, 1910–11); Walden's *Dafnislieder* (1910); and Max Pechstein's woodcut *Killing of the Banquet Roast (Erlegung des Festbratens)* from the periodical *Der Sturm*, 2:93 (January 1912), with watercolour additions by hand. This second version of the Borchardt catalogue should therefore be dated around the first half of 1912.
5 On the Futurists in Germany, see Meier-Lenz (1974), Reisz (1976), Chiellino (1978), Eltz (1986), Demetz (1987), Schmidt-Bergman (1991), White (2000), Versari (2006a and 2006b), Puri Purini (2009), Weissweiler (2009), Bressan (2010).
6 For the philosophical roots of this association, see Lang (2006).
7 Kanehl significantly refers to the example of Michelangelo. See also Chiellino (1978: 180).

8 See Busoni (1916) and Pfitzner (1917). On Busoni's support of the Futurists, see Rodoni (1998) and the letter (19 June 1913) by Busoni to Egon Peter, in Busoni (1987: 169).

9 See also Huelsenbeck's 'Erste Dadarede in Deutschland' (1980: 104–8).

10 The text cited continues thus: 'What kind of formal education [Bildung] do we need when we ourselves create forms? Education is always a hindrance. Is there something more impotent than an educated artist?' Behne's play on words refers to the double meaning of the German word *Bildung*, as 'form', 'giving form [to artworks]', 'formation' as well as 'learning', 'knowledge' and the process of acquisition of both, thus 'conformation' and 'education'. Behne's essay was influenced by the contemporary debate on Expressionism and its relation with form, such as the one taking place in the periodical *Das Kunstblatt* (see Coellen 1918 and Uhde 1919).

References

Alms, B. (2000). *Der Sturm: Corporate Identity für die internationale Avantgarde*, in B. Alms and W. Steinmetz (eds), *Der Sturm im Berlin der zehner Jahre* (Delmenhorst: Städtische Galerie Delmenhorst Haus Coburg), pp. 15–34.

Bahr, H. (1916). *Expressionismus* (Munich: Delphin-Verlag); trans. (part) N. Roth, 'Expressionism', in R.-C. Washton Long (ed.), *German Expressionism. Documents from the End of the Wilhelmine Empire to the Rise of National Socialism* (Berkeley and Los Angeles: University of California Press, 1993), 87–91.

Behne, A. (1919). 'Werkstattbesuche. II. Jefim Golyscheff', *Der Cicerone. Halbmonatsschrift für die Interessen des Kunstforschers und Sammlers*, 11:22, 722–6.

Benson, T. O. (2001). *Expressionist Utopias: Paradise, Metropolis, Architectural Fantasy* (Berkeley and Los Angeles: University of California Press).

Bernini, B. (1995). *Ideologia e utopia nell'opera letteraria di Ludwig Rubiner*. Tesi di Laurea. (Florence: Università degli Studi di Firenze).

Bloch, M. (1999). *Réflexions d'un historien sur les fausses nouvelles de la guerre* [1921], (Paris: Editions Allia).

Boccioni, U. (1912). 'Die Aussteller und das Publikum', in *Der Sturm, Zweite Ausstellung: Die Futuristen. Umberto Boccioni, Carlo D. Carra* [sic], *Luigi Russolo, Gino Severini* (Berlin, Königin Augusta-Strasse 51, 12 April–21 May), 10–22.

Bressan, M. (2010). *Der Sturm e il Futurismo* (Mariano del Friuli: Edizioni della Laguna).

Busoni, F. (1916). *Entwurf einer neuen Ästhetik der Tonkunst* (Leipzig: Insel Verlag).

Busoni, F. (1987). *Selected Letters*, trans., ed., introd. A. Beaumont (New York: Columbia University Press).

Carrà, C. (1997). *La mia vita* [1942] (Milan: Se).

Chiellino, C. (1978). *Die Futurismusdebatte. Zur Bestimmung des futuristischen Einflusses in Deutschland* (Frankfurt am Main: Peter Lang).

Coellen, L. (1918). 'Die Formvorgang in der expressionistischen Malerei', *Das Kunstblatt*, 2:3, 69–74.

Coen, E. (ed.) (2009). *Illuminazioni. Avanguardie a confronto: Italia / Germania / Russia* (Milan: Mart-Electa).

Crispolti, E. (ed.) (2010). *Nuovi archivi del Futurismo*, vol. 1. *Cataloghi di esposizioni* (Rome: De Luca/CNR).

Demetz, P. (1987). *Italian Futurism and the German Literary Avant-garde*, Bithell Memorial Lecture, University of London (London: Institute of Germanic Studies).

Demetz, P. (1990). *Wörte in Freiheit* (Munich: Piper Verlag).

Döblin, A. (1912). 'Die Bilder der Futuristen', *Der Sturm*, 3:100, 41–2.

Döblin, A. (1913). 'Futuristische Worttechnik', *Der Sturm*, 3:150–1, 280–2.

Drygulski Wright, B. (1983). 'Sublime Ambition: Art, Politics and Ethical Idealism in the Cultural Journals of German Expressionism', in S. E. Bonner and D. Kellner (eds), *Passion and Rebellion. The Expressionist Heritage* (South Haley, MA: J. F. Bergin), pp. 82–112.

Elial, C. S. (1989). *The Apocalyptic Landscapes of Ludwig Meidner* (Los Angeles: Los Angeles County Museum of Art).

Eltz, J. (1986). *Der italienische Futurismus in Deutschland 1912–1922. Ein Beitrag zur Analyse seiner Rezeptionsgeschichte* (Bamberg: Bamberg Lehrstuhl für Kunstgeschichte und Aufbaustudium Denkmalpflege an der Universität).

Ewers-Schultz, M. (1996). *Die Französischen Grundlagen des 'Rheinischen Expressionismus' 1905 bis 1914: Stellenwert und Bedeutung der französischen Kunst in Deutschland und ihre Rezeption in den Werken der Bonner Ausstellungsgemeinschaft von 1913* (Münster: Lit Verlag).

Fechter, P. (1919). *Der Expressionismus. Mit 40 Abbildungen* [1914] (Munich: Piper & Co. Verlag).

Huelsenbeck, R. (1951). *En Avant Dada: Die Geschichte des Dadaismus* (Hanover and Leipzig: Paul Steegemann Verlag, 1920); 'En Avant Dada: A History of Dadaism', trans. R. Manheim, in R. Motherwell (ed.), *The Dada Painters and Poets: An Anthology* (New York: Wittenborn, Schultz, Inc., 1951), 21–47.

Huelsenbeck, R. (1980). *Dada Almanach* [1920], facsimile edition with French translation, eds S. Wolf and M. Giroud (Paris: Éditions Champ Libre).

Kandinsky, W. (1912). 'Über die Formfrage', *Der Blaue Reiter* (Munich: Piper Verlag), 77–100.

Kandinsky, W. (1914). 'Malerei als reine Kunst', *Der Sturm*, 4:178–9, 98.

Kanehl, O. (1913). 'Futurismus: ein nüchternes Manifest', *Die Aktion*, 3:34, 813–15.

Lang, K. (2006). *Chaos and Cosmos. On the Image in Aesthetics and Art History* (Ithaca, NY: Cornell University Press).

Mann, T. (1920). *Betrachtungen eines Unpolitischen* [1918] (Berlin: S. Fischer).

Meier-Lenz, D. P. (1974). 'Der Futurismus und sein Einfluss auf Alfred Döblin und August Stramm', *Die Horen*, 19:94, 13–30.

Meidner, L. (1995). 'Anleitung zum Malen von Grossstadtbildern', *Kunst und*

Künstler, 12:5 (1914): 312–14; 'An Introduction to Painting the Metropolis', trans. V. H. Meisel, in R.-C. Washton Long (ed.), *German Expressionism. Documents from the End of the Wilhelmine Empire to the Rise of National Socialism* (Berkeley and Los Angeles: University of California Press), pp. 101–4.

Pacini, P. (ed.) (1977). *Esposizioni Futuriste 1912–1918* (Florence: SPES).

Pfitzner, H. (1917). *Futuristengefahr. Bei Gelegenheit von Busoni's Ästhetik* (Leipzig: Süddeutsche Monatshafte GmbH).

Puri Purini, I. (2009). *Berlino*, in Coen, E. (ed.), *Illuminazioni. Avanguardie a confronto: Italia / Germania / Russia* (Milan: Mart-Electa, 2009), 131–8.

Reisz, J. (1976). 'Deutsche Reaktionen auf den italienischen Futurismus', *Arcadia*, 11, 256–71.

Rodoni, L. (1998). '"*Caro e terribile amico!*" L'incontro a Pallanza di Busoni e Boccioni', *Verbanus*, 19, 25–84.

Rubiner, L. (1912). 'Der Dichter greift in die Politik', *Die Aktion*, 2:21, 645–52, and 2:22, 709–15; in Rubiner, L. (1917), 17–32.

Rubiner, L. (1917). *Der Mensh in der Mitte* (Berlin-Wilmersdorf: Verlag Die Aktion).

Rusker, U. (1919). 'Dada: Aufführung und Ausstellung im Salon Neumann, Kurfürstendamm', *Freie Zeitung* (8 May).

Schmidt-Bergman, H. (1991). *Die Anfänge der literarischen Avantgarde in Deutschland: Über Anverwandlung und Abwehr des italienischen Futurismus* (Stuttgart: M&P Verlag).

Schreyer, L. and N. Walden (eds) (1954) *Der Sturm. Ein Erinnerungsbuch an Herwarth Walden und die Künstler aus dem Sturmkreis* (Baden-Baden: Klein).

Simmel, G. (2000) 'Die Krisis der Kultur', *Frankfurter Zeitung*, 6:43 (13 February 1916), 1–2; 'Crisis of Culture', transl. D. E. Jenkinson, in G. Simmel, *Simmel on Culture. Selected Writings*, eds D. Frisby and M. Featherstone (London: Sage Publications), pp. 90–101.

Uhde, W. (1919). 'Formzertümmerung und Formaufbau in der bildenden Kunst', *Das Kunstblatt*, 10 (Oktober 1919), 317–19

Versari, M. E. (2006a). 'International Futurism Goes National: The Ambivalent Identity of a National/International Avant-garde', in J. Purchla and W. Tegethoff (eds), *Nation Style Modernism, CIHA Conference Papers 1* (Krakow and Munich: International Cultural Centre – Zentralinstitut für Kunstgeschichte), pp. 171–84.

Versari, M. E. (2006b). 'Futurismo 1916–1922: Identità, incomprensioni, strategie. I rapporti internazionali e l'evoluzione dell'identità del Futurismo negli anni Venti', Scuola Normale Superiore di Pisa, Ph.D. dissertation.

Walden, H. (1912a). *Der Sturm, Zweite Ausstellung: Die Futuristen. Umberto Boccioni, Carlo D. Carra [sic], Luigi Russolo, Gino Severini* (Berlin, Königin Augusta-Strasse 51, 12 April–21 May); reprint Florence: SPES 1977.

Walden, H. (1912b). *Die Futuristen: Umberto Boccioni, Carlo D. Carra, Luigi Russolo, Gino Severini, Künstlerische Leitung: Zeitschrift Der Sturm* (Berlin: Verlag Der Sturm, n.d., Druck von Carl Hause).

Walden, H. (1912c). *Die Futuristen: Umberto Boccioni, Carlo D. Carra, Luigi Russolo, Gino Severini, Gesellschaft zur Förderung moderner Kunst m.b.H., Künstlerische Leitung: Zeitschrift Der Sturm* (Berlin: C. Hause, n.d.).

Walden, H. (1914). 'Zur Einführung', *Die Futuristen-Ausstellung* (Leipzig: Galerie Del Vecchio 1 January–15 February); reprint Florence: SPES 1979.

Walden, H. (1918). *Expressionismus. Die Kunstwende* (Berlin: Verlag Der Sturm).

Washton-Long, R. C. (ed.) (1993). *German Expressionism. Documents from the End of the Wilhelmine Empire to the Rise of National Socialism* (Berkeley and Los Angeles: University of California Press), pp. 101–4.

Weissweiler, L. (2009). *Futuristen auf Europa-Tournee. Zur Vorgeschichte, Konzeption und Rezeption der Ausstellungen futuristischer Malerei (1911–1913)* (Bielefeld: Transcript Verlag).

White, J. J. (2000). 'Futurism and German Expressionism', in G. Berghaus (ed.), *International Futurism in Arts and Literature* (Berlin and New York: de Gruyter), pp. 39–74.

6

'An infinity of *living* forms, representative of the absolute'? Reading Futurism with Pierre Albert-Birot as witness, creative collaborator and dissenter

Debra Kelly

Artist, poet, witness

> Wanting to introduce new ideas is good, being unable not to introduce new ideas is much better. The ism is a bit like a magnifying glass. It magnifies the precise point under examination, but you can no longer see anything around it, and this point is so magnified that it attracts: you throw yourself into it, it swallows you up, and you end up spending your life inside, devoted to the service of the ism. I don't know why it makes me think of a eunuch …
>
> The time has come when we must be complete. It's not a question of this ism or that ism, it's a question of WRITING. It's not a question of being an …ist or an …ist, but of being a WRITER. (Albert-Birot 1930)

Born in Angoulême in 1876 and dying in Paris in 1967, Pierre Albert-Birot lived in and alongside the adventure of the European literature and art of much of the twentieth century.[1] Yet, he remained largely removed from his century's most prominent artistic movements, holding 'isms', 'ists' and 'ismisme', as he referred to them, in little regard, as the epigraph here demonstrates. He preferred to pursue his own rigorously individual path, and has consequently suffered at the hands of the chroniclers of literary and artistic history.

However, for a period between 1916 and 1919 – therefore mainly during the First World War – he occupied a position at the very heart of the Parisian avant-garde and its continued experimentation in art and literature. His own poetics during this period develops with, for, against Marinetti's and the Futurist painters' articulations of Futurism, Apollinaire's 'esprit nouveau', Tzara's Dadaism and the early Surrealism of Breton, Aragon

and Soupault, all of whom are to be found in the pages of his review *SIC*. The importance of these creative influences is finally most apparent in the relation to Cubism, however, which he continued to take as a reference point in his writing well into the twentieth century. Indeed, his best-known work, the epic prose narrative *Les six livres de Grabinoulor* (begun in 1917, parts of which were published in 1921, 1933 and 1964 and finally published in its entirety in 1991, republished in a revised edition in 2007), can be read as being structured like a Cubist canvas. The multidimensional space of modernity is at work in the narrative space of *Grabinoulor*.[2] The figures of the circle and the straight line, generating forces of all Albert-Birot's artistic creation, produce a space that is concrete and symbolic, material and figurative. Nonetheless, it is also evident that this 'language of lines' and of geometric figures is also developed directly through contact with the Futurist painters, as will be discussed below.

Albert-Birot's own conception of modernity in literature and art came into being slowly – and late. His artistic production covers a range of modes of artistic expression: beginning with figurative paintings and sculpture, still life, landscape, moving to Cubist and abstract painting; poetry in traditional verse form, then punctuated and non-punctuated poetry and prose, sound generated and visual poetry; translation; a substantial body of dramatic works; cinematic scenarios; a short attempt at autobiography; and epic, non-punctuated narrative in *Grabinoulor* (although that text might also be read as a form of extended life-writing). Although Cubism remains an important context for reading Albert-Birot's work, it is also essential to understand his relationship to the two artistic movements with which he has been readily associated with by critics – Futurism and Surrealism; the focus here is on his interactions with Futurism.

To consider the extent of his involvement with Futurism means largely an exploration of the literary and artistic review *SIC* published monthly from 1916 to 1919.[3] It is important to insist on this regularity and comparative longevity when compared to other, more ephemeral, reviews of the period such as Reverdy's *Nord-Sud* (and the many, many others chronicled within the pages of *SIC*).[4] *SIC* has been labelled a 'mouthpiece of Futurism' in France, and Albert-Birot's meeting with Futurism's ideas as articulated by Gino Severini in 1915 certainly had a profound effect on the then sculptor, painter, occasional poet, and his sudden, late advent to modernity.[5] Albert-Birot's position with regard to the prevailing concepts of the avant-garde and of modernity in the decade leading up to the First World War is a paradoxical one, resulting in the enigmatic status of a literary *oeuvre* that, while lying at the very heart of twentieth-century artistic preoccupations, continues to resist rupture with the past. He had lived alongside the adventure of modernity, seemingly unmoved by the artistic revolution

of Cubism and the Futurist manifesto of 1909, and untouched by the poets who were to become the contributors to *SIC*, until his meeting with Severini in 1915 and, through him, with Apollinaire.[6]

Albert-Birot therefore comes to be a 'witness' to Futurism in the First World War from a position of total obscurity, and of confusion, even ignorance, regarding 'modernity' and the 'avant-garde'.[7] What is important, however, during that first decade of the twentieth century – and this would provide the foundation for the movement from witness, to creative collaborator, to dissenter – is the influence on him of Vitalism, originating in the works of Spencer and of Bergson and with which Albert-Birot had come into contact during his attendance at public lectures in literature and philosophy at the Collège de France and the Sorbonne. He was especially impressed by the teaching of the sociologist Alfred Espinas, rationalist philosopher and disciple of Spencer. It is within this dynamic, optimistic, *Vitalist* perspective and in the positive idea accorded to the human will that Albert-Birot's own philosophy and poetics would develop.[8] Despite evidence of a long gestation period for *SIC*, Albert-Birot preferred to insist on his sudden 'rebirth' with the 'birth' of *SIC* and on the dramatic change of everyday circumstances offered to him by the war, coupled with his sudden clearer insight into the type of review he wished to produce after several abandoned projects from 1904 onwards.[9] But the meeting with the modern was, of course, a more complex encounter and one that did significantly bring about personal and artistic rupture (for a time, and despite the insistence above on his resistance to a break with the past). The isolated and hesitant individual abruptly moves to a position in the collective adventure of the avant-garde and his public voice, heard for the first time, is expressed through *SIC*. The review is both a form of personal expression and a literary and historical document of the period, important for the history of Futurism among other things. It is not only in the work of the writers, artists and musicians who published there that the vitality of *SIC* can be apprehended. In its slogans, manifestos, critical reviews of literature, exhibitions and plays, correspondence (including from soldiers at the Front), advertisements for bookshops, galleries, publications, it is also a site of cultural memory. *SIC* warrants close rereading, not only as a collective adventure and personal poetics, and not only for its place in literary and artistic history (a history which we believe we already know, but that in fact needs re-evaluating with different perspectives to those readings which have become canonised) but also as a cultural artefact in all its vitality and imperfection, in the process of development, and which in itself bears witness to its moment in history.

Artist, poet, editor, creative collaborator

> [SIC] It means it is 'thus', it's the absolute cry, of course the initials stand for
> *s*ound, *i*dea, *c*olour, but what it really means is a desire to affirm something.
> (Albert-Birot 1964, n.p.)

The focus here is primarily on two examples in which the Futurist influence
on Albert-Birot's thinking and artistic production is most evident. It is
in the visual arts that Albert-Birot first articulates and gives form to a
poetics to which he will constantly return, and at the heart of which is the
relationship between text and image. This is a relationship of particular
pertinence for the painter turned poet, and more generally within the
artistic experimentation of the period: Apollinaire seeking to express the
visual language of Cubism in words, or in his reciprocal dialogue with the
paintings of Delaunay, for example; the polemics regarding the labels 'cubist
poetry', 'plastic poetry', etc. amongst Reverdy, Max Jacob and Apollinaire
once again; the aesthetic and philosophical problems of rendering the
experience, excitement, apprehension of modern urban life in image and in
words with which many artists and writers were concerned.

In the case of Albert-Birot, the most complete expression of ideas
assimilated from Futurism (most notably from the Futurist painters, with
Severini being of most importance for him) is to be found in his large
canvas *La guerre (1916)* (1916).[10] The importance of the visual arts as an
essential element in *SIC* cannot be overemphasised. After Albert-Birot's
completion of the first issue single-handedly, the first contribution to
the review is not a text but a reproduction of Severini's *Train arrivant à
Paris* (*SIC* 2, February 1916), a work representative of Futurist research
into the re-creation of velocity on canvas, and revealing an affinity with
Balla's conception of the 'interpenetration' of planes. The interpenetration
of planes is an attempt to capture the fusion of object and environment
as they dynamically interact, and is fundamental to the Futurist aim of
representing the speed of the modern world in poetry and painting. In
accordance with this, the Futurists developed a concept of dynamic motion
as opposed to a static concept of reality as Futurism tried to represent the
new rhythms generated by, for instance, advances in science and technology
(in, for example, Boccioni's *Absolute Motion + Relative Motion = Dynamism*
(1914) and the *Futurist Painting: Technical Manifesto* (1910) signed by the
painters Boccioni, Carrà, Russolo, Balla, and Severini) (Apollonio 1973:
150–4; 27–31).

The Futurist painters had particularly explored the use of the simultaneous
contrast of lines, planes and forms and Severini's 1913 manifesto, *The
Plastic Analogies of Dynamism* discusses these in terms of the production

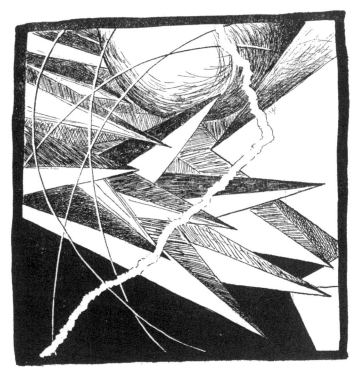

6.1 Sketch for Albert-Birot, *La guerre: Essai d'expression plastique.*
SIC, 5, May 1916.

of a 'constructive interpretation in order to achieve a dynamic composition open in all directions towards space' (Apollonio 1973: 123). This theoretical thinking on shape and form would eventually lead to Albert-Birot's own elaboration of a theory of the dialectic between the straight line and the circle which would underpin both the structure and the metaphysics of his poetry and of *Grabinoulor*.

This first example, then, *La guerre (1916)* was conceived at a turning point in the journey of Albert-Birot's artistic production, and was painted concurrently with the planning, drafting and execution of the early issues of *SIC* (as papers in the Albert-Birot archive show, sketches for the canvas appear alongside and on the back of notes for issues of the review). Indeed, there are several points of intersection between Albert-Birot's own elaboration of the dialectic between the straight line and the curved line ('la droite et la courbe') and the visual theories of Futurism. The space of *La guerre* is divided up by line (shape) and colour. An initial division may

be made between the right and left sides of the canvas, with an important (figurative) focal point in the centre. The space can then be further divided into the visual oppositions of shape, and the direction of these shapes: the large circular shape in the top centre; the elongated triangular shapes pointing across and up that originate on the left side; the broader, flatter triangles that originate on the right. Further divisions are made by the bold, curved lines that reverberate across the canvas from the right, suggesting if not concentric, then overlapping circles. There is, then, an opposition between straight and curved lines, and the divisions in the canvas's space are made more complex by three straight lines that divide the whole into four unequal parts, and radically fragment the shapes within them. Vibrant primary reds, yellows and bright blues dominate the left side, moving to dark blues, greens and browns, and finally to greys and black on the muted right. Each shape is subdivided into complementary shades of colour, adding density to what otherwise would be flat planes. The key to the meaning of these forms lies in the sketches that precede the composition of the oil painting. One sketch in particular titled by Albert-Birot as 'En Tristesse' [In Sadness] is composed of flat, broad, obtuse triangles similar to those found on the right side of the ink drawings for the final painting.[11]

Futurist theory had explored the use of the simultaneous contrast of lines, planes and forms as in Severini's 'The plastic analogies of dynamism' previously referred to. A direct comparison can therefore be made between the work of the Futurist painters and Albert-Birot. The dialectic between acute and obtuse angles and circles had been formulated by Carlo Carrà in his 'Plastic planes as spherical expansion in space' (1913):

> A pictorial composition of right angles cannot go beyond what is known in music as plainchant (*canto fermo*). The acute angle, on the other hand, is passionate and dynamic, expressing will and a penetrating force. Finally, a curved line has an intermediary function and serves, together with the obtuse angle, as a link, a kind of transitional form between the other angles. (Apollonio 1973: 96)

It is difficult not to read, therefore, the triangles of Albert-Birot's canvas in these terms; if 'tristesse' is expressed by broad, flat, plain forms, then the acute triangles of the left side promote a dynamic, life-giving, positive force.[12] Throughout Albert-Birot's work the circle is associated with eternity and constant becoming, as is made explicit in *Les six livres de Grabinoulor*: 'long live the curved line a true immortal soul cannot make do with the poor straight line' (Albert-Birot 1991: 253). This 'language of lines' and of forms structures Albert-Birot's own canvas, giving articulation to both the surface and the deep structures of this composition and informing the whole of the textual production (poetry, prose) to follow (including, in a

way that may seem counter intuitive for a long prose narrative, *Les six livres de Grabinoulor*). Albert-Birot's sensitivity to the effects of colour and light places him closer also to the Orphism of Delaunay than to the analytical Cubism of Braque or Picasso, and invites further comparison with some of the Futurist painters. This first example is, therefore, that of the influence of Futurist theory and practice in the visual arts and Albert-Birot's own individual response in the form of his most accomplished canvas.

The second example of clear Futurist influence and of collaboration with the Futurists is the early issues of *SIC* – a period that exemplifies the review as collective adventure and Albert-Birot as creative collaborator. The role of *SIC* is multiple. It is the manifestation of a theoretical discourse finding its articulation, a personal thought process in movement – considering, accepting, rejecting elements of the artistic ferment around it – and with it the consideration (and sometimes production) of artistic creation in response to those thought processes. The review is the crystallisation of the talent of Albert-Birot the sculptor, painter and nascent poet that allows him to find an artistic identity and to situate himself in relation to others.

Futurism occupies a central place in the early years of this collective adventure. On the one hand, *SIC* was originally one of the most consistent outlets for the diffusion of Futurism in France during the First World War – even though it never promoted one movement or 'ism' to the exclusion of others. On the other hand, it is in fact striking that although *SIC* has, as noted previously, been considered a 'mouthpiece' of Futurism in France, the actual number of Futurist contributions in the review is comparatively quite small, far fewer (for example) than those of individual poets such as Apollinaire and Reverdy, or the input of Aragon as literary critic. Severini contributes in fact only four times, and one of these is a tribute to Boccioni on his death, and all appear in the first year of *SIC*'s existence; Balla contributes only once, 'Ballets Russes – Cubistes et Futuristes' (*SIC*, 17, May 1917) with a drawing of a stage setting, 'Dessin du Peintre Futuriste Giacomo Balla, tiré de sa scène plastique pour la symphonie de Strawinsky "le Feu d'Artifice"'; Depero contributes twice, with a drawing for Stravinsky's ballet 'Le Chant du rossignol' (*SIC*, 17, May 1917), and drawings for the Teatro di Piccoli in Rome (*SIC*, 34, November 1918); the musician Pratella contributes once with an extract of a musical score (*SIC*, 8–10, August–October 1916) in the same issue as 'Les tendances nouvelles', an interview with Apollinaire; the poet Luciano Folgore who signs himself 'Futuriste' contributes five times with various poems (*SIC*, 8–10 to 45–6, May 1919). Of most importance after the early role of Severini are the five contributions of Enrico Prampolini: on the Ballets Russes (*SIC*, 17, May 1917); a woodcut entitled 'Le Dieu Plastique, costume chorégraphique grotesque futuriste' (*SIC*, 21–2, September–October 1917); a woodcut

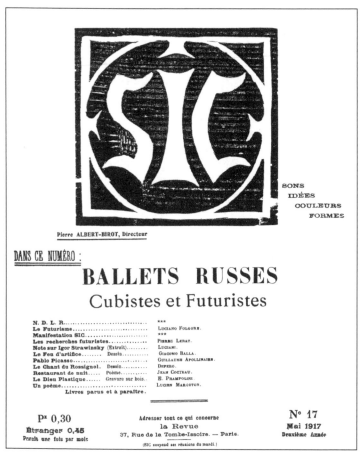

6.2 Cover of *SIC*, 17, May 1917.

entitled 'Piccolo Giapponese'); and an advertisement for the opening of his 'Casa d'Arte Italiana' in Rome (*SIC*, 42–3, March–April 1919); and especially with designs for a production of a play by Albert-Birot in Rome (*SIC*, 47–8, June 1919), which will be discussed below.

Nonetheless, there is a considerable initial Futurist impact with the presence of Severini, who played a key role in the shaping of the early issues of *SIC*, and in the rapid changes of tone that take place there. The effects of the 1916 exhibition 'Première exposition futuriste d'Art plastique de la guerre et d'autres oeuvres antérieures' and of the associated lecture in its attempts to examine the war in a pictorial language developed in the prewar period are indisputable. Albert-Birot is already enthusiastic about

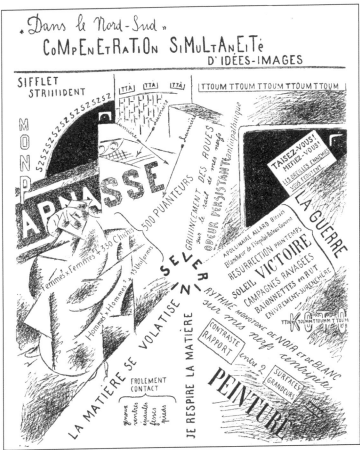

6.3 Gino Severini, *Dans le Nord-Sud compénétration simultanéité d'idées-images, SIC*, 4, April 1916.

Severini's work, and by extension Futurism more generally, in the second issue:

> Here is a whole new world that obviously makes the objective world seem very small: hurl yourselves, Futurists, towards this enticing unknown. Your enthusiasm alone, already, is beauty, your faith is refreshing; it is our duty to hold you up as the precious generators of intellectual activity. You love the *unknown*, you love *life*, your projects are *limitless* and for all this we must love you. (*SIC*, 2, February 1916)

However, despite this early Futurist-inspired rhetoric, the nature of the influence of Futurist thinking on Albert-Birot is complex. This reading of

Futurism is compatible with his own philosophical training and inclination towards Vitalism, and his later stance in *SIC* will be more critical of Futurism. Despite Albert-Birot's clear admiration for Severini's work, the Futurist label applied to the review is an oversimplification, even in the early issues. In 1917, he comments when discussing the Ballets Russes and the collaboration between Cubists and Futurists: 'It will be one more occasion for the ignorant to label *SIC* a Futurist review. There's nothing we can do about it. With or without epithets, *SIC* goes on' (*SIC*, 17, May 1917). It is however, a curious moment to make the point given that this particular issue devoted to the Ballets Russes contains two short prose pieces on Futurism, a sketch by Balla, Depero's costumes for a Stravinsky ballet and a woodcut by Prampolini. Albert-Birot perhaps protests too much?

Albert-Birot publishes his own type of 'Manifesto' (*SIC*, 5, May 1916) following his discussions with Severini, and in the same issue he begins his 'dialogues nuniques' on modern art.[13] He offers his equation of the elements of artistic energy in a page set out as a type of slogan:

war + cubists + futurists = will (order = style)
war + cubists + futurists = style = art
war + cubists + futurists = x = NEXT FRENCH RENAISSANCE

War is an artistic catalyst, seen as a release of vital energy, not as a destructive force, just as the energy of war is similarly celebrated in several Futurist works and writings (while in Dada, the absurdity, destruction and futility of war would be questioned), and issue no. 5 is evidently a Futurist-inspired moment. Giovanni Lista's analysis is pertinent:

> Taking in its turn into consideration the relationship between art and war, Albert-Birot synthesised his convictions on this subject in a page of *SIC* of anodyne appearance, but nonetheless important to understand his thought. The war is directly associated with Cubist and Futurist research. Their common product would be for Albert-Birot 'will', synonymous with 'order' and 'style', which he assimilated to art itself. At the risk of exegesis, it can be affirmed that for Albert-Birot there is a complementarity between the destructive force of the war and the formalist research of Cubo-Futurism. The energy freed by the former must end in, thanks to the avant-garde spirit, a new composition of the elements. (Lista 1979: 37)

In fact, the greatest impact of Futurist contributions to *SIC* is to be seen in Futurist design and experimentation in the theatre – Balla, Depero and Prampolini for works by Stravinsky and Prampolini's decor and costumes for Albert-Birot's *Matoum et Tévibar* and – once painting has been 'abandoned' for poetry by Albert-Birot after the completion of *La guerre*[14] – it is in Albert-Birot's ideas on theatrical design and production

that the collaboration with the Futurists is most evident. The idea of 'nunic' and of 'nunism' from the Greek 'now' is Albert-Birot's own articulation of modernity and is again linked to 'will' [*volonté*], an important element of his cubist + futurist 'equation' and, it should not to be forgotten, of his Vitalist interests: 'Is not will indeed dear to all the strong minds which constitute what is called the modern movement, the nunic movement' (*SIC*, 13, January 1917). The 'nunism' concept had appeared for the first time in the issue in which his 'war + cubists + futurists' slogan appears (*SIC*, 5, May 1916). In typical contradictory fashion, 'nunism' is one 'ism' to which Albert-Birot can sign up – one which significantly assimilates modern tendencies, retains his personal emphasis on life, energy and Vitalism without breaking with artistic heritage:

An 'ism' which must survive all others
Nunism was born with man and will only disappear with him
All the great philosophers, the great artists, the great poets, the
Great scholars, all the leading lights, the creators from all ages
Were, are, will be nunists
All of us who seek, let us first be nunists
Outside nunism there is no life at all
To be nunist or not to be.

Having discussed these two main examples, it is also significant to add a brief word concerning Futurist influence on Albert-Birot's poetry during this period. While he followed to some extent the techniques advocated by Marinetti in his own multiple-voice poems and in his typographical experimentation, his exploration of language differs radically from that of Marinetti. Like Apollinaire, who also recognised the importance of Marinetti's ideas for his typographically experimental poems, Albert-Birot differs from the Italian, most notably concerning the position of the self in the creative process. In *Destruction of Syntax-Imagination-Without Strings-Words-in-Freedom*, Marinetti advocates the 'death of the literary I' and the destruction of syntax, the removal of punctuation, the destruction of the creative self: 'My technical manifesto opposed the obsessive "I" that up to now the poets have sung, analysed and vomited up' (Apollonio 1973: 98). In the poetry of Apollinaire and Albert-Birot even at its most experimental, fragmented and visually arresting, the creative self is never absent, acting as a force of synthesis. In his 'poèmes à crier et danser', Albert-Birot's use of sound (for example) is not that of Marinetti's 'language of the new mechanised human life', but reflects his research into the primitivism of expression rather than the reproduction of 'modern' sound. His is an exploration of a language discharged of its semantic weight, an attempt at 'pure expression', closer to Barthes's 'bruissement de la langue' than to

Futurism's 'bruitisme': 'I had the idea of carrying out some research towards what could be called pure poetry, or a poetry, how shall I put it, which would be pure because of its primitivism, because of its simplicity'.[15]

However, it is finally equally undeniable that Futurism had a significant effect on the way Albert-Birot began to look at the world and to conceive of artistic production. Futurist ideas, spreading as they did from painting, sculpture and poetry to theatre, architecture, stage design, music, ballet, photography, cinema, furnishing and fashion, provide all those areas of creativity that *SIC* initially sets out to explore. In *SIC* the interaction from page to page between poetry, prose, drama and theatrical design, reproductions of paintings, woodcuts and sculptures, musical compositions, theoretical considerations, interviews, reviews of literary works and exhibitions, allows a very different perception of the synthesis between the arts (a major tenet of 'modernity' and of 'l'esprit nouveau') during this period. The dynamic action of these creations is displayed in the pages of *SIC* with much greater impact than any amount of critical theorising on the aims of the Futurists or the Cubists. For example, in the same 1916 issue, Apollinaire is interviewed by Albert-Birot on 'Les tendances nouvelles', followed by the reproduction of a woodcut by Severini, one of Albert-Birot's experimental 'poèmes-simultanés', his theoretical considerations on a new type of theatre (which he terms 'le théâtre nunique', followed by two of his typically aphoristic 'Réflexions', and a piece of musical composition by the Futurist musician Pratella (*SIC*, 8–10, August–October 1916).[16]

From witness and creative collaborator to dissenter

> I immediately took up a positive, constructive position. I absolutely never intended that my review should become a demolition site. We already had the war that had taken on the job of destroying everything … The system of *tabula rasa* works very well in philosophy but it is not imperative in art. (Albert-Birot 1988: 49).

How and why then does Albert-Birot move from his initial celebration of Futurism and rapidly follow a divergent path? As noted in the introductory section, Albert-Birot's philosophical inclinations tended towards Vitalism as propounded by Espinas, and to the work of Spencer and Bergson. The title of *SIC* is an explicit articulation of such a positivist, vitalist stance, and of his perception of and artistic relationship to the world around him. He remains categorical on the constructive aspects that he continued to consider the propelling force of the review and his own work. It is this emphasis on the positive, constructive nature of his aesthetics and on the

evolution of artistic principles that will eventually bring him into conflict with other forces in the avant-garde:

> I began with the idea of an affirmation in reaction to all negatives. I immediately orientated myself towards the Latin 'SIC' in which I saw a categorical 'Yes' as well as the sign for the general concepts to which the review was devoted: it was SOUNDS, it was IDEAS, it was COLOURS, and I made a wood engraving of a huge central 'SIC' surrounded, like a frame, by two 'F's which gave the central YES, plus SOUNDS-IDEAS-COLOURS, the whole contained within the FORM.[17]

The title of his review is revelatory of his philosophical position (even in the middle of a most brutal war) and of his artistic relationship to a cultural heritage superimposed on a personal understanding and a claim on the concept of modernity. It is also a direct and energetic response to the perceived power of art and its importance in fulfilling the potential of a life. In due course, the energy poured into the review would be transposed into poetry and above all into his epic narrative *Les six livres de Grabinoulor* which he himself considered a prototype of what he called 'l'esprit *SIC*' (the spirit of *SIC*).[18]

Albert-Birot's early texts on Futurism are admiring, as previously noted. The visual style and rhetoric of the early issues reveal a reading of a Futurism newly (if rather tardily) discovered. In the second issue of *SIC* in February 1916, again in praise of Severini (as previously noted), his comments reveal his reaction to and understanding of Futurist technique, particularly the endeavour to represent movement:

> [I]n the work of the Futurists and in your [Severini] work in particular, the idea evokes an ensemble of forms in movement, whereas in the work of other painters one or several isolated and immobilised forms evoke a idea. Now I say to myself that the association of ideas is to some extent an infinity, and therefore it seems to me that to remain logical in your thoughts, you must envisage the interpenetration of ideas, the reality of the interpenetration of planes … there are therefore only two ways to choose: either a form that is isolated and voluntarily fixed outside everything else, a conventional plastic representation of abstraction, which is what has been done until now; or an infinity of *living* forms, representative of the absolute, which is what you want to do today … In short we can say, that until now a painting was a fraction in space, and that it becomes with you a fraction in time … I think, therefore, that it would be interesting to push the limits of the consequences of the principle of subjective realisations, to aim for the maximum possible whole, in order that you am to attain even more realism. (*SIC*, 2, February 1916)

This idea of an 'infinity of *living* forms, representative of the absolute … the maximum possible whole', is the goal towards which he believes

Futurist techniques should work. There is furthermore an insistence on the experience of time in his reading of Futurism and on the importance of the subjectivity at work in such creation. His dissent is no doubt largely a result of disappointment with what he considers that Futurism achieves. Most importantly, this extended reflection on Severini divulges rather Albert-Birot's own creative preoccupations, the communication of 'Infinity' and of the 'Absolute' through art and a poetics that is in perpetual movement, a dynamic self-perpetuating creation. It is not only Futurism that will disappoint – painting more generally also does – and it is in the extended epic prose of *Grabinoulor* that infinity, the absolute and openly dynamic creation, are given form for Albert-Birot, as the present moment is perpetually renewed and then made eternal in the work of art.[19] This is an artistic 'quest' that is finally more Bergsonian-inspired than any Futurist-inspired celebration of the present and rupture with the past. The problem of temporality, and particularly the expression of 'durée' in the work of art, brings Albert-Birot closer to Bergson (and indeed to Proust, although formulated very differently). Bergsonian principles of the many-layered dynamism of experience were influential for many in the avant-garde of the period. His theories of change, relativism and flux made Bergson the most important philosopher of the pre-First World War period, and his notion of the 'élan vital' is essential for an understanding not only of Albert-Birot, but of much of the work of the early decades of the twentieth century.

To return finally to this period of 'witnessing' however, by *SIC*'s third year there is a significant change in the review's character generally, and Albert-Birot is overtly distancing himself from Futurism. By 1918, he comments on a recently published volume dedicated to Carrà, 'who seems to us the most sympathetic among the Futurists precisely because he seems to be distancing himself from them' (*SIC*, 28, April 1918). Yet, remaining true to the aims of presenting 'all new tendencies' in *SIC*, an interest in Futurist production remains, and later the same year Albert-Birot writes: 'As we must not ignore any of the research taking place around us, it seemed right to signal here these Futurist attempts' (*SIC*, 34, November 1918). He publishes reproductions of two marionettes from Depero's *Ballets plastiques* at the Teatro dei Piccoli in Rome on the cover of this issue, a piece by Settimelli inside. The tone is at best guarded, yet ultimately Albert-Birot never quite relinquishes the original spirit of *SIC* which owed much to Futurism. Issue 47–8 (June 1919), one of the final issues that contains a diverse range of contributors (the final issues to number 54 are mainly a collaboration between Albert-Birot, Léopold Survage and Roch Grey only), includes the reproduction of Prampolini's costumes and decor for the production of Albert-Birot's own play *Matoum et Tévibar: Histoire édifiante et récréative du vrai et faux poète* (1919) in Rome. This issue

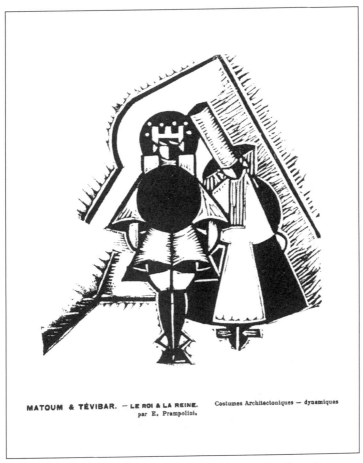

MATOUM & TÉVIBAR. — **LE ROI & LA REINE.** Costumes Architectoniques — dynamiques
par E. Prampolini.

6.4 Enrico Prampolini, *Matoum & Tévibar. Le Roi & La Reine. Costumes architectoniques – dynamiques*, SIC, 47–8, June 1919.

incidentally also sees a return to the rhetoric of the poster-like editorial page which had been absent for many months. A letter from Prampolini is published in this issue together with these production designs, giving details of the performance and his 'costumes architechtroniques-dynamiques' for the king and queen and the 'architecture luminueuse' that he designed for the decor. He notes the considerable success of the play amongst 'toute la Rome intellectuelle':

> Now, I urge you to make this first attempt at exceptional puppet theatre known to the Parisian reviews, an attempt undertaken and successfully delivered by the 'Casa d'Arte Italiana', and you will give me great pleasure by also talking about

my plastic-dynamic scenographic system, and of the dynamism obtained with coloured light which creates an architecture of the stylisation of the plastic-dynamic puppets.

A reciprocal artistic friendship which endures until the final year of *SIC* therefore, but Prampolini was a Futurist open to the wider European avant-garde, collaborating with Dada in the First World War, and with Der Sturm, De Stijl, the Bauhaus … More than an 'ist' within an 'ism' therefore, like Albert-Birot himself.[20]

Notes

1 For a complete presentation of Albert-Birot's life and work and their intersections, see Lentengre (1993).
2 For a full analysis of the cubist space of *Grabinoulor*, see Kelly (1997: 280–91).
3 *SIC* has been republished three times in the series of facsimile editions of avant-garde journals by Jean-Michel Place, most recently in 1993. There is an invaluable index of the names of the contributors and of their contributions by title; an index of all names referred to throughout the review; an index of all works referred to and a thematic index. These appendices read like a reference list of major poets, artists, literary movement and artistic developments of the early years of the twentieth century. In addition to the numerous contributions of Albert-Birot himself, the most frequent contributors are Apollinaire, Aragon, the Catalan Perez-Jorba, Reverdy, Soupault and Tzara.
4 Amongst the many reviews referred to within the pages of *SIC* can be noted: *Nord-Sud*; *l'Instant*; *Dada*; *Procellaria*; *Noi*; *391*; *Valori Plastici*; *La Revista*; *Vell i neu*; reviews produced in Paris, Rome, Barcelona, Liège, Nice and several other places.
5 Albert-Birot and Severini were living in the same building in Paris, but the story goes that they did not meet until their wives got talking to each other and introduced their husbands.
6 Albert-Birot was already forty years old in 1916 (even though he frequently declared that he was actually born in 1916 with the birth of *SIC*, an important part of his personal mythology), and this precision is more than merely anecdotal since it indicates a generation gap between him and many of the young writers he would publish in the review. He had lived in Paris since the age of sixteen, had trained as a sculptor and painter, apparently untouched by the modern artistic movements of the end of the nineteenth and beginning of the twentieth centuries. Already the father of four children whom he was raising as a single father, he married the musician Germaine de Surville in 1913. His personal circumstances may account for his distance from literary and artistic circles until the First World War. Considered unfit

for service, he spent the period of the war in Paris. The period 1915–1916 is a transformative moment.

7 Here I am taking the notion of the 'witness' which has become prevalent in literary, cultural and notably memory studies, and using it to suggest Albert-Birot as a 'witness' to literary and artistic history as well as to the collective history of a period which included the First World War.

8 See especially the research done by Lentengre (1993) on this period of Albert-Birot's life.

9 Albert-Birot had plans from as early as 1904 to found a literary review with titles such as *L'Elan Littéraire Universel*, *Le Flux*, *L'Ardeur Littéraire* and *L'Oeuvre Idéaliste*, and one might read the embryo of *SIC* in the dynamic of such titles although there is nothing to substantiate any idea that he was sure at this stage of what would develop into *SIC*. In 1909 he produced two covers for a review to be called *Le Bois Sacré et les Heures Littéraires*. The most advanced project for a literary review was *1915*, immediately preceding *SIC*, yet this was still far from anything that could be considered 'avant-garde'.

10 *La guerre (1916)* (1916) oil on canvas, 125.5 cm x 118 cm, Musée d'Art Moderne, Centre Georges Pompidou, Paris. The painting has been displayed at the following exhibitions among others: 'Abstraction: Towards a New Art. Painting 1910–1920' (Tate Gallery, London, 1980); 'Parade 1901–2001' (Museu Nacional de Arte Moderna, São Paolo, 2001). It is reproduced in Fauchereau (1991), Cork (1994), Kelly (1997) and in the São Paolo exhibition catalogue.

11 For a detailed analysis of the development of the canvas via its many sketches, and of this 'language' of lines and colour, see Kelly (1997: 28–57).

12 Giovanni Lista (1979) places Albert-Birot in what he terms the 'second wave' of the avant-garde and considers both Albert-Birot's inheritance and autonomy with regard to the ideas of Marinetti and Severini. Lista discusses both his painting and his theatre from the viewpoint of Futurist theory. He also stresses the iconography of *SIC* from a Futurist perspective, but is dismissive of Albert-Birot's own 'cubist poetry' which he considers merely 'ornamental'. Lista's analysis of *La guerre* considers it to be a similar experiment to that of Balla's 'peinture conceptiste'.

13 Of Albert-Birot's personal statements on modernity, the most important and sustained is 'le nunisme' as expressed in both his 'dialogues nuniques' (in which, in a form of Socratic dialogues, 'A' and 'Z' debate modern art and can be read as representing the 'old' and 'new' Albert-Birot). He explains that the term's etymology derives from the Greek 'Nun, now, at present', providing another classical root, like the title of *SIC* itself. The adjective 'nunique' first appears in issue of 5 May 1916, with no explanation of its origins. The final 'dialogue nunique' takes place in the same issue (*SIC*, 21–2, September–October 1917) as the design for the 'nunic theatre'.

14 This is an important element in Albert-Birot's self-mythologising, as is his insistence on his 'rebirth' with *SIC*.

15 Albert-Birot, Interview with 'Les Jeunesses Poétiques', Knokke le Zoute, Belgium, September, 1963, p. 6 (typescript, Albert-Birot Archive, IMEC).

16 Music is an important feature of *SIC*. Albert-Birot's wife during this period, Germaine, was a musician and created the score for the notorious production of Apollinaire's *Les mamelles de Tirésias* on 24 June 1917. Albert-Birot was key in getting the 'drame sur-réaliste' staged.

17 Albert-Birot, 'Naissance et vie de *SIC*' (1988: 48–9).

18 Albert-Birot, letter to Léo Tixier (Albert-Birot Archive, IMEC).

19 Grabinoulor's is an unlimited adventure (literally, with no final full stop at the end of the six volumes): 'Grabinoulor happy to have legs a strong heart and a good spleen was going along and going along with such gusto and his mind so elsewhere that he took like this the path of Infinity what a walk even for a man who walks well and still will he ever reach this unique point where parallels meet?' (Albert-Birot 1991: 364). One place Grabinoulor is unable to find on his many adventures is the 'Empire of the Dead' and he constantly evades the questioning of M. Oscar Thanatou on the subject of death.

20 I am grateful for the comments made by Günter Berghaus who drew my attention to Prampolini's position with regard to the Futurist movement.

References

Albert-Birot, P. (1930). 'Ismisme', *L'Intransigeant* (6 February).

Albert-Birot, P. (1964). Interview with Pierre Berger, *Les Lettres françaises*, 1057 (3 December).

Albert-Birot, P. (1988) *Autobiographie* followed by *Moi et moi* [1952–59] (Troyes: Librairie bleue).

Albert-Birot, P. (1991). *Les six livres de Grabinoulor* (Paris: Jean-Michel Place); partial publications 1918 to 1988, most notably 1933 (Paris: Denoël et Steele) and 1964 (Paris: Gallimard).

Apollonio, U. (1973). *Futurist Manifestos* (London: Thames and Hudson).

Cork, R. (1994). *A Bitter Truth. Avant-Garde Art and the Great War* (London and New Haven: Yale University Press).

Fauchereau, S. (1991). *Peintures et dessins d'écrivains* (Paris: Belfond)

Kelly, D. (1997). *Pierre Albert-Birot. A Poetics in Movement, A Poetics of Movement* (London: Associated University Presses).

Lentengre, M.-L. (1993). *Pierre Albert-Birot. L'Invention de soi* (Paris: Jean-Michel Place).

Lista, G. (1979). 'Le Futurisme de Pierre Albert-Birot', *Cahiers Bleus*, 14:1, 27–50.

SIC. 54 issues (Paris: January 1916 – December 1919); facsimile edns (Paris: Jean-Michel Place, 1973, 1980, 1993).

The dispute over simultaneity: Boccioni – Delaunay, interpretational error or Bergsonian practice?

Delphine Bière

The dispute opposing the Futurists and Robert Delaunay between 1913 and 1914 focused on notions that were commonly discussed among the avant-garde and gave those artists the opportunity to define their own conception of simultaneity. This dispute also demonstrated the overlapping of various trends in contemporary art, and the artists' endeavours to distinguish themselves from one another at a time when critics tended to confuse and assimilate the Delaunay's creative process with that of the Italian Futurists. The point of the dispute was first of all to prove the precedence of the Futurists' pictorial innovations over Delaunay's. Secondly, the debates it provoked revealed some interpretational errors in the way some driving principles were received at the time, including Chevreul's law of simultaneous contrasts and complementary colours, but above all Bergson's theories about duration and intuition. In the 1910s, the philosopher influenced a whole new generation of artists and writers, whose key words were 'energy', 'vital impulse', 'dynamics'. The reception of his philosophy – occasionally appropriated by extremist, political or nationalistic movements (Antliff 1993) – is evidence of the extent to which his philosophical proposals had suffused the various layers of French society and culture, so much so that their usage had become unconscious (Azouvi 2007), thus constituting what Frédéric Worms has called a 'Bergsonian moment' (Worms 2009: 33). Outside of France, Bergson's ideas spread quickly through translations, articles and publications devoted to his works. In 1900, the first book about Bergson was published in Italian under the title *Un nuovo idealismo. H. Bergson*, by Emilio Morselli. *Leonardo*, a journal created in 1903 by Giovanni Papini and Giuseppe Prezzolini, published texts by and about Bergson (Pighi 1981) as well as William James. In 1908, Papini also translated Bergson's *Introduction to Metaphysics* before taking part in the Futurist adventure by introducing Bergsonian ideas as early as

1909. Between the publication of *Creative Evolution* (1907) and the First World War, Bergson's works were translated into all the main European languages, and found themselves at the centre of the main issues of the time, as Tancrède de Visan (1913: 135) put it: 'This is the nourishment that we need, and that each of us will consume according to his abilities'. Bergson's philosophy was of particular interest to artists in that it introduced a novel analysis of what constitutes immediate knowledge and experience. Moreover, it asserted the superiority of intuition over discursive intelligence as a method as well as recognising the decisive role of pure perception: 'Thus art aims at impressing feelings on us rather than expressing them; it suggests them to us, and willingly dispenses with the imitation of nature when it finds more efficacious means' (Bergson 1965: 12). Indeed, Bergsonian terminology soon found its way into the field of art, and its circulation gave rise to varying incomplete or sketchy interpretations. While the problem of the 'spirit' (Worms 2009: 13) discussed by Bergson touched a whole generation, the various solutions offered differed profoundly, as they depended on the relation between science and philosophy. Both fields concern themselves with the question of the relationship between *spirit* and *reality* and the tension between them. Among artists, new spatio-temporal conceptions were influenced by Bergson as much as by the principles of non-Euclidian geometry. The theories of Poincarré, the theory of relativity discovered by Einstein in 1905, Charles Henry's theory of relativism, the works of Gaston de Pawlowski, all developed concepts of the relativity of time and space, but above all the concept of energy which was the true catalyst of their thought. The questions of the dimension of time and the properties of matter (movement, continuity and energy) as revealed by science and theorised by Bergson fascinated painters who were attempting to escape the tyranny of the flat static vision produced by traditional perspective.

A controversy: between exchange of views and circulation of ideas

Many researchers have examined the dispute that opposed the Futurists and Robert Delaunay, in which Guillaume Apollinaire played such an important part (Bergman 1962). The notion of simultaneity that was central to this dispute was a favourite subject for part of the Western avant-garde,[1] but it also made it necessary to interpret the law of contrasts and of complementary colours developed by Chevreul.

Ever since the Italian group had exhibited their works at the Bernheim Gallery in February 1912, the dispute over simultaneity had been in the latent stage. It finally went public after *L'équipe de Cardiff* was exhibited

at the Salon des Indépendants in 1913. Guillaume Apollinaire's comment hailed the first entirely 'simultaneist' creation: 'There is nothing successive in this way of painting ... That is simultaneity' (Apollinaire 1913b). Delaunay reduced the Cubist technique of fragmentation and made free use of chromatic contrasts in a rendering of modern life in which dynamism and simultaneity were at the core of his aesthetics.

Boccioni, having been informed of Apollinaire's comment by Severini, replied with an article titled 'I futuristi plagiati in Francia', denouncing what he called Delaunay's plagiarism. Orphism, he wrote, was nothing but 'an elegant travesty of the fundamental principles of Futurist painting' (Boccioni 1913a). At the end of his article, Boccioni recalled that one day, in Severini's studio, Apollinaire had remarked that 'we [Futurists] were Orphic Cubists and that he wanted to devote a special study to the Futurists' art under the name of Orphism'. He reproached the poet for praising in Orphism the very things he had disliked in Futurism the year before and accused the French of chauvinistically defending the prominence of their art as a model.

In two other articles, 'Il dinamismo futurista e la pittura francese' and 'Simultanéité futuriste', Boccioni claimed the priority of the Futurists on the one hand, together with notions of 'plastic dynamism' and 'innate complementarities' in the use of colour and, on the other hand, 'simultaneity' (Boccioni 1913b, 1913c). The battle that raged in 1913 between Futurism and Orphism offered an excuse for the radicalisation of the differing currents of thought, as Ester Coen (2008: 53) has shown. Moreover, this dispute is a telling sign of how, as Cubist and Futurist values were confused by the press around 1913, the artists felt the urge to display and claim their singularity.[2]

The word 'simultaneity', which had been claimed by the Futurist painters' manifesto as the undisputable property of Italian painting, was central to the controversy. In France, the word simultaneity started being used by painters only after the manifesto was published in the catalogue of their first exhibition in the Bernheim Jeune Gallery (5–24 February 1912) in Paris: 'the simultaneity of different moods in a work of art is the exalting aim of our art' (Delaunay 1957: 63). For Delaunay, it meant making his own contribution to *simultanism*.[3] Moving away from the Cubists as well as distinguishing himself from the Futurists, he defined himself as a 'Cubist heretic' ['[h]érésiarque du cubisme'] (Delaunay 1957: 87). Exchanging views with Boccioni through the means of various articles led Delaunay to clarify his ideas about simultaneous contrasts as opposed to the Italian painter's understanding of simultaneity. Boccioni had theorised and published his ideas as early as 1909 (in the first Futurist manifesto), while Delaunay started publishing his own writings on the subject – rather

tentatively at that – only at the end of 1912, in Herwarth Walden's German review *Der Sturm*. He began to develop his theory on *simultanism* only in the summer of 1912, and the following year, at the Berlin Autumn Fair, he renamed most of his paintings 'simultaneous contrasts', adding for instance a second title to *L'équipe de Cardiff,* renaming it: *Troisième représentation simultanée: l'équipe de Cardiff*: 'I don't understand the meaning of *L'Équipe de Cardiff* after *La Tour* in those postcards (????) [sic], and it's definitely a mistake as the title is "Third simultaneous representation" (sic). *I do not want the title to be mutilated'.*[4] Around that period, Delaunay often signed his name as 'le simultané', evidence of the extent to which the painter identified with his work. Scholarly research on the dispute insists on the fact that the opposition between Delaunay and Boccioni rested both on the precedence of the use of the word 'simultaneity' and on its belonging strictly to Futurist vocabulary (Coen 2008, Gaeghtens 1985, Zimmermann 1985). However, while Boccioni as good as accused Delaunay of having borrowed the notion of simultaneity from the Futurists, Delaunay seemed more concerned about defining the concept than about fighting for the precedence of a word that he seldom used anyway, preferring to speak of 'simultaneous contrasts' or 'simultaneous'. In a letter sent to Herwarth Walden on 17 December 1913 Delaunay explained that he 'heartily despises that kind of dispute over words', but he admitted that 'Futurism does to a certain degree influence the terminology used these days about the most modern painters'. Then in a note he added that he had already explained in his writings of 20 and 27 November 1913 that 'the word "simultaneous" is an archaic French word that [he] only uses for its utilitarian value as a concept – that of simultaneous contrast' (Delaunay 1914). Delaunay refused to come out in favour of the declarations of either Boccioni or Apollinaire and deliberately chose to turn towards his own practice to justify the use of that terminology.

Beyond its two main protagonists, the dispute over simultaneity spread within part of the European avant-garde thanks to the two articles written by Apollinaire, 'Réalité, peinture pure' (1912) and 'La peinture moderne' (1913),[5] which were based on Delaunay's ideas and, especially in the latter text, asserted another pictorial trend, Orphism which, in the poet's view, encompassed not only Delaunay, Léger and Picabia but also German painters such as Meidner, Macke, Censky, Münter and Freundlich, as well as Kandinksy and the Italian Futurists (Apollinaire 1912, 1913a).[6] Apollinaire added to the confusion of the critics of his time who were already confusing Futurism and Cubism (Boccioni 1975: 52). As Severini wrote to Marinetti (31 March 1913): 'The Cubists and other avant-garde painters are conscious of the danger of being called Futurists … which is why they have invented Orphism' (*Severini futurista: 1912–1917*: 146).

Apollinaire asserted his global vision once again in his 'manifesto=synthesis', 'L'antitradition futuriste' (1913), where the poet offered a list of artists practising modern painting, in which he mixed Delaunay, Boccioni, Severini, Léger, Kandinsky, Duchamp and others (Apollinaire 1913c). In Europe, Apollinaire's words were taken up – 'pure painting', 'Orphism' and 'simultaneity'; their meaning specified, and sometimes clarified, as by Nikolaï Minsky, a poet, philosopher and editor of *Novaya Zhim*, who introduced the most modern trends in art to the Russian public.[7] His approach differed from that of the Germans who 'wrote philosophical articles in which they established connections between them [the paintings] and the Bergsonian concept of "creative evolution"'.[8] Minsky based his approach on a more materialistic method, combining observation and knowledge and refusing 'philosophical' interpretation.

In *L'Intransigeant* (4 March 1914) Apollinaire evokes the 'whirling Futurism' of Delaunay's *Hommage à Blériot*, which incensed the French painter[9] who had given precedence to Blaise Cendrars in the field of simultaneous poetry.[10] In *L'Intransigeant* dated 8 March, the Futurists – Carrà, Papini and Soffici – insist that '[t]he Futurist aspect of Mr Delaunay's compositions has been repeatedly underlined ... We challenge Mr Delaunay to prove the precedence of his work over ours'. As the dispute developed, it drew into it not only Cendrars who, together with Sonia Delaunay, had created the 'first simultaneous book', *La prose du transsibérien*, but also another controversy about that book which raged from September 1913 to July 1914 (Sidoti 1987). This new dispute involved Barzun, Salmon, Apollinaire, Fort, Hertz, Beaudouin, Quilbeaux, Billy, Lévy, Divoire and the Futurists.

Thus the notion of simultaneity spread to Germany and Russia with diverse understandings of the concept, and fuelled the aesthetic theories of modern painting in which plastic means were favoured to the detriment of iconic elements. Justifications for the use of the concept were found both in the ideas developed by French philosopher Henri Bergson, whose fame had spread at home and abroad, and in the scientific theories of the nineteenth and early twentieth century which were used to serve this new form of painting.

Chevreul + Bergson = simultaneity?

While the concept of simultaneity was at the heart of the dispute between Boccioni and Delaunay, their aspiration for pictorial dynamism fuelled their rivalry. The origin of the notion of dynamism as applied to painting can be traced back to the divisionism of colour practised by the neo-impressionists. Simultaneity and dynamism also have different objectives as far

as the process of abstract form is concerned. For Delaunay, the dynamism of colour corresponds to the 'vital movement of the world', perceptible through vision, and the only way to achieve representative rather than descriptive painting. Vision – at the core of his experimentation – results from light, which enhances the movement of colours. For Boccioni, the conception of the reality of painting appears in a more totalising way, as dynamism and simultaneity presuppose a synthesis of all the aspects connecting the observer and the perceived object: 'the synthesis of what we remember and what we see', or 'atmospheric simultaneity' ('Les exposants au public', Lista 1973: 169). Reality can be captured only with the help of memory, experience and sensations. Consequently, the object appears as an entity only successively and in its complex forms. Therefore, another meaning of the word simultaneity refers to putting on canvas the successive phases of a single movement.

Beyond the dispute about the precedence of the concept of 'simultaneity', both artists used the same starting points and adopted, albeit to various degrees, Bergson's reflections on simultaneous contrasts and his philosophical propositions. While Boccioni finds confirmation of his position in Bergson's conclusions, Delaunay focuses on the concrete examples of the chemists Chevreul and Rood to define a method in which simultaneous contrasts are a way of organising the abstract relationship of colours.

Michel-Eugène Chevreul's *De la loi du contraste simultané* (1839) questioned traditionally established relations between vision and the perceived object. Chevreul distinguished between two types of colour contrasts – simultaneous and successive. His demonstration insists on simultaneous contrast, and on the fact that 'the eye [perceives] all the parts in one single moment'. Chevreul became a source of inspiration both for Delaunay and for the Futurists. Boccioni (1913c) alluded to the concept indirectly through the 'analysis of colour (Seurat, Signac and Cross's divisionism)', that is to say through neo-impressionist painting, whereas Delaunay referred to Chevreul's discoveries more directly (in a letter to August Macke) through his own 'observation of the movement of colours' (Delaunay 1957: 186), and through his study of the works of Signac and Cross. In Boccioni's work, colour contrasts – whether simultaneous or complementary – serve dynamism: 'As far as colour is concerned, there are no set colours, but merely the results of the juxtaposition of a colour with its complementary colour' (Boccioni 1913c). The treatment of colour is extended to shape: the simultaneous contrast of colours becomes the idea of 'simultaneous atmospheres', and the notion of complementary colours evolves into that of 'complementarism'. As with the principle of complementary colours, complementary images consist of creating a new reality by confronting and even combining two realities: 'the bus speeds into the

houses it soon passes by and the houses in turn rush down towards the bus and mingle with it' (Lista 1973: 164–5).

In his *Visioni simultanee*, the 'first painting that asserts simultaneity' (Boccioni 1975: 87), Boccioni painted 'a figure on a balcony, seen from inside a flat … we endeavour to convey the global visual sensations that person must have felt while standing on the balcony – the sunny bustle of the street, the double line of houses stretching to the right and to the left' (Lista 1973: 169)'.[11] What this woman sees is the same as what the viewer can see – a swarming street, the agitation of urban life, another aspect of the woman's face seen face on – all these elements draw the eye into a multiplicity of sensations felt by the female figure. The interpenetration of the various planes produces the feeling that the human character is intruding on the urban landscape whose elements are shattering its physical integrity. The shock of the confrontation is emphasised by the chromatic palette in the blue curls, the orange-red hues of the face and the purple tints of the hair, thus establishing a dissonance at the centre of the composition. The Futurists have subjected shape to a process of interpenetration emphasised through their use of colours. Memory makes possible the expansion of shape as well as colour, and the evocation of both contrasts and affinities. Subjective effects underline the importance of sensation and of memory as well as the primacy of the 'emotive atmosphere' over the rendering of shape. Simultaneous contrasts evoked by objects and intensified by memory become 'analogical realities' which make it possible to associate different perceptions. Therefore, the origin of perception is to be found in sensations rather than in objects.

Simultaneity also seems to be the main theme in Robert Delaunay's *Tour Eiffel* series, which belongs to his 'destructive' period and identifies him as a Cubist.[12] The fact that Delaunay chose to paint Paris resulted in a misunderstanding as it tended to put him in the same category as the Futurists: three of his canvases (*The Tower, The City No. 1, The City No. 2*) shown at the Futurist exhibition of the Der Sturm Gallery (12 April–31 May 1912) were labelled a French version of Futurism by the German critics. In his *Tour Eiffel* series, Delaunay renders a global vision of the various visual angles offered to the observer while moving around the tower. The monument is literally recreated through those various moments reunited into a single picture, where we perceive the simultaneity of coloured forms through an 'optical sensation' due to the effect of light. The painter thus offers a new notion of space that is very different from the static – even rationalist – character of analytical Cubism. Some versions of the tower, such as the one that hangs in the Art Institute of Chicago, ultimately rely more intensely on chromatic representation than on the rendering of form.[13] The red hues that are reflected by the neighbouring buildings participate in the

dematerialisation of the tower. While the notion of 'simultaneous' was meant from the start to describe the sensation experienced while seeing all the different parts of the represented object at the same time, Delaunay did not use the notion of 'simultaneous contrasts' before 1912, and did not solely ground it in the work of Chevreul, as Georges Roque (1997: 349–50) argued: 'Delaunay also associated the notion of simultaneous contrast with Rood, perhaps even more than with Chevreul … For him … Chevreul brings to mind the idea of complementary contrasts, which could not, on their own, provide a strong enough basis for the construction of a painting through colour'. That is why Rood introduced, among other things, the notion of 'small intervals', the juxtaposition of colours that are close to each other on the chromatic circle. In the *Tour Eiffel* from the Kunstmuseum in Basel,[14] the red tower is gnawed at by the intrusion of oranges and yellows, colours which are also close on the chromatic circle, and their juxtaposition produces a fast vibratory movement that is opposed to the slower movement produced by colours that are further apart on the chromatic circle, the blues and the whites of the background and of the buildings. The simultaneous perception of the slow and fast vibrations of the colours that clash in the composition also guarantee its dynamism. Together with the idea of the simultaneity of points of view, Delaunay offers another understanding of simultaneous contrasts that he was to explore thoroughly in the *Fenêtres* series. 'On the one hand, in its narrower sense, it refers to the juxtaposition of complementary colours … but on the other hand, and in a wider sense, it indicates in fact the simultaneous perception of the opposition of 'complements' and dissonances whose contrast … provides the dynamism and movement of the painting' (Roque 1997: 353–4). The simultaneity of points of view would later be dropped in favour of the simultaneity of colours: ' "the simultaneity of colours" through simultaneous contrast … is the only reality in the construction of a painting' (Delaunay 1957: 159). The only reality is in the painter's subjective vision, in the subjective effects of contrasts. Consequently, Delaunay's understanding of subjectivity as pure pictorial sensitivity to chromatic dynamism offers no longer a vision of space but the logic of a conception of time where objects must become 'mimicries of movement' in order to appear in their mobility.

At the beginning of the twentieth century, by focusing on internal experience (that of the spirit, of duration), as well as the qualitative multiplicity of interiority, Bergson's philosophy provided a counterpoint to sciences, which studied reality as an external, measurable experience.[15] The influence of Bergson's philosophy on the Futurists was acknowledged as early as 1912, but, as is often the case with avant-gardes, public interest focused mostly on Bergsonian philosophical ideas – duration, intuition, life and vital impulse – while plastic consequences were hardly mentioned.[16]

Boccioni and Delaunay developed their own idea of simultaneity by tapping into Bergsonian philosophy, while recognising the contradiction between painting and time that is intrinsic to the notion of representation, and applying to painting a new conception of the space–time continuum. Thus they took into account the fact that our perception is divided into successive images,[17] but they did not use the same aspects of Bergsonism to bridge that gap, nor did they endow perception with the same objectives (Petrie 1974, Davies 1975, Zimmermann 1987). However, they did follow the Bergsonian principle that consists in placing perception before idea or concept: 'What the artist has seen we shall probably never see again, or at least never see in exactly the same way' (Bergson 2007b: 124). Conveying this perception – 'revealing' form and matter as they are about to happen, for Boccioni, and the mobility of light and its effects, for Delaunay – implies the invention of a new pictorial language whose finality is no longer reproduction but production, and where the question of abstraction must be addressed.[18] Bergsonian philosophy gave people a way of accessing a reality that could not be expressed in ordinary language, but that could be accessed through other means, and especially through art. While Bergson's philosophy consists first and foremost of an accurate intuition, it also contains a strict distinction between space and time, or rather *duration*. Intuition is not a characteristic of representation but a movement of the spirit to identify with reality. In his 1885 thesis, *Essai sur les données immédiates de la conscience*, Bergson (1965: 42) introduces his intuition of duration and starts from a simple problem that often occurs in science: 'I said that time was not space'. Bergson realised that science considered time 'whose essence is to flow', like space, whose essence is simultaneity, which is quite the opposite. 'The connection between those two notions, space and duration, is simultaneity, which could be defined as the intersection of time and space'. Bergson argues that simultaneity is the relationship or the contact between a specific duration and another reality. In other words, we all make simultaneous mental pictures of moments in time that are never there at the same time. Moreover, we imagine them not in 'time' but spatially. Thus the Bergsonian notion of simultaneity qualifies the overlapping of internal time (as felt by the individual) or duration, and of spatial time (as perceived through the senses). This notion of simultaneity is a prerequisite when it comes to conceptualising the relationship between beings and the passage from duration to homogeneous time.

Boccioni's pictorial simultaneism is based on the interpenetration of bodies and objects, and the fusion of time and space, and aims at the expression of a 'duration' shaped by memory. It is a fact that simultaneity translates the experience of the senses in terms of psychological dynamism and combines the psycho-physiological data of perception with the contents

of consciousness. When used to express the temporal process of perception, simultaneity refers to the combined presence of the subject and the environment: it is the 'necessary condition for the different elements that constitute DYNAMISM to appear' (Boccioni 1975: 88). The two versions of the triptych entitled *Stati d'animo* (States of mind)[19] give concrete expression to the idea of painting 'plastic' frames of mind, in Boccioni's words. He translates the 'movements' of the feelings and 'sensations' experienced while parting on a station platform. Three aspects of that moment – *Gli addii* (Farewells), *Quelli che vanno* (Those who are leaving) and *Quelli que restano* (Those who are staying) – enable the painter to translate the spatio-temporal simultaneity of different psychological states.

In the second version of the triptych, Boccioni suggests the movement of the shapes and seems to be translating his theory into painting especially through force-shapes or, as he writes in the preface to the catalogue of the 1912 exhibition, 'potentiality of the real form'. The force-form 'springs from real form', thanks to the lines of force or the 'directions of the colour-forces' (Boccioni 1975: 76). Blue diagonal lines from left to right in *Quelli che vanno*, undulating arabesques in *Gli addii*, and vertical lines in *Quelli che restano* provide rhythm to the compositions and constitute open force-lines that keep on rising and growing. Depending on their direction, these force-lines support the movement of the states of mind and combine with subjective chromaticism to evoke the nature of those feelings – 'moving colours conceived in time rather than in space' (Carrà 1913). The demand for a temporal painting – since 'space no longer exists' (Lista 1973: 172) – raises the issue of perception as being the only direct and immediate contact with reality. By declaring memory such an important part of perception, Boccioni is close to the Bergsonian poetics of the 'state of mind' which implies a convergence of memory and perception. He recreates objects from an emotive power in which memories play a role. In *Gli addii*, Boccioni paints the heartbreak of the farewells: the embrace and the separation.[20] The composition is divided by an undulating diagonal that separates the embracing couple(s) on the platform. The artist's choice of spiralling shapes expresses the continuous progression of life while the accumulation of eye-catching signs aimed at communicating internal and external agitation are entirely at odds with analytical Cubism. Simultaneity and the interpenetration of planes are a natural consequence of the principle of continuity. The latter can be obtained only through matter. Thus the work expresses the continuity of matter by endowing the perceived object with dynamic evolution. Consequently, objects are extended into space, like the couple embracing whose shape develops into spiralling forms on both sides of the undulating diagonal. An extended perception of matter reveals that it 'extends into space without really spreading and … by conferring on matter

the properties of pure space, we are transporting ourselves to the terminal point of the movement of which matter simply indicates the direction' (Bergson 2007a: 204–5). For Boccioni and the Futurists, just as for Bergson, immediate perception is the pure perception of matter. Boccioni (1914) attributes to painting the aim of 'giving life to matter by translating it into its movements'. Furthermore, matter, as 'flux', 'possesses in very truth the indivisibility of our perception' (Bergson 2007b: 247). Hence perceived matter – endowed with energy, movement and continuity by the Futurists – takes us back to the fact that 'our knowledge of objects, in its pure state, truly takes place within the things' (Bergson 2008c: 66–7). Bergsonism is translated in Boccioni's as well as in Delaunay's paintings through the fact that they restore and dilate perception with all its potential: 'Perception, therefore, consists in detaching, from the totality of objects, the possible action of my body upon them. Perception appears, then, as only a choice' (Bergson 2008c: 257). Bergson's writings about perception make it possible to distinguish perception from the mental copy of things, and thus to connect the work of art to the concrete and subjectivity through the division of images, as well as to the realism of matter.

While claiming that 'seeing is a movement', Delaunay does not distinguish it from sensitivity (the eye) since 'our eyes are the windows of our nature and of our soul ... We can't do anything without sensitivity, that is to say without light' (Apollinaire 1912; Delaunay 1957: 158).[21] The painter seems to adapt the idea of a continuum between sensation and perception by introducing movement in the pictorial space as early as the *Saint-Séverin* series (1909) where light emanating from the centre of the composition tends to dissolve the architecture. In this series, Delaunay developed a temporal experience in the simultaneity of the various points of view expressed by the pillars' concavity rather than by the deconstruction of form. Hence the experience of time – or duration – is, as Bergson insisted, an experience that cannot be separated from the conscience that is experiencing it. As a 'continuation' (or continuous succession of content) it is opposed to space. His work *Creative Evolution* (1907) goes deeper into the definition of the status of space. Space is envisaged as the continuation, in an imaginary mode, of a stopped process. It is the means by which we represent any object as composed of simultaneous, homogeneous, discontinuous and infinitely divisible parts. Finally, space is the result of a process of conceptualisation that is specific to our mind. In his series of *Windows* and in *Circular Forms*, Delaunay developed an aesthetics of the visual process. These works pioneered what Apollinaire called 'pure painting', and asserted a 'new reality' that would be freed from any descriptive representation of nature. In *Windows*, for instance, colour structures space. The painter's search for coloured luminous phenomena results in the creation

of a non-representative space. As visual phenomena, colours make the 'total mobile form' possible and influence vision through their 'synchronic movement'. The colours blend into one another so as to give the painting what Bergson calls a 'truly pure duration', that is the 'continuous progress of the past which gnaws into the future and which swells as it advances' (Bergson 2007a: 5).

Delaunay (1957: 146–50) also discussed duration in an essay called 'La lumière' [On Light]: duration as it is rendered by simultaneity remains a reality of the senses, conditioned by physiology. Delaunay highlights optical information in painting and visually materialises 'duration' (or the 'vital movement of the world') when it is approached by painting as a programmable reality. While the painter maintains that the eye is capable of sensing luminous phenomena and their correspondences in a global, enduring way, the philosopher ends up with a paradoxical notion of duration as 'qualitative heterogeneity'. Bergson defined duration as the indivisible and therefore substantial 'continuity' of the 'flux' of interior life. For him, 'duration' is to be apprehended not in a physiological way through the senses – the way Delaunay sees it – but through conscience. However, it seems that, both for Delaunay and for Bergson, the true symptom of duration is the correspondence of the different elements – simultaneity – and that 'duration' and 'vital movement' are one and the same thing. We can suppose that if Chevreul provided Delaunay with a confirmation of his pictorial practice, notably his use of colours (their contrasts, their harmonies or disharmonies), Bergsonism allowed him to integrate a broader reflection on the representation of reality in which subjectless painting expresses the temporal simultaneity of visual activity, into the activated vision of colours (their complementarity, the synchronicity of their action). What was really important to Delaunay was subjectless painting as specifically optical information solely devoted to the vision of colours.

Thus the problem of simultaneity – a corollary of pictorial dynamism – served as a catalyst for a new conception of painting whose conventions were being questioned. The spatio-temporal energy of any representation presupposed that it was open to the infinite dimensions of consciousness, and, as a consequence, one could reasonably question the representation of a reality in a state of permanent evolution.

From vital impulse to pictorial dynamism: towards 'organic' representation

At the same time as scientific theses, such as the notion of simultaneity developed by Albert Einstein in his theory of restricted relativity, according to Leo Stein, 'Bergson's creative evolution was in the air with its seductive

slogan of the élan vital or life force' (Antliff 1993: 74). Indeed, in *Creative Evolution*, published in 1907, Bergson developed a philosophy of biological creation. The notion of life force, at the heart of the work, makes it possible to explain the structures of matter and organs. The 'vital impulse', that is the original common impulse which explains the creation of all living species, is defined as a current of creative energy opposed to matter and directed towards the production of free acts. Through the vital impulse and the process of differentiation, Bergson presents his contemporaries with a theory of evolution, an act through which life divides itself and takes a specific direction: 'an original impetus of life passing from one generation of germs to the following generation of germs through the developed organisms which bridge the interval between the generations. This impetus ... is the fundamental cause of variations, at least those that are regularly passed on, that accumulate and create new species' (Bergson 2007a: 88). Because it is an immaterial but permanently creative principle, the notion of vital impulse is of universal significance, offering the avant-gardes an open conception of reality. While Bergsonism transforms the concept of being into an ontology of becoming, Marinetti's *Futurist Manifesto* develops the superiority of becoming over being, that is to say of movement over immobility: 'We intend to sing the love of danger, the habit of energy and fearlessness ... We intend to exalt aggressive action, a feverish insomnia' (Lista 1973: 83). Marinetti also opposes 'intellectual dogmatism' and 'the cult of creative intuition', and promotes an art focused on the concept of becoming and the ephemeral. By discovering the properties of matter, the Futurists elaborated a plastic dynamism that must, according to Boccioni, be in relationship with sensorial experience and feed on a constantly evolving reality. In *Materia* (1912), Boccioni depicts an old woman seated, her body occupying the whole pictorial space.[22] His composition of forms and face is Cubist in essence. The originality of the theme and the title of the painting highlights the kinship between the Italian word *materia* and its French counterpart *matière*. For Claude Frontisi (1994: 12) the title reveals the painting's ambivalence' and 'the incredible violence done to the mother's body' as well as the telescoping of the relationships between language and image. Among the title's possible connotations, the most literal evokes the plastic possibilities of matter, the energy it diffuses or releases, and movement and continuity as 'flux'. Matter in expansion materialises its plasticity through this mother/*mater* image, and the 'lines of force' or 'directions of the colour-forms' enliven the composition by creating a continuity of matter within movement. While for Bergson the vital impulse – the unique effort at the origin of life – faces the resistance of matter, Boccioni uses this resistance to prove matter's inherent ability to be the medium of dynamism.

However, he senses the limits of the medium: 'there may be an age when painting will no longer suffice. Its immobility, its childish means will be anachronistic in the vertiginous movement of human life!' The future of matter – a vehicle for energy, sensations and action – turns the pictorial field into a living act concretely inscribed in the artist's subjectivity: 'the artist ... *senses*, and the sensations that surround him dictate the shapes and colours that will evoke the emotions that made him react pictorially' (Boccioni 1975: 106). Boccioni aims to express the unceasing fluid course of the vital impulse, that is to translate reality (the multidimensional content of the ever moving data of consciousness). Thus painting leads to a dynamic perception of reality as an absolute evolution, but it also retains the energetic dimension of the creative act. In *Elasticità* (1912), Boccioni achieves a synthesis of the various phases of a movement in which the rider, the horse and the environment, whose planes all clash with each other, are tilted towards the foreground.[23] The elasticity of matter (from the trinomial horse-rider-landscape corresponding to form-forces) is paralleled by a concept of creation as an energetic act where the creator is perpetually acting and the viewer reinterpretating. Futurist painters can bring about the great 'evolutive dynamic realisation' (Boccioni 1913b: 171; 1975: 120) because 'the painting ... is an irradiating architectural structure in which the artist, rather than the object, forms a central core. It is an emotive, architectural environment that creates sensations and surrounds the viewer ... As a consequence, forms and colours must represent and convey a plastic emotion by including the observer in the plastic rhythm, and by resorting as little as possible to the concrete forms (*objects*) that occasioned them' (Boccioni 1975: 86, 100). The evolution of form and its tending towards abstraction imply a new reality of the work of art; for Boccioni 'a plastic creation is both an act of the mind and an action in the double sense of the word as it allows the universe to perpetuate itself and to act in turn' (Blumenkranz-Onimus 1971: 362). It is through action – celebrated by the Futurists – that creation is undistinguishable from the creator, as 'in action the entire person is engaged' (Bergson 2007b: 109). In *Creative Evolution*, the idea of creation is implied by that of duration, which becomes a permanent creation of novelty through its development and its growth. Like Delaunay, Boccioni agrees with the Bergsonian idea of creation as a surge [*un surgissement*]. Whenever creation takes place, it attests the reality of duration: 'time is invention, or it is nothing at all' (Bergson 2007a: 341).

Delaunay, by defending the idea of a plastic art based on colours and light, is connected to the Futurists in his paintings about modern life: *L'équipe de Cardiff*[24] (1913) or the *Hommage à Blériot* (1914). The players in *L'équipe de Cardiff* thus reflect not only the game's intensity of

movement but also the vitality of the signs of modernity, advertising (the Astra billboard), aviation (the bi-plane), the urban landscape (the big wheel and the Eiffel Tower). The painter introduces language through the word and its visual referent within the colour itself: red letters (ASTRA) on a yellow background, white letters ((DELAUN)) on a green background, and the letters AL painted in bright green on a white background. Delaunay telescopes colour planes in which the words and the various iconic elements are inserted. Through the application of colour, the billboard has been transformed into an expression of the new space-time reality. Vision is engaged in a double mnemonic activity: one that is attached to perception, and the reminders of the artist's former works (the Eiffel Tower, the big wheel). The yellow plane of the billboard appears to jut out of the pictorial plane and helps the eye to move around the painting. In this active vision, Delaunay reinforces the confusion between what comes from memory and what comes from perception, and the coalescence between the two brings us back to Bergson: 'perception ends by being merely an occasion for remembering' (Bergson 2007a: 68). For the painter, movement cannot be suggested through drawing: movement is much more likely to be obtained through carefully chosen and composed shades of colours. He believes that there is such a thing as 'synchronic action' that can be made present by the use of colours, a 'global mobile form' made possible by colours. These paintings must be understood as multiple-perspective systems challenging the eye to perceive the complex interdependence of colour relations and their vibrations. Delaunay strives towards a widening of optical knowledge, an entirely optical reality devoid of contradictions on the optical level, towards a harmony of colours that 'the very rhythm of ... vision feeds on' (Delaunay 1957: 186). The painting *Formes circulaires, soleil n° 2* (1913)[25] is composed of a system of circular forms in which the colours are distributed in a very similar manner, the lighter colours surrounding the stronger colours. The various degrees in the intensity of the colours, together with their disharmonic and harmonic contrasts, create rhythms, that is to say a 'synchronic movement'. The eye simultaneously sees a colour, its complementary colour (for example, red and green – a harmonious and complementary contrast) and another disharmonic colour (for example, red and blue), which compels the viewer's attention. The sensations produced by the succession of tension and release, of fast and slow colour impulsions, alternate, but the eye sees the colours simultaneously and perceives them both separately and as a whole. The 'vital movement of the world' is revealed through the complexity of simultaneous vision. While colours stimulate the eye, paint is the matter that the artist must transform so that vision can apprehend the vitality of the world. Consequently, 'pure painting' – or subjectless painting – participates in this vital movement.

Thus Delaunay turns the moving external optical sensations of space into internally animated sensations of colour and light. The process of animated vision elaborated by Delaunay was very similar to Boccioni's conception of the perceptible creative process of the painting. It integrates duration, which was the essential attribute of this new painting form and led Boccioni to advocate a concept of art-life-action that went beyond the traditional scope of artistic practice. For Delaunay, pure painting, which was the answer to an experience of vision, would spread and take an active part in a collective work. In the thirties, Delaunay went on to define painting in a different way, when he pursued his research of the 'architectural laws of colour' that would lead him to integrate his art into architecture.

The place of Bergsonism in the dispute over simultaneity reveals how synchronic artistic systems – whether Delaunay's or the Futurists' – work in connection with each other. In fact, and in spite of being understood in slightly different ways, Bergson's philosophical proposals appear as part of the connections between those systems at a moment when individual explorations were finally converging around the problem of abstraction.[26] Although Bergson never developed an aesthetics of intuition,[27] the idea of creation as growth translates into a *surgissement* [surge] through the flow of the duration of novelty (Bergson 2007a: 165). For that reason, the Bergsonian idea of creation breaks with the classical understandings of that notion because it merges with the notion of growth and does not suppose any kind of model or transcendental will. The philosophical notions have been materialised in the practice of the avant-gardes who aspired to bring art closer to life and to giving it an existence outside knowledge. In the first chapter of *Matter and Memory*, Bergson insists on the notion of images: 'I am now in the presence of images, in the vaguest meaning of the word, images that I perceive when I open up my senses, that I don't perceive when I close them … By *image* we mean a kind of existence which is more than what the idealist calls a representation, but less than what the realist calls a thing – an existence midway between the *thing* and the *representation*' (Bergson 2008c: 1). This general hypothesis apparently opens a path outside all systems. It seems indeed that Bergsonism provided an incentive to develop personal practices and a condemnation of all systems as well as the assertion of 'free action' underlying his entire philosophy. Does that make Bergson a philosopher of modernity and the avant-garde? He seems to have been rather indifferent to the experimentations of the avant-gardes, as reported by Villanova (1913): 'Strangely enough, it is generally believed that I have sympathies for the Cubists, for the Futurists! I have never seen that sort of painting! I have no idea what they represent! … I declare that I cannot approve of revolutionary forms in art'. However, a few years later, Bergson would complete his philosophy of creation with

the work of art as a model. Part of the first chapter of *Deux sources de la morale et de la religion* (1932) is devoted to the analysis of emotion under the title 'Emotion and Creation': 'creation signifies, above all, emotion' (Bergson 2008b: 41). Consequently creation is neither a truth of faith nor an idea that springs from reason, but a fact of experience. Neither Boccioni ('Creation and emotion are the same thing'; 1975: 102) nor Delaunay would have disowned this.

Notes

1 The simultaneist dispute which opposed Delaunay and Cendrars on the one hand, and on the other Henri-Martin Barzun, editor of *Poème et Drame*, also illustrates this new fashionable phenomenon. For an in-depth analysis of this controversy, see Bergman (1962: 263ff).

2 Roger Allard (1911: 62), critic and supporter of the Cubists, made scathing attacks against Delaunay while paradoxically underlining what distinguished him from the Cubist group in room 41 of the 1911 Salon des Indépendants: 'Delaunay dissociates the objects that constitute an aspect, so much so that he creates a flowing interpretation between them – this reminds us in a rather remarkable way of a certain Futurist manifesto that, for some reason, has been made much fun of'.

3 The word was used by Delaunay. The difference in spelling indicates the distance the painter wished to establish between his own and Futurist terminology.

4 Postcard sent by Delaunay to Walden on 23 December 1913 (Sturm-Archiv, Berlin). Delaunay himself underlined the title and his own requirements.

5 This text was also given as a lecture in Berlin on 18 January 1913 on the occasion of Delaunay's exhibition in the Sturm Gallery.

6 The word 'Orphism' is mentioned by the poet for the first time in the only issue of the *Revue de la Section d'Or* (9 October 1912) and in a lecture on the 'agonising struggle of Cubism' in the Boétie Gallery on the occasion of the Section d'or exhibition.

7 See Biere (2005) for the circulation and reception of Delaunay's works and ideas.

8 Nikolaï Minsky, in a cutting from an undated and unidentified Russian newspaper (*Novaya Zhizm*), belonging to the Sonia Delaunay, album de presse (1911–1914) (Bibliothèque Nationale de France, microfilm M 220509).

9 Delaunay replied in *L'Intransigeant* (5 March 1914): 'I never have been and never will be a Futurist … I am surprised at the ignorance of Mr Apollinaire on simultaneous contrasts which form the framework and the novelty of my art'.

10 Pierre Francastel (Delaunay 1957: 29) has suggested that the whole story could have been a matter of literary vexation for Apollinaire.

11 Boccioni, *Visioni simultanee*, 1911, oil on canvas, 60.5 cm x 60.5 cm, Von der Heydt Museum, Wuppertal.

12 Delaunay painted the Eiffel Tower more than thirty times between 1909 and 1928.

13 Delaunay, *Champ-de-Mars, la Tour rouge*, 1911, altered in 1923, oil on canvas, 162.5 cm x 130 cm, The Art Institute of Chicago, Joseph Winterbotham collection.

14 *Tour Eiffel*, 1910–1911, oil on canvas, 195.5 cm x 129 cm, Kunstmuseum, Basel, Emanuel Hoffman Foundation.

15 The philosophy of optimism was opposed to the pessimistic movement of the end of the nineteenth century and the beginning of the twentiech century represented by the philosophy of Schopenhauer.

16 Auguste Joly, 'Le Futurisme et la philosophie', *La Belgique Artistique et Littéraire* (July 1912) in Lista (1973: 415–19). See also Julien Benda's critique in *Une philosophie pathétique* (1913).

17 Bergson calls objects 'images': 'this is not the same as transforming the world into a representation', but on the contrary, it 'inscribes our representation in the world' (Worms 2000: 30).

18 What I mean by abstraction is the type of abstract work that is organised along a network of internal relationships rather than the kind of abstract art that no longer refers to 'reality', whether objective or not.

19 The first version was painted before Boccioni's trip to Paris in October 1911 and was on show at Bernheim-Jeune in February 1912 during the first Futurist exhibition. Boccioni painted the second version after his stay in Paris.

20 *Gli addii* (*Les adieux*), 1911, oil on canvas, 70.5 cm x 96.2 cm, The Museum of Modern Art, New York.

21 'Note sur la construction de la réalité de la peinture pure': this was an article written by Apollinaire for *Der Sturm* from the manuscripts Delaunay had given him.

22 Boccioni, *Materia*, 1912, oil on canvas, 225 cm x 150 cm, Mattioli collection, Milan.

23 Boccioni, *Elasticità*, oil on canvas, 100 cm x 100 cm, Civico Museo d'Arte Contemporanea (CIMAC), Milan.

24 *L'equipe de Cardiff (troisième représentation L'équipe de Cardiff)*, 1913, oil on canvas, 326 cm x 208 cm, Musée d'Art Moderne de la Ville de Paris.

25 Robert Delaunay, *Formes circulaires n° 2*, 1913, distemper on canvas, 100 cm x 68.5 cm, Centre Georges Pompidou, Musée National d'Art Moderne, Paris.

26 That is, a system that aims at another reality, that of the work itself and dynamism.

27 Raymond Bayer, 'L'esthétique de Bergson', *Revue Philosophique* (March 1941), quoted by Dufrene (1971: 39).

References

Allard, R. (1911). 'Sur quelques peintres', *Les Marches du Sud-Ouest*, 2, 62.

Antliff, M. (1993). *Inventing Bergson* (Princeton: Princeton University Press).

Apollinaire, G. (1912). 'Réalité, peinture pure', *Der Sturm*, 138/9 (December).

Apollinaire, G. (1913a). 'La peinture moderne', *Der Sturm*, 148–9 (February).

Apollinaire, G. (1913b). 'A travers le Salon des Indépendants', *Montjoie!* (18 March).

Apollinaire, G. (1913c). 'L'antitradition futuriste', *Gil Blas* (3 August).

Apollinaire G. (1914). 'Le salon des Indépendants', *L'Intransigeant* (5 March).

Azonvi, F. (2007). *La gloire de Bergson. Essai sur le majestére philosophique* (Paris: Galliard NRF Essais).

Bergman, P. (1962). *'Modernolatria' et 'Simultaneità': Recherches sur deux tendances dans l'avant-garde littéraire en Italie et en France à la veille de la Première Guerre mondiale* (Stockholm: Nordstedt, Svenska Bokförlaget, Paris: Bonniers).

Bergman, P. (1987). 'Simultanéisme simultanéita', *Quaderni del Novecento Francese*, 10 (Rome: Bulzoni, Paris: Nizet).

Bergson, H. (1965). *Essai sur les données immédiates de la conscience* [1889] (Paris: PUF).

Bergson, H. (2007a). *L'evolution créatrice* [1907] (Paris: PUF, Collection Quadrige).

Bergson, H. (2007b). *Le rire. Essai sur la signification du comique* [1900] (Paris: PUF, Collection Quadrige).

Bergson, H. (2008a). *Durée et simultanéité* [1922] (Paris: PUF, Collection Quadrige).

Bergson, H. (2008b). *Les deux sources de la morale et de la religion* [1932] (Paris: PUF, Collection Quadrige).

Bergson, H. (2008c). *Matière et mémoire* [1896] (Paris: PUF, Collection Quadrige).

Bière, D. (2005). *Le réseau artistique de Robert Delaunay. Echanges, diffusion et création au sein des avant-gardes entre 1909 et 1939* (Aix-en-Provence: PUP).

Blumenkranz-Onimus, N. (1971). 'Quand les artistes manifestent', in L. Brion-Guerry (ed.), *L'année 1913. Les formes esthétiques de l'oeuvre d'art à la veille de la première guerre mondiale* (Paris: Klincksieck), pp. 351–69.

Boccioni, U. (1913a). 'I futuristi plagiati in Francia', *Lacerba*, 7 (1 April).

Boccioni, U. (1913b). 'Il dinamismo futurista e la pittura francese', *Lacerba*, 15 (1 August).

Boccioni, U. (1913c). 'Simultanéité futuriste', *Der Sturm*, 190–1 (2 December), 151.

Boccioni, U. (1975). *Dynamisme plastique. Peinture et sculpture futuristes* [1914] (Lausanne: L'Age d'Homme).

Carrà, C. (1913). 'La peinture des sons, bruits et odeurs', *Lacerba*, 1 (1 September), 185–6.

Carrà, C., G. Papini and A. Soffici (1914). 'Une querelle artistique', *L'Intransigeant* (8 March).

Coen, E. (2008). 'Simultanéité, simultanéisme, simultanisme', in *Le Futurisme à Paris. Une avant-garde explosive* (Paris: Centre Georges Pompidou, Milan: 5 Continents Editions), pp. 52–7.

Davies, I. (1975). 'Western European Art Form Influenced by Nietzsche and Bergson before 1914, Particularly Italian Futurism and French Orphism', *Art International*, 19:3, 49–55.

Delaunay, R. (1914). 'Lettre ouverte au Sturm', *Der Sturm*, 194–5 (January).

Delaunay, R. (1957). *Du cubisme à l'art abstrait*, ed. P. Francastel (Paris: SEVPEN).

Dufrene, M. (1971). 'L'esthétique en 1913', in L. Brion-Guerry (ed.), *L'année 1913. Les formes esthétiques de l'oeuvre d'art à la veille de la première guerre mondiale* (Paris: Klincksieck), pp. 25–57.

Fauchereau, S. (2005). 'Entre cubisme et futurisme', in *Hommes et mouvements esthétiques du XXè siècle* (Paris: Cercle d'Art), pp. 241–52.

Frontisi, C. (1994). 'La création et son double', in Majastre Jean Olivier (ed.), *Le texte, l'oeuvre, l'émotion* (Brussels: La lettre volée), pp. 9–21.

Gaeghtens, T. (1985). 'Delaunay in Berlin', in P.-K. Schuster (ed.), *Delaunay und Deutschland* (Cologne: DuMont), pp. 264–84.

Lista, G. (1973). *Futurisme: manifestes, documents, proclamations* (Lausanne: L'Age d'Homme).

Marinetti, F. T. (1909). 'Le Futurisme', *Le Figaro* (20 February).

Petrie, B. (1974). 'Boccioni and Bergson', *Burlington Magazine*, 116, 852 (March), 140–7.

Pighi, L. S. (1981). 'Henri Bergson e la cultura francese', *Leonardo* (Bologna: Arnoldo Forni), 1, 15–22.

Roque, G. (1997). *Art et science de la couleur. Chevreul et les peintres, de Delacroix à l'abstraction* (Nîmes: Jacqueline Chambon).

Severini futurista: 1912–1917 (1995). (New Haven: Yale University Art Gallery).

Sidoti, A. (1987). *Genèse et dossier d'une polémique. La Prose du Transsibérien. Blaise Cendrars, Sonia Delaunay* (Paris: Lettres Modernes, Archives Blaise Cendrars n° 4).

Villanova (1913). 'Celui qui ignore les cubistes', *L'Eclair*, 29 (29 June).

Visan, T. de (1913). 'La philosophie de M. Bergson et l'esthétique contemporaine', *La vie des lettres*, 1 (April), 135.

Worms, F. (2000). *Le vocabulaire de Bergson* (Paris: Ellipses).

Worms, F. (2009). *La philosophie en France au XXème siècle* (Paris: Gallimard, Folio Essais).

Zimmermann, M. (1985). 'Der Streit zwischen Orphismus und Futurismus im Sturm. Zur Interpretation der Selbstäusserungen von Künstlern', in P.-K. Schuster (ed.), *Delaunay und Deutschland* (Cologne: DuMont), pp. 318–25.

Zimmermann, M. (1987). 'Delaunays *Formes circulaires* und die Philosophie Henri Bergsons. Zur Methode der Interpretation abstrakter Kunst', *Wallraf-Richartz Jahrbuch*, 48–9, 335–64.

Fernand Léger's *La noce*: the bride stripped bare?

Elza Adamowicz

'My painting in the Salon des Indépendants is going to have lots of people befuddled' [*embarquer des tas de gens dans l'abracadabra*], writes Fernand Léger in a letter (7 August 1912) to André Mare (*Fernand Léger* 1997: 299). The work he refers to, *La noce* (or *Les noces*), was first exhibited at the Salon (20 March–16 May 1912) under the title *Composition avec personnages*.[1] The Salon was held one month after the Futurist exhibition at the Bernheim-Jeune Gallery in Paris (5–24 February 1912). While a number of art historians have situated this painting within Léger's own development as an artist, as a transitional work between the more figurative series of paintings *Fumées sur les toits* (1910–11) and the more abstract *La femme en bleu* (1912) (Green 1976: 39), I should like to consider the painting as a space of conflict and convergence. It will be anlysed firstly as a case study of the battle between Cubism and Futurism, two antagonistic movements, at least in their manifestos and declarations, a battlefield where swords cross; secondly, and less belligerently, as a crossing of paths, a place where Cubism and Futurism intersect and dialogue; and thirdly as a pictorial space of convergence between Léger's practice and that of the wider avant-garde. In situating *La noce* in relation to contemporary discourses, the underlying argument of this study is not merely that paintings are situated at the intersection between a pictorial practice and a verbal narrative but that paintings are above all a discursive reality, as Roland Barthes (1982: 140) has argued in his discussion of the semiotician Jean-Louis Schefer: 'The painting, for whoever writes it, only exists in the *account* I give of it; or else in the sum and organisation of the possible readings of it: a painting is nothing more than its own plural description'. As a consequence the painting is apprehended as a shifting discursive reality as much as a fixed material or pictorial reality, producing an unbridgeable gap, a necessary inadequacy, between (plural) description(s) and material reality.

Description(s)

'What does that represent?' asks Léger (1996: 25) about his paintings in a lecture he delivered in May 1913. (Léger's theorising about art came as a consequence of his painting practice, unlike the Futurists, who wrote programmatic texts.) He distinguishes two types of 'realism' in painting: 'visual realism', based on the imitation of a subject, and 'conceptual realism' (also referred to as 'pictorial realism'), the organisation of line, colour and form. This distinction between figurative and pictorial modes provides guidelines for an initial description of the painting. On the one hand, the painting represents a wedding procession broken up by vertical smoke-like or cloud-like shapes. The traditional subject of collective festivity has been given a radical interpretation. The central figures of the married couple are surrounded by a crowd of guests represented as dismembered cylindrical arms, legs, faces, hands and hats, like intersecting machine-like parts, stacked up vertically in two totemlike columns: '[T]he people at the wedding hide behind each other', wrote Guillaume Apollinaire in his review of the Salon (1980: 105). On the right a receding row of trees can be made out as well as a high perspectival view of a village. Léger, Apollinaire argues, thus rejects single-point perspective in 'le réalisme visuel': 'One more effort to get rid of perspective, that pathetic trick of perspective, the fourth dimension inside out' (Apollinaire 1991: 44).

The interpenetration of figures and landscapes with the cloud-like shapes constitutes the second mode of realism, 'conceptual' or 'pictorial' realism. Far from having a representational function, it is based on 'the simultaneous ordering of the three great plastic qualities: Lines, Forms and Colours' (Léger 1996: 26). In opposition to academic painting, grounded on harmonious relations, for Léger pictorial contrasts, hence dissonance ('contrast = dissonance'), now constitute the central structural principle, reflecting the fragmentation and dissonance of modern life (Derouet 1997: 43–5). He takes as an example his series *Les fumées sur les toits* (1910–11), where the curved shapes of the rising smoke contrast with the angular shapes of the rooftops, creating a maximum contrast. In *La noce* contrasts are created between the muted whitish or ochre colours and the more intense colours, the blues, greens and pinks of the wedding scene, between the softer curved contours of the cloudlike elements and the harder tubular volumes of the figurative elements. In addition, the vertical structuring of these contrasting elements gives the painting a sharply disjunctive rhythm, while movement is suggested both by the cloudlike shapes pushing forward from the picture plane, and by the tubular shapes which appear to rotate.

A Cubist or a Futurist painting?

La noce was exhibited at the Salon des Indépendants in March 1912 in the Cubist room (Salle 20) with second-phase or Salon Cubists, alongside paintings such as Robert Delaunay's *La ville de Paris*, Albert Gleizes's *Les baigneuses* and Roger de La Fresnaye's *L'artillerie*.[2] Léger's *Le fumeur* (1912) was also exhibited at the Salon. The art dealer Alfred Flechtheim, who bought the painting (probably when it was exhibited in 1913 at Berlin's Der Sturm Gallery), later declared that the work was among the most important of the time and a Cubist masterpiece.[3] Although the art critic Louis Vauxcelles preferred the term 'tubiste' to characterise Léger's style from this period, because it promoted (Cézannian) volume over (Cubist) planar surfaces, its rhythmic interplay of figurative and non-figurative elements and its spatial ambiguities are indeed characteristic of the Cubism of Picasso and Braque. For example, the smokelike or cloudlike forms are part of the wedding procession (the white bridal gown in the central lower section), while simultaneously overlaying and partly hiding the mass of wedding guests; similarly, the diagonal shapes to the left of the canvas appear to advance into the wedding scene. However, while in Braque's paintings solid volumes dissolve into flat pictorial space, the contrasting spaces in Léger's painting remain conflictual. Léger was linked to Cubists of the Puteaux group of painters – which included Robert Delaunay, Marcel Duchamp, Raymond Duchamp-Villon, Jacques Villon and Francis Picabia – whose works were characterised by large formats (contrasting with Picasso and Braque's more *intimiste* still lifes), bright colours (in opposition to the muted tones of early Cubism) and movement (in contrast to the more static early Cubist compositions). Hence, if Léger's works of this period could still be called Cubist, it has to be seen as a 'dynamic Cubism' (Green 1976: 42) with strong affinities with Futurism.

'What they [the Futurists] say is good', declared Delaunay in a letter dated February 1912 (Ottinger 2008: 188). As Christopher Green (1976: 42–5) argues, the Futurist exhibition at the Bernheim-Jeune Gallery in February 1912 appears to have had a liberating impact on the Paris Cubist artists, their syntax becoming more dynamic, and their colours more vibrant, after their encounter with Futurist paintings: Jean Metzinger's *Danseuse au café* (1912), for example, has affinities with Gino Severini's *La danse du 'pan-pan' au Monico* (1909–11). Léger started work on *La noce* in late 1911, and an analysis of an oil study, *Etude pour La noce* (1911), shows that his original composition was more static.[4] The figurative elements are fewer, more solid and less fragmented, while the tension between central figures and lateral smokelike elements is absent. The final painting, however, is a more dynamic, complex composition, its disjunctive pictorial

syntax generated by the tension between its figurative and more abstract elements. Green suggests that Léger may have reworked his canvas in light of the exhibition and the catalogue preface in the month before the Salon des Indépendants held in late March. Green points in particular to the resemblance with Umberto Boccioni's *Gli addii* [Farewells], from his 1911 *Stati d'animo* [States of Mind] triptych, which also combines figurative and non-figurative elements and is stuctured by force-lines, creating disjunctive spatial relations. It must be added, however, that Boccioni's intensity of emotion contrasts with Léger's intensity of sensation. Moreover, Virginia Spate (1979: 248) suggests that Severini's *Danse du 'pan-pan' au Monico* (also exhibited at the Futurist 1912 exhibition) shows a similar theme and treatment, and might well have impacted on Léger, who could have seen it in Severini's studio before the exhibition.

To what extent then can *La noce* be considered a Futurist painting? Apart from the resemblances discussed above, there are also strong affinities between Léger's pictorial practice and the principles of Futurist aesthetics developed in their exhibition catalogue preface, 'The Exhibitors to the Public'. *La noce* thus appears to correspond to Futurist principles at least as much as the Italian Futurist paintings themselves exhibited at the Bernheim-Jeune Gallery. The convergence between Léger's painting and Futurist aesthetic theory is embodied for example in the painting's dissolved forms: 'the dislocation and dismemberment of objects, forms, the scattering and fusion of details, freed from accepted logic and independent from each other'. Moreover, its dynamic structure of diagonals and angular shapes is a materialisation of Futurism's 'horizontal lines, receding, rapid and staccato which brutally cut through the blurred profiles of faces and strips of countryside, broken up and dynamic'. Futurist force-lines figure in the work: 'Every object, by means of its lines, reveals how it will be decomposed according to the direction of its forces ... Moreover, every object impacts on its neighbours, not by reflections of light, but by a real competition of lines and a real conflict of planes' (Apollonio 1973: 99).

Such a convergence does not necessarily imply a direct influence of Futurist declarations on Léger's practice, however. If his painting appears to embody a number of Futurist aesthetic principles, it may well be intuitively, experimentally, rather than programmatically. Furthermore, *La noce*, with its evocation of the naked female body (discussed more fully below), is contrary to one of Futurism's interdictions, since in their 1910 *Manifesto of Futurist Painters* they had rejected the traditional subject of the nude figure in painting: 'We demand the total suppression of the Nude in painting for ten years!' (Apollonio 1973: 29). The catalogue of the Bernheim-Jeune exhibition, confirming their position, declared that the proliferation of

nudes had 'made the Salons into little more than rotten meat fairs'. Léger's painting was one of several works of nude female figures exhibited at the Salon des Indépendants in March 1912 – including Delaunay's *La ville de Paris* (1910–12) and Gleizes' *Les baigneuses* (1912) – and this could be seen as a retort to the Futurist interdiction. As for Marcel Duchamp's painting *Nu descendant l'escalier no 2* (1912), although listed in the catalogue, it was removed from the exhibition by Gleizes and Metzinger, on the grounds that it was too close to the Italian Futurist paintings exhibited at Bernheim-Jeune in February 1912, despite the artist's denial of any such influence.[5]

Relations between Cubism and Futurism were thus both adversarial and dialogic, their manifestos and exhibition prefaces being the arena for the former, their practice the concretisation of the latter. The 1912 Futurist exhibition catalogue *The Exhibitors to the Public*, is thus prefaced by a violent criticism of Cubist paintings:

> They insist on painting what is immobile or frozen, and all of nature's static aspects; they adore the traditionalism of a Poussin, Ingres, or Corot, ageing and petrifying their art with a backward-looking insistance. There is absolutely no doubt that the aesthetics of several French comrades manifest a sort of disguised academism. (Apollonio 1973: 99)

Cubist paintings are thus denounced for their link to academic art, their static compositions, and the absence of a subject. In his art criticism, on the other hand, as Marianne W. Martin argues (1969), Apollinaire does not hide a certain ambivalence towards Futurism. In his review of the Bernheim-Jeune exhibition for *L'Intransigeant* (7 February 1912) he is critical of their preoccupation with the subject ('this could well be the reef against which their pictorial goodwill could founder'), their absence of pictorial concerns, the overtly emotional content ('they share with most second-rate artists the mania of painting emotional states') and the ebullience and provocativeness of their declarations, as well as their poor imitation of artists such as Picasso or Derain (Apollinaire 1991: 407). Apollinaire is more equivocal, however, in his second review of the Futurism exhibition a few days later, published in *Le Petit Bleu* ('Chroniques d'art. Les Futuristes', 9 February 1912). Here, while acknowledging that the originality of the Futurists stems from their reproduction of movement, he claims that French artists had already resolved that pictorial problem. He argues that Futurist painters are stronger on ideas than practice, in contrast to French artists, who grapple with pictorial issues:

> Futurists are not preoccupied by pictorial matters. Nature does not interest them. They are interested above all in the *subject*. They want to paint *emotional states*. This is the most dangerous painting that could possibly be imagined. It will lead Futurist painters to becoming mere illustrators. (Apollinaire 1991: 411)

In spite of such reservations, Apollinaire does however recognise that the Futurist exhibition could teach young artists to be more adventurous. Moreover, the reciprocal influences among French and Italian artists are acknowledged in an unpublished text, 'Le futurisme n'est pas sans importance' (October 1912), even though Apollinaire claims that the influence of the avant-garde French artists on Futurism is predominant: 'There appears to have been a reciprocal influence, but we can rightfully say that the influence of Futurism is nothing compared to what it owes the new French artists … Its Italian nationalism (panitalianism) keeps it quite separate'. Apollinaire reveals his own nationalistic position when he claims that Futurism is an Italian imitation, and misunderstanding, of French Fauvism and Cubism (Apollinaire 1991: 487–9).

What characterised the French artists for Apollinaire was embodied in the concept of 'pure painting', of which Léger's *La noce* is an example, as he states in his review of the 1912 Salon des Indépendants: 'Léger's painting belongs to pure painting. No subject and a lot of talent'.[6] In 'Du sujet dans la peinture moderne' (*Soirées de Paris*, 1, April 1912), Apollinaire rejects Futurism's preoccupation with the subject, and defends instead an entirely new form of form of painting or 'pure painting', characterised by pictorial dynamism. Thus, writing about Léger's painting of this time, he declares that 'this painting is liquid, the sea, blood, rivers, rain, a glass of water and also tears, with the sweat of great effort and lengthy fatigue and humid embraces' (Apollinaire 1991: 44).

In his lecture titled *L'écartèlement du cubisme*, delivered on the occasion of the Section d'Or exhibition in October 1912, Apollinaire developed the notion of an 'exploded Cubism' [*un cubisme éclaté*], coining the term 'Orphisme' to describe the work of Picasso, Léger, Picabia and Duchamp. This was seen as neither Cubism nor Futurism: 'It is the art of painting new compositions with elements drawn not from visual reality, but entirely created by the artist and endowed by him with a powerful sense of reality … It is pure art' (Apollinaire 1980: 69). The following year, his review of the 1913 Salon des Indépendants (*L'Intransigeant*, 25 March 1913) has nationalist overtones and Orphism is given a purely French lineage: 'This tendency … is the slow and logical outcome of Impressionism, Divisionism, as well as the Fauvist and Cubist schools'] (Apollinaire 1991: 547). This provoked a renewed dispute between Futurism and Cubism in which Boccioni (1913), accusing the French artists of plagiarism, declared scathingly: 'Orphism is merely an elegant masquerade of the fundamental principles of Futurist painting'.

Since the function of the manifesto is to constantly contest and rewrite the history of art, it is not surprising that the Futurists and Cubists denounced each other in seeking to differentiate themselves from the other. However,

such overtly antagonistic writings often stage what is in fact an agonistic position, a scarcely suppressed 'anxiety of influence', their rejection of each others' theories hiding a fascination that reveals proximity rather than fundamental aesthetic opposition between two avant-garde movements, convergence rather than conflict, aesthetic affinities, continuing exchanges and dialogue rather than oppositions. French critics were interested in Futurist ideas but largely indifferent to Futurist paintings. Cubist pictorial practices impacted on Futurist artists, who adopted and adapted them, formulating in response an innovative theory which stimulated Cubist practice.[7] In general, in contrast to Cubist and Futurist manifestos and declarations, which promote radical antagonistic positions, their artistic practice reveals a convergence, theorised by the art critic (Jean Metzinger), confirmed by the artist (Marcel Duchamp), embodied, as we have shown, in Léger's *La noce*.[8]

Léger and other Salon cubists were indeed challenged by Futurist texts (the 1910 *Manifesto of Futurist Painters* and the introduction to the 1912 Futurist exhibition at Bernheim-Jeune in particular), which stimulated them to experiment in the pictorial representation of dynamism and simultaneity, developing a form of dynamic Cubism which combined figuration and abstraction. The notions of 'divisionism' and 'dynamic sensation', for instance, formulated in the Futurist 'Technical Manifesto of Painting' (*Comoedia*, 18 May 1910), by Boccioni, Carrà, Russolo, Balla and Severini, might well have impacted on Léger's notion of 'dynamic divisionism' (Spate 1979: 261). While the Futurists experimented principally with 'divisionism of colour', mainly through the use of Impressionist broken colour, Léger expanded the technique in his dynamic contrasts of colour, form and line (as did Le Fauconnier in his painting *Le chasseur*). Hence one can argue that the Futurists' bold aesthetic programme was embodied not only in their own paintings but also, and often more radically, in the innovative experimentation of the Salon Cubists.

Beyond Cubism and Futurism

I suggested at the outset that Léger's painting was situated at a crossroads not only between Cubism and Futurism but also within the broader avant-garde context, where several iconographic and stylistic affinities intersect. Among these, the subject of the wedding party was treated in other avant-garde paintings, revealing affinities with Léger's *La noce*. For example, Henri Rousseau's *La noce* (1904–5) evokes the artificial poses and frontality of the wedding photograph which had impacted on the artist. Léger claimed he had also been 'inspired by self-consciously posed wedding photographs', and had chosen to treat the subject rigidly and

non-sentimentally, in the manner of Cézanne.[9] As in Léger's painting, the steep perspective of the line of trees on the right of Rousseau's canvas contrasts with the flatness of the wedding group, while the bride's gown, a large flat white plane in the centre of the canvas, partially covers the figures around her. Marc Chagall's *La noce* (1910) also combines figurative and non-figurative elements. The composition is divided into three horizontal bands: an upper band of brightly coloured rectangles, a central series of squares which serve as the ground for the wedding procession, and a lower band of triangular shapes. The framing of the figurative elements between bands of abstract forms presents a structure similar to Léger's painting. Affinities can also be drawn with Delaunay's *Tour Eiffel* series (1910–11), also painted on large vertical canvases, combining abstract and figurative forms. As in *La noce*, the view is framed between the abstract blocks of cloudlike planes, in a reference to *repoussoir* curtains.

An analysis of the motif of the cloud-shapes will illustrate, however, how *La noce* cannot be fully contained by the aesthetics of Cubism or Futurism. It has its formal origin in the series of paintings from 1910–11 titled *Les fumées sur les toits*, based on the view from the artist's Latin Quarter studio window looking north over the Paris rooftops. The initial description of the painting given above, based on Léger's own comments on binary oppositions in his *Fumées* series, suggested that the smokelike shapes have a purely pictorial effect, the tubular forms of the figures contrasting with the curvilinear shapes of the smoke. The effect of the cloudlike elements which both push back and overlap the figurative elements is to disrupt the pictorial space of the wedding procession. '*Les Fumées* confirms the luminous passages in *La noce* as smoke', argues Christopher Green (1976: 42). For Hubert Damisch (1972: 318), too, the cloud motif is read as a purely formal element.

This formal reading is complemented by a semantic interpretation of the motif in terms of Jules Romains's poetic image of urban smoke in his collection of poems *La vie unanime* (1908), uniting people with each other and their environment: 'Buses creak and chimneys smoke; people are bound together by their disparate rhythms; active groups are born, pullulate and transform themselves' (Romains 1983: 59–60).[10] Displaced from the psychological to the physical, the painting represents an interpenetration of figures and objects. The image of smoke takes on a dynamic ascending movement in Romains's text which parallels the vertical dynamism of Léger's painting: 'A factory yonder with proud clouds of smoke stretching through the fog to touch the stars' (Romains 1983: 159). *La noce* can thus be read as an allegory of Unanimist thought, in which individual figures are fragmented and merge into the collective festivity, figures and objects wedded or welded together.

I should like to argue, however, that such approaches fail to account for the essential ambivalence and originality of Léger's use of the smoke motif. Contemporary reviews of the painting focused on the formlessness and ambiguity of the scene. André Salmon (*Paris-Journal*, 19 March 1912), for instance, underlined the sense of confusion of the painting: 'Fernand Léger still has a lot to learn. His painting is still too confused and poorly balanced'. The art critic Louis Paillard in *Le Petit Journal* (21 March 1912) also stressed the painting's formlessness:

> Large coloured blocks, blue, pink or green on dirty grey patches, here and there the fragmented features of human faces, make the painting quite incomprehensible. It's what Mr Fernand Léger, one of the leaders of the Cubist school, calls *Composition with figures*. 'Composition'? It is more like decomposition. The Cubists favour these vague titles and as a consequence we couldn't reproach them for having failed. (quoted in Laugier 1981: 22)

Maurice Dekobra (*Revue des Beaux-Arts*, 24 March 1914), on the other hand, evoked a much more hallucinatory vision:

> a conglomeration of soap-bubbles which represent, higgledy-piggledy, sections of faces, an assortment of profiles and bulging eyes, the whole sprinkled with breasts, thighs and stomachs creating a most harmonious effect. I was told that it represents a slice of brawn with pistachios seen through a magnifying glass. (quoted in Laugier 1981: 22)

This review, despite its tone of persiflage, in fact points to a space of fantasy which undoes the formality of the social ceremony. The motif has a sensuous sculptural quality, suggesting naked thighs and breasts, and the female body is present, fragmented and fantasmatic, along the cloudlike vertical axes of the painting. The figure in virginal gown in the lower central section is duplicated in the upper section which hints at the outline of a naked female torso.[11] Figures jostle around her, their many hands seeming to touch or approach her breasts and hips. Moreover, the rounded cloud-shapes to left and right of the central image, far from functioning simply as *repoussoir* curtains, push forward, humorously echoing and multiplying the breasts and buttocks of the bride. Hence, the curvilinear smokelike elements compose both the naked body and the bridal gown that clothes it, the formal and the fantasmatic. The social space of the wedding party is thus overlaid with the imaginary space of desire, formal occasion tips into orgy, the clothed into the naked. The social ceremony and its sexual implications coexist and merge, echoing Bergson's notion of *durée*, the subjective experience of time, the flux of mental images, unbound by mathematically measurable time: 'Duration is the continual progress of the past which gnaws away at the future, swelling as it advances' (Bergson

2007: 5). By 1911 the avant-garde in general had adopted some form of Bergsonism – if sometimes skewed or schematised. Bergson's *L'evolution creatrice* was discussed in particular by the Puteaux group. The link between smoke and the female figure is made by Léger himself in a text he sent to Kahnweiler in 1919: 'Volumes in movement, tinted in local colours, and to accentuate the movement, oppositions of contrasts. Series of plumes of smoke (contrast of hard and soft forms). Women: same thing' (Kahnweiler 1950). In other contemporary paintings, such as Léger's *Nude Model in Studio* (1912–13), the female nude is constructed from interlocking curved smokelike forms

Beyond its affiliation to Cubism or Futurism, *La noce* can also be linked to Marcel Duchamp's experimentations in movement in the sequential portrayal of the human figure. 'Find the woman!' ironised *American Art News*, commenting on Duchamp's *Nu descendant l'escalier no 2* (1912), which was exhibited at the Armory Show in 1913, and savagely caricatured by the American press for its hermetic portrayal of the nude female figure. *La noce* has further affinities with Duchamp's earlier *Portrait (Dulcinea)*, exhibited at the Salon d'Automne in 1911, where Léger was represented by his *Nus dans un paysage*. In Duchamp's painting, the figure of the woman walking her dog is repeated five times, moving sequentially from clothed to partially naked, enacting 'a psychological fantasy' (Ades, Cox and Hopkins 1999: 38). Similarly, the female figure in *La noce* is doubled, simultaneously clothed and naked. The dialogue continues with Duchamp's *Passage de la vierge à la mariée* [Passage from Virgin to Bride] of 1912, which has been read as a response to *La noce* (Ades, Cox and Hopkins 1999: 57).[12] Its title evokes the implicit narrative of *La noce*, and its interlocking figures stage the transformation from virgin to bride.

Analysing Léger's *La noce* in its contemporary context has thus revealed a web of interrelations, affinities and conflicts and situated it at the intersection of several discourses, not only Cubist and Futurist but also the aesthetic debates and practices of the wider avant-garde. It shares the rejection of mimeticism, fragmentation of pictorial surface and issues of representation of movement, along with features of Bergsonian or Unanimist philosophy. It shows that seeking to identify who was the first artist to suggest movement or to paint abstract cloud-shapes fails to engage with the fact that these experiments were already circulating in the collective space of the avant-garde, over which neither (French) Cubist nor (Italian) Futurist had a monopoly. Unidirectional contextualisations – denoted by such terms as 'influence' (Apollinaire) or 'plagiarism' (Boccioni) – and the oppositional rhetoric of conflictual -isms are to be jettisoned in favour of multidirectional relations, a web of exchanges and conflicts, convergences and divergences.

Notes

1 *La noce* (1911–12) (257 cm x 206 cm), Paris, Musée National d'Art Moderne (Alfred Flechtheim Collection). On the back of the canvas are the words: 'Fernand Léger / Composition avec personnages / Salon des Indépendants / 1911–12'. See Laugier (1981: 20).

2 The painting was also exhibited at the Section d'Or exhibition in October 1912. Léger had already exhibited with the Cubists in April 1911 his *Nus dans un paysage* (1911) and two drawings. See Apollinaire (1980: 211–12).

3 Alfred Flechtheim in a letter (4 February 1937) to Georges Huisman, director of Fine-Arts in Paris, quoted in Laugier (1981: 22). The painting was exhibited in Flechteim's Berlin gallery in 1928 in a retrospective of Léger's paintings.

4 Kahnweiler archives. Reproduced in Laugier (1981: 20) and Green (1976: 37).

5 Duchamp claimed that his painting, completed in January 1912, was the result of his interest in early cinema, as well as in Marey's, Eakins's and Muybridge's experiments in chronophotography (Sanouillet: 1994: 151).

6 See also Apollinaire's review of the Indépendants exhibition (*L'Intransigeant*, 3 April 1912): 'Léger's painting is also worthy of attention. It is an incomplete work which can strike only informed minds. Its subject relates it to Seurat's works while the spirit of Léger's drawing distinguishes him from the master of the dot' (Apollinaire 1960: 293).

7 'It would thus seem that the Futurists' written ideas stimulated the imagination of the French painters before they themselves could realise them, and that it was only when they had seen French painting that they were able to do so' (Spate 1979: 23).

8 See Didier Ottinger, 'Cubisme + futurisme = cubofuturisme' (Ottinger 2008: 20–41).

9 'Cézanne taught me the love of forms and volumes, he made me concentrate on drawing. I felt that the drawing had to be rigid and not at all sentimental' (Laugier 1981: 20).

10 Léger frequented the Closerie des Lilas at this time with the Abbaye de Creteil group. See Sund (1984).

11 For Spate (1979: 99) the 'soft fleshy pinks and rounded forms' suggest the naked female body.

12 See also Hopkins (1998).

References

Ades, D., N. Cox and D. Hopkins (1999). *Marcel Duchamp* (London: Thames and Hudson).

Apollinaire, G. (1960). *Chroniques d'art 1902–1918* (Paris: Gallimard, Collection Idées).

Apollinaire, G. (1980). *Les peintres cubistes* [1913] (Paris: Hermann, Collection Savoir).

Apollinaire, G. (1991). *Œuvres en prose complètes* II (Paris: Gallimard, Collection Pléiade).

Apollonio, U. (ed.) (1973). *Futurist Manifestos* (London: Thames and Hudson).

Barthes, R. (1982). 'La peinture est-elle un langage?' [1969], in *L'obvie et l'obtus. Essais critiques III* (Paris: Points Essais), pp. 139–41.

Bergson, H. (2007). *L'evolution créatrice* [1907] (Paris: PUF, Collection Quadrige).

Boccioni, U. (1913). 'I futuristi plagiati in Francia', *Lacerba*, 7 (1 April).

Damisch, H. (1972). *Théorie du nuage. Pour une histoire de la peinture* (Paris: Seuil).

Derouet, C. (1997). 'Les contrastes de formes, 1912–1914', in *Fernand Léger* (Paris: Editions du Centre Pompidou), pp. 43–5.

Fernand Léger (1997) (Paris: Editions du Centre Pompidou).

Green, C. (1976). *Léger and the Avant-Garde* (New Haven and London: Yale University Press).

Hopkins, D. (1998). *Marcel Duchamp and Max Ernst: The Bride Shared* (Oxford: Clarendon Press).

Kahnweiler, D.-H. (1950). 'Fernand Léger', *Burlington Magazine*, 92, 63–8.

Laugier, C. (1981). *Œuvres de Fernand Léger (1881–1955)* (Paris: Editions du Centre Pompidou).

Léger, F. (1996). *Fonctions de la peinture* (Paris: Folio Essais).

Martin, M. W. (1969). 'Unanimism and Apollinaire', *Art Journal*, 28:3, 258–68.

Ottinger, D. (ed.) (2008). *Le Futurisme à Paris: une avant-garde explosive* (Paris: Editions du Centre Pompidou).

Romains, J. (1983). *La vie unanime: poème* [1908] (Paris: Gallimard, NRF Poesie).

Sanouillet, M. (ed.) (1994). *Duchamp du signe* (Paris: Flammarion, Collection Champs).

Spate, V. (1979). *Orphism. The Evolution of Non-figurative Painting in Paris (1910–1914)* (Oxford: Clarendon Press, Oxford Studies in the History of Art and Architecture).

Sund, J. (1984). 'Fernand Léger and Unanimism: where there's smoke …', *Oxford Art Journal*, 7:1, 49–56.

Nocturnal itineraries: Occultism and the metamorphic self in Florentine Futurism

Paola Sica

Usually, when one thinks about Futurism, the traits that immediately come to mind are: rejection of the past, emphasis on modernity, provocative action, energetic virility and the deification of the machine. In the second wave of Florentine Futurism,[1] however, emphasis shifts from machines to night, the sky and their various shades of blue.[2] For example, members of this Futurist contingent, affiliated with the Florentine journal *L'Italia Futurista*, were called the 'blue patrol' (Franchi 1938), or else the 'builders of the blue' (Ginanni 1917b: 132) – very likely in homage to Stéphane Mallarmé and the German avant-garde group Der Blaue Reiter. Moreover, a few of the women were defined as 'blue women writers'. In her introduction to *Un ventre di donna*,[3] for example, Enif Robert, who belonged to the group, describes some of her female peers as blue women writers. In her opinion, these writers, unlike herself, are reluctant to speak explicitly about sexuality and free love. This is why they so often digress in useless and ornate representations of 'aerial wavering in the blue' (Marinetti and Robert 1919: xiii).

With regard to images, those of night, illuminated skies and blue expanses are pervasive in Florentine Futurist art and literature, for example Fulvia Giuliani's 'Notte' (1916), Mario Carli's *Notti filtrate* (1918), Irma Valeria's *Fidanzamento con l'azzurro* (1919), Maria Ginanni's 'Folata d'azzurro' (1917b: 39) and Marj Carbonaro's 'Luci nel buio' (1918).

This type of image is obviously not limited to titles, but recurs in the body of numerous works. For example, Arnaldo Ginanni Corradini (whose pseudonym was Ginna), refers to the night when he describes the mysterious, dangerous and addictive process of creation – a process that, according to him, helps reveal occult forces:

> To those of you recommending that I be prudent [when I create], I answer that the person who has set off along a path at night while staring at his guiding

star, can only see the brightness of that star and will never be able to see other things. And this person walks on, even if his feet are bleeding and he is running the risk of a fatal gangrene. (Ginanni Corradini 1917a: [2]).

Like Ginna, Rosa Rosà and Bruno Ginanni Corradini (or Corra), in several of their works express the idea that the night is a privileged moment for dream, clairvoyance and inspiration. One of Rosà's drawings for Corra's experimental novel *Sam Dunn è morto* (1915) offers a particularly effective example of this. In Rosà's drawing a man is sprawled in an armchair, either asleep or in a trance. Dark curtains, slightly parted and suggesting that the mystery and darkness of the night are waiting to be unveiled, occupy a prominent place in the background. In vivid contrast, the man himself is framed against a backdrop of light. The background here is composed of dynamic geometrical forms that intersect with one another and represent different degrees of depth. The observer has the impression that individuals like this man, who dare to abandon themselves to the power of dreams and mediumistic phenomena, can have access to an abstract and multilayered reality that in normal circumstances lies hidden beneath the surface.

The night, the sky and the varying shades of blue deserve particular attention when one examines the work of these Futurists. I should like to argue that these elements reflect an aesthetic imagery stemming from a revival of a spiritual impulse that emerged in various North American and European locations. The impulse was particularly strong in Florentine Futurism, and especially in the representatives of *L'Italia Futurista*, many of whom aspired to transcend the human condition and gender connotations. This occurred at a time when the First World War had led masses of women to join the workforce and lured legions of men, motivated by propaganda messages that extolled their indestructible virility and the future Italian victory, to fight the war with new weapons of mass destruction, including machine guns, grenades, poison gas, tanks, warplanes and submarines.

My goal here is firstly to explore the specific texture of the Florentine cultural milieu in which the group of *L'Italia Futurista* operated; and secondly to focus on the work of one of its representatives, Irma Valeria. I would like to determine what the different shades of blue, together with illuminated nights and skies, stand for in this writer's vision of the world, and in her conception of gender and the self.[4] As the Futurist programme was well known for its emphasis on superior virile behaviour, it is important to analyse how a woman like Valeria responded, and in particular how she developed her authorial voice by proposing new female models. I intend to build upon previous scholarship on gender issues in Futurism, focusing especially on the paradoxical virile aspects of new female subjects that the women of the movement emphasised in order to gain more power and recognition.[5] Citing Valeria's work, I propose to show the cultural roots of a

9.1 Illustration by Rosa Rosà in Bruno Corra's *Sam Dunn
è morto: Romanzo sintetico con 6 illustrazioni di Rosa Rosà*,
Milan: Studio Editoriale Lombardo, 1917: 16.

new type of metamorphic self (a type at times female, and at others gender neutral), and its political implications in the context of early twentieth-century Italian society.

Articles and books by humanists and scientists based in early twentieth-century Florence, where Valeria was active, make frequent reference to the proliferation of centres, and notably Florence, devoted to lively debates on spiritualism, mysticism and idealism (Cigliana 2002: 50). In his 1907 essay 'Franche spiegazioni: A proposito di rinascenza spirituale e di occultismo', for example, Giovanni Papini (1981: 130–1) reports the flourishing of spirituality, mysticism and new idealism throughout Italy, along with a renovated interest in the mysteries of the hereafter, the super-sensible

world and occult phenomena. According to Papini, these new ferments were particularly noticeable in specific Italian cities, and certainly in Florence. This was due to the creation of numerous societies for psychic and theosophical research; to the founding of a Biblioteca Filosofica in 1905; to an Italian church of Christian Science; and to frequent mediumistic séances that attracted the attention of the press and the public at large.

Mario Manlio Rossi (1929: 17–18) recalls the animated meetings at the Società Teosofica and the Caffè Le Giubbe Rosse in the Tuscan city. These sessions attracted a diverse company of writers and cultural promoters, including Dino Campana, Giovanni Papini and Filippo Tommaso Marinetti, and such noted theosophists and philosophers as Annie Besant, Arturo Reghini, Mario Calderoni and Giovanni Vailati. These thinkers elaborated new principles and contributed to the circulation of ideas from other parts of the world, including the magic idealism of Julius Evola, the theosophical esotericism of Rudolf Steiner and the sacred principles of Asian religions.

Numerous works by these philosophers, theosophists and cultural promoters illustrate the major directions of the Florentine spiritual trend. These works often centre on specific themes, stressing the value of spirituality over materialism, and the rejection of mainstream positivist theories and empirical thought. Consequently, they foster the cultivation of mystical, theosophical and mediumistic practices. Without referring to gender distinctions, they assert that the highest evolution in humans goes hand in hand with the achievement of enhanced spirituality and modernisation. They also discuss the possibility that all elements in the cosmos are interconnected and continually undergo a metamorphic process. Finally, they argue that matter is both visible and invisible, and that boundaries are ephemeral, including those separating death and life, subjectivity and objectivity, humanity and divinity.

Arturo Reghini (1907), who belonged to the Martinist order in Paris and was the founder of the Società Teosofica in Florence, maintains in 'La vita dello spirito' (1907) that the universe is permeated by life and intelligence. He asserts that differences among mineral, vegetable, animal and human worlds are evident in degree but not in quality; they are relative and not absolute. In general, the most elevated goal for everyone and everything is the manifestation of the spirit; and spirituality is superior to intellect. Among all created things, humans have the most profound life of the spirit. They aspire to a 'super-human condition of consciousness'. However, not all of them tend toward this super-human condition with the same intensity. Those who excel are superior types, for example St Francis and Buddha. Reghini laments that people are too often frightened by the prospect of the future and of death. This he considers groundless, because

the elements constituting an organism are not destroyed with death; they are only transformed to assume new interconnections. Moreover, a process of dispersion does not occur only with death but throughout one's life.

What Reghini proposes is in line with the principles that other contemporary Italian scientists and humanists present in their writings, especially those who were intrigued by spiritism and its manifestations. For example, the scientist Cesare Lombroso, who became popular in Florence for a lecture series in 1896, wrote a revealing preface to *Nel mondo dei misteri*: a 1907 biography of the popular medium Eusapia Paladino by Luigi Barzini. In the preface, entitled 'Sui fenomeni spiritici e la loro interpretazione', Lombroso (1907: 25–6), like Reghini, describes the porous borders between life and death, the existence of a superior consciousness and those who can access it. Unlike Reghini, however, he pays particular attention to mediumistic phenomena and the presence of spirits. As to spirits, Lombroso claims that they are bodies in which matter is so thinned and so refined that it is visible only on special occasions. These living entities do not manifest themselves to our senses in ordinary circumstances, but they are a constant presence in our psychic universe. At times they may use the molecules surrounding them to form a material structure that can manifest itself to our senses. In Lombroso's opinion, all eras and cultures have been intrigued by the thought of the existence of spirits, and by the possible survival of the souls of the dead. In the past, it was a widespread belief that these souls would appear almost exclusively at night, and that some people – for example, magicians, medicine men and prophets – were able to communicate with them, as these gifted seers could act in our space as they would in a fourth dimension, a space not governed by our laws of time, space and gravity (1907: 29). Those whom we call mediums today seem uniquely able to reach this fourth dimension. Lombroso (1907: 28) also reminds readers of the recent discovery of an additional type of consciousness that could be defined as 'subliminal' or the 'unconscious'.[6] This is independent of the organs and the senses, and leads to clairvoyance, hypnotic sleep, ecstasy and inspiration. He posits that, if the action of the subliminal consciousness manifests itself during sleep and in ecstasy, it is reasonable to suppose that it may also be prolonged in the state of death.

Thus Lombroso, like Reghini and others, believed that an invisible world coexisted with the visible world.[7] This belief, widespread in theosophical and psychological speculations, was reinforced by recent scientific discoveries: the use of X-rays by Wilhelm Röntgen that made possible the observation of the internal parts of solid objects; the experiments with radium by Madame Curie that enabled her to formulate her theory of radioactivity; and the proof of the existence of sound waves by Heinrich Hertz that later led Guglielmo Marconi to develop his radio telegraph system.

The impression that the fields of inquiry were multiplying and deepening thanks to a spiritual revival and new scientific theories – and the anxieties provoked by the war – had a substantial impact on the making of literature and the arts. In this atmosphere, certain theosophical works became fertile sources of reference for the creation of a new type of imagery in the Futurist Florentine circle. To this purpose, the book *Thought-forms*, written by Annie Besant together with C. W. Leadbeater in 1905, may be conceived as a stimulating text for those who embarked on creative ventures. As mentioned earlier, Annie Besant, famous social reformer and theosophist, occasionally attended literary gatherings at the Caffè Giubbe Rosse in Florence. Moreover, she delivered talks at the Società Teosofica in Rome, a forum occasionally attended by some of the women affiliated with *L'Italia Futurista*, including Maria Ginanni and Eva Emma Kühn Amendola, whose pen name was Magamal.

In Annie Besant and C. W. Leadbeater's *Thought-forms* (1905), psychological states and sensations are represented through forms and colours. The chapter titled 'The Meaning of Colours' specifically refers to the colour blue, which was dominant in the work of Florentine Futurists. According to Besant and Leadbeater, 'the different shades of blue all indicate religious feeling'. However, their relative intensity expresses subtle differences: 'selfish devotion', for example, 'is dark brown-blue', and 'self-renunciation and union with the divine' is 'the beautiful pale azure of that highest form'. Colours also may be linked to movement and shape. For example, while colours that give the impression of rising stand for a 'thought ... of ... spiritual nature and tinged with love and aspiration of deep unselfish feeling', colours that give the impression of falling stand for a 'thought [that] has in it something of self or of personal desire' (Besant and Leadbeater 1905: 33–4).

Among the women of *L'Italia Futurista*, Irma Valeria was particularly influenced by the work of Besant and Leadbeater, as she was by considerations of a spiritual nature elaborated by such thinkers as Reghini and Lombroso. She was also one of the most vocal in supporting the occult trend. Her full name was Irma Valeria Gelmetti Zorzi. She was born in Verona in 1897, and joined Futurism in 1914 together with her sister Mimì, who was a painter (Cammarota 2001: 515–16). In her Futurist phase, Irma Valeria published the essay 'Occultismo e arte nuova' (1917). She also wrote several creative works in which dark nights, or other blue expanses populated by metamorphic subjects, often appear. These works include pieces of poetic prose from *Morbidezze in agguato* (1917) and *Fidanzamento con l'azzurro* (1919), and the free-word table 'I gufi: Triangolo della notte' (1917).

In 'Occultismo e arte nuova' Valeria (1917b) elucidates her aesthetic position (see Sica 2009). She affirms that the new artists are occultists. In the past, only subtle traces of paranormal art were discernible; but

nowadays these traces are stronger, because modern individuals have evolved spiritually. Modern individuals are aware of a vast, supernatural universe that is waiting to be revealed: 'an infinite field offering a surface that is perfectly sharp, rigid and polished like that of enamel'. Because of this heightened awareness, contemporary thinkers can more easily transpose their perceptions of paranormal experiences into what they do, including art. However, not all modern individuals have the same vision, talent and taste. Alluding to an aesthetic hierarchy of values, Valeria explains that artistic quality is determined by the intensity of the visionary elements that one can express, or detect, in a work. In her opinion, the masses cannot understand the new art, because they can only appreciate what can be perceived through the senses and, thus, remains on the surface.

Not surprisingly, she dismisses art that is sentimental, traditional and linked to earthly dimensions, and opts for an art that unveils the mysteries of a universal consciousness. She explains this through nocturnal images, recalling those used by Ginna in his 'Il coraggio delle ricerche dell'occultismo', which appeared in *L'Italia Futurista* in May 1917, one month before her essay was published. As an artist interested in the occult, Ginna felt compelled to walk at night, following the light of a star.

New artists, for Valeria, are those who are able to see 'a boundless sky without the moon and bewitched and attracted to the stars'. These artists – whether women or men – have visionary powers,[8] and, because of these powers, they can open themselves to a perpetually changing universe. When this happens, 'the occult atom of [their] being and of the world become one'. As a consequence, human limits are challenged, and distinctions of gender are erased. Subjectivity becomes a fluid and abstract entity, which, through different metamorphoses, fuses with its dynamic surroundings.

The free-word table 'I gufi' portrays a nocturnal scene in which an epiphany occurs.[9] This work, which lacks explicit references to human traits (apart from the figurative representation of four eyes), may be considered as a creative manifesto of the new art. It is composed of two parts: the first is a written description of a special experience, and the second is its visual interpretation.

The two parts refer to the never-ending 'symphonic clarity' of two owls. These two nocturnal birds, which in theosophy represent wisdom, knowledge and clairvoyance, remind us of the new artists. Their gaze can penetrate darkness, and their sound, like poetry, music and art, can harmonise and bring to light the hidden relations among the elements in the universe. In the free-word table, the sound of the owls corresponds to a vibration, the repeated letter 'r,' and to the movement of two lines, which initially overlap horizontally. However, one of these lines gradually rises until it reaches a perpendicular position. This provokes the

I GUFI (*Triangolo della notte*)

Limpidezza sinfonica accuratamente trillata dai due unici gufi
instancabili .
Le due note cominciano in sordina; perfettamente *orizzontali:*
poi, mentre l'una continua uguale in basso profondo, l'altra
si stacca in senso ascendente *verticale:* poco per volta s'in-
nalza e scorre il cielo come un compasso sinché non forma con
la prima un perfettissimo angolo retto.
 +
Allora , anche l'ultima stella, perforata , si spegne.

IRMA VALERIA.

9.2 Free-word table: Irma Valeria, 'I gufi: Triangolo della notte'
(The Owls: Triangle of the Night), *L'Italia Futurista*, 2 December 1917: [3].

extinguishing of the only star that is placed at the top of the vertical line,
suggesting that a climactic moment has been reached through an upward
movement (and a vibration) towards a light.

Other geometrical forms and figurative elements appear in the drawing.
In addition to a circle surrounding the star (symbolising God's eye
in theosophy), two overlapping equilateral triangles are placed at the
intersection of the perpendicular lines. Each triangle has two eyes close
to its base. They may represent the two owls (in the title, these birds are
associated with a triangle of the night); however, they may also represent a
divine trinity.

It is as if the unveiling of an occult truth could be reached by creating multiple associations among sounds, colours, figurative elements, geometrical forms and movements. These associations lift one into a fantastic universe in which material limits do not apply. Here, as in the night, everything easily blurs, and everything becomes potential. Everything exists, and yet does not. But if one, like a new artist, follows a guiding star that illuminates the way, suddenly the fleeting multiple signs of the fantastic universe make sense, creating an alternative order.

With the exclusion of a few sentimental works (which seem to undermine some of Valeria's intents), and a few provocative works condemning outdated traditions,[10] most pieces of poetic prose in *Fidanzamento con l'azzurro* and *Morbidezze in agguato*, like 'I gufi', deal with a search for supreme knowledge. This more substantial body of poetic prose contains numerous images of boundless blue expanses with their lights and their upward movements which, as Besant and Leadbeater suggest, are connected to spiritual elevation.

Moreover, this body of poetic prose often presents unidentified individuals (usually women), who strive, more or less successfully, to enter an invisible world that is infinite and far more meaningful than the visible one. At times these individuals transcend their material forms and lose their sexual characteristics and, at other times, become mere corporeal fragments: they appear transformed into eyes, brains and hands, even wings, to follow the ascending throbs of a universal soul.

In the poem 'Mendicanti d'azzurro' in *Morbidezze in agguato*, for example, the female subject yearns to reach vast blue expanses, so that she will be able to prove her power and attain her freedom. She is initially afflicted because, according to her, empirical principles shackle her to an earthly world, and prevent her from ascending to a realm where everything harmonises through 'invisible connections'. This harmonious dimension is described as 'a dazzling sky of overlapped visions', and as 'a bright blue strip of blinded sea, without consciousness of a former life, without direction for the future life' (Valeria 1917a: 6–8).

Only those with highly developed spiritual faculties can enter these blue spaces, in which time seems suspended and spatial orientation is unnecessary. These individuals are portrayed with 'clear wings' (6), and can 'evaporate through all of the purest raptures [and] walk towards death, as the simplest gesture of eternal life' (8).

The fluid construction of a female subject in blue spaces reflects a desire to become immaterial and unleash an unlimited vital energy that the masses do not possess. This construction presupposes the negation of natural, biological rhythms. It follows that death – as for Reghini – is conceived not as a conclusion of an existential cycle but rather as a beginning that,

paradoxically, is in perpetual, metamorphic becoming. Here, Valeria's new woman symbolises both the beginning and the becoming, but not the end. This new woman lacks bodily features. In one sense, her representation may suggest an avoidance of cultural references (of gender and nationality, for example). In another sense, however, her extraordinary force and vision seem to allude to a desired change in the androcentric social structure, in order to empower the feminine gender.

Through her attempts to create new female representations Valeria gives voice through her vision. According to her, the recourse to paranormal powers is essential for women to reach deeper forms of knowledge and for their liberation. In certain works this conviction is firmly expressed. In 'Tremosità', the female subject reports a success: 'I ran magnificently last night, inebriated by a sidereal conquest' (Valeria 1917a: 14). In other works, however, this conviction wavers. In 'Un suicidio', the female protagonist declares that, because of her 'frail feminine brain', she does not have the energy to go beyond the 'windows of [her] soul', 'divinely die' (Valeria 1917a: 59) and become part of a metamorphic eternal universe.

Irma Valeria, like other Futurists, expresses concerns with gender-role identifications in an age of profound social change. But she distinguishes herself by her personal aesthetic strategies. In her work, there are no men who gain immortality by becoming one with machines, as in Filippo Tommaso Marinetti. On various occasions, in fact, Marinetti (1916a: 103, 1916b: [1]) announces the coming of new eternal men created from the 'fusion of steel with flesh'.[11] Also lacking in Valeria are female characters who are invigorated by transforming themselves into virile individuals, like those mentioned by other Futurist women. Rosa Rosà, for example, in 'Donne del post-domani' (1917), states that women are becoming 'a superior type' because they are transforming themselves into 'men'. And Enif Robert (Marinetti and Robert 1919: 192) and Maria Ginanni (1917b: [1]), in describing the war, declare that they would like to be men, so that they could valiantly defend their nation against enemy attacks.[12]

Valeria's women characters are defined by their exceptional power, but they gain this power through the activation of their occult faculties. In doing so, they erase gender traits and attempt to transform themselves into spiritual entities fading into blue expanses (it should be noted, however, that a similar type of representation, among others, occurs in some works of her female peers).[13] As mentioned earlier, Valeria, with her art, could express a desire to revise the rules of an androcentric system through the reinforcement of feminine power. However, she could also manifest something else: an attempt to avoid a direct critique of the social order.

If one thinks of Valeria's constructions of subjects dispersed in the blue, one may recall that these often include such images as delicate wings,

little stars and languid flowers, which could be associated with traditional feminine taste. Valeria may have similar goals to those of the Florentine Futurist men in search of the blue and new empowered selves, but what differs is the setting in which their characters are placed. For example, in Mario Carli's *Notti filtrate*, dedicated to Valeria, exceptional male characters are those who can experience supreme forms of spiritual life, and the rare women characters who appear are not represented in the activation of such powers. Instead, they are traditionally represented as sensual creatures alleviating the pains of the male heroes.

Finally, in a broader context, Valeria's search for the blue colours of a spiritual dimension may be interpreted as her response to what the critic Robert Hughes has defined as the 'shock of the new' in early twentieth-century culture – a shock provoked by the many promising yet unsettling possibilities raised by new philosophical theories and scientific discoveries. It may also be regarded as a way to confront profound social anxieties at a time when these radical new theories were engaging with the hope for national empowerment and the distressing reality of the First World War.

Notes

1 The first wave of Florentine Futurism is commonly considered the one represented by the journal *Lacerba* (1 January 1913–22 May 1915), and the second wave the one represented by the journal *L'Italia Futurista* (1 June 1916–14 February 1918). See Salaris (1985: 88).

2 Gloria De Vincenti (2009 and 2013) claims that the dominant poetics of Florentine Futurists embraced the technological and modern directive of Milanese Futurists, adding a psychic and dreamlike dimension.

3 This was an experimental novel that Enif Robert co-authored with Filippo Tommaso Marinetti (1919).

4 On a sociological level, identity originates from a dialogue between self and society; and, on an aesthetic level, identity is a symbolic reflection that either replicates or contrasts that dialogue. In addition, I agree with Linda McDowell (1999: 8), who claims that 'the construction and significance of sexual differentiation is a key organizing principle and axis of social power, as well as a crucial part of the constitution of subjectivity, of an individual's sense of self-identity as a sexed and gendered person'.

5 If one excludes the introductions to anthologies dedicated entirely to Futurist women like Salaris (1982), Bello Minciacchi (2007) and Carpi (2009), critical studies dealing with gender issues in Futurism include Guerricchio (1976), Nozzoli (1978), Sartini Blum (1986), Mitrano (1988), Re (1989), Vergine (1980), Berghaus (1994), Orban (1995), Parati (1995), Adamson (1997), Sica (2002), Bello Minciacchi (2005), Contarini (2006), Larkin (2007), Bentivoglio and Zoccoli (2008).

6 Lombroso (1907: 28) states that Alexander Aksakov, Jay Harman and Giuseppe Sergi were among the first scholars to mention this type of consciousness.

7 At that time the so-called 'spirit photography' practised by Edvard Munch and others was very popular, as the spirits of dead people were thought to leave their traces. James Coates explored this phenomenon in *Photographing the Invisible* (1911).

8 Valeria (1917b) describes the new artists as 'visionaries' [*veggenti*]. By doing so, she evokes Arthur Rimbaud's poetics – especially his emphasis on the hidden correspondences among the elements of creation, which poets, thanks to their visionary powers, can bring to light through their work. She writes about the new artists: '[their] souls stretch and arch in space like those of visionaries, like the vault of the sky itself'.

9 Bentivoglio (Bentivoglio and Zoccoli 2008: 94) writes that Valeria was very probably influenced by Giacomo Balla and Francesco Cangiullo when she created her free-word table 'I gufi', in which certain upward movements and circular forms resemble those that appear in Balla's and Cangiullo's free-word tables of 1914 and 1916.

10 Sentimental works include such pieces of poetic prose as 'Pioggerellina', in which Valeria describes a series of affected images like 'coquettish little raindrops' (*Fidanzamento con l'azzurro*, 105). Provocative works refer to poetic prose like 'Protesta', in which Valeria criticises outdated traditions through the parody of famous characters like the Shakespearian Ophelia. Ophelia is in fact transformed from a virtuous woman into a loud libertine (Valeria 1917a: 53).

11 Marinetti (1979: 112–15) returns to the idea of a new mechanical man in his essay 'L'homme multiplié et le règne de la machine' (1911).

12 In her novel, Enif Robert (Marinetti and Robert 1919: 192) writes: 'I would like to get up, go to war, to the trenches, and shoot'. In her article about Marinetti, Maria Ginanni (1917a: [1]) declares that she hates her 'women's clothes forbidding her to take her position [in the trenches]'.

13 In certain works of Futurist women such as Maria Ginanni and Fulvia Giuliani, there are also female subjects who diffuse into blue spaces.

References

Adamson, W. (1997). 'Futurism, Mass Culture and Women: The Reshaping of the Artistic Vocation, 1909–1920', *Modernism / Modernity*, 4:1, 89–114.

Bello Minciacchi, C. (2005). 'La concezione della donna tra futurismo e fascismo. La proposta della futurista Maria Goretti', *Quaderni del '900*, 5, 25–38.

Bello Minciacchi, C. (ed.) (2007). *Spirale di dolcezza + serpe di fascino. Scrittrici futuriste. Antologia* (Naples: Bibliopolis).

Bentivoglio, M. (1999). 'La poetica futuristica di Irma Valeria', *Il cristallo. Rassegna di varia umanità*, 41:3, 92–8.

Bentivoglio, M. and F. Zoccoli (2008). *Le futuriste nelle arti visive* (Rome: De Luca).

Berghaus, G. (1994). 'Fulvia Giuliani: The Portrait of a Futurist Actress', *New Theatre Quarterly*, 10:38, 117–21.

Besant, A. and C. W. Leadbeater (1905). *Thought-forms* (London: Theosophical Publishing Society).

Cammarota, D. (2001). 'Gelmetti Zorzi Irma Valeria', in E. Godoli (ed.), *Il dizionario del futurismo*, vol. 1 (Florence: Vallecchi), pp. 515–16.

Carbonaro, M. (1918). 'Luci nel buio', *L'Italia Futurista*, 3:38, [2].

Carli, M. (1918). *Notti filtrate* (Florence: Edizioni dell'Italia Futurista).

Carpi, G. (2009). *Futuriste. Letteratura, arte, vita* (Rome: Castelvecchi).

Cigliana, S. (2002). *Futurismo esoterico* (Naples: Liguori).

Coates, J. (1973). *Photographing the Invisible: Practical Studies in Spirit Photography, Spirit Portraiture and Other Rare but Allied Phenomena* [1911] (New York: Arno Press).

Contarini, S. (2006). *Femme futuriste. Mythes, modèles, et représentations de la femme dans la théorie et la littérature futuristes (1909–1919)* (Paris: Presses Universitaires de Paris, 10).

De Vincenti, G. (2009). 'Il "pensiero peregrino" nel secondo futurismo fiorentino: quando la macchina investe lo spirito', *Rivista di studi italiani*, 27:2, 93–106.

De Vincenti, G. (2013). *Il genio del secondo futurismo fiorentino: tra macchina e spirito* (Ravenna: Longo).

Franchi, R. (1938). *Memorie critiche* (Florence: Fratelli Parenti).

Ginanni, M. (1917a). 'Marinetti ferito in guerra'. *L'Italia Futurista*, 2:15, [1].

Ginanni, M. (1917b). *Montagne trasparenti* (Florence: Edizioni dell'Italia Futurista).

Ginanni Corradini, B. (1915). *Sam Dunn è morto: romanzo futurista* (Milan: Edizioni Futuriste 'Di Poesia').

Ginanni Corradini, A. (1917a). 'Il coraggio nelle ricerche di occultismo', *L'Italia Futurista*, 2(12): [2].

Ginanni Corradini, A. (1917b). *Pittura dell'avvenire* (Florence: Edizioni dell'Italia Futurista).

Ginanni Corradini, B. (1919). *Madrigali e grotteschi* (Milan: Facchi).

Giuliani, F. (1916). 'Notte', *L'Italia Futurista*, 1:3, [4].

Guerricchio, R. (1976). 'Il modello della donna futurista', *Donne e Politica*, 6:35–6, 35–7.

Hughes, R. (1981). *The Shock of the New* (New York: Knopf).

Larkin, E. (2007). '"Il mio futurismo": Appropriation, Dissent, and the "questione della donna" in Works of Women of Italian Futurism' (Dissertation, Yale University).

Lombroso, C. (1907). 'Sui fenomeni spiritici e la loro interpretazione', preface to L. Barzini, *Nel mondo dei misteri con Eusapia Paladino* (Milan: Baldini and Castoldi), pp. 3–30.

Marinetti, F. T. (1916a). *Come si seducono le donne* (Florence: Edizioni da Centomila Copie).

Marinetti, F. T. (1916b). 'Donne, preferite i gloriosi mutilati', *L'Italia Futurista*, 1:2, [1].

Marinetti, F. T. (1979). *Le futurisme* [1911], ed. G. Lista (Langres: Guéniot).

Marinetti, F. T. and E. Robert (1919). *Un ventre di donna* (Milan: Facchi).

McDowell, L. (1999). *Gender, Identity and Place: Understanding Feminist Geographies* (Minneapolis: University of Minnesota Press).

Mitrano, I. (1988). 'Il ruolo della donna nella ricostruzione dell'universo futurista', *Terzo Occhio*, 14, 39–41.

Nozzoli, A. (1978). *Tabù e coscienza. La condizione femminile nella letteratura italiana del Novecento* (Florence: La Nuova Italia).

Orban, C. (1995). 'Women, Futurism and Fascism', in R. Pickering-Iazzi (ed.), *Feminine Feminists* (Minneapolis: University of Minnesota Press), pp. 52–75.

Papini, G. (1981). 'Franche spiegazioni. A proposito di rinascenza spirituale e di occultismo' [1907], in M. Quaranta and L. Schram Pighi (eds), *Leonardo*, vol. 2 (Sala Bolognese: Arnaldo Forni Editore), pp. 129–43.

Parati, G. (1995). 'The Transparent Woman: Reading Femininity within a Futurist Context', in R. Pickering-Iazzi (ed.), *Feminine Feminists* (Minneapolis: University of Minnesota Press), pp. 43–61.

Re, L. (1989). 'Futurism and Feminism', *Annali d'Italianistica*, 7, 253–72.

Reghini, A. (1908). 'La vita dello spirito', in G. Balbino, G. Ferrando and A. Reghini (eds), *Per una concezione spirituale della vita: conferenze* (Florence: Biblioteca filosofica e successori Seeber), pp. 135–56.

Rosà, R. (1917). 'Le donne del postdomani', *L'Italia Futurista*, 2:30, [1–2].

Rossi, M. M. (1929). *Lo spaccio dei maghi* (Rome: Doxa Editrice).

Salaris, C. (1982). *Le futuriste. Donne e letteratura d'avanguardia in Italia (1909–1944)* (Milan: Edizioni delle Donne).

Salaris, C. (1985). *Storia del Futurismo* (Rome: Editori Riuniti).

Sartini Blum, C. (1996). *The Other Modernism. F. T. Marinetti's Futurist Fiction of Power* (Berkeley: University of California Press).

Sica, P. (2002). 'Maria Ginanni: Futurist Woman and Visual Writer', *Italica*, 79:3, 337–50.

Sica, P. (2009). 'Regenerating Life and Art: Futurism, Florentine Women, Irma Valeria', *Annali d'Italianistica*, 27, 175–85.

Valeria, I. (1917a). *Morbidezze in agguato* (Florence: Edizioni dell'Italia Futurista).

Valeria, I. (1917b). 'Occultismo e arte nuova', *L'Italia Futurista*, 2:17, [2].

Valeria, I. (1919). *Fidanzamento con l'azzurro* (Milan: Istituto Editoriale Italiano).

Vergine, L. (1980). *L'altra metà dell'avanguardia (1910–1940). Pittrici e scultrici nei movimenti delle avanguardie storiche* (Milan: Comune di Milano-Ripartizione Cultura).

'A hysterical hullo-bulloo about motor cars': the Vorticist critique of Futurism, 1914–1919

Jonathan Black

Futurism was never likely to be taken at all seriously in the London of King-Emperor George V. It was regarded with disdain, principally because it was championed by Italians who were commonly perceived in England as emotional, hysterical, superficial and economically and technologically backward (Black 2004: 19–20). As Wyndham Lewis put it in 'Long Live the Vortex!', published in the first issue of *Blast*, early in July 1914: 'Automobilism (Marinetteism) bores us. We don't want to go about making a hullo-bulloo about motor cars, anymore than about knives and forks, elephants or gas pipes' (Lewis 2002: 8). At the same time Lewis's statement took a calculated swipe at the vocabulary Marinetti prominently deployed in his February 1909 *Founding Manifesto of Futurism*.

Lewis and his fellow Vorticists were thus very much building on an existing critique of Futurism within England (specifically) which damned it on racial, imperial and nationalistic grounds. The Futurists claimed to embody the Future and yet Italy was a relatively new country, unified in the early 1860s, with a record of military defeat against Austria and against so-called 'savages' in Abyssinia and Libya. The Italo-Turkish War of 1911–12 was also widely regarded as having been humiliating for the supposed victor, Italy, whose supposedly 'modern' army had struggled all too publicly to defeat poorly equipped Turkish troops and tribal levies (Wheatcroft 2003: 33).

Wyndham Lewis, self-proclaimed leader of the Vorticist 'gang', attacked Futurism in 1914 for its inconsistency and superficiality and the patent absurdity of claiming that Italy was at all in the same league as Imperial Britain. Lewis stressed that Britain, or more specifically England, was the birthplace of the modern industrial world. It had the largest empire, the largest merchant marine, the most powerful navy, especially after the launch of the revolutionary big-gun turbine-driven battleship *HMS Dreadnought*

in 1906 (Blom 2009: 163). Britain had a much greater manufacturing base, its engineers had built what railway system Italy possessed, it could still just about be described as 'the workshop of the world'. However, anyone with any intelligence could not help but be aware in the years immediately prior to the outbreak of the First World War that Britain was rapidly being outstripped as a major economic power and in the field of technological and industrial innovation by Germany and the United States (Strachan 2006: 38). Thus, the very shrillness of Lewis's assault on Futurism in 1914 may well have been underpinned by a distinct sense of anxiety for Britain's future as a Great Power; for how much longer should Britain maintain its self-confident pose of 'splendid isolation' on the increasingly menacing stage of international power-politics?

One straw in the wind was a speech David Lloyd George gave three years previously, in July 1911, in which he declared that 'Britain should at all hazards maintain her place and her prestige amongst the Great Powers of the world'. If the country lost this place it would be a 'humiliation intolerable for a great country like ours to endure' (Strachan 2006: 40).

Lewis and Edward Wadsworth would also belabour Futurism on stylistic and aesthetic grounds; for being in thrall to the 'real', to incorporating within their canvases large indigestible hunks of the recognisable. It was too much in debt to Cubism and did not constitute any form of advance on that movement, whose hour was already well passed, according to Lewis (2002: 139–40). He maintained in 1914 that the future actually lay with the Vorticists – whose very name derived from the term applied to London in January 1913 by an American from Hailey, in Idaho, Ezra Pound: 'London is … like Rome of the decadence … She is a main and vortex drawing strength from the periphery' (*The New Age*, 30 January 1913, 300). Pound used the term again, towards the end of 1913, describing London to fellow poet William Carlos Williams (Wees 1972: 13). London, therefore, constituted the Vortex, the point of maximum energy and creativity. Rather than simply painting machines, Vorticists evoked their humming power through construction, angular geometry, hard, precise, unyielding line allied to flat, pulsating, metallic colour.

At this stage, it would be helpful to sketch in some key dates and telling British press reactions to Futurism. The First Futurist exhibition in the UK was held at the Sackville Gallery, London, in March–April 1912. The *Daily Express* (1 March 1912, 2) reviewed the show under the telling headline: 'Picture Gallery of a Madhouse. Crazy Dreams Put On Canvas'. On 19 March 1912 Marinetti lectured in French on Futurism at the Bechstein Hall in London. According to *The Times* (21 March 1912, 2) he outlined 'his ideal world of the future [which] showed a place so stripped of all tenderness and beauty that an American was overheard

to say it would be like New York at its worst ... He [Marinetti] ended with a passionate defence of war. Whatever element of truth may underlie doctrines depreciating an excessive veneration of the past, the anarchical extravagance of the Futurists must deprive the movement of the sympathy of all reasonable men'. The unsigned piece explicitly linked Futurism with Anarchism – a political movement which in England at the time was almost automatically associated with the political instability of contemporary Italy. Indeed, only a week before Marinetti's lecture, an Italian anarchist had attempted spectacularly, yet unsuccessfully, to assassinate the Italian King, Victor Emmanuel III. The *Manchester Evening News* (15 March 1912, 3) was typical of many British newspapers when it ascribed the assassination attempt to the 'hot-blooded and hysterical' nature of the Italian people and took care to remind its readers that the King's father, Umberto I, had fallen prey to a more competent anarchist assassin in 1900.

During April and May 1913 Gino Severini held his debut solo show in the UK at the Marlborough Gallery, London. During the show's run he met, among others, Lewis, Wadsworth, C. R. W. Nevinson and Bomberg, and tirelessly promoted Futurism. Writing in May 1913, he gave Marinetti the distinct impression that the 'younger' British artists could not wait to put themselves under his command to launch Futurism in England (Walsh 2002: 54–5). In fact this perceived enthusiasm was far more nuanced; C. R. W. Nevinson and his father, Henry, were both very taken with Marinetti as a person and his ideas when he visited London in November 1913. Wadsworth thought, after attending a poetry reading Marinetti gave that month at the 'Cave of the Golden Calf' nightclub, on Heddon Street, London, that 'the caffeine of Europe' was undoubtedly 'stimulating', but he told his wife there was simply something too 'excessively Latin' in Marinetti's delivery and body language for him to truly convince a London audience (Black 2005: 17).

Still, awareness of Futurism is evident in work exhibited in October 1913 at the 'Post-Impressionists and Futurists' exhibition, organised by Frank Rutter (Curator of Leeds City Art Gallery) and held at the Doré Galleries on New Bond Street, London. This included Nevinson's Futurist homage to the hit ragtime tune of the day, *Waiting for the Robert E. Lee*, and works by Lewis, Wadsworth and Etchells (Walsh 2002: 56–7). Marinetti's presence in November 1913 was key to prompting Lewis and his allies to organise a new broad-church avant-garde art society – the London Group – while Lewis, Wadsworth and Nevinson began to discuss the urgent need to launch an arts magazine, provisionally entitled *Blast*, which would promote all avant-garde artistic experimentation – not necessarily Futurism alone (Walsh 2002: 159).

Early in March 1914, Lewis, Wadsworth, Etchells, Bomberg and

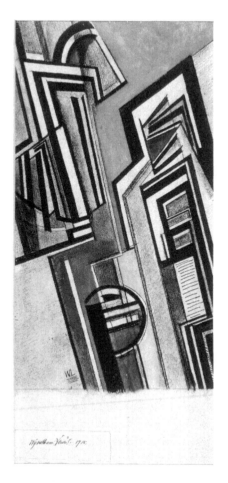

10.1 Percy Wyndham Lewis, *Vorticist Composition*, 1915, pen and ink and watercolour on paper, 31.4 cm x 17.8 cm, Tate, London.

Hamilton featured prominently in the debut exhibition of the London Group, held at the Goupil Gallery, on Regent Street, London. It was here, I would argue, that a visitor could encounter work by Lewis and Wadsworth that encapsulated the essential 'Vorticist look': precise, angular, hard-edged, geometrical abstraction with very few concessions to even the observer who was comfortable with Fauvist Post-Impressionism. There is also a sense that the Vorticists-to-be were more aware than the Futurists of the latest developments in German Modernism – in particular the more geometrically orientated Expressionism of Kandinsky's Munich-based Der Blaue Reiter Group. Especially influential were prints produced by Kandinsky, Franz Marc and August Macke, as well as reproductions of woodcuts by Berlin-based Max Pechstein, displayed during March 1914 at the Twenty-One Gallery in the Adelphi area of London. Significantly, this was where

Wadsworth chose to exhibit his first woodcuts; he began working in that medium in November 1913 and he was one of the few British modernists thoroughly at ease with the German language (Black 2005: 24).

Towards the end of March 1914, Lewis, Wadsworth, Nevinson, the poet Ezra Pound and the philosopher T. E. Hulme formed – with the money of collector Kate Lechmere – the Rebel Art Centre, at 38 Great Ormond Street, London (now part of the Great Ormond Street Children's Hospital) (Wees 1972: 68). It was also significantly advertised, from the outset, not as a vehicle for Futurism but as a 'Cubist School and Centre for Revolutionary Art'. Initially, Marinetti was advertised as one of the star attractions among the lecturers – he was in town to prepare for the opening, towards the end of April, of the second Futurist exhibition in London – at the Doré Galleries (Walsh 2002: 72).

The Second London Futurist Exhibition included: for the first time 'Ensembles Plastiques' (sculptures) by Boccioni; work by Severini, Russolo, Carrà, Ardengo Soffici (1879–1964), and, for the first time, by Giacomo Balla (1871–1958). Much was made of the fact that the Futurists exhibited alongside landscapes depicting *The West That Has Passed* by C. M. Russell 'the Cowboy Artist' (*The Times*, 8 May 1914, 1). They were thus readily dismissed as a similar form of music hall novelty act. Predictably, the *Daily Express* (30 April 1914, 4) scornfully dismissed Futurism as 'Lunacy Masquerading as Art'.

Early in May 1914 was the point when Lewis began to turn against Futurism. One straw in the wind was his reference in the *New Weekly* (30 May 1914) to Marinetti as 'the intellectual Cromwell of our time' – not quite the encomium one might imagine (Wees 1972: 100).[1] At the time Oliver Cromwell was widely regarded as an authoritarian religious fanatic, decidedly 'un-English' for regarding himself as 'God's Instrument' on earth and for his supposed very personal relationship with the Almighty. The catalyst for Lewis to turn on Futurism proved to be the publication in the *Observer* (7 June 1914) of *Vital English Art* – Nevinson's and Marinetti's *Manifesto of English Futurism*. The manifesto committed the cardinal error of implying that the majority of artists who were members of the Rebel Art Club sympathised with and approved of Futurism – indeed willingly acknowledged the leadership of Marinetti. Another factor was that it was all very well for Lewis and his allies to perceive British art as decadent and moribund, it was quite another thing to have this proclaimed to the world in a leading British newspaper by a foreigner; Lewis and Wadsworth automatically assumed that Marinetti was the prime author of *Vital English Art*, with Nevinson serving as window-dressing and as a conduit to favourable press coverage through his well-connected journalist father, Henry (Black 2005: 17–18).

The following week *Vital English Art* was denounced in the *Observer* (14 June 1914) in a letter written by Lewis and signed by him, Wadsworth, Roberts, Bomberg, Etchells, Atkinson, Hamilton, Gaudier-Brzeska, Richard Aldington and Ezra Pound (Cork 1976: 232).

Lewis, Wadsworth, Gaudier, Hamilton and Epstein, plus some other unidentified Rebel Art Centre proceeded to noisily interrupt a lecture on Futurism and *Vital English Art* that Marinetti and Nevinson attempted to give at the Doré Galleries. A fistfight broke out among the audience at the gallery, the speakers were pelted with fruit and Gaudier let off firecrackers at the entrance (Walsh 2002: 81). It was during this period, during the second half of June 1914, that the term 'Vorticism' was first widely advertised in the popular press as: 'the English parallel movement to Cubism and Expressionism ... [a] death blow to Impressionism and Futurism' (*Daily Express*, 11 June 1914, 4). A week later Lewis published an article in *The New Weekly* (20 June 1914) accusing Marinetti of 'Automobilism' and the Futurists of displaying a 'Latin childishness' towards machinery (Wees 1972: 114).[2] His adjective of abuse had been carefully chosen; Nevinson had already appeared in *The New Age*, towards the end of April 1914, in the provocative guise of a charcoal drawing of a heroically goggled *Chauffeur* (Walsh 2002: 70). Lewis's vocabulary also anticipates the line of criticism directed at Futurism which permeates the first issue of *Blast*, tellingly subtitled *Review of the Great English Vortex* and published at the beginning of July 1914. It was deliberately labelled a review, and not a 'manifesto', so as avoid sounding too indebted to the example of Futurism.

Blast's initial declamation 'Long live the Vortex' declared bluntly:

> We stand for the Reality of the Present – not for the sentimental Future ... BLAST will be popular ... The Man in the Street and the Gentleman are equally ignored ... AUTOMOBILISM (Marinettism) bores us. We don't want to go about making a hullo-bulloo about motor cars, anymore than about knives and forks, elephants or gas-pipes ... Wilde gushed twenty years ago about the beauty of machinery ... Gissing, in his romantic delight with modern lodging houses was futurist in this sense. (Lewis 2002: 8)

Wilde had indeed, in *The Soul of Man Under Socialism*, first published in the *Fortnightly Review* in February 1891, anticipated an age dominated by the machine which would free 'the workers' to develop their creative potential (Ellmann 1988: 309). Lewis here refers to George Gissing (1857–1903), author of novels exploring with unsparing gusto the 'sordid' underside of lower middle-class and working-class existence in fin-de-siècle London, such as *New Grub Street* (1891) and one tellingly entitled *The Whirlpool* (1897). Gissing was a prophet of the impact of mass circulation popular journalism over a decade before Marinetti published his Founding Manifesto on the

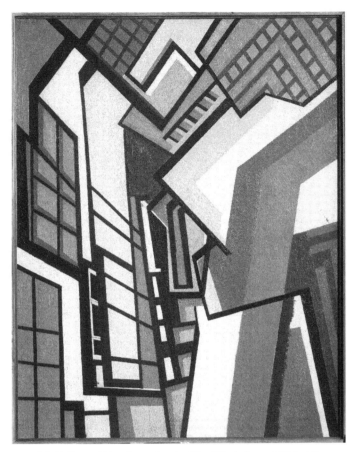

10.2 Percy Wyndham Lewis, *The Workshop*, 1914–15, oil on canvas, 76.5 cm x 61 cm, Tate, London

front page of *Le Figaro*. Lewis (2002: 9), moreover, branded Futurism as 'a sensational and sentimental mixture of the aesthete of 1890 and the realist of 1870'; he was certainly not going to permit Marinetti and Nevinson to annex avant-garde credibility through the noisy abuse of Wilde and the deliciously decadent 'Naughty Nineties' while Lewis was equally determined to make plain Futurism's debt to the literary tradition of Zola and Maupassant – so closely connected with the intellectual milieu that had given birth to Impressionism. In the section entitled 'Melodrama of Modernity' Lewis dismissively wrote 'Futurism, as preached by Marinetti, is largely Impressionism up-to-date' (Lewis 2002: 143).

In the 'Bless England' section of *Blast*, Lewis (2002: 23–4) proceeded to trumpet the country as the cradle of the Industrial Revolution and

10.3 Edward Wadsworth, *Fustian Town / Hebden Bridge*, 1914–15, woodcut, 10 cm x 6 cm, Private Collection.

thus, technological modernity: 'Bless England, Industrial island machine, pyramidal workshop'. It is no coincidence that Lewis was working on *Workshop* at the time, while in recently executed woodcuts Wadsworth imagined his native West Yorkshire as a heavily industrialised factory-scape.

Lewis, additionally, also 'blessed' the ports of 'Hull, Liverpool, London, Newcastle-upon-Tyne, Bristol and Glasgow'. One of Wadsworth's very first woodcuts, reproduced just a few pages later, evoked Newcastle as an entirely mechanised world composed from whirring mass-produced, machine-tooled elements, and later designs would be directly inspired by his reverence for the bustling Pool of London, situated between London and Tower Bridges.

Lewis proceeded to bluntly assert: 'The Modern World is due almost entirely to Anglo-Saxon genius – its appearance and its spirit. Machinery, steam-ships, all that distinguishes externally our time, came far more from here than anywhere else'. He also implicitly associated the new movement with British Imperialism when he wrote: 'By mechanical inventiveness … just as Englishmen have spread themselves all over the Earth, they have brought all the hemispheres about them in their original island'. Once they have opened their eyes the future 'will be more the legitimate property of Englishmen than of any other people in Europe' since they are 'the

inventors of this bareness and hardness', the very qualities with which the Vorticists sought to infuse their art. Meanwhile, '[t]he Latins are at present ... in their "discovery" of sport, their Futuristic gush over machines, aeroplanes, etc the most romantic and sentimental "moderns" to be found' (Lewis 2002: 39–41).

In 1914 the British Empire did indeed own 45 per cent of the world's shipping while the UK accounted for 17 per cent of the world's trade (Barnett 2002: 72). The British Empire, at the time, covered just over 24 per cent of the Earth's surface, 13 million square miles, with 444 million people. The Empire would actually increase in size post 1918 by a further 2 per cent (Ferguson 2004: 240).

The main Vorticist Manifesto was signed by the poet Richard Aldington, the photographer Malcolm Arbuthnot, Laurence Atkinson, Henri Gaudier-Brzeska, Jessica Dismorr; Cuthbert Hamilton; Ezra Pound; William Roberts (though he subsequently claimed Lewis had added his name without his permission – something Lewis was more than capable of doing (Roberts 1957: 3)), Helen Saunders (though her surname was misspelt as 'Sanders'), Edward Wadsworth and Lewis.

One of the most significant contributions, regarding aesthetics within *Blast*, was provided by Wadsworth in the section entitled *Inner Necessity*, his translations into English of key passages from Wassily Kandinsky's 1911 essay *Über das Geistige in der Kunst*, more accurate than M. T. H. Sadleir's later title, *Concerning the Spiritual in Art*. Wadsworth offered what would be by far the most accurate existing interpretation then available in English on Kandinsky (Black 2005: 24–5). Unusually, even then, Wadsworth understood German fluently and managed to penetrate to the essence of Kandinsky's often confused and verbosely expressed theories. At the end of the section Wadsworth offered his most important summation of Kandinsky's book: '[the] insistence on the value of one's feelings as the only aesthetic impulse means logically that the artist is not only entitled to treat form and colour according to his inner dictates, but that it is his duty to do so and consequently his life (his thoughts and deeds) become the raw material out of which he must carve his creations ... the artist is absolutely free to express himself as he will in art' (Lewis 2002: 125). On that basis, Wadsworth was critical of Futurism for lacking the will to fully embrace geometrical abstraction and banish lingering fragments of readily identifiable daily reality.

Towards the end of the first issue of *Blast*, Pound and Lewis offered a series of somewhat opaque definitions of Vorticism. To Pound ('Vortex. Pound'), 'the vortex is the point of maximum energy. It represents the greatest efficiency ... the most highly energised statement ... All experience rushes into this vortex. All the energised past, all the past that is living and

worthy to live. All momentum, which is the past bearing upon us ... All the past that is vital, all the past that is capable of living into the future, is pregnant in the vortex, Now ... Futurism is the disgorging spray of a vortex with no drive behind it, Dispersal'. It lacks the single-minded compression and concentration of Vorticist design, it was Vorticism in the grip of rigor mortis – 'Marinetti is a corpse' (Lewis 2002: 153–4).

In 'The Melodrama of Modernity', Lewis jeered at Marinetti for his 'sententious war talk', which he had 'picked up' from the German philosopher Friedrich Nietzsche, and for preaching 'Impressionism up-to-date' as part of the 'Melodrama of Modernity'. Futurism was attacked for being in thrall to 'sentimental rubbish about Automobiles and Aeroplanes – it capered beneath the romance and pedantic romanticism' of H. G. Wells (1866–1946); his novel *The World Set Free*, which prophesised the development and use of atomic weapons, had recently been published in March 1914. Meanwhile, Kandinsky, Picasso and Giacomo Balla – the one Futurist who, according to Lewis, had seriously explored abstraction (he described Balla as a 'rather violent and geometric sort of Expressionist') – were offered grudging and guarded praise (Lewis 2002: 144). In his 'Note on Some German Woodcuts at the Twenty-One Gallery', Lewis (2002: 136) waxed lyrical about the contemporary German woodcut as a vehicle for expressing the verities of modern existence: 'disciplined, blunt, thick and brutal' – a definition that could equally be applied to the most impressive examples of extant Vorticism.

Lewis, perhaps, came closest to offering an initial definition of the characteristics and aims of his movement in the section 'Our Vortex' in which he proclaimed:

> Our vortex regards the Future as sentimental as the Past ... The Vorticist is at his maximum point of energy when stillest. The Vorticist is not the Slave of Commotion, but its Master ... We hunt machines, they are our favourite game. We invent them and then hunt them down ... This is a great Vorticist age ... Our Vortex is proud of its polished sides ... Our Vortex desires the immobile rhythm of its swiftness. Our Vortex rushes out like an angry dog at your Impressionist fuss. Our Vortex is white and abstract with its red-hot swiftness. (Lewis 2002: 147–9)

The general impression lingers, however, that Lewis was more confident about describing what Vorticism was not than in setting out its tangible, positive qualities. Ironically, the more he heaped abuse on Futurism the more the reader suspects that there was not a great deal to separate the two movements. P. G. Konody in the *Observer* (5 July 1914, 8) offered his verdict on *Blast*: 'without Marinetti *Blast* would have been inconceivable. The Manifestos are based on the Italian Futurists but far behind them as

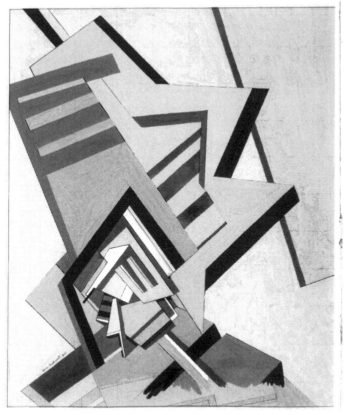

10.4 Edward Wadsworth, *Rigid Drawing*, 1915, pen and ink and watercolour on paper, 1915, 41.9 cm x 34.3 cm, Tate, London.

regards force, literary form, wit and original thought'. The *New York Times* (9 August 1914, 10) meanwhile loftily described Vorticism as 'the latest cult of the Rebel Artists ... the *reductio ad absurdam* of mad modernity' and, most damningly from Lewis's point of view, as 'merely a rather dull imitation of Signor Marinetti and the Futurists'. Vorticism was furthermore defined with some accuracy as 'a rebellion against Futurism, a development of Futurism to its ultimate absurdity ... Signor Marinetti and his friends forced their exotic radicalism on London and the noses of the native revolutionaries were put out of joint ... Vorticism is made in England. Support native industries! Buy British wares! Buy Blast!'

By the time the *New York Times* article was published, Britain was already at war with Imperial Germany. Unlike the hundreds of thousands of British men aged between eighteen and thirty-five who rushed to join

the armed forces, the Vorticists displayed a marked reluctance to become involved in the fighting. Certainly, Lewis wanted to stay in London to organise the first Vorticist group show and publish a second issue of *Blast*. Civilian Vorticists, especially Lewis, were rather needled to see the publicity Nevinson attracted in March 1915, walking around the London Group show as the sole English Futurist conspicuously wearing a dashing uniform largely of his own design. Nevinson was not in fact in the forces but serving as a volunteer with the Friends Ambulance Unit: largely in the role of male nurse and medical orderly though he did his best to give the impression he had frequently cheated death as an ambulance driver throughout his time in France (Walsh 2002: 99–101).

On 10 June 1915 the first, and what proved to be the last, Vorticist Group exhibition opened for a fortnight at the Doré Galleries, London. Lewis, as chef des Vorticists, exhibited, as did Wadsworth, Roberts, Dismorr, Saunders and Gaudier. Nevinson, David Bomberg, Laurence Atkinson, Jacob Kramer and Duncan Grant were among the 'invited guests'. Reaction was scanty; the activities of avant-garde artists, however provocative, seemed sadly paltry and irrelevant when compared to the mass carnage of the Eastern and Western Fronts (Hynes 1992: 58).

Towards the end of July 1915 the second issue of *Blast* was published. Still edited by Lewis, it was noticeably shorter than the first. The tone was decidedly subdued, and less jingoistic, presumably in recognition of the grave wartime conditions and the ever lengthening casualty lists. As Lewis acknowledged in the editorial: 'Blast finds itself surrounded by a multitude of other Blasts of all sizes and descriptions' (Lewis 2000: 25).

Lewis pursued the inability of Futurism to compete with the reality of the war, which 'will take Marinetti's occupation of platform boomer away' (Lewis 2000: 26). He conceded the 'compact Milanese volcano' must be 'in seventh heaven … He must be torn in mind as to which point of the compass to rush to and drink up the booming and banging, lap up the blood!' As for 'Marinetti's solitary English disciple [Nevinson]',[3] he had discovered that 'War is not Magnifique, nor that Marinetti's Guerre is la Guerre' (Lewis 2000: 25). Regarding 'war art', Lewis claimed perceptively that the future lay with 'Messrs Lewis, Wadsworth, Etchells and Roberts': within the next three years all three were to receive official war art commissions from the British Ministry of Information and the Canadian War Memorials Scheme (Lewis 2000: 24). Lewis promised to define how exactly Vorticism differed from Cubism, Futurism and Expressionism but did not follow through, although he argued that, contrary to Futurism, 'In Vorticism the direct and hot impressions of life are mated with Abstraction' (Lewis 2000: 78). Elsewhere, he significantly singled out Kandinsky for approval as: 'the only Purely abstract painter in Europe' (Lewis 2000: 40). He then proceeded

to lash Futurism for its 'savage worship' of the machine ... on a par with Voodooism and Gauguin-Romance' (Lewis 2000: 42), in other words, over-emotional Latin 'primitives' indulging in frivolous escapism from the prosaic reality of mass-manufactured modernity automatically identified as Western European or Anglo-Saxon in origin.

Few works were sold at the Vorticist exhibition and there was an equally unenthusiastic response to the second issue of *Blast* (Wees 1972: 197). What Lewis predicted as the fate of Marinetti's Futurism would also befall his very own movement: 'The War has exhausted interest for the moment in booming and banging' (Lewis 2000: 26). The urge to become directly involved with the war was also catching up with many individual Vorticists. By September 1915 Wadsworth had joined the Royal Naval Volunteer Reserve and the following June he was posted to the north-eastern Aegean island of Mudros to interpret reconnaissance photos taken by Royal Naval Air Service seaplanes for Naval Intelligence (Black 2005: 28). Early in 1918, recovering in London from a bout of dysentery, he was recruited by the relatively traditionalist marine painter Norman Wilkinson to become part of a team devising so-called 'dazzle' camouflage schemes to protect merchant ships from U-Boat attack (Black 2005: 29–34). Meanwhile, in March 1916 Lewis and William Roberts enlisted together in the Royal Artillery and by the summer of 1917 both were at the front in France – though Lewis deftly pulled strings to become an officer which allowed for somewhat better living conditions and a regular whisky ration (Lewis 1937: 98). As gunners, Roberts and Lewis were well placed to depict the true face of modern industrialised Total War. Indeed, as the more intelligent generals had come to appreciate by 1918, the key to British victory on the Western Front was massed artillery delivering ever more devastating bombardments with ever greater accuracy (Sheffield 2002: 236).

Towards the end of 1917 Lewis became an official war artist for the Canadians and then for the British Ministry of information. Early the following year he spent a month in France making sketches of artillery positions and the nightmare world in which they were situated. He was then commissioned by the Ministry to paint a large work for the planned Imperial War Museum, *A Battery Shelled*, which was widely hailed as a 'masterpiece' when it was exhibited in 'The Nation's War Paintings and Other Records' organised by the Ministry of Information and held in December 1919 at the Royal Academy (Brock 1919a: 13 and Malvern 2004: 94–6). Lewis achieved a level of recognition he never enjoyed as a Vorticist – as did Roberts who had also been appointed an official war artist for the British in the summer of 1918. Both men produced numerous drawings and watercolours that impressed observers when exhibited in 1919 as an authentic image of the British soldier on the Western Front, huddled

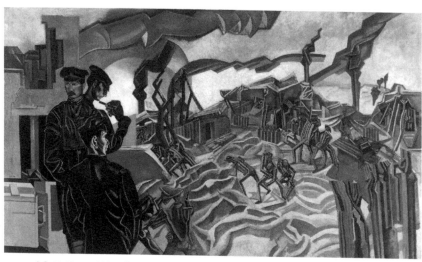

10.5 Percy Wyndham Lewis, *A Battery Shelled*, 1919, oil on canvas, 217.2 cm x 352.5 cm. Imperial War Museum, London.

in shapeless uniforms, festooned with awkwardly shaped equipment and moving like mechanical toys whose mechanisms were winding down (Rutter 1919, Brock 1919a and 1919b).

In March 1919, Pound insisted in *The Little Review* article, 'The Death of Vorticism', that the movement had plenty of life left in it (Wees 1972: 208). Early in September of the same year Lewis wrote to the American art collector John Quinn that he had recently formed a group of ten painters who were going to exhibit together and keep the flag of Vorticism flying. He also hoped to publish a third issue of *Blast* in November (Corbett 1997: 129).

This new 'band', however, exhibited as Group X at Heal's Mansard Gallery, Tottenham Court Road, in March–April 1920. It comprised those who had been closely associated with Vorticism, such as Lewis, Wadsworth, Roberts, Dismorr, Cuthbert Hamilton and Fred Etchells, as well as less formally experimental artists such as Charles Ginner, the American Edward McKnight Kauffer and Frank Dobson and a wild card and discovery of Lewis: the former RAF fighter pilot John 'Jock' Turnbull whose work intriguingly both harks back to the prewar Futurism of Balla as well as anticipating the *Aeropittura* of the late 1920's. In his 'Foreword', to the exhibition catalogue Lewis (1920: 5) acknowledged the need for retrenchment, stability, a pause for breath – thus anticipating Cocteau's slightly later *rappel à l'ordre* [call to order] – while identifying as the most important art movements of 'the last ten years', Cubism, Expressionism and

Vorticism.[4] Futurism was thus literally written out of the past while Lewis's remarks still retained a pungent streak of English nationalism as he urged young artists to look not to the continent for artistic stimulus but to the great satirical British tradition of James Gillray and Thomas Rowlandson (Lewis 1920: 6). Intriguingly, the critic Frank Rutter commented at the time that the members of Group X, while disposing of Futurism and embracing 'a new realism', surreptitiously kept 'the armour' of Vorticism beneath their coats; ready for battle with their continental rivals (*Sunday Times*, 28 March 1920, 7).

In the exhibits Wadsworth submitted, of the Black Country area to the north-west of Birmingham, he renounced geometric abstraction while continuing to explore the British countryside as 'island machine' via a fusion of Cézanne, eighteenth-century Japanese woodblock prints and early nineteenth-century British images of industrialisation by, for example, Philip James de Loutherbourg (1740–1812) and Joseph Mallord William Turner (1775–1851) (Black 2005: 37–9). Meanwhile, Lewis harked even further back in art historical time to the chiselled draughtsmanship of such Italian Renaissance masters as Paolo Uccello (1397–1475), Andrea Mantegna (1430–1506) and Luca Signorelli (1440–1523), which first became evident in the haunting images of the Western Front he produced in 1918 for the Ministry of Information and exhibited in his *Guns* exhibition at the Goupil Gallery in February 1919 (Lewis 1919: 4).[5] Indeed, he had earlier referred positively to both Uccello (Lewis 2000: 26) and Mantegna (Lewis 2000: 43) in the July 1915 issue of *Blast*. Ironically, many of the ex-Vorticists now looked to that very hallowed Italian artistic heritage of the Renaissance Marinetti had so vehemently derided before the war as a defining central tenant of Futurism. Indeed, a year after the 'Group X' show, Lewis signalled his continuing faith in early sixteenth-century Italian art as an irrefutable guarantee of excellence by titling a major self-portrait he exhibited in his April 1921 solo show, *Portrait of the Artist as the Painter Raphael* (1921) (Edwards and Humphreys 2008: 26). Perhaps Marinetti, 'one of the most irrepressible figures of our time', as Lewis had previously conceded in the July 1915 issue of *Blast War Number*, had had the lasting measure of Vorticism after all? (Lewis 2000: 26).

Notes

1 Intriguingly, Cromwell was among those 'blessed' in the first issue of *Blast*.
2 Nevinson exhibited a plaster bust/self-portrait entitled *The Automobilist* with the Friday Club in February 1915.
3 After an unhappy period serving as a private in the Royal Army Medical Corps, at a military hospital in south London in 1915, Nevinson had an

extremely successful solo exhibition at the Leicester Galleries, London in September–October 1916. The following spring he was engaged as an official war artist by the Department of Information and produced work in a markedly more conventional manner. He publicly renounced his belief in Futurism in an interview with the *Daily Express* published in January 1919 (Walsh 2002: 185).

4 To be fair to Lewis, he was highly suspicious of Cocteau, the vogue for a 'new neo-classicism' and Picasso's 'return to Ingres' (Edwards and Humphreys 2008: 19).

5 Lewis specifically mentioned Uccello's *Battle of San Romano* (c.1438–40, tempera on panel, National Gallery London) and the frescos Signorelli produced for Orvieto Cathedral (executed c.1499–1508) as models he had aspired to match in his own war art.

References

Barnett, C. (2002). *The Collapse of British Power* (London: Pan Books).

Black, J. (ed.) (2004). *Blasting the Future: Vorticism in Britain* (London: Philip Wilson).

Black, J. (2005). *Form, Feeling and Calculation: The Complete Paintings and Drawings of Edward Wadsworth* (London: Philip Wilson).

Blom, P. (2009). *The Vertigo Years: Change and Culture in the West, 1900–1914* (London: Phoenix).

Brock, A. C. (1919a). 'The Gunner in Art', *The Times* (11 February), 14.

Brock, A. C. (1919b). 'The New English Art Club', *The Times* (5 June), 12.

Brock, A. C. (1919c). 'Modern War Pictures', *The Times* (27 December), 13.

Corbett, D. P. (1997). *The Modernity of English Art: 1914–1930* (Manchester: Manchester University Press).

Cork, R. (1976). *Vorticism and Abstract Art in the First Machine Age. I, Origins and Development* (London: Gordon Fraser).

Edwards, P. and R. Humphreys (2008). *Wyndham Lewis: Portraits* (London: National Portrait Gallery).

Ellmann, R. (1988). *Oscar Wilde* (London: Penguin).

Ferguson, N. (2004). *Empire: How Britain Made the World* (London: Penguin).

Hynes, S. (1992). *A War Imagined: The First World War and English Culture* (London: Pimlico).

Lewis, W. (1919). 'Modern War as a Theme for an Artist', *Daily Express* (10 February), 4.

Lewis, W. (1920). 'Foreword', in *Group X* (London: Mansard Gallery), pp. 5–6.

Lewis, W. (1937). *Blasting and Bombardiering* (London: Eyre and Spottiswoode).

Lewis, W. (ed.) (2000). *Blast. War Number No. 2, July 1915* (Santa Rosa, CA: Black Sparrow).

Lewis, W. (ed.) (2002). *Blast. Review of the Great English Vortex No. 1, June 20th, 1914* (Santa Rosa, CA: Black Sparrow).

Malvern, S. (2004). *Modern Art, Britain and the Great War* (London and New Haven: Yale University Press).

Roberts, W. (1957). *Some Early Abstract and Cubist Work: 1913–1920* (London: Favill Press).

Rutter, F. (1919). 'The Canadian War Memorials', *Sunday Times* (5 January), 4.

Sheffield, G. (2002). *Forgotten Victory. The First World War: Myths and Realities* (London: Review Books).

Strachan, H. (2006). *The First World War* (London: Free Press).

Walsh, M. J. K. (2002). *C. R .W. Nevinson: This Cult of Violence* (London and New Haven: Yale University Press).

Wees, W. C. (1972). *Vorticism and the English Avant-garde* (Toronto: Toronto University Press).

Wheatcroft, A. (2003). *Infidels: The Conflict Between Christendom and Islam, 638–2002* (London: Viking).

11

Futurist performance, 1910–1916

Günter Berghaus

Introduction

In 1983, I was asked to contribute an essay to a Festschrift honouring the achievements of my colleague William Edward Yuill. I considered writing something on Dada performance (Bill, whom I directed on several occasions, could be a Dada actor in more than one respect!) and threw myself with gusto into the documents related to the Cabaret Voltaire. When I discovered that both Hugo Ball and Tristan Tzara had conducted a correspondence with the Italian Futurists, it seemed justified to make the statement: 'The Futurists used performance as a medium of expression, and their *serate* in many ways prefigured the later soirées of the Dadaists' (Berghaus 1985: 293).

I remember pondering over that sentence for some time, as my knowledge of the *serate* was entirely based on the autobiographical account of one participant, Francesco Cangiullo (Cangiullo 1961). Consequently, I began to investigate the history of Futurist performance. Little did I know that it would take more than ten years to complete these studies and to gather the results in the volume *Italian Futurist Theatre, 1909–1944*.

During that time, my work found the enthusiastic support of two people: Luce Marinetti and Mario Verdone. Luce Marinetti kindly opened her house to me and let me study her father's papers and books that had not been deposited in the Beinecke and Getty archives. Mario Verdone, who, more than anybody, had put Futurist theatre back on the historical map with his groundbreaking study *Teatro del tempo futurista* (1969), advised me in my research and introduced me to the families and thus to the personal papers of many recently deceased Futurists. Over the years, both became good friends and collaborators in various projects, also in matters unrelated to Futurism.

Despite their advanced age, Luce and Mario were fully engaged in the preparations for the 2009 centenary of Futurism. I visited them both in

February 2009 and we made plans for the years *after* the centenary. Sadly, on 20 June, Luce passed away and Mario followed her on 26 June. To both these inspiring figures this essay is dedicated.

Another word of gratitude is due to the Estorick collection that was hosting part of the symposium 'Back to the Futurists' (London, 2009). In 1995, Luce Marinetti had kindly put me in touch with Alexandra Noble who was then in charge of the gallery's education department. She truly brought to life the Estorick's educational agenda of fostering our understanding of the Futurist movement, and it was due to her support that my study *Italian Futurist Theatre* could be completed and issued with its full complement of 100 illustrations. So, when in 2009 I returned to this institution to talk about Futurist performance, I could truly say that the Estorick played an important role in making possible the insights that I was communicating on that day and which have now been incorporated into this chapter.

Futurist theatre: From the page to the stage

The plethora of exhibitions, conferences and performances of the year 2009 testified that Marinetti's engagement for a renewal of art and life in the spirit of Futurist modernity was blessed with longlasting success. Yet, in 1909, Marinetti was not fully satisfied with the stir the numerous editions of the founding manifesto had caused. He felt a need to go beyond the printed page and to enter into a closer contact with the cultural establishment. A few years later he remembered: 'I suddenly sensed that articles, poems, and polemics were no longer enough. The approach had to be totally different; we had to go out into the streets, lay siege to the theaters, and introduce the fist into the struggle for art' (Marinetti 2006: 151).[1]

And how did Marinetti execute this idea? By issuing yet another manifesto, *The Manifesto of Futurist Playwrights* also known as *The Pleasure of Being Booed*. What strikes me most about this proclamation is that the signatories had hardly written any plays in their lives! Well, as they said: Futurism is about anticipating the Future. And this manifesto certainly contained a number of ideas that were going to become central to Futurist theatre in the years to come. The first was: 'We want dramatic Art to cease being what it is today, namely, a wretched product of a theatre industry' (Marinetti 2006: 181).

And indeed, Italian theatre of the late nineteenth and early twentieth centuries was a system in which money and vanity reigned supreme. Theatre as an *artistic* institution, in the manner of the Théâtre Libre, the Théâtre de l'Œuvre, the Freie Bühne in Berlin, or the Moscow Art Theatre, was unknown in Italy. Here, theatres were owned by rich impresarios or consortia of shareholders, who catered entirely for the audiences' vulgar

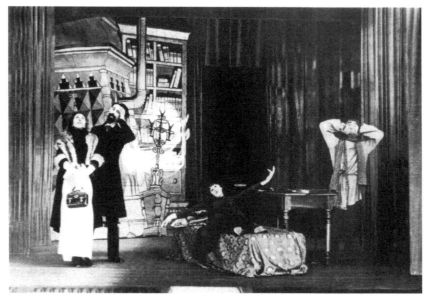

11.1 Chekhov's *Birthday* in a production by the Acting School E. Duse

tastes of amusement. These businessmen operated along capitalist principles and rented the buildings out only to companies who had a popular lead at their helm. These troupes of itinerant players were totally dependent on immediate box-office returns and could not afford the luxury of long rehearsals or intellectually challenging plays. Their assembly-line productions were put together within a week or two (and often less than that) and served the sole aim of providing the main actor with a vehicle for his or her personal glory. There were no directors or scenic designers involved as we know them nowadays. Whatever the play, it had to fit into one of the generic 'sets' the companies were travelling with.

The centre of attraction in these shows was never the play, but always the star actor or actress. He or she was loved by the crowds and celebrated in the salons of the bourgeoisie. The play or the playwright served no other function than to furnish them with a framework, in which they could exhibit their craft and arouse the interest of the audience (Pandolfi 1954: 5; Livio 1989: 119–30). The idols of the stage tailored the suit to make it fit their figure. It was not them who adapted to the role, but the role was adapted to the star. Texts were often changed beyond recognition. Scenes that did not demand the presence of the star on stage were cut; interpolations were inserted into plays that did not offer maximum opportunity for the display of the protagonist's artistry. If an author had occasion to see his

play on stage, he would have difficulty recognizing it as his own (Tofano 1947: 181–97).

But most audiences did not go the theatre to see a play; they only came to watch a star performance, a firework of vocal and gestural brilliance set off by a *mattatore*. And the star actor would not be in the least worried about preserving dramatic consistency or sustaining theatrical illusion. The only thing that mattered was applause. Alfredo de Sanctis remembers how Tommaso Salvini, one of the greatest stars of the Italian stage, sought to improve his performance in a heroic death scene by shifting it downstage to the footlights in order to give the audience a better view of his virtuosic death throes. Of course, his accomplished mimic display brought him thunderous ovations. He acknowledged the audience's enthusiastic response by rising from the dead and taking a curtain call. He then returned to the centre-stage position and lay down for his burial (De Sanctis 1946: 71).

If we bear this state of affairs in mind, then we begin to understand why Marinetti exhorted dramatists 'to despise the public' and actors to enjoy 'the pleasures of being booed' (Marinetti 2006: 181–3). The audiences of the Italian Belle Epoque consisted of satiated, narrow-minded philistines, who went to the theatre first and foremost to be entertained. After dinner, they did not wish to strain their brains. They wanted to see a good comedy with enough intervals to allow for social intercourse in the foyer or boxes. Theatre was a forum of social representation, an occasion for showing off dresses and jewels, for parading intellectual vanities and pretensions, or simply for digesting a heavy evening meal in the merry company of stars and starlets.

But Marinetti was not going to satisfy these demands. He had first made his intentions known when he toured France and Italy with a recitation programme that was laced with incendiary Anarchist poetry. And then, on 15 January 1909, came the premiere in Turin of his pre-Futurist play *Poupées électriques*. It went down in the chronicles of Italian theatre history as an event comparable to the *Bataille de Hernani* and the scandal that surrounded *Ubu Roi*.

When Marinetti took the curtain call at the Teatro Alfieri in Turin, he had to face a massive concert of booes and catcalls. Not in the least perturbed by this response, he approached the audience and returned their 'compliments' by declaring: 'I thank the organisers of this whistling and hissing concert which profoundly honours me' (Antonucci 1975: 37). The reaction of the audience was predictable. I quote from some contemporary reviews:

> Imagine the uproar that followed these words! There was a long, insistent and interminable hullaballoo unleashed by the most diverse voices, shouts, screams and exaggerated hissing. (*Gazzetta del Popolo*, 17 January 1909)

The audience went into a rage! Somebody shouted: Let's go on honouring the audience! (*La Scena di Prosa*, 22 January 1909)

For many years one has not experienced a scene like this in the theatre. (*Il Momento*, 16 January 1909)

Confronted with such a negative reception, the author aunched haughty and contemptuous invectives from the stage, just like a political speaker would do against his adversaries. (*La Ribalta*, 25 January 1909)

And indeed, for Marinetti, theatre was a natural progression from politics. The performance was a first demonstration of the Futurist concept of theatre as *art-action* that invades society and provokes active responses from the spectators rather than serving as an object of consumption.

For the next years, the Futurists treated the theatre as a means for launching an all-round attack on traditionalism and the social strata who sustained it. The only problem was that there existed, as yet, no Futurist repertoire of plays and no Futurist theatre company. Therefore, Marinetti had to make use of his entourage of poets and painters to organise a variety of events that mixed poetry and politics, music and painting, manifesto readings and diatribes against the cultural establishment.

The term used for these presentations was *serate*. In Italian, it is employed for any kind of evening entertainment, just like the French *soirée*. But the Futurists developed the *serate* into a theatrical genre where art and life were fused into a compact union. These events did not only serve to glorify war and revolution, they *were* an act of insurrection, like 'a well-primed grenade over the shattered heads of our contemporaries' (Marinetti 2006: 32). This aggressive stance turned every *serata* into a veritable battlefield, where the anarchist conception of 'regenerative violence' found a concrete application. As an example of this, I should like to describe a particularly 'successful' performance.

The Futurist serata at the Teatro Verdi in Florence

On 30 November 1913, an important exhibition of Futurist paintings opened at the Libreria Gonnelli in Florence.[2] To coincide with this show, the publisher Vallecchi hired the Teatro Verdi for a Futurist *serata*.[3] The performance went down in the chronicles of Futurist theatre as the 'Battle of Florence'. Hours before the performance, there was an incredible rush to the theatre. Estimates of how many people managed to squeeze into the auditorium vary between five thousand (*Lacerba*) and seven thousand (*Corriere della Sera*). Soffici says that nearly as many were left outside the theatre without a ticket. Those who managed to find a seat or some standing room had to wait for nearly two hours before the show could

begin. The general spirit of excitement and expectation fomented such an electric atmosphere that Soffici felt that the show had begun long before the curtain had gone up. When, eventually, the performers appeared on stage, 'an inferno broke out. Before any of us could open our mouths, the hall was boiling over. Agitation everywhere, the echo of savage voices. There was an atmosphere like on an execution field before the capital punishment is about to be carried out'.

Francesco Cangiullo confirmed Soffici's account in his memoirs:

All scoundrels and hooligans of Florence had come together for an assembly at the Teatro Verdi ... A howling tribe of cannibals raised their thousands of arms and greeted our appearance with a volley of objects from the animal, vegetable and mineral world ... None of us thought of taking the first word. We were totally overwhelmed by this reception. We looked at our audience and began to read the banners that were displayed from the dress circle: 'Perverts! Pederasts! Pimps! Charlatans! Buffoons!' (Cangiullo 1961: 160–1)

After about five minutes, the audience began to calm down. Marinetti approached the footlights and judged: 'I have the impression I am down below the Turkish fortresses in the Dardanelles. But I see that your ammunition is running out and you still have not vanquished us'. And immediately he was given proof that his assumption was wrong. The spectators had still masses of missiles left, causing Viviani to ask why the management of the theatre and the many policemen on the premises had not prevented people from carrying sackloads of projectiles into the auditorium. But it was not only the ammunition that caused disturbances. People had also arrived with car horns, cow-bells, whistles, pipes, rattles etc.

After a while, Marinetti managed to make himself heard again:

It seems to me that this game has been going on for too long. We expect there to be at least an intermittent silence. We ask those who are favourably disposed towards us to get the upper hand over our adversaries, if necessary with force. Listen to us first, and when you have heard our innovative ideas, then you may whistle. Your asphyxiating and stinking projectiles only demonstrate that passéism seeks to defend itself as best it can ... You are six thousand examples of mediocrity against eight artists, whose genius cannot be annihilated! (Marinetti 1968: 499)

As was to be expected, the audience proved him wrong. They responded to the tirade with an ear-splitting noise and exhorted him: 'Go and hide in a lunatic asylum!' To which he retaliated: 'I prefer our loony bin to your Pantheon!' And immediately the fracas started again. Marinetti advised his fellow-players: 'We have to attack at all costs'.

The performers tried their best to get through the programme they had announced on the posters and in the newspapers: Soffici talking on Futurist

painting, Carrà explaining his theory of paintings of odours, Boccioni speaking on plastic dynamism (Boccioni 1971: 422–3), Marinetti and Cangiullo declaiming poems and, as the high point of the evening, Papini giving a lecture against *passéist* Florence. Since hardly any of their words reached the ears of the spectators, the Futurists printed them in the next issue of *Lacerba*.

From the workers to the aristocrats, from the students to the bourgeois, from the anarchists to the conservatives, everybody seemed to behave in the same fashion. *L'Unità Cattolica* wrote with amazement: 'It was not only the workers perched on the balcony who were throwing potatoes. No, also the upper classes and the petty bourgeoisie gave a nice demonstration of the civil education they had received in their colleges and grammar schools'. There were a few dozen friends of the artists who made some attempt at cooling down the spectators. However, brandishing a club that had been broken out of the banister only produced the opposite effect. Brawls broke out between philo-Futurists and anti-Futurists. Rosai describes how he and a few friends sought to pacify the Futurists opponents: 'Up in the gods, Zannini and I took a fanatic by his legs and let him dangle for a few minutes from the parapet. When we pulled him up again, he was the calmest and humblest person in this tide of frenetic beings'.[4]

Police had to intervene to prevent worse incidents from happening. But the turmoil continued. Cangiullo and Papini watched the audience and smoked a cigarette. Marinetti observed the scenes on the balcony through binoculars. The hail of vegetables turned the stage into a cess-pit. 'Throw an idea, not a potato, you idiot!' Carrà hissed at a spectator, whose neighbour answered with blowing a children's trumpet. Marinetti commented to everybody's amusement: 'That's the signal for the departure of his intelligence!' And Boccioni shouted: 'The projectiles you are throwing with such profusion are the fruit of your cowardice multiplied by your ignorance'. A spectator came up to the stage and offered Marinetti a pistol. 'Go on, commit suicide', he suggested, to which Marinetti replied: 'If I deserve a bullet of lead, you deserve a bullet of shit!' But it was not only the actors who had to suffer the belligerent behaviour of their enemies. Soffici remembered:

> Not everything that was destined to hit us actually reached its target. A cauliflower, an egg, a slice of maize cake, a chestnut pudding thrown from the upper balcony hit the bald heads and shoulders of gentlemen in dinner jackets, the elegant hats of the ladies down in the stalls, where they provoked furious protests and screams … We could observe from the stage how here and there in the auditorium altercations of words developed into altercations of fists. Infuriated people leaned out of their boxes and disputed with those bending down from the galleries. They may have been members of high society, but their

I FUTURISTI DALLA RIBALTA ALLA TRINCEA *(disegno di R. M. Baldessari, futurista)*

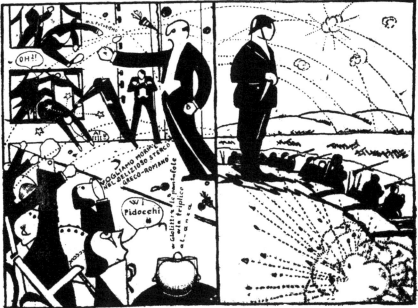

I nostri avversari furono sempre i nemici d'Italia. Nei teatri, i passatisti triplicisti, sul campo, i tedeschi.

11.2 R. M. Baldessari, *Futurismo dalla ribalta alla trincea.*

vocabulary was that of hawkers and fishwives. The whole thing degenerated into an exchange of heated phrases and a skirmish of invectives and repartees between stage and auditorium (Soffici 1955: 330).

As was to be expected, Papini's vitriolic attack on traditionalist Florence provoked the most violent reactions. The audience did not take very well to his vilification of 'this worm-eaten tomb of the arts ... [which] suffocates all vigorous life with its provincial narrow-mindedness and passéist bigotry', or his summons 'to throw all professors, museum guardians and academicians into the Arno', or his exhortation to clean the city with 'the energizing and disinfecting cure of Futurism' (Papini 1977: 441–5). After all, Papini was a Florentine, and to revile his native city in such a manner was like fouling one's own nest. This, the spectators felt, deserved a severe punishment. 'Down with Papini! Traitor! Shame on you! You have been bribed by the Futurists!' were some of the kinder invectives thrown at him. *La Nazione* was amazed that after two hours of the most extraordinary straining of their lungs and vocal chords, the spectators were still able to surpass themselves by making even more of a racket after this speech.

Towards the end of the evening, Marinetti tried to explain the *Futurist*

Political Programme, which had been published three months earlier in *Lacerba*. His attack on 'the cowardly pacifists and eunuchs' and 'the miserable mire of Socialists and Republicans' was given a reception equal to that after Papini's speech, and finally brought the house down. The police came on stage and declared the performance to be suspended.

Most of the *serate* in the 1910s took place in large theatres and presented key ideas of the Futurist movement to audiences ranging between two thousand and five thousand people. They always contained a combination of the reading of manifestos and the presentation of artistic creations that had arisen from these theories. This allowed Marinetti to introduce the Italian public, successively, to Futurist poetry, painting and music.

It was characteristic of the *serate* that the audiences comprised all sections of society. Several newspapers observed that they attracted people who were rarely to be seen in the theatre. During a Futurist *serata* they would rub shoulders with the *gente perbene*, who occupied the 5 to 10 Lire seats in the stalls, dress circle or boxes. This audience composition invariably proved to be explosive to a high degree and created situations that fully lived up to the Futurists' principal objectives: activating the spectators, forcing them to give up their complacency in the theatre, changing their attitude towards art as something separate from life.

It is patently obvious from all reports that soon after the first *serate* had made the headlines in the national press, everybody arrived at the theatre well prepared for what was going to happen. People were not only expecting a rowdy evening; they had also filled their pockets with various objects that could be used as projectiles. Before the show began, all vegetable and fruit stalls in the vicinity of the theatre did record business and could hang up their 'sold out' signs.

The *serate* were the Futurists' first attempt at revolutionising the established forms of theatrical communication. Marinetti described the events as 'the brutal introduction of life into art'.[5] And indeed, the *serate* represented a clear break with the conventions and traditions of theatrical culture. They were not 'scandals' in the normal sense of the word, i.e. spontaneous eruptions of public ire. Marinetti had *planned* and *organised* the *serate* in a systematic and logical manner in order to *provoke* such reactions. He had initiated the *serate* with a clear political aim in mind: to storm the citadels of bourgois culture and turn them into a battleground of a new socio-political praxis. Or as Carrà put it: 'Having issued our appeal to youth with a manifesto, we realised that this was still too indirect a way to rouse public opinion. We felt the need to enter into a more immediate contact with the people: thus were born the famous Futurist *serate*' (Carrà 1945: 663).

The Futurists did not choose the theatre because of the artistic possibilities it offered, but rather because it was the most effective medium for polemics

and propaganda in an evolving mass society. Papini underlined this fact when he wrote that through the *serate* the Futurists could divulge their ideas to a large number of people, who otherwise would not have taken notice of them, had they simply and quietly been issued in printed form. And Marinetti explained: '90 percent of all Italians go to the theater, while a mere 10 percent read books and journals' (Marinetti 2006: 200).

Shock and provocation were the Futurists' preferred means of changing people's attitudes. More than any other form of artistic discourse, the *serate* challenged the autonomous position of art in bourgeois society. The stage actions broke down the fourth wall which, traditionally, separated the actors from the audience. Marinetti organised the *serate* in a manner that allowed audiences to take over the main part of the show and bring to fruition a strategy he had outlined in his *Variety Theatre Manifesto*: 'Drag the most sluggish souls out of their torpor and force them to run and to leap', seek the audience's collaboration, so that 'the latter does not sit there unmoving, like some stupid voyeur, but noisily participates in the action'. This will produce a performance, in which 'the action takes place on stage, in the boxes and in the stalls, all at the same time. It continues after the show is over, among the hordes of admirers' (Marinetti 2006: 187).

The Futurists derived great pleasure and satisfaction from provoking the spectators and arousing their emotion to such a degree that they could not help but respond with shouting, whistling or throwing objects on to the stage. To foment such an atmosphere in an institution that was regarded as an artistic sanctuary, but in reality had the deadening effect of a mortuary, was an achievement the Futurists justifiably felt proud of. They relished the 'pleasure of being booed' and were prepared to suffer a few bruises from the missiles hurled at them during the show, or from the blows they received afterwards in the streets.

Futurist Variety Theatre

Between 1910 and 1913, the Futurists organised some twenty *serate*. Towards the end of that period, Marinetti saw a need to go beyond the use of theatre as a means of provocation and propaganda and to initiate a reform of the dramatic traditions in his country. The *serate* had offered an effective formula for combating the commercialism and intellectual mediocrity of Italian theatre, but, once established, they tended to become repetitive. Therefore, Marinetti investigated new models that would offer more variety and open up new possibilities. He found one particularly suited to his aims in a form of popular theatre usually referred to as Music-hall, Variety, Cabaret, or Café-concert.

Marinetti had been an assiduous visitor of such venues in Paris, London

and Berlin, as well as in Italy, and came to regard them as an antidote to traditional culture based on the values of introspection, meditation and reflection. In a world where academies, museums and libraries were regarded as Temples of the Muses, nothing could be more of a contrast than the incarnation of contemporary collective sensibilities in the form of a Music-hall performance. In the manifesto of 1913, *The Variety Theatre*, Marinetti summed up a number of innovative features of this genre and outlined how it could serve his fight against the traditionalist theatre in his home country. He felt that nothing contradicted the rules of Aristotelian dramaturgy more than the heterogeneous mixture of numbers performed in a Variety show. There is no unity of time, place, or action. There are no plots, no characters, no psychological depth, nor any logical connections between the individual items on the programme. Whilst conventional theatre is meditative, psychological, concerned with realistic scenes of daily life and bound to cultural traditions, Variety theatre has no 'traditions, masters, or dogmas' (Marinetti 2006: 185). Like Futurism, it is indifferent to the 'immortal masterpieces' of the past; it destroys 'the Solemn, the Sacred, the Serious, and the Sublime in Art with a capital A' (Marinetti 2006: 189) and ridicules the 'tired old stereotypes – the Beautiful, the Great, the Solemn, the Religious' (Marinetti 2006: 186). Music-hall distracts and amuses; it is anti-academic, primitive, naive, erotic. It offers 'an instructive schooling in sincerity' in erotic matters (Marinetti 2006: 187) because it 'devalues idealised love and its romantic obsessions' (2006: 188) and exalts the male's predatory instincts and the female's seductiveness and animalistic qualities.

The Music-hall pays tribute to emotion, action and intuition, and destroys psychology through the use of *fisicofollia* (body madness; i.e. acrobatics and a highly physical style of performance). The fast and simultaneous events on stage, the noise, energy and dynamism provide pure spectacle. Instead of representation and impersonation the audiences witnesses a presentation. The innate characteristics of the performance itself, rather than what it signifies, serve as the main attraction of the show. We love the singer for the quality of his or her voice, the acrobat for the agility of his or her body, the dancer for the beauty of his or her movements. We are taken in by the material aesthetics of the performances, not the breadth or depth of their meaning.

As regards the spectators, they are always an active ingredient of the performance. Nobody is allowed to remain passive 'like some stupid voyeur' (Marinetti 2006: 187). The audience collaborates with the performers by singing along with the *chanteuses*, bantering with the actors, larking about with the musicians, etc. And if they don't like the show, they can boo and whistle, or comment loudly on the presentation. Because of these reactions, there is always a dynamic relationship between actors and spectators.

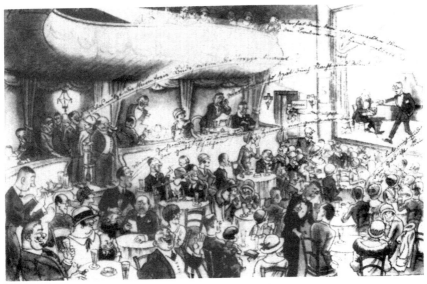

11.3 Performance in a cabaret.

The smoke of cigars creates a relaxed atmosphere that unites stage and auditorium and ensures that 'the action takes place on stage, in the boxes and in the stalls, all at the same time' (Marinetti 2006: 187).

Having presented the positive elements of Variety theatre, Marinetti then proceeds to discussing how he wants to transform the Music-hall tradition into a Futurist 'Theatre of amazement, of record-setting and of body-madness'. His aim is to 'rejuvenate the face of the world' by means of

- destroying all logic and making everything look absurd
- introducing surprise effects by selling the same ticket to ten people, spreading glue on some seats, sprinkling sneezing powder in the auditorium, etc.
- prostituting classic art on stage by, for example, playing a Beethoven symphony backwards, inserting Neapolitan folk-songs into a Wagner opera, reducing all of Shakespeare's plays to the length of a single act; or reciting a famous tragedy with the actors stuck up to their necks in sacks
- preventing any fossilisation from setting in by keeping the 'terrifying dynamism' of constant change in perpetual motion. (Marinetti 2006: 191)

Finally, in the third part of the manifesto, Marinetti offers a poetic evocation of the atmosphere in a Futurist Variety theatre. His *words-in-freedom* conjure up images of 'hilarity + the din of the music-hall', 'froth of electric light in a glass of champagne', 'slaps in the face for that dozing

gouty old fogey in bookworms' slippers' and 'music-hall gaiety = tireless ventilator of the world's Futurist mind'.

With the publication of this manifesto, Marinetti showed that, after several years of experimentation with the format of the *serate*, he was ready to move into new theatrical terrain. For the next years, he collaborated with some of the finest stars of the Variety circuit. But he also undertook concerted efforts to modernise the dramatic repertoire of his county.

The Futurist Theatre of Essential Brevity

In 1913, Bruno Corra and Emilio Settimelli became artistic managers of the Compagnia dei Grandi Spettacoli of Gualtiero Tumiati and staged Marinetti's *Elettricità* in Palermo (13 September 1913). In 1914, they put together a programme of plays that had been written by the Futurists in the past year or two, and sent it on tour through Italy, performed by the company of Giuseppe Masi and Ettore Berti. For the premiere in Ancona (1 February 1915), they penned, together with Marinetti, a manifesto, *Il teatro futurista sintetico*, and published a first volume of plays written for this new genre.[6]

The use of the term *sintetico* is slightly ambiguous, despite the opening statement: 'Sintetico, cioè brevissimo' [Synthetic, that is very brief]. *Sintetico* has a variety of meanings. In the *Futurist Playwrights' Manifesto*, Marinetti had spoken of 'a synthesis of life at its most typical and most significant' (Marinetti 2006: 183), and in the *Variety Theatre Manifesto* he had called for 'a synthesis of everything that humankind has hitherto instinctively refined to lift its spirits' (2006: 186). These ideas were not too far removed from Corra's theory of synthesis, which aimed at a unification or fusion of the different arts (Apollonio 1973: 66–70).[7] Corra's synaesthetic experiments tied in with the well-established theory of the Total Work of Art (Berghaus 1986: 7–28) and were, in fact, based on the same spiritualist sources (Verdone 1969: 111–16; Ringbom 1970; 1982a: 85–101; 1982b: 102–5). But in the 1915 manifesto, the emphasis was not so much on the multimedia constitution of the stage work but on its brevity and speedy course of action. Instead of the minute and detailed reconstruction of reality in Verist drama, the authors aimed at 'concentrating action and ideas into the smallest number of words and gestures' (Marinetti 2006: 201) and at achieving, by force of its conciseness and dynamism, an entirely new form of theatre, 'perfectly in harmony with our lightning-fast yet pithy Futurist sensibilities' (2006: 201).

These mini-dramas written for this Futurist Theatre of Essential Brevity offered a highly condensed rendering of the diversity of human experience in rapid theatrical scenes. They were sketches rather than fully

elaborated dramas. The Futurist playwright sought to abolish the worn-out dramaturgical clichés, as they were no longer able to reflect a rapidly changing world. Instead, they developed new techniques that offered infinite possibilities of dealing with the complexities of life in the modern era. Just as a passenger in a modern metropolis is bombarded with fragments of sense impressions, so should the spectators of a Futurist play be exposed to an interpenetration of simultaneous levels of aesthetic reality, which have the same dynamism and vitality as the world outside the theatre. All action on stage possesses novelty value, offers astonishment to the spectators and surprises them with unpredictable events. The plays' current of energy was meant to establish a close contact between stage and auditorium. If this was to be complemented by the abolishing of the proscenium arch and footlights and the installation of all sorts of electro-mechanical devices, Italy would finally see the arrival of a Futurist Theatre of Essential Brevity, capable of

- 'raising its audience's spirits, of making them forget the monotony of their daily lives, by hurling them across a labyrinth of sensations'. (Marinetti 2006: 205)
- 'launching networks of sensation, back and forth, between stage and audience; the action on stage will spill out into the auditorium to involve the spectators'. (2006: 206)
- 'instilling in our audiences the dynamic liveliness of a new, Futurist kind of theater'. (2006: 206)

However, for the time being, the Futurists had to make do with mediocre actors performing their plays in traditional theatre buildings. The professional theatre companies of Zoncada, Berti et al. could hardly live up to the elated dreams of a truly Futurist theatre. Consequently, Marinetti and his companions became aware of an issue that had been missing so far from their theatre reform: the art of the actor.

Conclusions for a Futurist acting style

The two companies Settimelli had put together in 1913–15 fulfilled the aim of popularising Futurist drama. But neither of them offered a solution to a problem, which the theatre critic Enrico Novelli summarised thus: 'For the audience to gain a true impression of the pieces and to judge them fairly, two things are required: a suitable theatre and a fitting company. A theatre equipped with the most incredible scenographic and mechanical contraptions, a troupe formed of agile, vibrant actors who can raise to the task of summing up in one gesture the whole role; in short: Futurist actors' (Antonucci 1975: 103).[8]

Marinetti's reflections on how to introduce Futurist aesthetics into the world of theatre took a new turn when a young artist of the Neapolitan Variety circuit, Francesco Cangiullo, gave his debut in the Futurist *serata* at the Teatro Verdi in Florence (12 December 1913). In 1914, he became a key performer and musician in the performances that were presented in the Permanent Futurist Gallery of Giuseppe Sprovieri. Marinetti realised that Cangiullo's acting style and particularly his voice work was innovative and full of potential. And as he himself had years of experience as a reciter, he wrote with him a text, *Dynamic, Multi-channelled Recitation*, that was to function as a preface to *Piedigrotta*, which Cangiullo had presented on 29 March, 14 May and 4 June 1914.[9] In this manifesto, they repudiated the Symbolist art of recitation as it was practised and taught in France, because it was entirely centred on 'vocal pyrotechnics' and 'a hotchpotch of gestures'. Marinetti criticised the fact that the performer's lower body was kept too immobile, and that the movements of the upper body were far too decorative and rhetorical. Instead, he wanted to mechanise the human body in a manner as indicated in his previous manifestos, *Geometrical and Mechanical Splendour and Sensitivity towards Numbers* and *Extended Man and the Kingdom of the Machine*. In these texts, he had praised the 'sparkling perfection of precision instruments' (Marinetti 2006: 136), the energy and communicative effusiveness stemming from 'a variety of tones, from vocal and facial expressions, ... the incisive, clear-cut power of our gestures ... [and] animal magnetism' (2006: 139). In the *Dynamic, Multi-channelled Recitation*, the descriptions of performance techniques were considerably extended and included the following suggestions:

- Costume: anonymous dress, preferably a tail coat

- Gestures: imitation of the rhythms of motors; sharp, rigid, geometrical gestures similar to pistons, wheels or spirals in order to express the dynamism and 'geometrical splendour' of Futurist Words-in-Freedom

- Facial expressions: blank and dehumanised

- Voice: wide range of intonations; a request 'to make his voice metallic, liquefied, vegetalised, be turned to stone and electrified, fusing it with the very vibrations of matter itself' (Marinetti 2006: 195); exclusion of typically human nuances and modulations

- Accompaniment: the reciter should wield simple noise-making instruments (e.g. hammers, saws, bells, horns etc.) in his hand and produce on them onomatopoeic chords

- Ensemble work: several reciters should work together and orchestrate their voices and instruments

- Movements: the body must support and relate to the lyrical enunciations; no fixed position but irregular pacing through the hall; the audience should not statically watch the performance but follow the reciter around the room

- Decor: simple blackboards on which images and lyrical signs can be drawn by the reciter.

These suggestions, when finally published, were complemented by another manifesto concerned with the physical language of the human body on stage: *Futurist Dance* (printed in *L'Italia Futurista* of 8 July 1917). However, during the First World War, these proposals did not attract much attention. The ideas contained in them only re-emerged in the 1920s, when Futurist theatre moved into new directions, indicated by the Theatre of Colours, the Theatre of Surprises, Futurist Mechanical Theatre and so on.

Summary

Marinetti saw in theatre a natural progression from politics. His early recitations of poetry, just like his public lectures, served his largely anarchist creed. And, as the use of theatre venues for political meetings was fairly commonplace in Italy, the public did not find it strange to see Marinetti advertise his aesthetic and social programme from the boards of the stage. When, in 1909, he founded the Futurist movement, he treated the theatre as a means of propaganda for his avowedly revolutionary movement and employed it as a weapon in the Futurist battle for a renewal of Italian public life.

The Futurists despised the traditional theatre both as a social institution and as a marketplace for the presentation of mediocre and regurgitated wares. They polemicised against 'the Solemn, the Sacred, the Serious, and the Sublime in Art with a capital A' (Marinetti 2006: 189) and against a dramatic tradition they deemed 'dogmatic, ridiculously logical, meticulous, pedantic, and strangulating' (2006: 202). They developed counter-strategies to demolish the repertoire and introduced new theatrical formats that were provocative, dynamic, activating.

The *serate*, Futurist Variety Theatre and Theatre of Essential Brevity were all designed to break down the stilted traditions of virtuosity acting and the stultifying conventions of dramatic literature. Futurist theatre sought to incorporate elements of modern life, and not just as a theme or subject matter but as an integral element of its performative texture. Instead of reflection and representation they offered immersion and visceral experience. Futurist theatre operated with the elements of dynamism, simultaneity, interpenetration, clashing noises and colours in order to express in a non-intellectual, poly-sensual manner the experience of the modern world.

By referring to popular traditions of theatre, they abolished the fourth-wall conventions and turned each and every spectator into an active component of the performance. Comparing the spontaneity and improvisatory quality of most Futurist performances with the predictable conventions and facile theatricality of the 'great and admired comedians of the Italian stage', one can easily imagine the cleansing effect Futurism had on the Italian theatre system. I can therefore only confirm what Francesco Flora wrote in 1921 with regard to the *Futurist Theatre of Essential Brevity*:

> The *Teatro sintetico* has been created by Marinetti & Co. in order to overcome the romantic decadence in which our contemporary theatre is rotting ... The *Teatro sintetico* is the necessary dissolution of the inert, stupid, bestial, pompous and melodramatic techniques that are employed by the insipid playwrights of today when they construct their cardboard figures and unforgivably primitive storylines. (Flora 1921: 150–3)

And indeed, the Futurists managed to demolish a system characterised by histrionic excess and artistic debility and instead created an avant-garde form of theatre that invaded society and helped to mould a modern civilisation.

Notes

1 A similar idea was expressed in an interview with Jannelli for *L'Avvenire* of Messina, 23 February 1915: 'When I created this effective propaganda in the form of the Futurist *serate*, Futurism became a sign of war bursting into the field of art'.

2 A 32-page catalogue was published on this occasion, which stated that 'questa Esposizione di Pittura Futurista a Firenze è la più importante manifestazione dell'arte italiana da Michelangelo ad oggi'. The exhibition is well documented in Manghetti 1984: 56–73.

3 For a documentation of the performance on 12 December 1913 see *La Nazione* (13 December 1913), *Corriere della Sera* (13 December 1913), *L'Unitá Cattolica* (14 December 1913), *Lacerba* (15 December 1913) and Cangiullo 1961: 152–68; Soffici 1955: 328–33; Soffici 1915: 257; Papini 1977: 769–80; Conti 1983: 33–7; Carrà 1945: 173–5; Marinetti 1968: 434–7; Viviani 1983: 65–70; Ottone Rosai, *Pagine di memorie* (unpublished Ms. in the Gabinetto Vieusseux); Däubler 1919: 117–42. Some of this material has been analysed by Manghetti 1984: 167–72.

4 Ottone Rosai, *Pagine di memorie*, unpublished manuscript in the Gabinetto Vieusseux, Archivio Contemporaneo, Fondo Rosai, Cassetta 17, Inserto 8, pp. 112–15.

5 Marinetti in an interview with Carlo Albertini. See 'In tema del futurismo', *La Diana* (Naples), 1 (January 1915), 27–9.

6 The first edition of the manifesto, a four-page leaflet of the Direzione del Movimento Futurista, dates the manifesto 11 January 1915. It was reprinted in the play collection *Teatro futurista sintetico* (Milan: Istituto Editoriale Italiano, supplement to the journal *Gli Avvenimenti*, 114, December 1915), which mentions the various stages of the tour undertaken, in February 1915, by the Berti-Masi company.

7 See his essay, 'Musica cromatica', in *Il pastore, il gregge e la zampogna* (Bologna: Beltrami, 1912), translated in Apollonio 1973: 66–70.

8 Enrico Novelli in *La Nazione* (10 March 1916), reprinted in Antonucci (ed.) 1975: 103.

9 The manifesto was typeset shortly after the 1914 performances, but for unknown reason the publication was delayed until 1916.

References

Antonucci, G. (ed.) (1975). *Cronache del teatro futurista* (Rome: Abete).

Apollonio, U. (1973). *Futurist Manifestos* (New York: Viking Press).

Berghaus, G. (1985). 'Dada Theatre or: The Genesis of Anti-bourgeois Performance Art', *Festschrift W. E. Yuill, German Life and Letters*, 38:4, 293–312.

Berghaus, G. (1986). 'A Theatre of Image, Sound and Motion: On Synaesthesia and the Idea of a Total Work of Art', *Maske und Kothurn*, 32, 7–28.

Boccioni, U. (1971). *Gli scritti editi e inediti*, ed. Z. Birolli (Milan: Feltrinelli).

Cangiullo, F. (1961). *Le serate futuriste: Romanzo storico vissuto* [1930] (Milan: Ceschina).

Carrà, C. (1945). *La mia vita* (Milan: Rizzoli).

Conti, P. (1983). *La gola del merlo* (Florence: Sansoni).

Däubler, T. (1919). 'Futuristenabende in Italien', in T. Däubler, *Im Kampf um die moderne Kunst* (Berlin: Reiss), pp. 117–42.

De Sanctis, A. (1946). *Caleidoscopo glorioso* (Florence: Giannini).

Flora, F. (1921). *Dal romanticismo al futurismo* (Piacenza: Porta).

Livio, G. (1989). *La scena italiana: Materiali per una storia dello spettacolo dell'Otto e Novecento* (Milan: Mursia).

Manghetti, G. (ed.) (1984). *Futurismo a Firenze 1910–1920* (Verona: Bi & Gi).

Marinetti, F. T. (1968). *Teoria e invenzione futurista*, ed. L. de Maria (Milan: Mondadori).

Marinetti, F. T. (2006). *Critical Writings*, ed. G. Berghaus (New York: Farrar, Straus and Giroux).

Pandolfi, V. (1954). *Antologia del grande attore* (Bari: Laterza).

Papini, G. (1977). *Opere* (Milan: Mondadori).

Ringbom, S. (1970). *The Sounding Cosmos: A Study in the Spiritualism of Kandinsky and the Genesis of Abstract Painting* (Åbo: ÅboAkademi)

Ringbom, S. (1982a). 'Kandinsky und das Okkulte', in A. Zweite (ed.), *Kandinsky und München* (Munich: Prestel), pp. 85–101.

Ringbom, S. (1982b) 'Die Steiner-Annotationen Kandinskys', in A. Zweite (ed.), *Kandinsky und München* (Munich: Prestel), pp. 102–5.

Soffici, A. (1915). *Giornale di bordo* (Florence: La Voce).

Soffici, A. (1955). *Fine di un mondo* (Florence: Vallecchi).

Tofano, S. (1947). 'Regia italiana di ieri', in S. D'Amico (ed.), *La regia teatrale* (Rome: Belardetti), pp. 181–97.

Verdone, M. (1969). *Teatro del tempo futurista* (Rome: Lerici).

Viviani, A. (1983). *Giubbe rosse* (Florence: Vallecchi).

Le Roi Bombance: the original Futurist cookbook?

Selena Daly

The themes of nutrition and digestion fascinated Filippo Tommaso Marinetti for much of his career. The beginnings of this interest can be traced to his pre-Futurist play *Le Roi Bombance*, published in 1905, in which the eponymous obese king is concerned only with satisfying his enormous appetite. Marinetti's most famous discussion of gastronomy and gastronomic habits came in 1932 with the publication of *La cucina futurista*, which was a development of the *Manifesto della cucina futurista* launched two years previously. Although *Le Roi Bombance* and *La cucina futurista* were born out of very different cultural and historical periods, I wish to suggest that a continuum of ideas exists between them, specifically with regard to the relationship between eating and creativity and between eating and identity. In a recent article, Enrico Cesaretti has proposed such a link between the two texts, writing that *La cucina futurista* could 'be considered as the 'logical' development of the culinary dystopia displayed in the nightmarish, 'hard to digest' and dyspeptic scenario of a text such as *Le Roi Bombance*' and continues that 'Marinetti may have eventually modulated the pessimistic, body-centered, progress-negating counter-utopia represented in his 1905 drama into a modern, mechanised, technologically obsessed and nature-taming "gastro-utopia [in the 1930s text]"' (Cesaretti 2009: 842–3). An analysis of both texts reveals that, despite the chronological distance between two works, certain ideas about a gastronomic revolution, which Marinetti articulated in *La cucina futurista*, had already been percolating from as early as 1905 and, thus, the French play must be acknowledged as an important precursor to aspects of the Italian cookbook.[1]

Both texts are positioned, consciously, in the shadows of two major preceding works, namely *Ubu Roi* by Alfred Jarry (1896) and *La scienza in cucina e l'arte di mangiar bene* by Pellegrino Artusi (1891), and yet they are also very much products of the time in which they were written and

show a desire to relate to the contemporary Italian political situation and not to become merely a pastiche of their literary and culinary predecessors. Prior to a discussion of the similarities which I believe are inherent between the two works, it is necessary to briefly contextualise them within their respective socio-political and cultural frameworks. The texts sprang forth not only from very different periods in Italian history but also from starkly contrasting periods of the Futurist movement.

Le Roi Bombance is not, strictly speaking, a Futurist work at all. Marinetti had conceived of the basic idea for the play in as early as 1902 (Berghaus 1995: 59). The play is part fairy tale, part grotesque farce and part social satire, considered by one literary critic of the time to be alternately lyrical, burlesque, fantastical and vulgar (Valdor 1907: 7). It is firmly situated in Marinetti's pre-Futurist, post-Symbolist phase and although it was first performed in April 1909, less than two months after the launch of the Founding Manifesto, it had not been influenced by Marinetti's new stance as a Futurist. Marinetti commented in 1920 that 'this fat-bellied king of mine stormed on to the Parisian stage, already bearing the scandal of Futurism in his symbols and grotesque actions'[2] (Marinetti 2002: 14). This, however, must be considered a revisionist stance on his part. After the first performance, which received an extremely critical response, he condemned the play and aligned himself with its detractors by uniting them all in their joint denunciation of it, writing:

> It is almost five years since I wrote this satiral tragedy, and I have never wished to present it to the public as a definitive expression of my art. *Le Roi Bombance* is not a plan, it is, I repeat, a work of youth, which does not appear to me very far removed from tradition … it is a work conceived in a traditional taste – conceived in bad taste, I hear you say. This satirical tragedy discusses the beauty of violent action, the march forwards towards the ideal banquet of universal Happiness; this proves that it is the work of a very young man. I willingly boo at it. You all booed at it. We are all futurists. (Marinetti 1960: 476–7)

Following the bad press the play received, Marinetti was far from claiming his corpulent king as a pioneer of his newly founded movement, finding it more convenient to reject him, and the whole play, completely.

The play is an allegory, critiquing the contemporary political situation in Italy, inspired by events that took place in the first years of the twentieth century during the 'age of Giolitti' (Mack Smith 1997: 193). The Italian translation of the play, *Re Baldoria*, published in 1910, is dedicated 'to the great cooks of Universal Happiness Filippo Turati, Enrico Ferri, Arturo Labriola' (Marinetti 2004: 9). The Socialists Turati and Ferri are portrayed by the so-called 'holy scullery boys' Béchamel and Syphon, while the revolutionary syndicalist Labriola is represented in the play by Estomacreux, the

leader of the starving citizens of the kingdom, the Bourdes. In the play, Béchamel and Syphon aim to achieve the socialisation of the means of culinary production and they try to inspire the hungry masses to revolt just as Filippo Turati and Enrico Ferri stirred up revolutionary fervour among the workers, which led to the general strike in Milan in 1904. (Marinetti had previously closely followed the social unrest in 1898, which had also been led by Turati.) Estomacreux tries to incite the Bourdes in *Le Roi Bombance* to violently revolt just as Labriola and his followers advocated violent action as a way to achieve their aims. None of Marinetti's revolutionaries, however, succeed in initiating any real change and at the end of the play the status quo has been restored, just as Giolitti's government retained power and was indeed strengthened by the failure of the Socialist-led general strike.

La cucina futurista was born out of a very different cultural and historical period. Marinetti announced the 'forthcoming launch of futurist cookery' (Marinetti and Fillia 1990: 18) after a Futurist-inspired banquet at the Penna d'Oca restaurant in Milan on 15 November 1930. The related manifesto, signed by Marinetti alone, appeared in the Turin-based newspaper *Gazzetta del Popolo* on 28 December of the same year. Undoubtedly Marinetti's most famous (or infamous) declaration of this manifesto, and certainly the one which caused the most controversy, was the proposed abolition of pasta (Marinetti and Fillia 1990: 18). Following the holding of a series of Futurist banquets, featuring Futurist cuisine in Italy and France Marinetti and Fillia[3] published *La cucina futurista*, which gathered together the original manifesto, press reports reacting to the movement, descriptions of the banquets and recipes for Futurist food and cocktails. Lesley Chamberlain has memorably described *La cucina futurista* as a 'serious joke' (Chamberlain 1989: 7) and while there is a comic element to many of the recipes and banquets described, which was undoubtedly part of Marinetti's instinct for self-promotion, there is still a coherent political and artistic theme which runs throughout the book.

La cucina futurista is a text that is deeply embedded in the rhetoric and ideology of the Fascist regime and, in some respects, can be interpreted as a critique of it. Preparing the masses for war was certainly one of Marinetti's primary intentions when he first envisaged his gastronomic revolution. He was convinced that 'in the likely event of future wars, it will be the most lithe, agile peoples who will be victorious ... we are establishing a diet in keeping with an increasingly airborne, faster pace of life' (Marinetti and Fillia 1990: 20; trans. Marinetti 2006: 395). Pasta was the principal target of Marinetti's culinary ire because it is not the food of soldiers (Marinetti and Fillia 1990: 37) and because, according to a Dott. Signorelli quoted in the Manifesto, it induced in the eater 'sluggishness, depression, inertia brought on by nostalgia, and neutralism' (Marinetti and Fillia 1990: 20;

trans. Marinetti 2006: 396). Clearly, none of these is a desirable trait for a Fascist or Futurist man on the brink of war. In pasta's stead, Marinetti advocated the use of rice, which had the fortunate advantage of being a patriotic foodstuff. The abolition of pasta would thus liberate Italy from the need to import costly foreign wheat and would help to promote the Italian rice industry. Marinetti's decision to favour rice, which could be easily produced in Italy, showed his desire to create an autarkic and self-sufficient Italian state. Marinetti used food as a 'tool of political dissent' (Helstosky 2003: 115) and his proposal in favour of the abolition of pasta was a reaction to Mussolini's agricultural policies, namely the *battaglia del grano*, which had begun in 1925. The battle for wheat was an economic and agricultural failure but a propaganda success. Marinetti's proposal to abolish pasta thus challenged Mussolini's policy by suggesting an alternative, and more pragmatic, means of achieving the same aim of self-sufficiency. There is also a thread of imperialism which runs throughout *La cucina futurista*. Although Marinetti did, of course, harbour expansionist dreams relating to the African continent, resulting both from his childhood spent in Egypt and his ardent nationalism, it must be noted that the two most overtly colonial sections of *La cucina futurista*, the *Pranzo sintesi d'Italia* and the *Pranzo desiderio bianco*, are both attributed to Fillia and not to Marinetti himself. Nonetheless, Marinetti did express a 'desire to interpret colonial motifs according to a modern and futurist sensibility' (Marinetti and Fillia 1990: 72), which belied an impatience with Mussolini's failure to push forward with colonial policies during the 1920s. In this way 'food became an urgent and visceral means to challenge the Fascist regime to do more for the sake of the nation' (Helstosky 2003:132).

Food and creativity

In the *Manifesto della cucina futurista*, Marinetti alluded to the interplay between food and art when he wrote 'what we think or dream or do is determined by what we eat and what we drink' (Marinetti and Fillia 1990: 19; trans. Marinetti 2006: 395). He touched on the same idea again in *La cucina futurista*, commenting that the influence of diet on creative impulses was a frequent topic of conversation among himself, Umberto Boccioni, Antonio Sant'Elia, Luigi Russolo and Giacomo Balla in the earliest years of the Futurist movement (Marinetti and Fillia 1990: 17). Marinetti had, however, already addressed this relationship between nutrition and creative production four years before the birth of Futurism, and twenty-seven years before the publication of *La cucina futurista*, in *Le Roi Bombance*. One of the central beliefs enshrined in *La cucina futurista* is that food should be divorced from the mere act of nourishing oneself and should instead be

explored as an aesthetic and artistic medium, capable of transcending its traditional dietary function. To this end, in the *Manifesto della cucina futurista*, Marinetti suggests that chemists should invent a method of administering the necessary calories in pill or powder form, which would be provided free of charge by the State (Marinetti and Fillia 1990: 21). This artificial means of nourishment would result in lower costs of living and salaries, and thus in a reduction in the hours in the working day.[4] He also predicted that the development of machines' capabilities would almost completely liberate people from manual labour, which in turn would 'allow the refinement and the exaltation of the other hours through thought, the arts, and the anticipation of perfect meals' (Marinetti and Fillia 1990: 21; trans. Marinetti 2006: 396).

The concept of artificial feeding is in fact an idea Marinetti had already considered in *Le Roi Bombance* twenty-five years earlier. In Act One, the King is desperate to restabilise the order of the kingdom's kitchens. Poulle-mouillet, one of the King's advisers, declares that Ripaille, the royal chef whose death has thrown the kingdom into turmoil, had carried to his grave the secret of those pills that calmed one's appetite, which he had distributed to the starving masses (Marinetti 1905: 25). Although the concept of artificial feeding through pills exists in both works, the pills envisaged in *Le Roi Bombance* did not have a transformative power on the lives of the citizens. These pills merely calmed the appetites of the Bourdes but did not have the effect of providing greater time for the pursuit of artistic endeavours.

According to *La cucina futurista*, the ideal Futurist man and diner would be freed from the demands of feeding himself in the traditional way and would therefore be able to devote his energies to higher goals, such as art and poetry. This figure does in fact have a prototype in *Le Roi Bombance*, in the form of the Idiot/Poet character. In the 1920 manifesto *Al di là del comunismo*, Marinetti suggested that the fusion of the artistic dynamism of the Idiot/Poet with the revolutionary dynamism of Estomacreux would bring about the only solution of the universal problem, namely 'all power to Art and to revolutionary Artists' (Marinetti 2005: 485; trans. Marinetti 2006: 348). Marinetti wrote that:

> We need to stimulate spiritual hunger that finds satiation in great, stupendous, and joyous art … Art must become the ideal nourishment to console and reanimate the most restless races, dissatisfied and deluded as they are by the eventual collapse of so many ideal yet insufficient banquets (Marinetti 2005: 485; trans Marinetti 2006: 347–8).

It is the Idiot in *Le Roi Bombance* who shares Marinetti's dream of exciting 'spiritual hunger', although he is ultimately unsuccessful in his aim. The

Idiot is the only character in the play who is not ruled by his body; he has a minute appetite and does not suffer any digestive troubles. His stomach is so small that a flower or a tear is enough to fill it (Marinetti 1905: 75). In his article 'Dyspepsia as Dystopia', Enrico Cesaretti identified the Idiot's lack of appetite as a kind of anorexia and suggested that the essence of *Le Roi Bombance* could be one that joins '"dyspepsia" and "dystopia" on one side and "anorexia" and "utopia" on the other' (Cesaretti 2006: 353). This is a persuasive argument up to a point. Certainly, the disturbed digestion of the King is linked to his *passatista* lifestyle filled with sleep and excessive consumption of food. The Idiot, however, is not an anorexic who refuses to eat but is a person whose appetite is sated quickly and who receives his nourishment from other sources, namely an artistic ideal, allowing him to strive for a utopian lifestyle – just as Marinetti would advocate in *Al di là del comunismo* in 1920 and later in *La cucina futurista*. The Idiot is nourished by substances other than food, such as sweet music and soft words (Marinetti 1905: 69). Although the Idiot offers the same sustenance to the citizens around him, he is doomed to be ignored and unheeded and the Bourdes continue in their endless cycle of eating, vomiting and re-ingesting.

It is possible to view the King and Père Bedaine, the royal chaplain, as the ultimate manifestations of *passéist* eaters that Marinetti so deplored in *La cucina futurista*. Their physical size is the most immediately visible aspect that sets them apart from the ideal Futurists imagined in the 1930s. The King's stomach hangs over his thighs, while the priest is praised for his mystical and warlike stomach that makes him appear pregnant. An article written in favour of Futurist cuisine, which was reprinted in *La cucina futurista*, expresses the need to rebuild the Italian man (Marinetti and Fillia 1990: 43). What is the use, the author Audisio asks, in requiring men to raise their arm in a Roman salute if he can rest it on his enormous stomach? Thus, Audisio declares that the modern man must have a flat stomach, in order to have clear thoughts and quick reflexes. The population of the Kingdom of the Bourdes in *Le Roi Bombance* is emblematic of the type of people whom Marinetti condemned in *La cucina futurista*. The Bourdes live only to gorge themselves and to be gluttonous. In the fourth act, having decried the fact that 'the sublime art of eating and drinking to excess has disappeared' (Marinetti 1905: 221), Père Bedaine outlines his theory of digestion, the basic thrust of which is that one must learn to stuff oneself in such a way as to never be forced to vomit. It is their method of eating that primarily influences their lifestyle; the Bourdes, and particularly Roi Bombance, are slow, sleepy, inept and passive – the antithesis of the model of the Futurist diner as laid out in the Cookbook but remarkably similar to the description of the Italian masses who stuffed themselves with pasta.

Pasta is singled out for criticism above all other foods because (as well as being anti-Italian) it is not easily digested, thus bloating the stomach and causing obesity. This however is only the physical effect of pasta, which I feel Marinetti regarded as less serious when compared with the dangerous psychological and emotional effects of this foodstuff. During the radio broadcast which launched Futurist cuisine, Marinetti announced that pasta was a *passéist* foodstuff because it 'weighs one down, makes one ugly, sceptical, slow and pessimistic' (Marinetti and Fillia 1990: 18). Traditional food impedes artistic expression – as was the case in the Kingdom of the Bourdes, where the only figure capable of rising above torpidity and general inactivity and of striving towards poetic creativity was the Idiot who was never hungry and rarely ate anything at all. Marinetti articulates this same idea in his description of one of the definitive Futurist dinners, the *Pranzo estivo di pittura-scultura*. He begins by describing how a painter or sculptor on a summer's afternoon might try and stimulate artistic inspiration by indulging in a traditional tasty meal. However, Marinetti warns that he will be weighed down and will have to walk around to try and digest his meal and as a result, 'between anxiety and cerebral pessimism, he will end up wasting the whole day artistically wandering about without creating any art' (Marinetti and Fillia 1990: 92).

In *La cucina futurista*, the separation of food and nutrition has further value than simply allowing people to devote more time to artistic pursuits. Once food is liberated from the constraints of having to provide nutrition, food itself can become an artistic medium and an aid to an artistic life. Thus, the process of eating assumes a theatrical and performative aspect. Associations between food and theatre have a long history within the Futurist movement, beginning, it has been argued (Berghaus 2001: 3–17; Salaris 1997: 291), with the impromptu banquets held after the *serate futuriste*. The first such banquet took place on 12 January 1910 in Trieste after the first *serata futurista* at the Politeama Rossetti. This banquet was a timidly anti-traditional affair in which the meal was served backwards beginning with coffee, moving on to desserts and fruit and passing through various other main courses before finishing with an antipasto and vermouth (Salaris 2000: 20). It was only in the 1930s that Futurist banquets were explored to their fullest potential and that their theatrical possibilities were exploited to the greatest extent. Günter Berghaus considers Futurist cuisine as a 'performative art' (Berghaus 2001: 12) and Giusi Baldissone has written that 'Futurist culinary art wanted to be a *happening* … [in which] the guests participated in a collective performance' (Baldissone 2009: 105).

Although critics have linked *La cucina futurista* to the post-*serate* banquets of the 1910s, the experience of Futurist banquets has not been extended further back to include the banquet that features in *Le Roi*

Bombance, however. The first half of Act Three, entitled 'L'Orgie', presents a banquet scene, prepared by Syphon, Béchamel and Torte, who are collectively labelled the cooks of universal happiness. This banquet, variously called the 'Ideal Banquet' (Marinetti 1905: 14) and 'Universal Banquet' (Marinetti 1905: 93), is described by Syphon as 'a satisfying and definitive banquet which will sate all appetites' (Marinetti 1905: 46). It can thus be argued that the first Futurist banquet took place on a Parisian stage in April 1909 during the premiere of *Le Roi Bombance*. Marinetti organised the 1930s banquets as a kind of 'savoury-olfactory-tactile theatre accompanied by music and poetry recitations' (Berghaus 2001: 3), a description also applicable to the scene he unveils in *Le Roi Bombance*. The banquet in *Le Roi Bombance* is a far more chaotic affair than the highly choreographed events described in *La cucina futurista*. Nonetheless, the banquet becomes a performative space and provides the climax for the whole play. Following the presentation of the roasted bodies of the King and his advisers as the culinary highlight of the meal, the banquet descends into a nightmarish scene of cannibalistic orgy.

Marinetti proposed that new states of mind could be created through his experiments with Futurist food. One of the principal methods was to bombard diners with sensory stimulation relating to all five senses and not just to taste, in order to confuse their expectations and to encourage them to experience eating in a new way. Marinetti's experimentation with the senses in *La cucina futurista*, aimed to confuse diners' sensory perception to such an extent that the distinction between them would appear arbitrary, and many of the dining experiences described border on a kind of willed synaesthesia. Synaesthesia has been defined as 'occurring when stimulation of one sensory modality automatically triggers a perception in a second modality, in the absence of any direct stimulation of this second modality' (Baron Cohen and Harrison 1997: 3). In *La cucina futurista*, Marinetti is most interested in exciting the senses of smell and touch, as well as obviously stimulating the taste-buds. Marinetti proposed a dinner during which the diners would not eat but would satisfy themselves with perfumes (Marinetti and Fillia 1990: 103). Fillia also experimented with creating specific dishes which would excite usually neglected senses. His *Aerovivanda tattile con rumori ed odori* begins with the use of perfumes to enhance the enjoyment of the food, while the second half of the experience instructs the diners to eat an olive, candied fruit and fennel while simultaneously stroking, with their left hand, a specially made board featuring a scrap of red damask, a piece of black velvet and a square of sandpaper (Marinetti and Fillia 1990: 63). A more extreme extension of this dish was the *Pranzo tattile*, based on tactile enjoyment of the food itself, including placing one's face in a dish of vegetables. This dinner also required all the diners to wear

a pair of pyjamas covered with different tactile materials, such as sponge, cork, sand paper, felt, sheets of aluminium, brushes, wire wool, cardboard, silk and velvet and concluded with diners being invited to 'nourish their fingertips' by stroking the pyjamas of their dining companions (Marinetti and Fillia 1990: 113).

However, long before *La cucina futurista*, Marinetti had already experimented with synaesthesia in *Le Roi Bombance*. At the beginning of Act One, when the King and his subjects are mourning the death of Ripaille and the subsequent loss of his wonderful sauces, the Idiot points out that the recipes are painted and embroidered on to the black velvet on the coffin. He then engages in a kind of synaesthesic experience when he says 'my eyes can taste them better than my lips!' (Marinetti 1905: 23). Shortly afterwards, Poullemouillet describes a sumptuous royal banquet, which the subjects observed in envy. The list of royal dishes was sewn on to banners that were carried around the hall and the style of the list was so tasty and sweet that all of the starving citizens licked their lips, to which Anguille replies that it would be more fitting for them to 'lick their ears' (Marinetti 1905: 33). The suggestions in *Le Roi Bombance* that taste can be experienced through visual and aural stimulation heralds Marinetti's more elaborate experiments with synaesthesia in *La cucina futurista*.

Food and identity

The motif of cannibalism is one common to both texts. The act of eating another person results in the complete domination of the devourer over the devoured. The anthropophagus is able to possess and conquer the 'other' that constitutes its human food. During the banquet scene, Roi Bombance, Père Bedaine, Anguille and the Idiot are all eaten by the Bourdes and subsequently vomited up during the fourth act. As Anguille comments, the cannibals 'held in their stomachs all the powers of the world ! Bombance, the power of this world! Bedaine, the power of the next world! [The Idiot] the impossible that cries! Me, the possible that laughs! Worldly Domination ... Heaven ... Dream ... Irony! (Marinetti 1905: 200). After the King and his allies have been regurgitated, Estomacreux, the leader of the opposition forces, seeks to re-ingest Roi Bombance, so that Justice, Equality and Liberty can reign at last in all stomachs and in all intestines (Marinetti 1905: 259). Estomacreux and his followers are doomed to fail, however, in their quest. The pessimistic conclusion of the play is that the Bourdes are destined to continue this eternal cycle of eating, vomiting and re-ingesting. Ptiokarum, the vampire son of the feared Moon Goddess, Sainte Pourriture, declares in the final lines of the play that the Bourdes will continue to improve their jaw bones in the act of eating one another,

and that this is the only progress possible (Marinetti 1905: 267). Even this cannibalism will never fully satisfy them, however, as 'because of their base materialism and anti-intellectual attitude, they are eternal enemies of art, poetry, and intellectual achievement' (Berghaus 1995: 64) and they cannot grasp the Idiot's concept that liberty is not something that can be eaten (Marinetti 1905: 250).

The object of possession resulting from the cannibalistic ritual differs in *La cucina futurista*. In 'Un Pranzo che evitò un suicidio', the section which opens the 1932 volume, Marinetti recounts his trip to Lake Trasimeno, along with Enrico Prampolini and Fillia to help their suicidal friend, given the pseudonym Giulio Onesti. In this case, it is the power of the feminine which must be dominated and controlled. Onesti had been abandoned by his lover and as an antidote to this heartbreak, Prampolini creates an edible sculpture of Onesti's lover (Marinetti and Fillia 1990: 9). Marinetti's fear of woman's power is a well-documented aspect of his rhetoric and manifests itself here in the need to eat, and thus destroy, the female body in order to eradicate the threat she poses to the men around her. Ingesting the sculpture of the female form results in the feminine power being imprisoned in the stomach. This anthropophagic ritual has a profound effect on Onesti. He feels himself to be at once 'empty and full … possessor and possessed' (Marinetti and Fillia 1990: 13). The image of eating women is not only a feature of *La cucina futurista* but is one which is evident in many of Marinetti's writings, among them *Come si seducono le donne* (1916) and the short story *Come si nutriva l'Ardito* (1930)[5] and demonstrates Marinetti's desire to dominate and destroy the female gender. As Cinzia Sartini-Blum has observed, 'the topos of erotic ingestion is played out by male anxieties regarding identity and power' (Sartini-Blum 1996: 97).

Michel Delville has made reference to the links between eating and identity in *La cucina futurista*, writing that 'the body in Futurist food aesthetics is … the site of a living experiment which questions the very notion of selfhood'. The authors' tendency to 'dissociate and individualise the guests' body parts … paves the way for a radical redefinition of body, art and world' (Delville 2007: 19). I believe that a similar link between food and identity can be established in relation to *Le Roi Bombance*, a connection Delville himself does not make. Marinetti's play features an analogous trend; the stomach is regularly considered as a completely separate entity from the body to which it is attached. Indeed, this idea is explicitly expressed by Crouton, who swears that Père Bedaine's stomach is detached from his body (Marinetti 1905: 17). More so than the mind or the heart, the stomach is the primary organ in the Kingdom of the Bourdes and is regularly elevated to a divine position. Roi Bombance is called 'the world's holy gut' (Marinetti 1905: 52) while the remainder of his body is presented

almost as an appendage to his stomach, which must take precedence over everything else.

Delville also relates this 'redefinition of body, art and world' to Marinetti and Fillia's interest in the insides of the human body. He notes that *Bianco e nero* is the only recipe to explicitly refer to the interior of the body. This recipe is for a cocktail (or *polibibita* to follow Marinetti's dictate regarding the use of Italian culinary terms in favour of foreign imports) which will be an 'individual exhibition played out on the internal walls of the stomach' (Marinetti and Fillia 1990: 141). However, Delville continues that 'the wealth of *stuffing* recipes contained in the Cookbook continually insists upon the necessity to consider corporeality as a fragile totality liable to be upset by the cook's transgression of inside and outside boundaries' (Delville 2007: 19). While there are only a few references to stuffing in strictly culinary terms in *Le Roi Bombance,* the act of stuffing is alluded to through the metaphorical language used throughout. Once the women of the kingdom have fled, for example, it leaves the men free to 'stuff themselves', and this verb 'empiffrer' appears many other times in the text. In the Italian translation of *Le Roi Bombance*, Père Bedaine becomes Fra Trippa – a name which in Italian means both tripe and, more informally, belly, thus drawing attention simultaneously to both the inside and the outside of the body.

Another kind of stuffing does however take place in *Le Roi Bombance*. The cannibalism in Act Three can be interpreted as the ultimate stuffing – one body being stuffed with another. I suggest, therefore, that corporeality is just as fragile a concept in Marinetti's French play as it is in his Italian Cookbook. The inviolability of the body is constantly threatened in *Le Roi Bombance*. People are eaten, then vomited up again and thus, our understanding of corporeal liminality is undermined. At the beginning of Act Four, the Bourdes are being tormented by the bodies that they ate during the banquet in the previous act. Once the bodies have been consumed, the eater's bodily integrity ceases to exist and his whole identity is compromised. The nature of the individual self is questioned in *Le Roi Bombance* when the eaten begin to corrupt their host bodies and take them over, speaking with their own voices from the stomach of the devourer. Thus, we are presented with the situation where there are two identities simultaneously residing inside the same body, a traumatic experience for both parties. For example, Estomacreux ate Roi Bombance so the latter's voice can be heard coming from Estomacreux's stomach. A similar situation features in Marinetti's short story 'Come si nutriva l'Ardito', when the soldier Guzzo carries the dismembered body of his beloved around with him and gradually eats it all. As a result of this cannibalistic act, he assumes also his lover's identity and speaks alternately with a tremulous female voice and with his own voice (Marinetti 2003: 263). The desire to eat her arose

from a deep-seated desire to possess, in its entirety, the female body, so that she could neither think nor see anyone else, nor ever escape (Marinetti 2003: 263).

A comment Marinetti made in 1938 in an article entitled 'Verso una imperiale arte cucinaria' is certainly relevant to the current analysis of Futurist experimentation with food. He wrote, 'Is it not time to declare culinary art as noble and attractive as poetry, painting, music and architecture, or in other words capable of creating spiritual harmonies worthy of admiration and susceptible to infinite evolution?' (Salaris 2000: 140). *La cucina futurista* was of course Marinetti's ultimate manifestation of this aim to render cuisine a noble art form. In *Le Roi Bombance* of 1905 Marinetti had not yet conceived of food as an art form, but rather viewed the separation of food and nutrition as a method of encouraging greater participation in traditional artistic pursuits. Nevertheless, the play constitutes Marinetti's first exploration of the interaction between food and art, which would be refined and developed through his experiments with Futurist cuisine in the 1930s.

Notes

1 An earlier version of this chapter (under the same title) was presented at the *Back to the Futurists* conference at Queen Mary University of London in July 2009. The formulation of my hypothesis regarding a link between *Le Roi Bombance* and *La cucina futurista* was not therefore influenced by Enrico Cesaretti's article, published only in November 2009.
2 This translation is taken from F. T. Marinetti (2006: 8).
3 Fillia (also Fillìa) was the pseudonym of the Futurist painter Luigi Colombo (1904–36).
4 In the manifesto 'Per una società di protezione delle macchine', published in *La Fiera Letteraria* (24 April 1927), Fedele Azari (1992: 95–9) had also predicted that artificial nutrition would become the way of the future.
5 This short story first appeared in the collection *Gli amori futuristi* in 1922 entitled *La carne congelata*. The title was changed in 1930 when it was included in the collection *Novelle con le labbra tinte*.

References

Azari, F. (1992). 'Per una società di protezione delle macchine', in L. Collarile (ed.), *Fedele Azari: Vita simultanea futurista*, exhibition catalogue (Trento: Museo Aeronautico G. Caproni), pp. 95–9.

Baldissone, G. (2009). *Filippo Tommaso Marinetti* (Milan: Mursia).

Baron Cohen, S. and J. E. Harrison (eds) (1997). *Synaesthesia: Classic and Contemporary Readings* (Oxford: Blackwell).

Berghaus, G. (1995). *The Genesis of Futurism: Marinetti's Early Career and Writings 1899–1909* (Leeds: Society for Italian Studies, no. 168).

Berghaus, G. (2001). 'The Futurist Banquet: Nouvelle Cuisine or Performance Art?' *New Theatre Quarterly*, 17, 3–17.

Cesaretti, E. (2006). 'Dyspepsia as Dystopia? F. T. Marinetti's *Le Roi Bombance*', *Romanic Review*, 97:3–4, 353–69.

Cesaretti, E. (2009). 'Recipes for the Future: Traces of Past Utopias in *The Futurist Cookbook*', *The European Legacy*, 14:7, 841–56.

Chamberlain, L. (1989). 'Introduction', in *The Futurist Cookbook*, trans. S. Brill (London: Trefoil).

Delville, M. (2007). 'Contro la pastasciutta: Marinetti's Futurist Lunch', *Interval(le)s*, 1–2, 14–24.

Helstosky, C. (2003). 'Recipe for the Nation: Reading Italian History through *La Scienza in cucina* and *La Cucina futurista*', *Food and Foodways*, 11, 113–40.

Mack Smith, D. (1997). *Modern Italy: A Political History* (New Haven and London: Yale University Press) (reprinted 2003).

Marinetti, F. T. (1905). *Le Roi Bombance* (Paris: Mercure de France).

Marinetti, F. T. (1960). *Teatro*, ed. G. Calendoli (Rome: Vito Bianco Editore).

Marinetti, F. T. (2002). *Scatole d'amore in conserva* (Florence: Vallecchi, 2002).

Marinetti, F. T. (2003). 'Come si nutriva l'Ardito', in *Novelle con le labbra tinte* (Florence: Vallecchi).

Marinetti, F. T. (2004). 'Re Baldoria', in *Teatro*, ed. J. T. Schnapp (Milan: Mondadori), pp. 5–173.

Marinetti, F. T. (2005). 'Al di là del comunismo', in L. De Maria (ed.), *Teoria e invenzione futurista* (Milan: Mondadori), pp. 473–88.

Marinetti, F. T. (2006). *Critical Writings*, ed. G. Berghaus, trans. D. Thompson (New York: Farrar, Straus and Giroux).

Marinetti, F. T. and Fillia. (1990). *La cucina futurista* (Rome: Banca Tiberina di Mutuo Soccorso).

Salaris, C. (1997). *Marinetti: arte e vita futurista* (Rome: Editori Riuniti).

Salaris, C. (2000). *Cibo futurista: dalla cucina nell'arte all'arte in cucina* (Rome: Stampa alternativa).

Sartini-Blum, C. (1996). *The Other Modernism: F. T. Marinetti's Futurist Fiction of Power* (Berkeley and Los Angeles: University of California Press).

Valdor, E. (1907). 'La Balance', *Poesia*, 2:5–8, 7.

The cult of the 'expressive' in Italian Futurist poetry: new challenges to reading

John J. White

Three years after publishing his *Foundation and Manifesto of Futurism* in 1909, Filippo Tommaso Marinetti began to set out his proposals for making Futurist poetry more 'expressive'. Accompanied by the caveat that his recommendations were 'neither categorical nor systematic' (Marinetti 2006: 124),[1] Marinetti's *Technical Manifesto of Futurist Literature* offered a series of practical guidelines in what was to become the first of a whole wave of specialised literary manifestos intended to complement those on painting, sculpture, drama, music and the much-vaunted Futurist sensibility. Equally radical instalments followed in the manifestos *Destruction of Syntax – Wireless Imagination – Words-in-Freedom* (1913), *Geometrical and Mechanical Splendor and Sensitivity toward Numbers* (1914) and *Futurist Reconstruction of the Universe* (1915), each suggesting a number of ingenious ways in which the 'expressive' potential of 'words-in-freedom' (*parole in libertà*) could be realised or offering recommendations for 'increasing expressive lyrical force' (Marinetti 2006: 138). Marinetti's authority as Italian Futurism's spokesman in all matters literary and artistic, coupled with his unrivalled status as the movement's leading avant-garde poet, furnished him with an ideal platform from which to launch his strenuous crusade on behalf of, *inter alia*, radical syntactical pruning, bold acoustic and visual effects, what he presented as *fait accompli* 'revolutions' in Futurist spelling and typography, as well as new group-specific literary genres such as free-word pictures (*dipinti paroliberi)*, free-word tables (*tavole parolibere*), verbal collages, mini-dramas (*sintesi*) and aero-poetry (*aeropoesia*).

Until the onset of the First World War, Futurism's literary manifestos tended to focus on what could be achieved by horizontal-linear words-in-freedom, claims mainly illustrated with examples from Marinetti's own published work. However, the concomitant theorising tended to lack rigour, even when judged by the standards of the time. As Marinetti himself

confessed, it was frequently 'arrived at intuitively and [was thus] difficult to demonstrate' (Marinetti 2006: 138). It was on the whole neither 'systematic' nor 'absolute' (Marinetti 2006: 113); and, despite the manifestos' manner and tone of delivery, it was emphatically 'not categorical', according to Marinetti (Marinetti 2006: 127). Many innovative possibilities were showcased using simple explanatory models, an understandable ploy under the circumstances, given that the movement's best poetic works were still to come. Moreover, the fact that Futurist manifestos were notoriously both formulated and delivered for provocative effect may account for the extreme positions adopted in some of them. For example, the suggestion that Futurist poets should create bold new analogies via nominal juxtapositions and then omit the first noun in each pairing; the familiar mantra according to which jettisoning superfluous parts of speech would automatically guarantee 'essentialism' of poetic discourse; or Marinetti's contrived four-part typology of onomatopoeias (Marinetti 2006: 140–1). The role played by intuition in Futurist manifesto-conception is often reflected in the lack of any strictly hierarchical order to the key proposals enumerated, the striking inconsistencies from one manifesto to the next, the theoretical works' various internal contradictions, and the anecdotal-cum-rhetorical mode of discourse adopted in some of the early manifestos. Unconstrained by Marinetti's draconian proposals, many Futurist poets chose to go their own 'Futurist' ways. As a consequence, some of Italian Futurism's most accomplished *parole in libertà* and *dipinti paroliberi* display a marked reluctance to follow the leading literary manifestos either in letter or in spirit. As a consequence, what have rightly been called the works of Marinetti's 'mature style' (Poggi 1992: 230) brilliantly transcend many of his early embryonic guidelines. Although he had initially sought to emphasise the importance of a horizontal-linear, syntactically pruned template for his new 'words-in-freedom', Marinetti himself soon started to experiment with configurations containing virtually no complete sentences and now departing radically from conventional (*passéist*) linearity. Of course, being out of step with one's prior literary prescriptions was hardly a problem, given that this could be read as meaning that Marinetti's own early manifestos had fulfilled their original purpose, namely to encourage and disseminate new forms of visual and typographical experimentation and to prepare the theoretical ground for new poetic sub-genres and the kind of inter-medial cross-fertilisation that had been less to the fore in the early years. The danger, as Marinetti implies (Marinetti 2006: 124), was experiment for experiment's sake, regardless of Futurism's true poetological and political goals. Fortunately, as we shall see, the cult of 'expressivity' in all its diverse forms and modalities gradually took free-word experimentation – and shaped poetry in general – in a number of fresh directions and in doing so it reinvigorated the Futurist aesthetic.

Marinetti's overarching concern with making Futurist language 'expressive' first surfaces in the section of his *Technical Manifesto of Futurist Literature* concerning *passéist* poetry's 'fatal time-wasting which destroys the expressive value [of a work as well as] its power to amaze' (Marinetti 2006: 109). Subsequently appearing in the context of 'liberating', 'enlivening' or making words-in-freedom more 'essential', this concern remained a theoretical *sine qua non* throughout the so-called 'heroic period' of Italian Futurism. It had first emerged in the sections on 'free expressive orthography' in the *Destruction of Syntax* manifesto (Marinetti 2006: 130) and their counterparts on 'freely expressive typography' in *Geometrical and Mechanical Splendor* (Marinetti 2006: 139). Thereafter it continued to be echoed in various reformulations at least up to the thoughts about 'liberating the cinema as a means of expression' and 'multifaceted expressiveness' in *The Futurist Cinema* of 1916 (Marinetti 2006: 261). As this range of manifesto proposals suggests, the terms 'expressive' and 'expressivity' remained suitably protean for Marinetti's theoretical purposes.

Initially, 'expressivity' tended to be associated with scripting poetic performance; after all Futurist words-in-freedom came into their own only when performed (ideally by Marinetti, Cangiullo or Armando Mazza). Typographical markers and elastic spelling were used to indicate the performer's appropriate 'facial expressions and other gestures' (Marinetti 2006: 139 and 194). 'Expressive' in this sense was a matter of facial codes, body language and above all acoustic delivery (Marinetti 2006: 115–16 and 193–9). Elsewhere it was simply code for the act of communicating the Futurist sensibility to the unenlightened or replicating 'the expressive cries of the violent life that surround us' (Marinetti 2006: 113). On some rare occasions it had more specific genre connotations, as for example when Marinetti recommended 'synoptic tables' as a 'means of increasing the lyrical force' of words-in-freedom (Marinetti 2006: 138). Surprisingly, one rarely finds the adjective 'expressive' being used comparatively, though Marinetti did at one stage (Marinetti 2006: 139) present a 'designed analogy' in *Zang Tumb Tumb* as a 'higher form of expression' – presumably in contrast even to the surrounding revolutionary words-in-freedom as well as what Marinetti once dismissed as 'commonplaces expressed typographically' (Marinetti 2006: 124). As all this suggests, 'expressive' had more connotations within the Italian Futurist movement than it retains in modern usage. Sometimes the meaning can be determined from the context. Elsewhere 'expressive' appears to be little more than a modish buzz-word or a literary call-to-arms. It was also a way of implying a major difference between Futurism's words-in-freedom and the post-Symbolist – and at times overly rhapsodic – proto-Futurist language that had preceded them. But, of course, it is the degree and quality of that difference that is of the utmost importance.

In what follows, I wish to look at a series of arguably unique examples of innovative 'expressivity' in some of the Italian Futurist movement's best-known shaped free-word poems and *dipinti paroliberi*. The emphasis will be on the works' amazing variety (as well as their power to amaze) and, equally important to my approach, on their generic or technical uniqueness. While their respective techniques are *sui generis*, the works in question were on the whole deployed in the service of common patriotic causes. Each of my examples was, for historical reasons, very much a product of the political phase of literary Futurism at a time when eye-catching propaganda content (i.e. politics 'expressively' mediated) was more important than one further attempt to invoke the Futurist sensibility or exploit what would nowadays be called 'the shock of the new'. By common consent, each work to be looked at marks an advance in the development of *parole in libertà* and, partly for this reason, each stands head and shoulders above the kind of mechanical free-wordism for which the early manifestos at times appear to give theoretical *carte blanche*. As a consequence, every one of my examples demands a bolder – at times heuristic – new reading strategy than was usually required in the case of horizontal-linear words-in-freedom. Such new reading strategies also require a methodological approach able to do more justice to the works' contemporary political context than most interpretations have done hitherto. That is to say, the examples that follow must be seen in terms of their contribution to the political campaigns that were a feature of Futurist activity in the second decade of the twentieth century (Berghaus 1996).

'Expressive' poetry in a geo-political cause: Parole in libertà (Irredentismo)

Following hard on the outbreak of the First World War, Marinetti produced one of his earliest political poems.[2] Its title, *Parole in libertà (Irredentismo)*, combines a typically Futurist genre attribution with a reference to the poem's historical context in a way intended to imply that Italy's disputed territories needed to be liberated by Irredentist Futurists, just as the country's *passéist* language had been. His subsequent introduction to *Les mots en liberté futuristes* makes clear that Marinetti regarded both in parallel as important patriotic causes (Marinetti 1919: 9–10). However, whether his primary concern at the time was with the resurgent Irredentist campaign or with war *per se* is a more difficult question to answer than was the case with such early Futurist tracts as *War, the World's Only Hygiene* and *The Meaning of War for Futurism*. Appealing to Irredentist sentiments was undoubtedly an effective way of strengthening the parallel Interventionist cause.

Deriving its name from the phrase 'Italia irredenta' [unredeemed Italy], what Marinetti once referred to as 'classical Irredentism' (Marinetti 2006: 240 and 322) was a right-wing political movement that campaigned for the 'redemption' (i.e. re-annexation) of disputed territories claimed by Italy yet at the time still under Austro-Hungarian rule. Although the movement's territorial campaign had been necessarily toned down following the ratification of the Triple Alliance between Italy, Austria-Hungary and Germany in 1882, Irredentism once more surfaced with renewed vigour at the time of the Futurists' Interventionist attempts to persuade the Italian government to enter the war on the side of the Entente powers (Britain, France and Russia). The Irredentist question also figured prominently in the Futurists' political demonstrations of 1914–15 as part of the movement's longstanding crusade against Austria-Hungary and Wilhelmine Germany. Geo-politics thus became an ideal subject for Marinetti's first free-word map-poem.

Maps figure in a number of Futurist collages, most effectively in Paolo Buzzi's *Conflagrazione* (1915–18) (Caruso and Martini 1974: 94–5). However, in *Parole in libertà (Irredentismo)* authentic map material is not juxtaposed with words, as it tends to be in Buzzi's collages. Instead, a sketch-map merely delineates the specific territories concerning which – and across which – the poem's imaginary battle is to be fought by liberated words and aggressive visual configurations. This is a classic illustration of what Marinetti once referred to as 'the lyricism that seizes hold of the reader ... with its aerial sketches of the landscape, its battles between typographical characters, and its onomatopoeic fusillades' (Marinetti 2006: 235). That the Italian peninsula is in this case presented as incomplete at its southernmost end possibly symbolises unfinished business regarding Italy's expansionist aspirations *vis-à-vis* North Africa.[3] Whatever the subtext of such local details, a rudimentary outline-map is undeniably the dominant feature of Marinetti's visual propaganda exercise. Take the map away and both images and words are deprived of thematic focus and interpretation becomes well nigh impossible. With Italy and Austria acting as focal points (as if on a campaign-map), Irredentism acquires the requisite geopolitical specificity and the poem metamorphoses into a powerful propaganda directive, ultimately the result of 'expressive' interfacing between dominant map-paradigm and boldly simplistic cartographic labelling. That said, the map's explanatory components do still require further comment, if the twenty-first-century reader is to understand what is being visually enacted.

In the top-left quarter of Marinetti's work, a series of hand-drawn variations on the word 'IRREDENTISMO' converge to form a hostile wedge pointing north-eastwards towards Vienna, as well as in the general direction of Austria, Italy's longstanding *bête-noire*. Standing out prominently within this wedge is the name 'Mazzini', the word's bold print reinforcing the

poem's variations on the word 'IRREDENTISMO'. Giuseppe Mazzini (1805–72), one of the guiding forces behind the Italian Risorgimento, is invoked in order to add legitimacy to early twentieth-century Italy's revival of the Irredentist cause. (The Pro Italia Irredenta Society even presented its goal as the ultimate fulfilment of the Risorgimento project.) At the time when Marinetti's collage was created, Italian Irredentists were vociferously calling for the restitution of Trieste and Fiume, two cities that had been reduced to the ignominious role of mere seaports for landlocked Austro-Hungary. This is why they are the only Italian ones to be named on Marinetti's map-poem and why the Trento region is delineated merely by the presence of a broken line, as if to emphasise its provisional status. *Parole in libertà (Irredentismo)* is in fact a Futurist poet's attempt to galvanise armchair Irredentists into action by presenting them with an 'expressively' formulated plan of action. As part of its empathic strategy, the work is also cleverly designed to transform many of its Italian readers into Irredentism's shock-troops in the making.

This is where the work's dynamic force-lines become important (Poggi 1992: 170–8; White 2010: 195–217). At top right of the layout, the italicised verb 'ripigliare' [to retake or begin again] points forward to the bold, larger-type word 'avanzata' [advance], itself giving way to a flight of thick hand-drawn directional arrows such as one might find on a plan of action. A precise military scenario now replaces geo-political sabre-rattling. The position of the noun 'avanzata' identifies the territory over which the Italian expeditionary force must advance. The words 'austria' (in lower-case) and 'Vienna' (upper-case, but in small, spidery handwriting) come across as static by comparison with the typographical flurry of Italian military activity going on around them. This agitated sector of the map-poem is not to be equated with Marinetti's well-known eyewitness reports from the front (hopes for any such front were at the time little more than Irredentist wishful thinking). Rather, it is an indication of what Marinetti and his fellow Futurists still hoped would soon happen. Yet instead of simply identifying the general path of attack, the numerous arrows flying across *Parole in libertà (Irredentismo)* at the same time emphasise the absence of any reciprocating Austrian counter-attack in the other direction. What is more, the positioning of the dark invasive arrows seems to presage an Italian strike reaching *deep into Austria*, not just the liberation of the named disputed territories with which Irredentism is traditionally associated. The multiple arrow-shapes also give the impression of a swift, unstoppable campaign. The implicit message contained in this part of the work is that some pre-emptive form of Blitzkrieg attack promises to be decisive and not necessarily costly in Italian lives.

One particularly innovative (and hence 'expressive') feature of the work is

its use of perspective. Linda Landis once suggested that the use of maps in words-in-freedom had a tendency to establish a quasi-aerial vantage point, just as aero-poetry effectively 'reduced the battlefield to a two-dimensional map' (Landis 1983: 60). But if, instead of opting for a similar 'aerial' reading, we interpret the work as representing a marked-up military map or battle-plan, it can hardly refer to some battle fought in the near-distant past (as much of Marinetti's earlier war poetry did) or in the present (unlikely in a prewar context). Rather, it challenges patriotic Italians to ensure that what is indicated on the map-poem is the course that future territorial re-annexation must eventually take.

Although glaringly minimalist in execution, Marinetti's *Parole in libertà (Irredentismo)* is a milestone in Futurist verbal map-collage. Individual words and signs have been strategically positioned so as to evoke dynamic propaganda slogans and simultaneously to represent armies on the move. The resultant amalgam of indexical and cartographic elements has the virtue, like many of the Futurist propaganda works of the period, of being both politically challenging and unambiguous (Poggi 1997: 17–62). Irredentism stands at the heart of the work, rather than losing its specificity among a welter of other Futurist-sponsored ideological causes.

An *Interventionist* Dipinto parolibero: Cangiullo's Milan-Demonstration

Italian Futurism's literary manifestos make no reference at all to the *dipinto libero*'s 'expressive' interplay between free-word configurations and graphic elements; indeed, they have precious little to say about the *dipinto libero*'s achievements in general. This is a surprising omission, given that some of the movement's most effective visual experiments are to be found in this area. In contrast to the above minimalist Irredentist example, my next illustration might be said to successfully combine propaganda impact with the 'power to amaze'.

Unlike his better-known *Tavola parolibera* of the previous year (Poggi 1992: 216; Rainey, Poggi and Wittman 2009: 260). Francesco Cangiullo's *Milano-Dimostrazione (Sensazione futurista)* of 1915 (Caruso and Martini 1974: 87) (hereafter referred to as *Milan-Demonstration*) brings together verbal, numerical and graphic elements for a cumulatively 'expressive' propaganda purpose. As its title suggests, the subject is again political: this time a mass demonstration calling for Italy's entry into the War on the Entente side. References to the Piazza del Duomo, the Victor Emmanuel Arcade and an equestrian statue of King Victor Emmanuel III, one of Interventionism's most ardent supporters, identify both date and location. The surrounding buildings are festooned with the national tricolour which

some agitators are also waving. The most striking feature of this work is, of course, the innovative way in which the mass of demonstrators is represented by lines of words of varying degrees of boldness (lines of slogans, but seldom sentences, it should be noted). Compared with what we know about the actual Futurist political demonstrations of the time (Marinetti 2006: 226–8; Cangiullo 1961: 207–16; Berghaus 1996: 75–80), the words arranged in rows in the lower half of Cangiullo's work are on the whole relatively ordered. Diagonally layered verbal sequences represent serried ranks of demonstrators, with the words nearest the bottom arranged in spaced-out rows so as to make their chanted slogans easy to read. Verisimilitude is in this respect sacrificed to legibility, as naturally befits a serious visual work of political propaganda.

The conventional top-down, left-to-right reading process is effectively subverted in this case. After we have registered the overhead title and generic subtitle, our attention is immediately propelled towards the bottom of the work, the obvious starting-point for the process of working upwards line by line. The densely crowded slogans predictably include the phrases 'long live war', 'down with Austria, Germany and Turkey', 'long live the King' (i.e. Victor Emmanuel III) and 'long live Salandra'. (In a surprising U-turn, Antonio Salandra, the Italian Prime Minister who had originally declared his country's neutrality at the start of the First World War, campaigned for its entry into the war in 1915.) Cangiullo's distillation of political slogans strikingly conveys the patriotic sentiments of the demonstrating Interventionists and their Futurist allies while simultaneously representing the chanting protesters themselves. This still happens, even in the upper reaches of the crowd image near the equestrian statue. Thanks to an almost Cubist shift in perspective, we can even look right along the Victor Emmanuel Arcade and witness the extent to which the mass demonstration reaches out well beyond the Piazza itself. Admittedly, we may no longer be able to identify individual words (the demonstrators they represent are too distant for that and their shouts have gradually become visually indecipherable). But the work's foreground details remain unequivocal.

A quarter of the way up the left side of the assembled crowd depicted in *Milan-Demonstration*, one finds a politically remarkable sequence. The line beginning with the chant 'Viva Mussolini' has been challengingly placed in front of the slogan 'Viva Marinetti'. Benito Mussolini may take pride of place; the dominant reading direction guarantees that we encounter his name first. Yet it is also possible to interpret Marinetti's significant position as an indication that, after Mussolini, he is the person the crowd actually identifies with the Interventionist campaign. Incidentally, this is the first poem to present the two men of the political moment demonstrating in a common cause. While Marinetti is never subsequently airbrushed out

of the picture, Cangiullo's work itself discreetly disappeared into a private collection.

Milan-Demonstration is one of the Italian Futurist movement's most memorable exercises in the harnessing of perspective and implied spatial depth for a politically 'expressive' purpose. The desired effect is achieved via a series of – for literary collage *unique* – devices. These include: systematic layering, the suggestion of lines of convergence, the dominant contrast between legibility and visual entanglement-cum-illegibility, the codification of size of character and alphabetical blurring to reinforce our sense of nearness or distance, and the familiar Futurist code, according to which typographical size and thickness register volume of noise and degree of importance (White 2003: 105–27). The Milanese political demonstration is presented from an elevated vantage point, not from down in the crowd among the various groups of participants. This creates in readers the impression of suddenly finding themselves standing alongside Marinetti and Mussolini (and, in spirit, Victor Emmanuel III) as they observe the demonstration they helped orchestrate. Perspective thus becomes part of the work's political rhetoric. The observers' receiving from on high the demonstrators' chanted slogans encourages reader-identification with the campaign's leaders. The work's overall aesthetic effect is excitedly rhetorical rather than reasoned, as befits the occasion.

Sadly, neither Marinetti nor Cangiullo has anything to say about this ground-breaking piece of 'expressive' political propaganda, a *dipinto parolibero* surely worthy of a place alongside Carlo Carrà's verbal collage-picture *Festa patriottica* (1914), about which Willard Bohn has taught us so much (1979: 246–71; 1986: 9–14, 24–8 and 69–70).

Après la Marne, Joffre visita le front en auto (After the Marne, Joffre visited the front in an automobile)

Although the 1914–15 phase of politicised literary Futurism brought with it a sizeable crop of Interventionist war poems and *dipinti paroliberi*, it was Italy's belated entry into the First World War that inspired Marinetti's most 'expressive' achievements in this area, 'expressive' in that they combined detailed historical content with explicit propaganda value. To test this claim, I shall look at three of his best works, starting with *Après la Marne, Joffre visita le front en auto* of 1915 (hereafter referred to as *After the Marne*). Composed during the First World War (in two cases at the front), all three works were eventually to assume pride of place in Marinetti's retrospective collection *Les mots en liberté futuristes* (Marinetti 1919: 99, 95 and 103).

In some respects, a quasi-mimetic work like Cangiullo's *Milan-Demonstration* is more like a snapshot than the kind of evolving narrative

one finds in Marinetti's *Zang tumb tumb* and some of his early war-reportage poems. Even in Carrà's dynamically organised *dipinto parolibero Festa patriottica* (alternative title: *Manifestazione interventista*), the event depicted tends to be the result of a relatively constant (albeit rotating) aerial perspective. In contrast, *After the Marne* is constructed using an essentially linear template.

Before this feature can be appreciated, it is necessary to bear in mind the main aspects of the work's contemporary context. Italy finally entered the war on 24 May 1915, i.e. the year *After the Marne* is dated. Whether we decide on this ground that it is, strictly speaking, an Interventionist work or one postdating Italy's neutrality will influence our reading. The one element common to the original title (*mountains + valleys + roads X joffre*)[4] and the long, conventionally formulated replacement one is 'Joffre'. Only Joffre's victory at the First Battle of the Marne in September 1914 accounts for his name being mentioned in *After the Marne*. Circumstantial evidence suggests that Marinetti's work was a product of the period January–February 1915. It was published in February 1915 in the booklet advertising *I paroliberi futuristi* (Coffin Hanson 1983: 76–117).[5] The chronology makes sense, given the fact that such a work would have quickly become an anachronism once the Italian Interventionists' call-to-arms had been answered in May 1915.

Marinetti could in any case not have seen action during the First Battle of the Marne, hence *After the Marne* is no work of eyewitness war-reportage in the manner of many of his earlier war-poems. At best, the work's author can only have shared (albeit vicariously) in the rapturous celebrations of the French soldiers and civilians greeting the victorious French General Josef Jacques Joffre (1852–1931) on his triumphal motorcade tour of frontline positions in mid-September 1914. Yet as an ardent Interventionist, Marinetti can have experienced few qualms when it came to exploiting French elation in the service of the Italian Futurists' increasingly energetic Interventionist campaign, an example (in his words) of the fact that war was 'an intensified form of Futurism', 'the finest Futurist poem' (*The Futurists, the First Interventionists: Manifesto of Italian Pride The Meaning of War for Futurism*. Marinetti 2006: 228; 241). In *The Futurists, the First Interventionists* of 1929, Marinetti recalled that 'while the Battle of the Marne was raging and Italy remained completely neutral, we Futurists organised the first two demonstrations against Austria and in favour of Intervention' (2006: 226). 'This present war', he claimed, 'is the finest Futurist poem that has materialised up to now' (2006: 234–35). In the year of its creation, *After the Marne* was as much an anti-neutralist demonstration as Cangiullo's *Milan-Demonstration* and Carrà's *Festa patriottica* were. Like them, it too involved its readers by inducing them to share the elation of a bonding cause and a battle won.

The work's combination of borrowed triumphalism and stage-managed empathy essentially results from the extended metaphor of a victorious lap of honour across another map-like surface. But in contrast to that in *Parole in libertà (Irredentismo)*, the cartographic dimension is in this case noticeably more schematic and underdetermined. Details are less easy to decode, and as a consequence the few available readings of the work have been more subjective than they were in previous cases. To start with the basic visual configuration: the word 'France' (in the top-right corner of the work) is geographically located where Paris stands in relation to the shielding Marne Front. References to the Prussians and 'WAR' are situated to the south, and Joffre's itinerary is represented by a snaking line running from the various mountainous M-shapes down through the war-zone to where his tour of honour terminates in the bottom-left corner of the work. The use of the journey topos is crucial to ensuring that readers retracing his route empathise with the victorious general as he acknowledges his celebrating troops. There is an enigmatic cluster of letter Ms surrounding 'FRANCE' in the top-left corner of the work, the location from which the anti-German war-slogans appear to be coming. Perhaps the multiple letter Ms represent the mountains mentioned in the collage's original title (if so, this particular geographical feature also seems to be symbolically protecting France from the Prussians); or they could refer to the River Marne itself. Yet M might also stand for another equally important presence in the work: that of Marinetti himself. By seeming to project himself on to the identificatory figure of General Joffre, Marinetti (along with his readers) 'becomes' the person triumphantly greeting France's representative soldiers and civilian inhabitants as 'Mon AMiiiii' and 'MaAA AAa petite'. The protracted meandering journey encourages readers to take a privileged part in the unfolding scene, not as observers but by the act of themselves empathically becoming the cavalcade's centre of attention. (This time perspective is more a psychological feature than a physical dimension of the work.) Empathy arrived at in such a way becomes an effective 'expressive' ingredient in a contemporary work of pro-war propaganda.[6] Marinetti's nationalist picture of war as celebrated victory, a typographical landscape where crosses represent lives heroically sacrificed rather than intolerable losses measured in gravestones, and where an internationally famous military leader's triumphant visit to his front-line troops is by implication more invigorating than nature's tired romantic mountains, valleys and river-banks referred to in the work's original title.

Although this striking visual poem makes its principal political point by facilitating empathy, we should not forget, as Marinetti clearly chose to, that the outcome of the First Battle of the Marne was at best merely 'a psychological, rather than a physical victory', in the words of Liddell Hart (1973: 111).

Bataille à 9 étages du Mont Altissimo (Battle at 9 Levels of Mount Altissimo)

Unlike my previous examples, which stood at best in a mediated relationship to war, Marinetti's *Battle at 9 Levels of Mount Altissimo* (hereafter referred to as *Battle at 9 Levels*) returns Futurist war-poetry to its original firsthand experiencing and reporting functions. The phrase 'at 9 Levels' would seem to refer to elevation levels, as relevant to a gun-battery's range-finder. The emphasis is now on precision: the enemy is kept at bay and warfare has become more mechanised and calculated than in Marinetti's early poems. The fact that modern warfare has moved on since the days of works like *The Battle of Tripoli* and *Zang Tumb Tumb* is reflected in this innovative poem's mathematically ordered elements. Thanks to an ingenious system of calibrated stratification (highly appropriate to the rationalised military context), the focus is no longer on battle proper but on contemporary Italy's preparedness for self-defence and counter-engagement.

In terms of making genre 'expressive', one important feature of the present work is the systematic way in which it is structured to give a vertical cross-section rather than something akin to aero-poetry's view from above: that is to say, a cross-section of the mountains on either side and of Lake Garda in the middle, a picture not from a position looking down on the lake-surface, but one presented in the form of a cross-slice or *tranche*,[7] the dark cluster of words in the lowest part of the configuration offering a new perspective on the Garda Valley and the surrounding mountains. Superimposed on this cross-section and contrasting the lake area with the steeply rising surrounding mountains is a grid-like series of indications of height specifying the military preparations being carried out at particular elevations. Bearing in mind that one of the few specific locations identified (at 800 metres) is Mount Brion, a fortified outpost north-east of Riva on the Austrian side of the Italian–Austrian border, we can assume that the poem's cross-cut *modus operandi* is designed to make a particular political point about Italy's military preparedness. By taking the conventional overhead map-influenced paradigm of a stretch of water and transposing it vertically, Marinetti presents a schematic image of two banks, one Austrian and the other Italian, with Lake Garda and the surrounding mountains literally and metaphorically *guarding* the Italian frontier against the Austrian enemy. The work gives substantially more information about what is going on in the inventorised Italian defensive positions than on the enemy side, as it must, given that this is a work of specifically anti-Austrian propaganda, not an impartially presented pre-battle inventory.

Despite its schematic cross-cutting approach, *Battle at 9 Levels* is richer in detail and offers a greater amount of factual information than the other

free-word poems and verbal collages by Marinetti looked at so far. We see Austrian aeroplanes reconnoitring high above Italian terrain, the sun's rays shining over the tops of the highest peaks, the sheer gradient of the mountain slopes rising up from the shore-line, and we know by inference just where the enemy lies in waiting (an image which will also be played with in my next and final example). Moreover, because this is potentially a combat setting, local details inevitably have important tactical implications. Yet despite this factual dimension, the overriding purpose of *Battle at 9 Levels* was not to give a picture of the military situation in a geographically important location, one at which the poet was doing active service at the time. It was also to reassure the folks back home that the Italian Army was protecting the nation's borders against the threat of hostile incursions. In doing so it highlights, with a – for Futurist words-in-freedom, rare – mathematical precision, the layers and spheres of responsibility and combat-readiness of all echelons, and, exceptionally for Marinetti, it focuses on combat-readiness at the front rather than hands-on military engagement *per se*. What such a relatively static work inevitably loses sight of as a Futurist war-poem is the dynamism, the noise of battle and the enthusiastic clash of combatants familiar from earlier free-word shaped poems. This will be restored in my final example of the expressiveness of Futurist free-word verbal collage when confronted with the challenging theme of modern warfare.

Le soir, couchée dans son lit, elle relisait la lettre de son artilleur au front (In the evening, lying on her bed, she re-read the letter from her artilleryman at the front)

Marinetti's sense of war as 'the finest Futurist poem that has appeared until now' (2006: 241), as somewhere where true Futurists could be 'in their element' (2006: 246) and 'sole cleanser of the world' (2006: 49, *and passim*), is well and truly done due justice to in my final example: *In the evening, lying on her bed, she reread the letter from her artilleryman at the front* of 1917 (hereafter referred to as *In the evening*). This is the most explosively 'expressive' verbal-cum-visual-cum-acoustic evocation of frontline experience Marinetti or any other serving Futurist ever produced. It is also the work which pays most memorable homage to Marinetti's conception of words as potential torpedoes (Marinetti 1912: 11). I shall concentrate my attention here on two features with important implications for most of the other words-in-freedom and verbal collages we have been looking at: (1) the relationship between the work's 'expressivity', especially its use of the poet as a mediator of battle-experience, thereby raising the question of his communication's authenticity or partisan power to convince;

and (2) the specific significance of the bond between the sender of a letter from the front and the reactions of the female recipient to his missive.

Of all Futurist war-poems, this free-word collage makes the most sophisticated 'expressive' use of the sender–receiver paradigm. The work's title seems to position Marinetti's verbal collage closer to the then fashionable genre of letter-poem than that of a commissioned war-report from the front. What we are offered appears to be first and foremost a private communication, not any run-of-the-mill piece of free-word pro-war propaganda. Note the intimate handwritten abbreviation 'F. T. M'. (top-right), followed by the personal detail: 'I received your book while bombarding Kuk'.[8] The resultant vivid (quasi-autobiographical) picture of battle-experience, coupled with the implicit equation of 'her artilleryman' with Marinetti, is ostensibly intended as a guarantee of authenticity. Yet twice publishing the personally dedicated letter-poem turns a private communication into something closer to a pro-war political gesture.[9] The soldier is evidently unwilling to spare his confidante's sensitivities when evoking what he presents as the true nature of modern mechanical warfare: its deafening sense-shattering impact, the way the massive bombardment dwarfs all participants, reducing modern warfare to mechanised slaughter, yet at the same time conveying the exhilarating sense of fighting bravely for one's country and participating in a truly Futurist event. In 1913 Marinetti had written lyrically of 'the immense symphonies of shrapnel and the bizarre sculptures that our inspirational artillery is creating among the enemy masses' (2006: 74). Now the impact is concretely conveyed in the sheer dimensions and shape of the collage he sends to a confidante. 'She', in contrast, has to content herself with being the mere recipient of 'her' artilleryman's evidently patriotic belligerent feelings. The difference between their worlds can be seen in the exchange of greetings. His bluff 'I received your book while bombarding Kuk' and her contrastingly cordial acknowledgement: 'Thanks and best wishes to you and your bold comrades'. While the sender (the poem's implied composer) is identified by a personal dedication and his values are summed up in a vivid collage focusing on his world of patriotic action, the addressee is represented by an unflattering black silhouette lying on her stomach as she returns to re-experience the vicarious pleasures conjured up by 'her artilleryman at the front'. She is pictured participating, in a manner bordering on physical self-surrender, in his military experiences. The collage is arguably voyeuristic in more senses than that implied by the woman's prostrate position as she reads lying stomach-down on her bed. Like her, we, the poem's readership, are presented with an experience we too can vicariously participate in, albeit again without personal risk. As was the case with my earlier examples of 'expressive' poetry designed to create political empathy, the perspective, structure and imagery all combine here

to invite us to join voluntarily in the festival of slaughter. According to most interpretations of *In the evening*, instead of being able to report what he has witnessed in conventional prose, the soldier can only communicate his experiences in the form of a Futurist free-word letter-poem. (If so, then perhaps the Kuk offensive spurred him on to produce his best propaganda collage ever.) Yet as I have argued elsewhere, the explosive imagery could just be a reflection of the images that appeared in the recipient's mind's eye upon reading the soldier's radically innovative letter-poem from the front (White 1999: 101). It would certainly be unfair to reduce the work to a series of – literal and figurative – black-and-white contrasts between soldier and civilian, male and female, interventionist patriot and apolitical stay-at-home. Such a reading would be more simplistic and defeatist than the work permits, for, as the woman's reply indicates, she has been inspired by his vivid account of battle. If the bold filled shapes are simply creatures of the woman's imagination, then she (along with the reader) shares in the artilleryman's battle experience and his sense of elation. Such an expressive account of events on the Isonzo Front (events many combatants must have found to be inexpressible in everyday language) is no knee-jerk indictment of heads-in-the-sand civilians. Rather, it is an attempt to convert anyone encountering this work to Futurism's systematic lionisation of war.

The resultant free-word imagery's potential simultaneity – bringing together past and present, letter-writer and recipient, war at the front and the civilian world – in fact thematises the new reception-processes that became a vital 'expressive' factor in the works of pro-Irredentist and Interventionist propaganda we have been looking at. Many of the patriotic slogans to be found in Marinetti's ground-breaking Irredentist poem, Cangiullo's *Milan-Demonstration* and Carrà's *Festa patriottica* would not be out of place here. Yet strangely, there is only one equivalent anywhere in the entire layout. By which I mean the attack slogan 'War to the Germano-philes!', surely a clumsy battle-cry with which to initiate the bombardment of Mount Kuk from a static artillery position! Italy's enemy is identified, not as 'the Austrians' or 'the Germans', but as the 'Germanophiles', a pejorative term at the time reserved in Futurist circles for a target much closer to home. During the Interventionist period, Marinetti remained highly critical of what, in a letter to Cangiullo, he once dismissed as 'the austrophile government' of Italy (Berghaus 1996: 49). By implication, the Isonzo letter-poem *In the evening* is aimed at Futurist Interventionism's detractors back in Italy, not the country's foes abroad. This perhaps justifies the need for a 'free-word' letter sent from the front to someone already sympathetic to the cause and potentially able to assist those engaged in the field to confront Italy's internal enemy.

I should like to conclude with some less specific claims and observations.

The most striking visual impression that Marinetti's letter-poem leaves me personally with is the unique way in which words become fragmented (disintegrating, not so much into 'immense symphonies of shrapnel', as into real life-threatening missiles, the equivalent of Marinetti's torpedo-words), as combatants are dwarfed or reduced to mincemeat by huge masses of what looks like exploding black metal. Faced with this image, I suspect that many of the work's recipients will find that the pacifist clichés of the home front come across as hollow and abstract in contrast to the materiality of direct battle experience and Italy's tangible successes at the front. The shift of emphasis from expressively arranged verbal pro-war propaganda to object-oriented visual mimesis is, I would suggest, an important part of the collage's 'power to amaze', one that also symbolises the importance of action over self-indulgent *passéist* verbiage. In this case, Marinetti's cult of the 'expressive' goes far beyond the first phase's repeated evocations of the Futurist sensibility or the reinforcement of a specifically radical cultural agenda. It is not clear to me just what this new quality should be called, but it is certainly something more aggressively in-the reader's-face than the orchestrated 'expressivity' and the 'power to amaze' that had been promoted in Italian Futurism's early literary manifestos. What it does still have in common with them, though, is something that Christine Poggi alludes to in her valuable study *In Defiance of Painting*. At one point, she reminds her readers of Carlo Carrà's attack on Cubist collage for creating 'not works but only fragments' and for lacking an 'essential centre in the organism of the whole' (Poggi 1992: 166–7). As we have seen, it was ultimately the politics of the moment that gave Futurist free-word collage its 'essential centre', while granting it the freedom to experiment with a variety of 'expressive' techniques, many of them blessed with a unique 'power to amaze' that was less in evidence in the work of many other literary avant-gardes of the early twentieth century.

Notes

1 Unless otherwise indicated, all further references to Marinetti's theoretical writings will be to this edition, with page numbers in parenthesis after quotations. The volume's US spelling and the translator's newly formulated replacement titles have been retained, where appropriate.

2 The poem is reproduced as Fig. 57 in Cork (1994: 62), and as Fig. 80 in Rainey, Poggi and Wittman (2009: 278).

3 In *Great Futurist Serata at the Verdi Theater, December 12, 1913*, Marinetti concludes with some pertinent remarks concerning what he calls 'the colonial Futurism of Italy' (Marinetti 2006: 177).

4 This is the title the work was given in *Parole, consonanti, vocali, numeri, in*

libertà (Milan, February 1915), a four-page booklet advertising *I paroliberi futuristi*, currently being prepared for publication.

5 In particular, see catalogue nos 65–68 and 101.

6 Cf. the parallel argument in Christine Poggi, *In Defiance of Painting*, according to which Carrà's *Festa patriottica* 'aspires to affect the viewer empathically through the direct power of colors, forms, and dynamically distributed words' (Poggi 1992: 25).

7 The work's subtitle, *Tranchées* [literally 'trenches'] *de Dosso Casina (Altissimo)*, often omitted when the work is reproduced, is possibly intended to encourage such a reading.

8 'At the battle of Kuk in June 1917', Marinetti notes in *The Futurists, the First Interventionists*, 'I am wounded in the groin in the attack on the Case di Zagora' (230). According to Berghaus (1996: 470), 'at the tenth Battle of the Isonzo (May 12–June 8, 1917), Mount Kuk was taken. On May 14, Marinetti was badly wounded and taken to a hospital in Udine, where he stayed until June 10'. Such details make the nature of the Futurist letter-writer's depersonalised depiction of the attack and his failure to record that the battle was an Italian victory all the more intriguing. The resultant verbal collage can be read as a gloss on the *Technical Manifesto of Futurist Literature*'s concluding injunction that 'the 'I' in literature' must be eradicated (110), albeit without implying that the 'you' also has to be deleted.

9 The work first appeared as *Morbidezze in agguato + bombarde italiane* in *L'Italia futurista*, 2 (1917), 28, only to be retitled and subsequently included in *Les mots en liberté futuristes*, 103–4.

References

Berghaus, G. (1996). *Futurism and Politics: Between Anarchist Rebellion and Fascist Reaction, 1909–1944* (Providence, RI and Oxford: Berghahn).

Bohn, W. (1979). 'Circular Poem-paintings by Apollinaire and Carrà', *Comparative Literature*, 31, 246–71.

Bohn, W. (1986). *The Aesthetics of Visual Poetry, 1914–1928* (Cambridge: Cambridge University Press).

Cangiullo, F. (1961). *Le serate futuriste: romanzo storico vissuto* (Milan: Ceschina).

Caruso, L. and S. M. Martini (eds) (1974). *Tavole parolibere futuriste (1912–1944)*, vol. 1 (Naples: Liguori).

Coffin Hanson, A. (ed.) (1983). *The Futurist Imagination: Word + Image in Futurist Paintings, Drawings, Collage and Free-word Poetry* (New Haven and London: Yale University Art Gallery).

Cork, R. (1994). *A Bitter Truth: Avant-garde Art and the Great War* (New Haven and London: Yale University Press).

Hart, B. H. L. (1973). *History of the First World War* (London: Cassell).

Landis, L. (1983). 'Futurism at War', in A. Coffin Hanson (ed.), *The Futurist Imagination: Word + Image in Futurist Paintings, Drawings, Collage and*

Free-word Poetry (New Haven and London: Yale University Art Gallery), pp. 60–75.

Marinetti, F. T. (1912). *I poeti futuristi* (Milan: Edizioni futuriste di 'Poesia').

Marinetti, F. T. (1919). *Les mots en liberté futuristes* (Milan: Edizioni futuriste di 'Poesia').

Marinetti, F. T. (2006). *Critical Writings*, ed. G. Berghaus, trans. D. Thompson (New York: Farrar, Straus and Giroux).

Poggi, C. (1992). *In Defiance of Painting: Cubism, Futurism, and the Invention of Collage* (New Haven and London: Yale University Press).

Poggi, C. (1997). '*Lacerba*, Interventionist Art and Politics in Pre-World War I Italy', in V. Hagelstein Marquardt (ed.), *Art and Journals on the Political Front, 1910–1940* (Gainesville: Florida University Press), pp. 17–62.

Rainey, L., C. Poggi and L. Wittman (eds) (2009). *Futurism. An Anthology* (New Haven and London: Yale University Press, 2009).

White, J. J. (1999). 'On Semiotic Interplay: Forms of Creative Interaction between Iconicity and Indexicality in Twentieth-century Literature', in M. Nänny and O. Fischer (eds), *Form Miming Meaning: Iconicity in Language and Literature* (Amsterdam and Philadelphia: John Benjamins), pp. 83–108.

White, J. J. (2003). 'Perspective in Experimental Shaped Poetry: A Semiotic Approach', in W. G. Müller and O. Fischer (eds), *From Sign to Signing*: *Iconicity in Language and Literature* (Amsterdam and Philadelphia: John Benjamins), pp. 105–27.

White, J. J. (2010). 'Marinetti's Experiments with Acoustic and Visual Poetry: A New Semiotic Approach', *Modernist Cultures*, 5:2, 195–217.

Visual approaches to Futurist aeropoetry

Willard Bohn

On 22 September 1929, F. T. Marinetti published a document that would profoundly affect the nature of Futurist research: *Prospettive del volo e aeropittura*.[1] In particular, he urged the Futurist painters to celebrate the immense visual and sensory drama of flight. The artists responded enthusiastically to Marinetti's challenge and produced a series of paintings that are as striking today as when they were originally created (Crispolti 1985; Mantura and Rosazza Ferraris 1990; Duranti 2002). Inspired by the latter, other individuals began to experiment with aerial aesthetics as well, including the Futurist writers. In 1931, Marinetti published a *Manifesto of Futurist Aeropoetry*, in which he encouraged the Futurist poets to emulate the aeropainters (Marinetti 1931).[2] During the next thirteen years, he and his colleagues celebrated the triumph of modern aviation in poem after poem. Evoking the physical and psychological sensation of flying, they described what they saw, what they experienced, and how it affected them. Curiously, despite the Futurist poets' longstanding commitment to visual effects, Marinetti insisted that radio was the best vehicle for aeropoetry. This undoubtedly explains why there are relatively few aeropoems that also function as visual poems. In theory at least, aeropoetry was meant to be heard and not seen.

Despite Marinetti's comments, a number of aeropoets occasionally experimented with visual poetry. One of the first poets to explore the possibilities of this hybrid form was Ignazio Scurto, who belonged to the Gruppo Futurista Boccioni in Verona. Claudia Salaris calls him the most interesting writer of the whole group (Salaris 1992: 226). In 1932, he published the following poem in *Futurismo*, edited in Rome by Mino Somenzi (Scurto 1932):

V O L O
S U
TR A Ù

(a e r o p o e s i a)

volare sui tubi infiam

mati del sole cromo

alluminio amplifica

tori del mio saluto

3000 HP Fiat all'in

sopprimibile

 diritto

biancorosso

verde delle

generazioni

d a l m a t e

m o t o r e s u c c h i a r e

dalle mie vene che

c o n t e n g o n o t u t t o

l' a d r i a t i c o

l'incontenibile ruggi

to contro i

 MERCANTI
 DI PORCI

t r a m u t a n d o l o n e l

suo rombo italianis

simo

F L I G H T
OV ER
TR O G I R

(a e r o p o e m)

flying over pipes lit

by the sun chrome

aluminium amplifi

ers of my greeting

3000 HP Fiat with the

irrepressible

re d w h i te

g r e e n

 C l a i m

of dalmatian

generations

motor drawing an

irresistible roar from

my veins which con

tain the entire

a d r i a t i c

directed against the

 HOG

BUTCHERS

transforming it into

a t o t a l l y i t a l

ian throbbing

TRAÙ

TRAÙTRAÙ

TRAÙTRAÙTRAÙ

TRAÙTRAÙTRAÙTRAÙ

TRAÙTRAÙTRAÙTRAÙ

raccolto religio

samente dai C
A
M
PA
NI
LI
———

veneti che sguscia
no verso di me cer
cando di avvinghiar
si alla mia carlinga

 fascista

QUANDO?

campane sonorizza
re grida dalmate in
occasione del pas
saggio in cielo del
futurista - dalmata

 SCURTO

QUANDDDD DODO

TRAÙ

TRAÙTRAÙ

TRAÙTRAÙTRAÙ

TRAÙTRAÙTRAÙTRAÙ

TRAÙTRAÙTRAÙTRAÙ

carefully gathered

from the venetian T
O
W
E
R
S
———

which reach

toward me seek

ing to cling to

my fascist

cockpit

WHEN?

dalmatian bells

celebrating the

celestial passage of the

dalmatian - futurist

 SCURTO

WHEEEE EN EN EN

QUAND ND DO? WHEN NNN NN?

TRAÙTRAÙTRAÙTRAÙ TRAÙTRAÙTRAÙTRAÙ

TRAÙ TRAÙ TRAÙ TRAÙ

1933 1933

TRAÙTRAÙTRAÙTRAÙ TRAÙTRAÙTRAÙTRAÙ

Flying over the Dalmatian port of Trogir (Traù in Italian), Scurto hears church bells ringing and observes his aeroplane's reflection in the shiny metal structures below. Responding to what he fondly imagines to be the town's greeting, he dips his wings in a quick salute. Since Scurto was born and raised in Verona, one wonders how he could possibly claim to be a Dalmatian Futurist. Eventually one perceives that he is speaking not as an individual but in his capacity as an Italian citizen. Like the Adriatic which pulses in his veins, Trogir belongs to Scurto because it belongs to Italy – represented by the red, white and green flag. Between 1420 and 1797, the town was part of the former Venetian empire. Among the important buildings that survive from this period are several Renaissance churches, whose prominent bell-towers are evoked in the poem. Dissolving the word 'CAMPANILI' into its individual letters, Scurto arranges them vertically to create a visual analogy. The latter not only designates the object in question but depicts it as well. Elsewhere he employs a series of ascending or descending fonts to indicate that a sound is getting louder or softer. As the poem concludes, Scurto makes one last pass over the town. We hear the airplane approaching initially: 'TRAÙTRAÙTRAÙTRAÙ', and then we hear it flying away: while most of the poem's visual effects are easy to decipher, one feature is frankly puzzling. For some reason, the text is compressed into a narrow ribbon that is justified on both sides. Why, one wonders, did Scurto choose such an unusual shape? Why is the poem so long and thin? Although it is tempting to conclude that it represents one of the bell-towers, a rapid review reveals they all have pointed roofs. For that matter, why did the poet choose such huge letters for the poem's title? And why are they arranged to form a rectangle? All of a sudden, the pieces of the puzzle begin to fall into place. The title represents Kamerlengo Castle, constructed by the Venetians in the fifteenth century. The remainder of the poem depicts Trogir's main street, which stretches from the castle to the other side of the town. Rising over the middle of Trogir is St Mark's Tower, which also dates from the fifteenth century.

While 'VOLO SU TRAÙ' recounts a personal experience (or purports to), it also dramatises Italy's desire to annex the Dalmatian coast. However, Scurto is not simply asserting Italy's right to reacquire former lands. He is thinking of the Treaty of London (1915), which promised to cede Northern Dalmatia and other territories to Italy in exchange for joining the Allies during the First World War. Although this promise was forgotten after the war, Scurto insists that Italy has a legitimate claim [*diritto*] to occupy Trogir. Indeed, he declares, the Christian population would welcome such a move, since the Muslim invaders (vilified as 'MERCANTI DI PORCI') would be expelled. Amid a flurry of rhetorical questions in ascending fonts, the poem concludes on a militant note. Insisting that the time is ripe, Scurto urges the Italian government to occupy Trogir by next year (1933).

Pino Masnata joined the Futurist movement at an early age, made a number of important contributions and eventually became a surgeon. Born and raised in Stradella (between Pavia and Piacenza), he published a collection of plays in 1930, a book of poetry in 1932 and, together with Marinetti, a *Manifesto futurista della radio* in 1933. Entitled *Tavole parolibere* (Free-Word Paintings), the second volume revolutionised the practice of visual poetry. Marinetti declared in the introduction, 'Pino Masnata's free-word poetry is original, expressive, aggressive, condensed and yet freely flowing like a sheet of ice in the sun' (Masnata 1984: 182).[3] The following year, Masnata decided to combine his interest in visual poetry with the recently invented genre of *aeropoesia*. Like Ignazio Scurto before him, he chose to publish his first attempt in *Futurismo* (16 April 1933) (Masnata 1984: 363). Entitled 'AEROPLANI', the composition was, in his own words, 'a long free-word painting celebrating aviation with squadrons of Ts in formation' (Masnata 1984: 363):

A I R P L A N E S

AIRPLANES ROAR FLYING SQUADRONS

r r r r r r r r r r r r r r

what are all of them saying

T?

The peaceful man T edium

 T urbulence T ax

 T opsy-turvy T urmoil

The painter T itian

 T able cloth T ablet

 T int or else T apestry

The merchant T ransfer

 T ransference T ransport

 T ariff or else T raffic

The anti-Italian T unnel

 T rap T rick

 T reachery or else T orment

The doctor T ibia

 T rachea T endon

 T riscuspid or else T hermocautery

The lawyer T oga

 T ribunal T rickery

 T estament or else T utelage

The worker Towel

Technique Tube

Trellis-work or else Tool

The coward Tremble

Tragedy Terra

Tremors or else Tomb

The obsolete poet Thalia

Terpsichore Tomes

Typography or else Tantalus

The musician Touch

The ivories Trumpet

Tone or else Trio

The mathematician Tangent

Trigonometry Trapezium

Trapezoid or else Triangle

The botanist Tea

Tolu balsam Thyme

Tulip or else Trefoil

The priest T unic

T heology T alaric

T emporal or else T rinity

The lady T atting

T affeta T halamus

T reasure or else T enderness

The soldier T owing

T roops T rain

T rap or else T actics

The futurist & fascist T hrong

T on T hud

T error or else T riumph

or better yet T rogir

Despite its relative simplicity, Masnata's visual design is extraordinarily effective. As wave after wave of aeroplanes sweeps by overhead, the viewer gazes in amazement. The cumulative effect is almost hypnotic. Flying in a series of V formations are eighty-two planes divided into sixteen squadrons. Contributing to the realistic effect, the capital Ts at the beginning of each word are shaped like aeroplanes. Although the aircraft in question have no insignia, they clearly belong to the Italian air force. In spite of Masnata's previous claim, the composition does not celebrate aviation in general but rather *Italian* aviation, which was attracting considerable attention. In December 1930, the Italian air minister Italo Balbo led a group of twelve Savoia-Marchetti S.55 flying boats from their base at Orbetello to Rio de Janeiro. Like the aeroplanes in Masnata's composition, they flew the entire

distance in military formation. Balbo performed a similar exploit two and a half years later, commanding twenty-four seaplanes on a round-trip flight to Chicago, where he received a hero's welcome. Chicago named a street after him, New York held a ticker-tape parade in his honour, and President Roosevelt invited him to lunch. As a result of this adventure, the expression *balbo* was coined in Italian to describe a large formation of aircraft (Segre 1990).

Since 'AEROPLANI' is composed entirely of nouns, whether it qualifies as a poem is open to dispute. Although Marinetti advocated the abolition of adverbs and adjectives, he recommended the use of verbs in the infinitive (Marinetti 1912). As we saw previously, Masnata viewed it as a free-word painting. Regardless of what one chooses to call this intriguing work, it occupies a unique place in the Futurist canon. Evoking Italian citizens from every walk of life, it portrays the Italian air force as the pride and joy of the entire nation. Each squadron is identified with a different kind of person, who evokes five things associated with his or her existence. Some individuals are worthy of praise, and some are not. While the Futurists admired painters, musicians, and soldiers, for example, they despised cowards, anti-Italians and obsolete poets. The first three individuals are juxtaposed with objects, concepts, or people related to their professions. Personified by Titian, the artist utilises a palette, the musician plays an instrument and the soldier employs clever tactics.

Unlike the coward and the anti-Italian in the group, who tend to be defined by their personal characteristics, the obsolete poet espouses outmoded concepts. Whereas the former tremble uncontrollably or engage in treacherous acts, the latter reveres the nine muses. Like Tantalus, he attempts to steal nectar and ambrosia from the gods. Influenced perhaps by Marinetti, who encouraged poets to write for the radio, Masnata includes typography among the list of obsolete practices. Since Futurist poetry was famous for its typographical effects, this is rather surprising. One wonders if the present composition is also outmoded, since it could never be transmitted via radio. In condemning typography, Masnata has unwittingly endangered his own enterprise as well. The front of the airborne formation is occupied by the peaceful man, who avoids turmoil, pays his taxes on time, and leads a boring existence. The rear is occupied by the Futurists, who are patriotic, successful, and certainly far from boring. As the last aeroplane reminds us, they continue to be interested in the question of Trogir.

Tullio Crali was a talented artist who resided in the town of Gorizia, near the Slovenian border. Although he exhibited all over Italy, he concentrated on Padua, Venice and Trieste in particular. In 1940, Crali was honoured with a one-person show at the Venice Biennial. Marinetti found his aeropaintings so impressive that he lectured about them on the

radio (Astori 1976: 96). In addition, he published an illustrated booklet with excerpts from numerous reviews. Crali declared in the preface: 'The aeroplane [is a] natural creature which incorporates the mystery of "cosmic motion". It draws us inexorably upward, higher and higher every day, so we may experience God's purity more intimately and more forcefully' (Crali 1940). The booklet concluded with two aeropoems by Crali that were also conceived as visual poems. Dated 1938, the first was entitled 'Altalenando sulle isole dalmate' [Flying Back and Forth over the Dalmatian Islands] (Crali 1988: 72):

<div style="text-align:center">miserable dalmatians</div>

restless wind above the islands

 into the wind boreal blast

 ô northwind

 flying back and forth high above

grossa *lunga*

 lesina *incoronata*

meleda *solta* *curzola*

WITH UNDERSEA WEBS CONCEALING INDIFFERENT

VENETIAN BANNERS THE SALTY FISHING BOATS FULL OF

SACKS AND BARRELS UNLOAD ROPES AND TAR TO CAULK

THE OLD SAILORS' AND THE OLD DISTRICTS' WRINKLES

AS OBLIVIOUS AS A WATERMELON *lissa* BOBS BLISSFULLY IN THE WATER

THE COASTAL MOUNTAINS GUARD THE HORIZON WITH

CLENCHED FISTS

In contrast to Ignazio Scurto, who concentrated on a single Dalmatian island, Crali painted an aerial portrait of a number of islands. Since he was born and raised in Dalmatia (now Croatia), he knew the region well. The composition itself is divided into six different scenes, some of which are depicted visually and some of which are not. The first thing the reader learns about the coast is that the people who live there are unhappy. Although Crali does not pause to elaborate, the inhabitants are presumably dissatisfied because they are subject to Dalmatian rule. They are eager for the Italians to reclaim the territory. Paralleling the situation on the ground, the wind turns out to be 'malcontento' as well. Crali's initial remarks are surrounded by a series of curved lines representing the restless wind. Since *altalenando* means 'swinging to and fro', the title suggests that Crali's aeroplane is being buffeted around quite a bit. While the view from the air is impressive, the experience is more chaotic than in Scurto's poem. Since the composition contains lots of local colour, we can situate it precisely both in space and in time. The *bora* is a violent, cold, dry wind associated with the northern Adriatic. Blowing from a northerly or a north-easterly direction, its appearance signals the arrival of winter. The *tramontana* is a cold north wind coming from across the mountains, in this case the Alps. Unfortunately, Crali seems to be experiencing both of them at the same time.

Below the drawing of the wind, a string of words represents Crali's aeroplane flying through the air: 'altalenando in quota su'. Following a sudden shift in perspective, we glimpse some of the 1185 islands that adorn the Dalmatian coast and part of the coast itself. The section depicted in the composition extends approximately 200 miles from Zadar, where Crali once lived, to the walled city of Dubrovnik. The fact that the islands all bear Serbo-Croatian names today makes them difficult to identify. As the title proclaims, Crali zigzags back and forth between them. In order to retrace his itinerary, one must read from top to bottom and from left to right. Beginning with Dugi Otok (Grossa), the northernmost island, Crali flies all the way to Mijet (Lunga), situated at the southernmost end. From there he heads up the coast to Hvar (Lesina), Šolta, and Dugi Otok (Lunga) in that order. In order to preserve normal reading conventions, he places Hvar above Šolta. In reality, however, Šolta is situated further up the coast than Hvar. Reversing direction one more time, Crali flies south to Kornat (Incoronata) and further south to Korčula (Curzola), located just above Mijet. Crali zooms in on several small fishing boats at this point that are busily unloading rope and tar. Like the *bora* and the *tramontana* encountered previously, *bragozzi* are found exclusively in the Adriatic. The 'trame sottomarine' are clearly fishing nets, which have been hung up to dry. The fact that they are draped over the boats' Venetian flags may or may

not be significant. Zooming back out, Crali briefly glimpses the island of Vis (Lissa), which resembles a watermelon floating in the water. Pausing to admire the coastal mountains at the end of his journey, he compares them to a silent band of sentinels.

The second poem by Crali describes flying over another group of islands, situated not in the Adriatic but in the Aegean Sea. Dated 1939, it is entitled 'Sorvolando le Cicladi' [Flying over the Cyclades].

vento annoiato caricare a lunghe ondate il caldo umidore del Levante

appiccicoso spalmato su strati di mica sospesa

s o r v o l a r e

altalendando a 2000 metri sul mare

CLA

le **CI** **DI**

di vetro cemento

al centro degli orizzonti sazi a nausea di azzurrini e madreperle

riverbereanti aspri grigiori pietra nuda al sole

ingonnelliamoci di spuma salsa tra roccia e roccia merlettando la verde

scura bottiglia del fondo sciacquare viscidumi – alghe – miele sul

viso collo mani

RECLAMATE PIOGGE TORRENZIALI O FRESCHI LIQUIDI

SPECCHI ALPINI

nella baia al riparo contesta disputare complicando intrigui nuvolosi sui

bordi in roccia aggrappati strappati dalla brezza

« non c'è tempo da perdere bisogna investire al più presto gli

eserciti di arsura che invadono l'Anatolia»

ovatta a brandelli sul promontorio ferito in costa da nevrastenico

pescespada

HRRRRRR HRRRRRRRRRRR HR MR HRRRR

HRRRRRRRRR **NO no è il motore di sinistra che**

annaspa e perde colpi condutture benzina filtri in

battibecco scioperare cocciuti un colpo alla manetta

riporta il rombo in cadenza precisa

ROOOmbare ROON ROON RON RON RON RON RON

mareggiate di suoni marmorei con zucchero cannellato sull'E G E O

in siesta:

 gradite isole di lucum **ZEA**

 SIRA

 PARO

 NIO

amare di mandorla spoglie di fiori

[bored wind filling the East's hot humidor in long sticky waves spread on

layers of suspended mica / f l y i n g o v e r / flying back and forth at

2,000 meters above the sea / the / **CY** / **CLA** / **DES** / of glass cement /

surrounded by horizons stuffed to the point of nausea with pale blues and

mother-of-pearl tones reflecting harsh grays bare stone in the sun /

let's put on a skirt of the salty foam between the rocks trimming the dark

bottle-green bottom with lace rinsing off slime – seaweed – honey

on our face neck hands / ASK FOR TORRENTIAL RAINS OR COOL

LIQUIDS ALPINE MIRRORS / in the sheltered bay contesting disputing

complicating cloudy intrigues on the rocky edges grasped tugged by the

breeze / ". don't forget we need

to assemble a mighty army as quickly as possible in order to invade

Anatolia" / tufts of cotton on the headland wounded in the side by an

irritable swordfish / **HRRRRRR** **HRRRRRRRRRRR**

HR MR HRRRR HRRRRRRRRR

NO no the left engine is coughing and sputtering gas lines

gasoline squabbling filters stubbornly going on strike

an adjustment to the throttle restores the engine's

precise rhythm ROOOaring ROAR ROAR RO

RO RO RO RO / swells of marble sounds with cinnamon

sugar on the sleepy A E G E A N: / congenial islands of lokum / **KEA**

/ **SYROS** / **PAROS** / **IOS** / loved by almonds / clothed in flowers]

In contrast to the preceding poem, which was situated in winter, 'Sorvolando le Cicladi' takes place during the dog days of summer. Whereas the wind in the Adriatic consisted of sharp, icy blasts, the Aegean wind is hot, lazy and bored. Although there is a slight breeze, it is not enough to alleviate the oppressive heat and humidity. Since the climate is normally hot and dry, a new front must be passing through the area. Whatever the explanation, it produces a curious atmospheric effect in the eastern Mediterranean, where the clouds are spread out like jam on a slice of toast. Crali compares them to layers of mica, which suggests they are long, flat and thin. In general, the composition's visual effects are fairly rudimentary. In addition to three visual analogies, it contains several elementary typographical effects. At the upper right, the word 'sorvolare' represents the poet's aeroplane, which has levelled off at 2,000 metres and is flying in a straight line. Crali inserts a space between each of the letters in order to make the word longer. Directly below, the notation CY / CLA / DES represents the three northernmost islands, which form a semi-circle like the syllables on the page. Viewed from an aeroplane, the sea seems to be made of glass and the islands of cement. Looking all around him, the poet complains that the horizon is drenched in pale iridescent hues, which he finds nauseating. 'Pietra nuda al sole' may refer to one of the islands baking in the sun or a simply to a large rock. Among other things, the phrase reminds us that the Cyclades are arid and the soil is thin. Since rain is a precious commodity, Crali parodies an advertising campaign a few lines later, demanding that readers ask for torrential downpours.

Beginning with a playful neologism, 'ingonnelliamoci' [let's skirtify ourselves], the next section presents a number of problems. Gathering up the delicate foam from the shoreline, the poet exhorts his companions to join him in making skirts for themselves trimmed with seaweed. Or does he? As one quickly perceives, too many things are wrong with this interpretation. How can Crali be on the ground if he is flying an aeroplane? Where did his companions come from? And when did he start wearing women's clothing? The explanation seems to be that the scene is purely fictitious. Zooming in on an imaginary setting, Crali pictures a family enjoying themselves at the seashore. The (awkward) use of suspension points in this section suggests the words in question are spoken by one of the imaginary characters. Like a later sentence, they should have quotation marks around them. In all probability the speaker is a young girl who, spying the beautiful foam, urges her friends to decorate themselves with it. When they grow tired of the game, they simply rinse the foam off. While the children are playing in the water, the adults sunbathe (or sit in the shade) and talk among themselves. Inspired perhaps by Germany's invasion of Czechoslovakia on 15 March, one of the men insists that Greece should invade Turkey. The

last sentence, which is purely descriptive, presents a special challenge. One suspects the tufts of cotton are really trees and that the angry swordfish is an old-fashioned sailing vessel moored at a dock.

Crali's reverie is interrupted at this point by a sudden emergency that requires all of his attention. One of the aeroplane's engines is threatening to quit. Fortunately, after a moment of suspense, the problem proves to be easy to correct. Adjusting the throttle, he increases the flow of gas and averts a potentially dangerous situation. The poem concludes with a final glimpse of the islands dozing in the sun. From the air, the poet jokes, the whitewashed houses look like pieces of Greek candy covered with powdered sugar. Since the Cyclades are far too numerous to depict visually, Crali chooses four representative islands. Kea [Zea] possesses important temple ruins and a picturesque monastery. Syros [Sira] contains the largest town in the Cyclades and the oldest acropolis. Paros [Paro] was the site of a famous marble quarry in antiquity. And Ios [Nio] is supposedly where Homer is buried. With one exception, the position of the islands on the page corresponds to their geographical positions in the Aegean. In actuality, Ios is located to the south-east of Paros. Although the Cyclades are hot and dry in the summer, Crali seems to say, they are covered with almond blossoms and countless flowers in the spring.

Since visual poetry played a prominent role in Italian Futurism, beginning with Francesco Cangiuillo in 1914, it is gratifying to note that some of the aeropoets insisted on continuing this tradition. Despite Marinetti's assurances, radio was a poor substitute for the printed page. While it gave him the opportunity to declaim his poetry before the entire nation, the presence of so much onomatopoeia-laden poetry posed a problem. Although the radio audience could hear the aeroplanes flying overhead, it had no idea what they looked like. Recognising the limitations of radio-aeropoetry, Scurto, Masnata and Crali felt compelled to try their hand at visual compositions. Despite their lack of experience, they chose three effective strategies. Deciding to depict the bell-tower at Trogir, Scurto opted for a realistic solution. Evoking a large formation of aeroplanes seen from below, Masnata transformed an entire poem into a visual analogy [*analogia disegnata*]. Evoking both the Dalmatian islands and the Cyclades viewed from above, Crali introduced a visual analogy into two different poems. Each poet created a work that was simultaneously a poem and a picture.

Notes

1 'Prospettive del volo e aeropittura', *La Gazzetta del Popolo* (Turin) (22 September 1929).

2 A French version was published in *Stile Futurista*, I:3 (September 1934).

3 Several of the compositions are reprinted in Masnata 1984: 329–40.

References

Astori, A. (ed.) (1976). *Mostra antologica di Tullio Crali* (Trieste: Azienda Autonoma di Soggiorno e Turismo).

Crali, T. (1940). *Alla XXII Biennale internazionale d'arte trionfa la mostra personale di Crali: Nuova grande vittoria dell'aeropittura italiana primato plastico sopravanzante le pitture estere e primato nella glorificazione aeropittorica della veloce bombardante guerra aerea* (Venice).

Crali, T. (1988). *Crali: aeropittorefuturista* (Milan: All'Insegna del Pesce d'Oro).

Crispolti, E. (1985). *Aeropittura futurista aeropittori* (Modena: Fonte d'Abisso).

Duranti, M. (2002). *Aeropittura e aeroscultura futuriste* (San Sisto: Effe).

Mantura, B. and P. R. Ferraris (1990). *Futurism in Flight: 'Aeropittura' Paintings and Sculptures of Man's Conquest of Space (1913–1945)* (Rome: De Luca).

Marinetti, F. T. (1929). 'Manifesto dell'aeropoesia', *La Gazzetta del Popolo* (22 October).

Marinetti, F. T. (1931). 'Manifesto dell'aeropoesia', *La Gazzetta del Popolo* (22 October).

Masnata, P. (1984). *Poesia visiva: storia e teoria* (Rome: Bulzoni).

Salaris, C. (1992). *Storia del futurismo: libri, giornali, manifesti* (Rome: Editori Riuniti).

Scurto, I. (1932). 'VOLO SU TRAÙ', *Futurismo*, I:16.

Segre, C. G. (1990). *Italo Balbo: A Fascist Life* (Berkeley: University of California Press).

The Untameables:
language and politics in Gramsci
and Marinetti

Sascha Bru

Gli indomabili [The Untameables] is one of the most intriguing allegorical narratives Filippo Tommaso Marinetti wrote. The *romanzo*'s tale is quickly retold. In a pit situated on a desert-like island a group of men coming from elite backgrounds have exiled themselves to live in a bestial state of carnage and bloodshed. These ferocious indomitables suffer from short-term memory loss, not knowing what it is they go through every night. Each night they are led by a group of black guardians into a fertile oasis further up on the island. There they slowly discover the pleasures of aesthetic and natural beauty, the potential of the human body and the ability to live together in harmony without an external force governing their actions. Yet what they lack is a language to express their elevated state of mind. Only then do the untameables enter the city of the so-called *Cartacei* or Paper People, deep within the oasis. These Paper People are literally what their name signals: their minds carry immense wisdom and their bodies consist of pages from books of wisdom – one of which contains the writings of a certain 'F. T. Marinetti'. The novel then goes on to recount how each night the untameables witness a veritable revolution in the city of the Paper People. Enlightened by language, and seizing upon Marinetti's *parole in libertà* as means to express their bodily heroism, the untameables promote themselves to leaders of that revolution. They address the insurgents in speeches and manage to unite a suppressed people into a single revolutionary mass or bloc willing to overthrow the status quo in the *polis* or 'State' of the Paper People. *Hélas*, each night the city subsequently floods, the water washing the untameables out of the oasis, back into their desert pit. As the indomitables awake the next morning they have forgotten everything that has happened.

There are many ways to interpret this circular narrative (Bru 2009: 72–3) but, among other things, it is clearly about the role of language in bringing

about practical political change. Interestingly, *Gli indomabili* was published in 1922, during a period in which Antonio Gramsci, the intellectual leader of the Italian Communist Party (PCI) whose politics too revolved around language (Bru 2005: 119–32), began to take a rather active interest in Futurism. Reading Marinetti's Futurist poetics, as it is voiced in his *Gli indomabili* and other writings, alongside Gramsci's political philosophy of language, my principal aim is to argue that Gramsci may have taken an interest in Futurism because he realised that the movement's linguistic experimentation indeed came with far-reaching practical political ramifications.

Gramsci had written about Futurism as early as 1913, yet especially from 1920 onward his interest in Futurism grew very lively. At that point Gramsci issued an essay entitled 'Marinetti Rivoluzionario?' in the communist daily *L'Ordine Nuovo* (Gramsci 1985: 49–52). The essay claimed that Marinetti and his Futurist comrades could count on considerable support from the working class (Salaris 1990; 1994: 109–27), and depicted the Futurists as true Marxists in the bourgeois aesthetic sphere. On 6 January 1921, *L'Ordine Nuovo* published the programme of Gramsci's newly launched Istituto di Cultura Proletaria in Turin, which announced educational and artistic projects for the working class. Throughout that year critical but constructive assessments of Futurism continued to appear in the communist daily, as if Gramsci was looking to win over the Futurists to join his Institute. And sure enough, a number of Futurist 'officials' (Carlo Frasinelli, Franco Rampa Rossi and Fillia) went on to co-operate with the Turin communists. In less than two years, they organised jointly various Futurist exhibitions (the first one opened by Marinetti giving a speech),[1] published a number of poetry collections and manifestos, produced Fillia's first play *Sensualità*, and eventually established a Futurist artistic syndicate. The latter managed to attract more than a thousand members in less than a year, which gave rise to plans to set up branches in Bologna and Genova as well (Berghaus 1996: 180–97). These further plans were never realised. After a year or two the flourishing Turin section of Futurism began to wither. The PCI's predominantly conservative aesthetic had unleashed a heated debate on the distinct roles of the artistic and the political avant-gardes, waged in left-wing newspapers and periodicals such as *Gioventù Socialista* and *Avanguardia* (Carpi 1985: 103). As Marinetti subsequently decided to continue Futurism under the constricting conditions of Mussolini's Fascism, the brief dialogue between Gramsci and Marinetti's movement also ended. Just before this dialogue came to a close Gramsci reiterated, albeit ambivalently, his admiration for Futurism in his famous letter to Leon Trotsky (reproduced in the latter's *Literatur und Revolution* of 1923). Later, when incarcerated by Mussolini from 1926 until his death, he began

to voice his outright disappointment in Futurism in his famous *Quaderni del carcere* or *Prison Notebooks* (in particular in notes 1670 and 2110). In a note from 1930 entitled 'The Futurists', he summarised the evolution of Futurism in the following, telling way: 'A group of schoolboys who escaped from a Jesuit boarding school, whooped up in a nearby wood, and … were led back under the policeman's stick' (Gramsci 1985: 19).

Gramsci's concise history of Futurism brings us straight back to *Gli indomabili*. The topography of his one-sentence history is not quite that of *Gli indomabili*. Yet it would seem that some ten years after *Gli indomabili* first appeared Gramsci was summarising the basic plot-line of Marinetti's novel. Whether Gramsci actually read *Gli indomabili* is unimportant. What is relevant is that Marinetti's *romanzo* dealt with issues that also took centre-stage in Gramsci's thought. In fact, it is almost impossible to conceive of Gramsci's thought without paying attention to the role of language in bringing about political change. This overlap of interests in the work of both men has been largely neglected in Futurism studies. Research on Gramsci and Futurism has contented itself mainly with pointing at the short-lived ideological congeniality between them so as to explain Gramsci's disappointment in the movement in later years (Kebir 1980: 94–7; Holub 1992: 17). Yet already in his letter to Trotsky Gramsci referred to Marinetti's *Al di là del comunismo* (1920), stressing that an intelligent political doctrine had been lacking in the movement from the start. It is somewhat surprising, therefore, that only a handful of scholars have actually looked at how Gramsci's assessment of Futurism figured within his more general approach to language and politics.[2] Why, for instance, did Gramsci deem Futurism worth critical attention even after it had become clear to him that it had been domesticated by bourgeois society? Why, moreover, did he write to his sister-in-law Tatania Schucht in 1931 that he wanted his next book to include a chapter on 'Reactions to the absence of a popular-national character of culture: the Futurists'? (Gramsci 1965: 464–7) Was this simply due to the fact that for a brief moment Futurism interacted with proletarians? Or had Gramsci, who was in part raised as a linguist at the University of Turin, discovered there was more to Futurism?

Taming language

Gramsci's 'philosophy of practice' (as his version of Western Marxism is most often called) does not amount to a clear-cut methodology (Verdicchio 1995: 169–77). Always embedding his object of enquiry in concrete contexts, his work proves too pragmatic to be able to derive simple theoretical formulae from it. Yet as Franco Lo Piparo and others have illustrated, there are a number of obvious continuities inscribed in his work that come to the

fore when we link his early work in linguistics to his later elaboration of the concept of hegemony (Lo Piparo 1979; Helsloot 1989; Salamini 1981: 181–96: Rossiello 1986). In his final *Prison Notebook* (29), entitled 'Notes for an Introduction to the Study of Grammar', Gramsci observed that 'every time that the question of language surfaces, in one way or another, it means that a series of other problems are coming to the fore' (Gramsci 1985: 183). One of the central problems addressed in *Notebook 29* is how a collective popular will is formed through language, that is, 'how heterogeneity and multiplicity [are] transformed into a collective unity' (Ives 2004: 36). Gramsci was first confronted with this issue during his years as a student of linguistics with Professor Matteo Bartoli in Turin. In his courses Bartoli dealt with the question of how and why one people could conquer another through language. Bartoli's interest appears to have cast a long shadow over Gramsci's work. Gramsci's journalistic writings, as is well known, often critically reflected on attempts to unify Italy linguistically and, as the aforementioned *Notebook* illustrates, the question of language would continue to attract his attention until his death. Such reflections gradually led him to approach language as the vehicle of an ever-changing culture and a multilinear history fuelled by hegemonic constellations. Significantly, Gramsci's concept of hegemony, too, can be traced back to his years as a student. Terms Bartoli frequently used, for instance, were *fascino* [appeal] and *prestigio* [prestige]. These terms were often employed synonymously with *egemonia* [hegemony] in linguistic writings of the latter half of the nineteenth century which Gramsci must have been acquainted with (Lo Piparo 1979: 106). Hegemony, in brief, was inseparable from language as well.

In the field of cultural studies today Gramsci's theory of hegemony is often only partially reproduced, by recalling his formula 'State = Civil Society + Political Society'. According to this formula civil society comprises all institutions mediating between the individual and the coercive state apparatus or political society. The latter is then seen as coterminous with government (bureaucracy, parliament, etc.). From political society a ruling group can exert power and exercise hegemony as long as it can rely on the voluntary co-operation of its citizens. To Gramsci, however, this formula only explained how things were in the present, not how to change them. In order to conceive of counter-hegemonic change, Gramsci went on to ask two questions. *Primo*, what would a state look like wherein (external) coercion is minimal (or even non-existent)? *Secondo*, what kind of language would be required to move away from the present, modern state, that is, what kind of language would people have to be addressed with for them to view society differently? When we chart Gramsci's responses to these queries, we are quickly made aware that he sympathised with Futurism for

more than party-ideological reasons. The main reason, we will see, might have tied in with language. For it appears that Gramsci had a good sense of how an ideal state should look. What he lacked, though, was a language to convince others of his being in the right. And Futurist poetics and literary experimentation may have provided him with precisely the tools required.

Gramsci's alternative to the modern bourgeois state came close to overlapping with the views developed in Marinetti's *Gli indomabili*. It is useful to recall here that when in the novel the untameables first enter the oasis there is a moment, however brief, when they find a way of coexisting in harmony without any external force governing their actions. Such a form of community was very much the penultimate horizon Gramsci had in mind as well. To illustrate this I need to recall his notion of 'regulated society':

> It is possible to imagine the coercive element of the State withering away by degrees, as ever-more conspicuous elements of regulated society (or ethical state or civil society) make their appearance. The expressions 'ethical state' or 'civil society' would thus [signal ...] a pure utopia, insofar as it was based on the presupposition that all men are really equal and therefore equally reasonable and moral, agreeing to accept the laws spontaneously, freely and not through coercion as imposed by another class, as something external to one's conscience. (Gramsci 1971: 263)

Overtly labelling this *self-*regulated society (or civil society without political society) a utopian metaphor, Gramsci in his *Notebooks* nonetheless went on to consider how such a society could come about. A transition from the present state to a regulated society, he argued, required 'a *coercive* [State] organization which will safeguard the development of ... regulated society, and which will therefore progressively reduce its own authoritarian and forcible interventions' (Gramsci 1971: 263). Clearly, he could only conceive *gradual* progress, under constrictive terms. Political society, he asserted, would have to become a 'nightwatchman', until civil society would eventually be able to organise itself. In so doing, his thought thus also located a *rupture* at some point in the future, after which society would no longer be directed by coercion but be governed only by 'spontaneous' consent.

In devising a strategy for gradual progress to be followed here Gramsci claimed that change could come about only through language. In this context, again, certain overlaps with Marinetti's *Gli indomabili* emerge, because, as we saw, it is only through language (and Futurist *parole in libertà* in particular) that the undomitables manage to promote themselves to leaders of the revolution in the city of the Paper People. As Gramsci wrote, '[f]or a mass of people to be led to think coherently ..., the question

of language in general [*linguaggio*] and languages in the technical sense [*lingua*] must be put in the forefront of our enquiry' (Gramsci 1971: 325; 348). Leaving the *lingua* ('la langue', in French, as opposed to 'le langage') aside here – for we would then be dealing with the (lack of a) national, Italian tongue – Gramsci noted that *linguaggio* or language in general is essentially a 'collective term', binding various common senses living among people on different social strata in civil society. These common senses – comparable to what Raymond Williams later called 'structures of feeling' in *Marxism and Literature* (1977) – are characterised by fragmentation, incoherence and a dogmatic as well as conservative outlook. Subject to coercion in the modern State, they are nevertheless also subject to continuous changes and cross-fertilisations, which illustrate that a more fundamental shift, such as the coming about of a regulated society, could be envisioned as well. A philosophy of practice, according to Gramsci, should open with a critique of 'popular' common senses, since only then can a philosopher get in touch with the people and devise a somewhat different language which collectively attains 'a single cultural climate' that could in turn lead to a self-regulated civil society (Gramsci 1971: 349).

Getting in touch with what people think and feel through language is one thing. Devising a different language that could *represent* a coherent counter-hegemonic ideology foregrounding the necessity of regulated society is another. Throughout Gramsci's prison writings, reference is made to how to construe an alternative, counter-hegemonic language with which a wide variety of social groups could identify. For example, his frequent use of quotation marks in the *Prison Notebooks* constantly warns readers that the tenor of the words thus highlighted should not be taken for granted. Rather, they were meant as new terminologies corresponding only in part to old meanings. 'Hegemony', obviously, is a case in point. Whereas the term traditionally indicated dominance or power over,[3] Gramsci pushed the concept's boundaries to make them appropriate to changed circumstances. As Anne Showstack Sassoon notes: 'What is at stake here is *his* own continuing struggle with language … in terms of the significations carried by individual words, as he attempts to find a way to depict not just old but new phenomena … Above all, he cannot *see*, or *comprehend*, these phenomena if they are reduced to one aspect, for example, if the state is only portrayed as having a monopoly of force without reference to its dependence on consent' (2000: 43–4). This observation correctly stresses the inherent ambivalence and opaqueness of many concepts in Gramsci, resulting from the continued interference of dominant meanings and connotations. However, as will be clear by now, a number of passages in Gramsci's writings suggest that, next to seeking a middle ground in language, one of his goals was a total redefinition of language's components. Hegemony, again, is a case in point, for

ideally it would come to stand for consent only and no longer for coercion. Gramsci's political project, in brief, came with the need for a language that could somehow still be familiar and at the same time convey a spontaneity unheard of, a language that could somehow generate a radically new outlook on the social without fully alienating its addressees. Throughout his work, unsurprisingly, he attempted to redefine individual words and push their semantic limits so that a new way of viewing society could be established.

Pragmatically, his aspirations in this sense of purpose diminished as time went by. When prospects grew rather dim in prison, for example, he noted that '[t]he crisis consists precisely in the fact that the old is dying and the new cannot be born; in this interregnum a great variety of morbid symptoms appear' (Gramsci 1971: 276). Yet even in this assessment it is the problem of (finding another) language that again stands out. As Marcia Landis observes, it was 'characteristic that Gramsci should frequently identify social problems in terms of language symptoms' (Landis 1986: 65). He regularly alluded to *neolalismo*, for instance, as a symptom of the separation of artists from the people: 'What are all the artistic and literary schools and groups if not a manifestation of cultural neolalism?' (Gramsci 1975: 2193) The irony of this rhetorical question will be clear, as Gramsci might have ranked himself among those 'neolalists'. That at least one offspring of neolalism, that is, Futurism, might have been of special value to Gramsci should therefore not come as a surprise either.

It is well known that Gramsci paid close attention to serialised fiction, theatre and other modes of aesthetic production. To Gramsci all of these formed part of a wider popular culture crisscrossing various common senses. As such, they provided a starting point for both the description and the innovation of the mass's thought. His attraction to Futurism also cannot be separated from Futurism's popularity among the working class. On 8 September 1922, he reported to Trotsky on a Futurist exhibition organised by the Turin Communists and Futurists, which Marinetti had opened with a speech. The often cited letter reads:

> Marinetti went round the exhibition with the workers and expressed his satisfaction at seeing that the workers were a great deal more responsive to Futurist art than the bourgeoisie. Before the war, the Futurist movement had been very popular with the workers. The review *Lacerba*, with a circulation of 20,000 copies, sold over 80 per cent of them to the workers. During numerous Futurist events in the theatres of major Italian cities, the workers defended the Futurists against the blows dealt out to them by upper-class and bourgeois youths. (Gramsci 1985: 52–4)

In Turin Gramsci thus clearly saw Futurism as an important counter-hegemonic voice emanating spontaneously from civil society. His writings

about the movement before the war, however, further suggest that he was familiar with the technicalities of the Futurist poetics and its literary experimentalism. Already in 1913, long before the opening of the Turin Istituto, Gramsci expressed his sympathy for Futurism in the Turin *Corriere Universitario*. Interestingly, he noted in the university periodical that 'so far, the Futurists have had no intelligent critic: that is why no one has paid attention to them. If a few Crocean journalists had written a couple of articles on the subject, who knows how many discoverers of America there would now be!' (Gramsci 1985: 49). He then went on to describe Marinetti's writings as transgressing traditional literary techniques by characterising his work as a language untying itself in a successive series of words, 'as a successive or parallel or intersecting series of noun-planes … Pity, though, that these poor people [the Futurists] are not really able to use their shotguns and daggers!' (Gramsci 1985: 48). Welcoming first and foremost the Futurist stir in the 'Italian intellectual hen-house', Gramsci's article in the *Corriere Universitario* also displayed his aesthetic sensibility and linguistic sympathy for Marinetti's poetics. Could it be that this poetics, the Futurist way of dealing with language, somehow attracted his attention as much as (or even more so than) the political and institutional role of the movement?

Untameable words

As Marinetti asserted in *Democrazia futurista* (1919), Futurism aspired to become no less than the new political elite (Marinetti 1983: 345). The poetics Marinetti had been developing since 1912 to this aim hardly requires an introduction. But when we briefly recall just some aspects of that poetics, in particular its defence of *parole in libertà* or words-in-freedom, it instantly becomes clear exactly what might have prompted Gramsci's early interest in Futurism from a politico-linguistic point of view.

In the *Manifesto tecnico della letteratura futurista* (1912) and *Distruzione della sintassi – Immaginazione senza fili – Parole in libertà* (1913), Gramsci may in particular have found the idea of substantivisation appealing, because it came with the promise of language being able to regenerate itself. In line with his 1913 essay on Futurism, of specific interest to Gramsci must have been Marinetti's promotion of *sostantivi doppi* or double nouns and 'semaphoric' adjectives. Pushing the paratactic use of language in favour of traditional syntax, Marinetti envisaged a literature that could ideally generate its own meaning. Paratactic series of substantives and substantivised adjectives had to work through analogies triggered while reading. (Additive) pairs of nouns, such as 'woman-wave' and 'mantorpedo-boat', to Marinetti, could give rise to a dynamic linguistic object that represented its own production of meaning through what might be called

resemanticisation. Instead of only highlighting conventionalised signifieds of individual words, double nouns were meant to engage a reader in a play between the signifieds of several words, making words and concepts flow into one another. To this aim, Marinetti also elevated adjectives to pendants of nouns, so that they would no longer 'decorate' substantives but lead to seemingly oxymoronic word pairs that pushed readers into semantic aporia and opened various interpretations at once. As such, Marinetti's poetics in a way formalised tactics also encountered in Gramsci's writings, tactics with which traditional meanings and connotations of words in political representation could both be eased off from material signifiers and replaced by novel meanings and connotations. Of course, word pairs such as 'woman-gulf' make poor forms of address in the political sphere. When we relate the Futurist poetics to Mussolini's language, however, it becomes rather apparent just how effective Futurist parataxis was to become – and why Gramsci felt compelled to isolate the times' 'morbid symptoms'.

Nowadays often jokingly, scholars refer to a private conversation of Mussolini in which the Duce signalled that without Futurism there would have been no Fascist 'revolution'. From the vast amount of research on Mussolini's discourse, it would appear that Mussolini's remark has to be taken seriously, however. For Mussolini picked up a thing or two from Marinetti's poetics, it seems. To start with, Mussolini's speeches and language too favour parataxis (Leso 1977: 33). At the same time, it is no secret that Mussolini's audience interpreted his syntactical constructions both as clear language use and as a sign of a masculine and monumental style. Typical of paratactic (especially Futurist) constructions, we saw, is that it is difficult to circumscribe their individual words' distinct meanings, because such constructions generate and thematise their own meaning relationally. It is thus highly remarkable that Mussolini's contemporaries viewed his speeches, with their often endless sentences comprising numerous *che*'s [that ... that ... that ...] as lucid. Obviously, we are to avoid depictions of the Italian people here, which take Mussolini's working class and bourgeois audience for an 'irrational' or 'barbaric' group of listeners. (Even Adorno, in his essay on Hölderlin, in fact characterised parataxis as rational.) Yet a closer look at some of Mussolini's preferred phrases does not instantly explain his audiences' responses, unless we approach them, again, through the lens of Gramsci's language philosophy.

Mussolini clearly lay under tribute to *parole in libertà*. One pair of words in freedom encountered in his speeches is *Italia proletaria!*, a slogan that was also frequently used in Fascist propaganda, as Ernesto Laclau points out (1977: 120). In political discourse the individual terms of this pair had a distinct meaning. For Communists like Gramsci, for example, the State of Italy obviously did not coincide with the working class. At first

sight, the pair therefore suggested an oxymoron, but in light of Marinetti's *parole in libertà* we could also characterise the pair as consisting of a noun and a 'semaphoric' adjective. Read in this way, Mussolini offered his listeners a choice between *Italia* or *proletaria(to)*, leaving his audience in aporia, inviting it either to let one of the words' meanings dominate over the other or to let the words' conventional meanings go in favour of a chiasmic game of analogies that managed to convey both unity and heterogeneity, difference as well as identity. Other such pairs encountered in Mussolini's speeches are *rivoluzione conservatrice* [conservative revolution] and *democrazia autoritaria* [authoritarian democracy] (Mussolini 1956, 34: 127). The latter in particular begs attention, since it highlighted just how close Gramsci's regulated society came to Mussolini's regime. Not unlike Gramsci, Mussolini envisioned a redefinition of hegemony. In fact, in his *Dottrina del fascismo* (1932) he, too, referred to the Fascist state as an 'ethical state'. Yet whereas Gramsci had dreamt of a civil society without a political society, Mussolini installed a political society claiming to fully coincide with civil society: 'Let no one kid themselves in believing that I do not know what is going on even in the smallest village of Italy. I may perhaps learn about it untimely, but I will know eventually' (Mussolini 1956, 22: 382). He could have added the free-word pair: 'Mussolini Italy'.

In this morbid constellation, Futurism may have been but a bunch of 'schoolboys who escaped from a Jesuit boarding school', as Gramsci observed, a group of untameables who after a brief spell were politically marginalised. Yet to the incarcerated author of the *Prison Notebooks* Futurism may also have confirmed his conviction that language alone can give the impression of social coherence, and that, for this impression or representation to gain foot, civil society cannot undo itself of political society or vice versa. This internal split or gap in both language [*linguaggio*] and society must never be denied or filled. Politics, in this sense, is a necessary evil. 'This is also the case with Futurism', Gramsci observed, 'and is part of the people's cult of the intellectuals (who are in fact admired and despised at the same time)' (Gramsci 1985: 273). Or how a group of schoolboys meant serious politics, without being taken seriously.

Notes

1 The speech, 'L'inaugurazione della mostra d'arte futurista', was published in an abridged version in *L'Ordine Nuovo* (28 March 1922).

2 Peter Ives's *Gramsci's Politics of Language* (2004) is perhaps the only exception worth mentioning here. Ives asserts that Gramsci saw the Futurists 'as a starting point' for a critical approach to language, since they represented 'the most creative and progressive response to ... bourgeois culture'. However,

whereas Ives successfully shows how Futurism provided Gramsci with insights to counter neo-grammarian and Crocean approaches to language and literature, he fails to take into account the close interconnection between Futurism and Gramsci in the early 1920s and therefore also avoids a reading of Futurism that points at the broader cultural stakes Gramsci invested in Marinetti's movement. Moreover, little effort in Ives goes to elucidating Gramsci's later disappointment in the movement. See Ives 2004: 61.

3 See Outhwaite and Bottomore, eds, 1993: 263–6.

References

Berghaus, G. (1996). *Futurism and Politics. Between Anarchist Rebellion and Fascist Reaction, 1909–1944* (Oxford: Berghahn Books).

Bru, S. (2005). 'Morbid Symptoms. Gramsci and the Rhetoric of Futurism', *Variations. Literaturzeitschrift der Universität Wien*, 13:13, 119–32.

Bru, S. (2009). *Democracy, Law and the Modernist Avant-Gardes: Writing in the State of Exception* (Edinburgh: Edinburgh University Press).

Carpi, U. (1985). *L'estrema avanguardia del novecento* (Rome: Editori Riuniti).

Gramsci, A. (1965). *Lettere del carcere*, ed. S. Caprioglio and E. Fubini (Turin: Einaudi).

Gramsci, A. (1971). *Selections from the Prison Notebooks*, ed. Q. Hoare and G. Nowell Smith (London: Lawrence and Wishart).

Gramsci, A. (1975). *Quaderni del carcere*, ed. V. Gerratana (Turin: Einaudi).

Gramsci, A. (1985). *Selections from Cultural Writings*, eds D. Forgacs and G. Nowell Smith (Cambridge, MA: Harvard University Press).

Helsloot, N. (1989). 'Linguists of All Countries …! On Gramsci's Premise of Coherence', *Journal of Pragmatics*, 13, 547–66.

Holub, R. (1992). *Antonio Gramsci. Beyond Marxism and Postmodernism* (London: Routledge).

Ives, P. (2004). *Gramsci's Politics of Language. Engaging the Bakhtin Circle & The Frankfurt School* (Toronto: University of Toronto Press).

Kebir, S. (1980). *Die Kulturkonzeption Antonio Gramscis. Auf dem Wege zur antifaschistischen Volksfront* (Berlin: Akademie Verlag).

Laclau, E. (1977). *Politics and Ideology in Marxist Theory* (New York: Verso).

Landis, M. (1986). 'Culture and Politics in the Work of Antonio Gramsci', *Boundary 2*, 14:3, 49–70.

Leso, E. (1977). 'Osservazioni sulla lingua di Mussolini', in E. Leso et al. (eds), *La lingua italiana e il fascismo* (Bologna: Consorzio Provinciale Pubblica Lettura), pp. 15–62.

Lo Piparo, F. (1979). *Lingua, intellettuali, egemonia in Gramsci* (Bari: Laterza).

Marinetti, F. T. (1983). *Teoria e invenzione futurista*, ed. L. De Maria (Milan: Mondadori).

Mussolini, B. (1956). 'Dottrina del fascismo', in *Opera Omnia*, ed. E. and D. Susmel (Florence: La Fenice).

Outhwaite, W. and T. Bottomore (eds) (1993). *The Blackwell Dictionary of Twentieth Century Social Thought* (Oxford: Blackwell).

Rossiello, L. (1986). 'Linguistica e marxismo nel pensiero di Antonio Gramsci', in P. Ramat, H.-J. Niederehe and E. F. K. Koerner (eds), *The History of Linguistics in Italian* (Amsterdam: John Benjamins), pp. 237–58.

Salamini, L. (1981). *The Sociology of Political Praxis: An Introduction to Gramsci's Theory* (London: Routledge).

Salaris, C. (1990). *Marinetti Editore* (Bologna: Il Mulino).

Salaris, C. (1994). 'Marketing Modernism: Marinetti as Publisher', *Modernism/Modernity*, 1:3, 109–27.

Showstack Sassoon, A. (2000). *Gramsci and Contemporary Politics. Beyond Pessimism of the Intellect* (London: Routledge).

Verdicchio, P. (1995). 'Reclaiming Gramsci: A Brief Survey of Current and Potential Uses of the Work of Antonio Gramsci', *Symposium*, 49:2, 169–77.

The dark side of Futurism: Marinetti and technological war

Marja Härmänmaa

A survival strategy

Marinetti was a specialist in war; as he wrote in 1942, he was 'the only poet who specialised in modern war' (Marinetti 1942: 2). Indeed, war was central in both Marinetti's life and his work: he was actively engaged in warfare, participating in different capacities in four conflicts (Agnese 1990; Salaris 1997; Viola 2004; Guerri 2009).[1] In his works, the topics of 'destruction' and 'fighting' in his pre-Futurist poems developed into a leitmotiv of 'war' in his Futurist writings, being present from the novel *Mafarka il futurista* (1909) until his last poems, such as *L'aeropoema di Cozzarini primo eroe repubblicano* (1944). The reasons for Marinetti's bellicosity were manifold. On the one hand, war seemed to be an inevitable phenomenon of the modern, industrialised world. As he wrote in *Democrazia futurista*:

> For me it seems useless to demonstrate here how, owing to rapid scientific development and the prodigious conquest of the terrestrial and aerial velocities, life has become ever more tragic, and the ideal of an agrarian serenity has definitively declined. The heart of man should acquaint itself ever more with the imminent danger, so that future generations can be reinvigorated with a true love towards it. (Marinetti 1996: 450)

The modern world was characterised by 'the coexistence and necessary conflict of hostile principles' (Marinetti 1996: 451). Industrial progress and the frenzy of the new machine age had greatly influenced people, and had increased the Darwinian struggle between nations so that by then 'the feverishness and the instability of the races had reached such a point that it had upset every estimation of historical probability' (Marinetti 1996: 450). For these reasons Italy must activate 'the double fervour of a possible proletarian revolution or a possible war' (Marinetti 1996: 451).

In addition to this, the concurrent pessimistic conception of human nature made him consider war as a natural condition, and, for instance,

the peace that followed the First World War only as a pause between one battle and another. Peace 'could not be the absolute ideal of a virile man, as sleep could not be the absolute ideal of a healthy body' (Marinetti 1996: 391). Thus, peace could only be a consequence of 'the tiredness resulting from the last war or the last revolution', for 'the absolute peace could triumph only after the disappearance of the human race' (1996: 477). These considerations partly explain Marinetti's constant (and unfortu-nately justified) scepticism towards the international situation in which 'the pederast voice of the diplomats' (1996: 656) and 'the bleak masturbation of impotent diplomacy' (1996: 678–9) contributed to making enduring peace impossible (Härmänmaa 2000: 206–7). However, his own nationalistic dream of making Italy a politically (and culturally) important country did not make the international situation any more secure (Berghaus 1996: 59–73; Gentile 1988; 2003; 2009).

These reasons together with complete devotedness to the fatherland (Marinetti 1942b: 17), created the need to transform the Italian people into 'supermen', in other words, heroic citizens. As he explicitly and prophetically stated in 1929: 'It is necessary to feed the spirit of the heroic citizen, friend of danger and capable of fighting, for it is essential to improvise tomorrow the indispensable volunteers of the new war. This, I shall repeat, is certain, maybe close' (Marinetti 1996: 620).

To 'feed the spirit of the heroic citizen', he used the arts. According to the concept 'arte – vita', Futurism was a programme of socially engaged art, with its own particular ideology. As a consequence, the glorification of violence and war, among other things as 'the world's only hygiene' or 'the red holidays of a genius' (Marinetti 1996: 339), is to be taken as propaganda in its favour, as a part of a formation of the 'heroic citizen', and not as glorification of war for its own sake, as some critics have maintained (Härmänmaa 2000: 204). In the 1930s, Marinetti's rhetorical abilities and his loyalty to the sanctified Fatherland were recognised by the Fascist regime (Gentile 1996; 2006). Not only was he a member of the Fascist National Party, and National Secretary of the writers' union, but he was also a member of a special network for 'the internal propaganda in case of war' (Härmänmaa 2000: 15). Marinetti's use of the arts to promote war reached a peak during the Second World War, when practically all his works were thematically geared to the glorification of war, when 'aeropoetry' and 'aeropainting' were transformed into 'aeropoetry and aeropainting of war', the purpose of which was to encourage Italians to participate to the war and defend the Fatherland (Härmänmaa 2000: 215–16).

In this chapter, my intention is to highlight how war is represented in Marinetti's works. I shall focus on the representation of the Italian soldier, of the enemy and of battle, and finally, on the meaning he assigned to

death on the front line. I shall concentrate on the representation of the First World War. However, as the basic reasons for Marinetti's bellicosity were nationalistic (to protect or sustain national interests), and although the historical and political circumstances were different in the 1910s and in the 1930s and 1940s, little of his rhetoric actually changed during the over the thirty-year period when Italians read, saw and listened to Marinetti's war propaganda.

The sixth soul

Marinetti and the Futurists had started the campaign in favour of war with Austria as early as 1910. It was on this occasion that the borders between culture and politics faded, when the arts were used for war propaganda, and propaganda became a form of art. The Futurists' interventionist campaign began with the so-called *serate futuriste*, to be carried out with manifestos, with demonstrations and with theatre (Berghaus 1996: 73–92). Finally, in 1914, Giacomo Balla designed the so-called 'anti-neutral suit' (*vestito antineutrale*), based on the idea that 'one thinks and acts as one dresses up', followed the same year by a manifesto with the same title (Hulten 1986: 606; Conversi 2009: 92–117). Marinetti himself later recalled the interventionist campaign on several occasions, as it had become concrete proof of the devotion of Futurism to the cause of the Fatherland, and with which he could defend his position in the cultural life of the regime (Marinetti 1996: 595–600).

Although in the Founding Manifesto, Marinetti glorifies war only as 'the world's only hygiene', the nationalistic motivations are clear in *L'aeroplano del Papa* [The Pope's Aeroplane, 1912]: one of the themes of the novel in 'free verses' was the need to declare war specifcally on Austria (Marinetti 1914). The war was imperative, as Italy had to conquer the territories which, according to many, belonged to it, but were still part of Austria.[2] For this reason human life was meaningless, and war came to be seen as an economic matter. In *In quest'anno futurista* (1915), addressed to students and supporting Italy's intervention, Marinetti stated: 'For a poor and a prolific nation, a war is a good deal: it permits the acquisition of missing territories with an overabundance of blood' (Marinetti 1996: 335).

Finally war broke out and Europe was engulfed in flames. The First World War, the Great War, the War that was supposed to end all wars, was celebrated by many European intellectuals of the so-called 1914 generation who saw it as a solution to every kind of problem. The destruction was imperative for the creation of a 'brave new world' – which in Futurist rhetoric took the form of a 'hygienic war' (Wohl 1979; Insenghi 1997). So Italy too entered the war in 1915, as Marinetti had eagerly advocated. The

Futurists, including Marinetti himself, Boccioni, Russolo and Sant'Elia, were among the first to go to the front (Crispolti 1986: 179; Härmänmaa 2000: 213–15). Many of them died in this conflict that, as a turning point in European cultural history, was supposed to be the tomb of Futurism. But it was not – only the Second World War turned out to be disastrous enough to bury Futurism for several decades under the ruins of Europe.[3]

The fatal conclusion according to which war was an inseparable part, or rather, 'the culminating and natural synthesis of progress' (Marinetti 1996: 335), placed technological war at the core of the Futurist modernolatry. As Edoardo Sanguineti put it: 'Marinetti's modernolatry has its psychothematic centre and its obsessive technical space (from Tripoli-Adrianople, with landings at Carso, to *The X Mas*) in the marvels of industrial war'. The very Futurist aesthetics, and stylistic innovations in literature, such as words in freedom and the theory of analogies, too, were born and developed in relation to the notion of 'aesthetic war' in a period of violent, imperialistic, capitalistic and industrial development (Sanguineti 1984: 229).

The necessity of making war attractive, wrote Carlo Carrà in 1915, was based on the theory that 'pleasure' was the foundation and the stimulus of every vital action of modern man. On the contrary, the 'priestly' principle of an imperative would only create a sense of 'duty', most inadequate for the Italians who would interpret it as 'sorrow' (*dolore*). As a consequence, Italians would never react in an appropriate way to nationalistic appeal (Carrà 1915: 48). So duty was transformed into a pleasure. This happened first by transforming warfare as a whole into a festivity (Isnenghi 1997: 180) – a sort of game that culminated with the manifesto *Giocattoli guerreschi per i figli dei combattenti* [War toys for the soldiers' children, 1942] – and then by the aesthetisation of battle as an artistic or erotic pleasure. Yet, and in addition to the conquest of missing territories, the 'hygienic' war also had the task of reforming man, and it is from this point that I shall begin my analysis.

L'alcova d'acciaio (1921) is an autobiographical novel about the First World War having two main themes: love and war. As Marinetti indeed participates in the conflict in order to 'cure' himself of love of women, the war becomes an inner battle of a man against himself, a sort of mental hygiene, and the novel turns into a parody of a *Bildungsroman*.[4] Since the creation of a 'new man', in addition to artistic reform, was one of Marinetti's main goals, the internal struggle of man against his feelings and his 'humanity' is also often present in his writings – starting from *Mafarka il futurista*. It is the main topic of the novel *8 anime in una bomba* (1919), in which the author has baptised his sixth soul 'The scary tenderness' (La spaventosa tenerezza) (Marinetti 1996: 791–918). Dominated by the

nostalgic figure of the mother who wants Marinetti to find a woman to love, the soul is 'too good': it is the one that loves 'dogs, fragile creatures and tiny women' (1996: 905–18). The fourth one, the 'explosive soul' made of erotic adventures, wants to slaughter it, but without succeeding. As a sign of recognition of his own weakness, all the eight souls are in the end enclosed into one bomb of '92 kilograms of company Marinetti'. Together they form a Futurist mixture that is fired at the Austro-Hungarian front line, thus symbolising the manifold national force of Italy.

Marinetti's constant polemic against love was based on the idea that it was precisely 'love of a woman' that impeded man from becoming a 'metalised superman', or a heroic citizen. As Marinetti declared in 'Contro l'amore e il parlamentarismo' (1910): 'We despise the horrible and heavy Love who blocks the March of man and prevents him from escaping from his humanity, from doubling himself, from surpassing himself, and from becoming what we call *a multiplied man*' (Marinetti 1996: 292).[5] From this point of view it is easy to understand that Marinetti criticised the woman as society had formed her (1996: 294), and the romantic conception of woman that made her dangerous for man: 'We despise women, considered as only ideal, divine reservoirs of love, the woman poison, the woman tragic plaything, the fragile woman, obsessive and fatal whose voice is heavy with destiny, and whose dreaming hair mingles with the foliage of forests washed by moonlight' (1996: 292).[6]

Like the sixth soul in *8 anime* who loves dogs, in *L'alcova d'acciaio* Marinetti himself is accompanied to the front line by his tiny female dog, Zazà. His inner struggle against love of women escalates when arriving at Polcenigo. As the civilians run towards the soldiers who come to liberate the city, and as Marinetti sees the women, the contest between Will and Heart begins. Although Will wins, the victory is not complete, as Heart suffers to the point that it is almost dying:

> I feel the brutal plunge of joy into my heart that jumps up in the throat. Stop, my dear heart, if you are not a heart of a woman! Under the bite of will, heart gives up, but immediately starts crying silently, almost dying in a huge lake of tears. (Marinetti 2004: 226)

In the novel, love of woman is replaced in the first place by love of the Fatherland anthropomorphised into a woman that Marinetti 'loves' with his vehicle by driving across the peninsula (Sica 2010). Successively, it is replaced by love felt for the armoured car. And finally, the night of a battle is transformed into an exciting, romantic scene in which 'the anger of the cannon shots fighting with all the whimpering echoes increases the fantasy and mystery of this ultra-romantic night in love with death and with cruel hilarity' (Marinetti 2004: 19). The description is focused on a technological

weapon, a machine gun, that becomes a woman, 'The legendary Lady on the balcony', of whom the enemy soldiers are admirers, yet fated to die: 'And the elegant lady in black bends herself on the abyss where the Austrian serenades are humming and she spits, spits her endless vehement flowers that kill her romantic and courageous night singers' (Marinetti 2004: 35).

The abolition of love left behind the glorification of sexual pleasures. As Marinetti wrote in *Futurismo e Fascismo* and repeated in *Marinetti e il Futurismo*: 'We wanted to launch our race into a world war. It was thus necessary to heal it from excessive emotionality and from nostalgia by glorifying rapid and hasty loves' (Marinetti 1996: 497, 620). Consequently, flirtations, erotic adventures, brothels and prostitutes become an integral part of the First World War, in both *Come si seducono le donne* and in *L'alcova d'acciaio*. In addition to this, in a metaphorical language, the war itself transforms into an erotic scene offering an example of Marinetti's endless fantasy. In order to renew literature and create modern poetry for the 'kingdom of the machine', Marinetti had emphasised the meaning of the analogy. According to him, it was not only the 'blood of the poetry' but also the way to get to know the material that was supposed to replace the human being in literature. The use of intuition that replaced logic would enable people to recognise the similarity between two things that were apparently different (Marinetti 1996: 46–54). Thus, in *L'alcova d'acciaio*, the machine gun becomes the lover of the machine gunner who 'pinches her', who 'tickles her' and who 'dominates her by holding her supple back' (Marinetti 2004: 35). Yet in his private diaries the erotic images are far stronger, as 'the bombards are not coffee machines frogs, sewing machines', but 'virile members in erection'. Their resistance becomes symbol of Italy, for 'as the cannons that shoot in erection as virile members under the entire horizon of the fighting Austrian batteries – also Italy has to resist shoot – virile members in erection – under an entire horizon of the batteries of scepticism pessimism physical tiredness (women business love etc.)' (Marinetti 1987: 114).[7]

Looking for an enemy

Marinetti's unquestionable nationalism was in some way quite peculiar. As he wrote in *Democrazia futurista*: 'We believe that every race is planned to obtain a special supremacy in a certain field of activity. We also believe that there is no race destined to conquer worldwide hegemony' (Marinetti 1996: 373). Italy had a special position in Marinetti's personal *plan*. According to him, whereas the country was not competent in agriculture, commerce or industry, a leading position belonged to Italy without any doubt in the field of creativity: 'Italy that cannot ever win all the competition in agriculture,

in commerce or in industry, must instead seize its absolute supremacy in thought [*pensiero*], in the arts, and in the sciences' (1996: 373).

These observations lead to a hypothesis according to which Marinetti, regardless of his nationalism, was a cosmopolitan whose devotion to the Fatherland did not prevent him from respecting other nations. Also, there is no systematic or rationally motivated propaganda against an inimical nation, either in the texts before the First World War or in his later works (Härmänmaa 2000: 235–42). On the contrary, in the play *Il tamburo di fuoco*, for instance, the protagonist Kabango finds xenophobia to be a form of barbarism (Marinetti 1960: 20–1). Racially motivated war propaganda was even parodied by Carlo Carrà at the beginning of the First World War, when he explains the reason to hate the Germans as follows: 'You are almost always corpulent like bulls, you are all blond and pinkish and lardish like pigs, and we are almost all slim and skinny, almost always brown like burnt coffee' (Carrà 1915: 13–14).

In Marinetti's war writings a human enemy is seldom present, and when he appears, he is naturally 'cruel', as in *L'alcova d'acciaio*, or 'cruel and cowardly' as in *Il poema africano* (Härmänmaa 2000: 236). Yet, on the representational level, rather than another nation, the true enemies against which Marinetti fought his entire life, are *passéism* and nature. The 'hygienic' quality of the war was due also to the fact that it implied the destruction of the old world, and thus provided an opportunity to build 'The Futurist universe'. Already during the First World War, in the manifesto *Sintesi futurista della guerra* [Futurist synthesis of war, 1914] the war is represented in the first place as a conflict between Futurism and *passéism*, whilst the war against the Central Powers is in the background (Marinetti 1996: 326–7). In *L'alcova d'acciaio*, too, rather than against the Austrians, Marinetti was fighting first of all against himself, against the 'sixth soul', and successively against *passéism* in order to remake Italy. As he asks in the novel: 'How can we, without elasticity, smash the Austro-Hungarian *passéism*, remake Italy completely after victory?' (Marinetti 2004: 18). Still, during the Second World War, he gave as the entire reason for the Italian defeat the conservative forces in the country: 'And if Italy should die who is guilty / Guilt of the numismatic monarchy of the past and of tradition / Tradition same as betrayal glory thus to Cozzarini hero of invention' (Marinetti 1944: 22; Härmänmaa 2000: 155). Futurism also evidences the modernist and enlightened conception according to which nature is no longer a divine Other with which human beings are supposed to live in harmony, but rather an inanimate enemy that needs to be dominated and exploited (Härmänmaa 2009b: 337–60). The pastoral image of Mother Nature was destroyed once and for all when the development of the sciences, such as geology, biology, astronomy and anthropology, drastically changed the conception of life on

Earth. The man of the twentieth century lost the miracle of the Incarnation and the myth of the Resurrection. Henceforth, there would be neither privileged treatment nor special dispensation for him. Humanity was at the mercy of natural forces that had no concern for its anthropomorphic illusions. Man was a part of Nature, but a Nature that was indifferent to his cravings, and it really did not care which species would survive in the furious struggle for existence that life had become (Glicksberg 1966: 14–15). The sublime landscapes of Pascoli and D'Annunzio were replaced by Marinetti not only by brick and steel but also by furious visions of aggressive wind or turbulent sea. They represented the forces of nature that were to be tamed by human beings with the help of technology (Härmänmaa 2009b: 337–60). From this point of view the Futurist modernolatry can also be interpreted as the victory of man over 'the obscure forces of Nature' (Marinetti 1996: 449). This existential battle between man and nature was to show up in the arts, too, as they, in addition to 'the individual force and freedom', were supposed to glorify 'the victory of science and the ever-growing control over the obscure forces of nature' (1996: 456).

Consequently in warfare as well, the other major enemy of the Italian soldier was nature. War becomes an existential battle, a struggle for survival against nature, as the soldiers try to satisfy basic needs, such as hunger and thirsts in both the Libyan and Ethiopian wars (Marinetti 1996: 733; 1937: 135–36).[8] The centrality of the idea of a battle between human beings and nature is further emphasised in Marinetti's metaphorical language, in which nature serves as a vehicle in analogies. So in *L'alcova d'acciaio*, before a fight, the Austrian grenades heard above the roof change into an immense river: 'While we are dressing, above we hear increasing, thickening and multiply the hiss of the Austrian shrapnel that, while passing over the rocks and over the tin roof, gives the illusion of an enormous flowing water with its noise of lacerated silk' (Marinetti 2004: 33).

Portrait of the Italian (Futurist) hero

In addition to the arts, with its all-encompassing programme Futurism aimed to remake the morals of human beings and finally to create a new man. However, it is worth pointing out that Marinetti showed little interest in improving the physical body. The masculine body in particular appears quite seldom in his writings, and also there is hardly any description of the body of an Italian soldier. A crucial example is to be found in *Come si seducono le donne*. Here too, it is not the body of the soldier that makes him an ideal lover but his clothes: 'boots, spurs and bandolier are essential for love' whilst jackets, tailcoats and tuxedos are made for the armchair, evoking a library (Marinetti 2003: 40). In *L'alcova d'acciaio* the machine gunner who

'dances' with 'the Elegant Lady' is a certain Buco: 'a thin, olive Apulian with small, foxy eyes full of lightning that mixes up with a continuous white laugh' (Marinetti 2004: 35). As man was to become master of the universe with the help of technology, no muscles were needed.

While Marinetti's main objective was to rebuild the character of the Italians, his interest was focused on the character of the soldier, too. Although, the Futurist soldier, according to the common war rhetoric, was represented as courageous and loyal, willing to die for the Fatherland, he had some peculiar features that well reflect Marinetti's idea of the Italian national identity. Supremacy in the field of creativity was the logical conclusion of the idea that without any doubt Italy produced the greatest number of geniuses in the world (Marinetti 1996: 405). Thus it was precisely the 'creative genius' upon which the national strength rested (Marinetti 1996: 543).

According to Glicksberg, the importance assigned to the arts in the second half of the nineteenth century was to be explained as a way to rebel against the destiny of a death without purpose and without resurrection, thus a way to rise above death and become immortal (1966: 14). In *The Birth of Tragedy*, Nietzsche had offered an interpretation of life as a mere aesthetic spectacle that requires no further justification. The essential metaphysical activity of man consisted of art rather than of ethics in a desolate and cruel universe in which God, as the creator of the world, was considered to be an amoral cosmic artist who recklessly created and destroyed, realising himself indifferently in whatever he did or did not do. In Italy the cult of aesthetics reached its peak with D'Annunzio, who found in beauty and in pleasure the reason for living and in the arts Italy's national force, and whose primary goal was to make his own life a perfect work of art.

Marinetti as well, continuing the fin de siècle tradition, considered Italy's national identity to be based on creativity. As early as 1905, in the play *Re Baldoria* [King Guzzle], he had presented his idea of a new society in which Art and the Artists would rule, as 'the vast proletariat of geniuses' (Härmänmaa 2009a: 857–73). The importance assigned to the arts led to an appreciation of creativity also in warfare. For instance, in 1924 Marinetti stated that the victory of the Italians in the First World War was actually due to the artistic quality of the Italian troops: to their 'creative genius, artistic elasticity, synthetic practicality, improvising velocity and rapid enthusiasm' (Marinetti 1996: 540). The whole conflict is turned into a creative game in which the Italians 'artistically improvising ... had pulled the Austrians' leg', and consequently won the war (Marinetti 1996: 541, 318). As proof of his conviction about the importance of creativity, at the end of the Second World War Cozzarini in *L'aeropoema di Cozzarini* is still defined as 'the hero of invention' (Härmänmaa 2000: 155).

In addition to this, war itself becomes an artistic spectacle. Marinetti began to aestheticise technological war in the early 1910s (Marinetti 1996: 338–9), and continued to do so in one way or another for the following thirty years. Since for the first time in (Italian) military history modern technology played an important role in the Libyan war, the 'artistic' dimension of battle is particularly important in *Zang Tumb Tumb* (1914).[9] As battle becomes an authentic Futurist work of art, its noise becomes music, 'the orchestra of the noise of the war' (Marinetti 1996: 776–7), 'the symphony of the shrapnel', whilst 'the Italian artillery moulds crazy sculptures in the masses of the enemy' (Marinetti 1996: 339). Battle, transformed into a work of art, served as a model for Futurist aesthetics that developed in relation to warfare (Poggi 2009: 821–40).

The representation of war as an artistic game, or as a supreme feast *per se* excludes hatred. As I said before, regardless of his patriotic or nationalistic feelings, Marinetti cannot be characterised as a racist or xenophobe (further evidence of this is also his genuine passion for Africa and the primitive that in *L'alcova d'acciaio* is represented in the form of the African wind, Simun, in love with Italy). Consequently, there is very little space in his war writings for hatred of an enemy. During the 1930s this feature becomes more evident as, after the Lateran pact, the influence of the Catholic Church grew ever stronger. Consequently, as the Ethiopian campaign changed into a 'civilising mission', the Italian soldier is characterised by his merciful attitude towards the enemy (Härmänmaa 2000: 221–7; 235–51). But already on the battlefields of the First World War the Italians are seen as remarkably generous, which is made clear by their giving food to prisoners, or by their forgiving behaviour towards female enemies (Marinetti 2004: 28, 232; Härmänmaa 2000: 224).

In *L'alcova d'acciaio*, instead of the soldiers, only the civilians are truly capable of hating the enemy. The urge for Revenge (baptised The Frightening Cosmic Force, 231) felt by mistreated Italian civilians (especially women) at the end of the war is manifested in both the city of Aviano and Vittorio Veneto (Marinetti 2004: 229–32). And for Marinetti, too, as he is not 'San Francesco', revenge becomes an understandable human reaction. Yet it is immediately counterbalanced by another force, 'the divine and most Italian *Allegria*' that circulates in the sky over the city of Vittorio Veneto. The same battle between the opposing forces that is metaphorically fought in the sky takes place within Marinetti, as 'The Human soul' understands and forgives, but 'the other one, savage and bloody' still urges revenge. Finally, Marinetti's message here too, is forgiveness. *Allegria* will finally triumph 'when the war will be forgotten, and the enemy forgiven' (Marinetti 2004: 208–10).

Finally, the positive effects of the war emerge in the civilians' feelings

when they are liberated by the Italian soldiers. The joy of the women, children and elderly form 'a magnificent garden of superhuman joys'. The gratitude of the liberated civilians competes with that of the people whom Jesus has healed, and thus the Italian soldiers are implicitly compared to Christ (Marinetti 2004: 227–8). This characteristic of war as an escalation of human goodness becomes more evident during the Second World War. In 1942 Marinetti and Cangiullo published *The Futurist Manifesto of the Friendship of War*, in which war was characterised as an intensifier of friendship; in *Bellicose Toys for the Soldiers' Children* (1942) it is depicted as 'a new form of inexhaustible terrestrial love'. Finally, the conception of war as a catalyst for loving kindness culminates in *Originalità russa di masse distanze radiocuori* (posthumously published, probably written in 1942), another autobiographical novel situated on the Soviet frontier during the Second World War. Curiously, the USSR had adopted the lesson taught by Maxim Gorky who had stated that those 'who cannot hate, cannot love either'. This was echoed in the principle according to which hating the enemy was a citizen's duty. Whereas the Soviet soldiers nourished their willingness to fight with hatred, from Marinetti's point of view the horrors of the eastern front became '3000 km of feelings from the Don to Rome' (Härmänmaa 2000: 221–8).

Overcoming death

On the representational level, war thus becomes an existential battle between human beings and nature, and a cosmic battle between opposite forces, such as Good and Evil, or Futurism and *passéism*. But it also becomes an existential battle of the human being against himself, and ultimately against death. The fin de siècle intellectual and literary tradition had strongly felt the problem of death in a secular world created by science, in which the death of God and consequently the annihilation of resurrection had made passing away meaningless (Glicksberg 1966). The horror in the face of a temporal and limited existence is felt by Marinetti too, who emphasises the brevity of human life on several occasions. In this regard, Futurism can be interpreted as an effort to exorcise both (linear) time and death (Luti 1972: 51–8; Härmänmaa 2000: 16). This takes place with the cult of velocity in which, in quite a banal way, Einstein's theory of relativity has been applied; with enthusiasm for the technological means of communication that, by creating a feeling of spatial and temporal simultaneity, increased the capacities of human beings; and, finally, with the utopia of immortal multiplied man (Härmänmaa 2001).

Zang Tumb Tumb in particular, but also *L'alcova d'acciaio,* belong to the period of Marinetti's boundless enthusiasm for progress, science and

technology that is embodied in the 'metallization of man' (Armstrong 1998; Berghaus 2009: 1–40). Consequently, in *L'alcova d'acciaio* there is no trace of the destructiveness of modern technology that occurred in the first 'technological war'. Instead, Marinetti celebrates the fusion of technology and man, and the birth of multiplied man in the front lines of the First World War. The presence of gas transforms the trenches into 'a chemical laboratory full of mad scientists' (Marinetti 2004: 24). A divinisation of the human being through technology takes place, as the soldier becomes a 'mechanical superman', and with the gas mask presenting a 'most original profile of a diver submerged in a sea of asphyxiating and tear gas' (Marinetti 2004: 24).[10]

Death on the battlefield is almost completely neglected in *Zang Tumb Tumb* and in *L'alcova d'acciaio*, appearing only in the execution of prisoners or deserters. In his works of the 1930s and 1940s this is no longer the case. There is no attempt to mask the cruelty of war, as in Marinetti's descriptions soldiers are constantly dying in combat. Yet the solution is either to make death meaningless, to banalise it on the linguistic level with two types of representation or to give it a profound meaning.

In his 'linguistic revolution' Marinetti had demanded the removal of the human being from literature and his or her replacement by 'material'. The reasons were twofold: on the one hand, 'logical and wise' human beings had nothing more to give to anyone, and, on the other, this was the way to eliminate 'useless' sentimentality from literature (Marinetti 1996: 46–54). The so-called telegraphic style that, among other things, consisted of the objective description of a phenomenon corresponds to the cold and anti-sentimental nature of the new man who had killed 'the Sixth soul' (and of which the representation of war in *Zang Tumb Tumb* is the major example). Likewise, in *L'alcova d'acciaio*, in order to deprive death of every meaning Marinetti only mathematically 'ascertains' that sunrise reveals on the battlefield 'few dead, many wounded' (Marinetti 2004: 46). In the Libyan war that Marinetti remembered some twenty years later, the shooting of an Italian soldier does not at all disturb his appetite during a breakfast that takes place as if nothing had happened:

> When, after the bombing of Tripoli, an Italian marine near me gets killed when he is shot fatally on the red sponge of his poor face, his companion artillery man drapes him on the back of a donkey pushing it as I do with all the bodies of memories towards the sea of hope // And actually there is no lack of appetite among us during the breakfast served by waiters. (Marinetti 1996: 1176)

The other way to exorcise death is to create somewhat brutal analogies in which the vehicle derives from different semantic fields. In *L'alcova d'acciaio* one of the final battles becomes a 'country fair' in which the Austrian 'herd'

will be 'slaughtered' and 'eaten' by 'the pot-bellied and greedy cannons' (Marinetti 2004: 47). In Libya the hanged bodies resemble 'sandwiches' (Marinetti 1996: 710). Again in *L'alcova d'acciaio*, the Bohemian soldier, hanged by the Germans, has his eyes open and head twisted up, 'as if he were looking at birds inattentively' (Marinetti 2004: 205). At the end of the war, the women of the liberated town of Vittorio Veneto shoot a Bosnian prisoner in the face that changes into 'a horrible red sponge' (2004: 210). The use of absurd analogies is a continuous stylistic characteristic of Marinetti's (war) writings. Thus, in the Ethiopian war, the body of a dead officer floating on the sea brings to his mind a 'new Indian idol' (Härmänmaa 2000: 232–3), or in *Canto eroi e macchine della guerra mussoliniana* (1942), a decapitated soldier becomes 'a haversack full of strawberries hung on a nail in a country inn' (Marinetti 1942a: 57).

During the Second World War, war finally serves to give death a meaning: in addition to the arts, also dying in war offers a way to immortality. This is quite clear in *Canto eroi e macchine della guerra mussoliniana* (1942), in which the macabre description of death is followed by a resurrection, and the dead heroes are taken to paradise (Härmänmaa 2000, 228–235). Dying on the battlefield for the Fatherland thus resolves the concern about meaningless death that Marinetti had expressed in the Founding Manifesto (Marinetti 1996: 8),[11] and that in one way or another is constantly present in his works, as he, echoing Islamic theology, declares heroism to be 'the greatest spontaneous impetus towards the Divine' (Marinetti 1942a: 24).[12]

The 'end'

Marinetti dedicated a great deal of his life and work to turning Italians into heroic warriors. Yet, at the end of the Second World War when Italy's ultimate defeat seemed more than obvious, it was clear that his efforts had failed. It was clear too to Farfa, who in 1944 in a sarcastic message wrote to Marinetti that 'the Italians have shown, show, will show that they are not a great nation'.[13] Maybe it was so, but Marinetti's labours in encouraging the Italians were recognised for instance by Ezra Pound, who remembered him in his Canto LXXII (1945) (Pound 1985: 826). In addition to this, proof of the effectiveness of Marinetti's rhetoric and his ability to persuade is the fact that he managed to encourage many young Italians to participate in the different wars he witnessed during his lifetime. A concrete example is the case of Corrado Forlin, a twenty-six-year-old Futurist painter who in November 1942 wrote the following letter to Marinetti:

> My dear Marinetti … Do you know I shall volunteer for the Russian front? I could not resist. First I shall be …? and then I shall be a machine gunner with

a heavy machine gun tatatatatatatata. I like enormously the heavy machine gun Fiat that you describe in your *Il Poema africano*.[14]

There is no doubt Marinetti's main qualities as a writer consist of his innovative way of using language and his power of fantasy thanks to which he was able to create surprising analogies, aesthetise everyday life, and represent it as a hilarious yet somehow absurd game. Better it would have been had he not used this creativity for the propaganda of war.

Postscript: Corrado Forlin never returned from the Russian front (Härmänmaa 2000: 214).

Notes

1 These were the wars between Italy and the Turkish empire in 1911–12, the First World War in 1915–18, the Ethiopian war in 1935–36 and finally the Second World War in which Marinetti served on the Russian front in 1942.

2 For instance, in *Manifesto del partito futurista italiano* (1918) Marinetti wrote: 'It is necessary to bring our war to total victory, to the destruction of the Austro-Hungarian empire, and to secure our natural borders both land and sea. Otherwise we cannot have free hands to empty, clean, renovate, and magnify Italy' (Marinetti 1996: 155).

3 With this sentence I am referring to the 'academic and scientific silence' that followed the Second World War: as Futurism was identified with Fascism, it aroused little interest among scholars, and for this reason its artistic innovations were also neglected.

4 Regarding the importance of the topic, it is worth remembering that the combination of war and women is central also in *Come si seducono le donne* (1916), another autobiographical novel that Marinetti dictated to Bruno Corra before returning to the front. See Marinetti 2003.

5 The manifesto was probably published first in 1910. Still, in *Marinetti e il Futurismo* (1929) Marinetti complained that 'Today Italy is full of strong and athletic young men. Unfortunately, many of them sacrifice for a woman their desire for conquest and adventure' (1996: 620).

6 On the utopian notion of a new futurist woman who was supposed to replace the 'old woman', see, for instance, Contarini 2006; Re 2009; Sica 2010.

7 According to Marinetti, the quotation is from a speech he gave during a dinner at the front line on 16 September 1917.

8 Also in *L'alcova d'acciaio* 'hunger' and 'eating' are central – although the festive character of war excludes their representation as a reason to suffer.

9 Although the aesthetisation of battle was central in the discourse related to the First World War, he continued to glorify the beauty of technological battle in the 1930s, too. See also F. T. Marinetti, 'La battaglia aerea', *Stile Futurista*, 1:3 (September 1934), 5; F. T. Marinetti, 'Invito alla guerra

africana. Manifesto futurista agli scrittori e agli artisti d'Italia', *Stile Futurista*,
2:11–12 (September 1935), 3; F. T. Marinetti, 'Estetica futurista della guerra',
Stile Futurista, 2:13–14 (November 1935), 9. In order to understand the
continuation of Marinetti's ideas, it is vital to point out that at least in 1935
and in 1942 he republished the first part of the last chapter of *Zang Tumb
Tumb*, dedicated to the bombardment of Adrianople. See F. T. Marinetti,
'Bombardamento di Adrianopoli', *Stile Futurista*, 2:15–16 (December 1935),
10; F. T. Marinetti, *L'esercito italiano. Poesia armata* (Rome: Cenacolo 1942),
pp. 44–6. On the aesthetisation of the war in *L'alcova d'acciaio*, see also
Isnenghi 1997: 181–2.

10 Interestingly, 'diver' was an important motif in Enrico Prampolini's works
in the 1930s. In addition, the same idea of a metalised human body and
mechanical man is to be found in the manifesto *Estetica futurista della Guerra*
that Marinetti published in 1935. See Härmänmaa 2000: 220.

11 'And like young lions we ran after Death, its dark pelt blotched with pale
crosses as it escaped down the vast violet living and throbbing sky. // But we
had no ideal Mistress raising her divine form to the clouds, nor any cruel
Queen to whom to offer our bodies, twisted like Byzantine rings! There was
nothing to make us wish for death, unless the wish to be free at last from the
weight of our courage!' (Marinetti 1996: 8). The English translation is from:
www.unknown.nu/futurism/manifesto.html. Accessed 20 February 2010.

12 The importance of heroic death has also been recognised by Baldissone and
Blum. See Baldissone 1986: 137; Blum 1996: 100–2.

13 Farfa, *Messaggio di Farfa a Marinetti per le direttive di Venezia 1944*: an
unpublished manuscript conserved in the Beinecke library, Filippo Tommaso
Marinetti papers, box 17, folder 1068.

14 The original letter is in the Beinecke library, Filippo Tommaso papers, box
10, folder 476. Now also in Härmänmaa 2000: 214.

References

Agnese, G. (1990). *Marinetti. Una vita esplosiva* (Milan: Camunia).

Armstrong, T. (1998). *Modernism, Technology and the Body. A Cultural Study*
(Cambridge: Cambridge University Press).

Baldissone, G. (1986). *Filippo Tommaso Marinetti* (Milan: Mursia).

Berghaus, G. (1996). *Futurism and Politics. Between Anarchist Rebellion and Fascist
Reaction, 1909–1944*. (Providence, RI, and Oxford: Berghahn).

Berghaus, G. (2009). 'Futurism and the Technological Imagination Poised between
Machine Cult and Machine Angst', in G. Berghaus (ed.), *Futurism and the
Technological Imagination* (Amsterdam and New York: Rodopi), pp. 1–40.

Blum, C. (1996). *The Other Modernism. F. T. Marinetti's Futurist Fiction of Power*
(Berkeley and Los Angeles: University of California Press).

Carrà, C. (1915). *Guerrapittura* (Milan: Edizioni futuriste di 'Poesia').

Contarini, S. (2006). *La femme futuriste. Mythes, modèles et representations de la*

femme dans la théorie et la littérature futuriste (Paris: Presses Universitaires de Paris, 10).

Conversi, D. (2009). 'Art, Nationalism and War: Political Futurism in Italy (1909–1944)', *Sociology Compass* 3:1, 92–117.

Crispolti, E. (1986). *Storia e critica del futurismo* (Rome and Bari: Laterza).

Gentile, E. (1988). 'Il futurismo e la politica. Dal nazionalismo modernista al fascismo (1909–1920)', in R. De Felice (ed.), *Futurismo, cultura e politica* (Turin: Fondazione Giovanni Agnelli), pp. 105–59.

Gentile, E. (1996). *The Sacralization of Politics in Fascist Italy* (Cambridge, MA: Harvard University Press).

Gentile, E. (2003). *The Struggle for Modernity: Nationalism, Futurism, and Fascism* (London: Praeger).

Gentile, E. (2006). *Politics as Religion* (Princeton: Princeton University Press).

Gentile, E. (2009). '*La nostra sfida alle stelle*'. *Futuristi in politica* (Rome and Bari: Laterza).

Glicksberg, C. I. (1966). *Modern Literature and the Death of God* (The Hague: Martinus Nijhoff).

Guerri, G. B. (2009). *Filippo Tommaso Marinetti. Invenzioni, avventure e passioni di un rivoluzionario* (Milan: Mondadori).

Härmänmaa, M. (2000). *Un patriota che sfidò la decadenza. F. T. Marinetti e l'idea dell'uomo nuovo fascista, 1929–1944* (Helsinki: Academia scientiarum fennica).

Härmänmaa, M. (2001). 'Time and Space Died Yesterday: F. T. Marinetti's Ideas about "Time" and "Tradition"', *CD Rom of the Proceedings of the 6th International ISSEI Conference (Haifa University, Israel, August 1998), Twentieth Century European Narratives: Tradition & Innovation*.

Härmänmaa, M. (2009a). 'Beyond Anarchisms: Marinetti's Futurist (Anti-)utopia of Individualism and "Artocracy"', in M. Härmänmaa and P. Antonello (eds), *Future Imperfect: Italian Futurism between Tradition and Modernity, The European Legacy*, 14:7, 857–73.

Härmänmaa, M. (2009b). 'Futurism and Nature', in G. Berghaus (ed.), *Futurism and the Technological Imagination* (Amsterdam and New York: Rodopi), pp. 337–60.

Hulten, P. (ed.) (1986). *Futurismo e Futurismi* (Milan: Bompiani).

Isnenghi, M. (1997). *Il mito della grande guerra* (Bologna: Il Mulino).

Luti, G. (1972). *La letteratura nel ventennio fascista. Cronache letterarie tra le due guerre: 1920–1940* (Florence: La Nuova Italia).

Marinetti, F. T. (1914). *L'aeroplano del papa. Romanzo profetico in versi liberi* (Rome: Edizioni futuriste di Poesia).

Marinetti, F. T. (1937). *Il poema africano della divisione '28 ottobre'* (Milan: Mondadori).

Marinetti, F. T. (1942a), *Canto eroi e macchine della guerra mussoliniana* (Verona: Mondadori).

Marinetti, F. T. (1942b). *L'esercito italiano. Poesia armata* (Rome: Cenacolo).

Marinetti, F. T. (1944). *L'aeropoema di Cozzarini primo eroe repubblicano* (Edizioni Erre, s.d., s.l.).

Marinetti, F. T. (1960). *Teatro*, ed. G. Calendoli (Rome: Vito Bianco Editore).

Marinetti, F. T. (1987). *Taccuini 1915/1921*, ed. A. Bertoni (Bologna: Il Mulino).

Marinetti, F. T. (1996). *Teoria e invenzione futurista*, ed. L. De Maria (Milan: Mondadori).

Marinetti, F. T. (2003). *Come si seducono le donne* [1916] (Florence: Vallecchi).

Marinetti, F. T. (2004). *L'alcova d'acciaio. Romanzo vissuto* [1921] (Florence: Vallecchi).

Poggi, C. (2009). 'The Futurist Noise Machine', in M. Härmänmaa and P. Antonello (eds), *Future Imperfect: Italian Futurism between Tradition and Modernity, The European Legacy*, 14:7, 821–40.

Pound, E. (1985). *I Cantos*, ed. M. de Rachewiltz (Milan: Mondadori).

Re, L. (2009). 'Mina Loy and the Quest for a Futurist Feminist Woman', in M. Härmänmaa and P. Antonello (eds), *Future Imperfect: Italian Futurism between Tradition and Modernity, The European Legacy*, 14:7, 799–819.

Salaris, C. (1997). *Marinetti. Arte e vita futurista* (Rome: Editori Riuniti).

Sanguineti, E. (1984). 'La guerra futurista', in I. Gherarducci (ed.), *Il futurismo italiano. Materiali e testimonianze critiche* (Rome: Editori Riuniti), pp. 227–32.

Sica, P. (2010). 'War, Bodies and Futurist Science in Enif Robert's and Filippo Tommaso Marinetti's *Un ventre di donna*', in G. Bottà and M. Härmänmaa (eds), *Proceedings of the XI ISSEI Conference* (Helsinki: Language Centre, University of Helsinki). http://blogs.helsinki.fi/issei2008/

Viola, G. E. (2004). *Filippo Tommaso Marinetti* (Palermo: L'Epos).

Wohl, R. (1979). *The Generation of 1914* (Cambridge, MA: Harvard University Press).

17

Rethinking interdisciplinarity: Futurist cinema as metamedium

Carolina Fernández Castrillo

Some of the most innovative artistic expressions at the beginning of the twentieth century came from the Futurist desire for provocation and rupture with tradition. After many unsuccessful attempts at the end of the nineteenth century, Futurism tried to formulate new strategies to reflect the transition of society and the arts to modernity. Its project consisted of an integral restructuring of the universe and a celebration of the future based on the hybridisation of art and media that was clearly formulated in *The Founding and Manifesto of Futurism* (1909). With astonishing lucidity the Futurists embraced the modern adventure, launching a cry of revulsion against the past, thus establishing the fundamental principles of subsequent avant-gardes. Their historical role was to announce the forthcoming changes as the result of the emergence of industrialisation, technology, new modes of transport and communication systems. The capacity to engage with reality by infusing it with the dynamism of the imaginary dominated the aesthetics of the works of Filippo Tommaso Marinetti. Above all, he tried to combat the uncertainty that was afflicting his contemporaries through the use of provocative techniques. His irrepressible yearning to channel the latent energy of society led to the foundation of the first avant-garde movement. It was the first example of a systematic set of principles in the cultural sphere designed to rescue a new society in crisis.

In this chapter, I will try to show how the works of Marinetti, Arnaldo Ginna and Bruno Corra, among others, led Futurism to achieve the total work of art. Their experiments reveal some interesting relationships with the concept of metamedium. By this term, I mean a medium which uses old media as its primary material. The logic of metamedia fits well with some key aesthetic paradigms of today, such as the remixing of previous cultural contents and forms of a given medium, or the remixing between the interfaces of various cultural forms and new software techniques. Finally, I

will argue that the conception of Futurist cinema links naturally with, and probably helped to spawn, the modern-day explosion in digital multimedia.

From Gesamtkunstwerk to Futurist reconstruction

The formulation of an innovative project to reconstruct the universe came from faith in progress in all its forms and spurred these artists on to incorporate new media to achieve a *Gesamtkunstwerk* or total work of art, setting Marinetti up as the most relevant figure in the genesis of the avant-garde movement. While the importance of Marinetti's contribution cannot be questioned, his strategies are indebted to previous experiences, in spite of his attempts to erase their origin. A disciple of the principal exponents of the literary revolution in France, Marinetti absorbed the fin-de-siècle spirit from Parisian intellectual circles. In contrast to Saint-Pol-Roux's 'idéoréalisme' or 'magnificisme', which praised a return to nature as a form of escapism, Marinetti was interested in all cultural movements that focused on the modern condition. Among his contemporaries, some of the most influential intellectuals included Paul Adam, Émile Verhaeren, Jules Laforgue, Jean Moréas, Alfred Jarry, Henri Bergson, Maurice Maeterlinck and Jules Romains.

His French experience was a key factor in the elaboration of the integration between art and daily life. Also significant was the Wagnerian theory that tried to respond to some of the main cultural changes introduced in the nineteenth century. In fact, Richard Wagner transformed cultural thought through his concept of the total artwork, a synthesis of the poetical, visual, musical and dramatic arts. Thus, the German composer established the principle of a collective work and the combination of opposing elements instead of specialisation. *The Artwork of the Future* (1849) is a long essay that explains how the *Gesamtkunstwerk* was conceived as a collective work of art, a 'fellowship of all artists', designed to promote their capacities to limits impossible to reach separately. Alberto Abruzzese suggests that the desire for the creation of a total artwork can be interpreted as the application of industrial systems to art: '*Kunstgesammeltwerk* means principally contemporaneousness, simultaneity of the significant functions; it means trauma, shock, production concentrated on the moment of its consumption' (Abruzzese et al. 1979: 19). In this context, Adorno associates Wagner's enterprise with that of Schopenhauer, who proposed the adoption of music as a point of reference in order to remove social relations in the bourgeois model of production (Adorno 1970). In this way, the collaboration between the different artistic disciplines would be a model for cultural and social reality. According to Wagner, '[n]ot one rich faculty of the separate arts will remain unused in the United Artwork of the Future; in it each will

attain its first complete appraisement' (Wagner 1993: 78). This quotation shows that Wagner tried to provide art with its own language, coherence and precise objectives. Similarly, the Futurists based their project of renewal of the arts on an interdisciplinary model of action. In fact, the idea of the *Gesamtkunstwerk* survived in the Futurists' techniques of agglutination, which represents the main link with present-day multimedia arts.

Futurism, always open to infinite possibilities of experimentation, emerged as the reformulation of every single aspect of life. Through a new structured aesthetic system, the members of this movement became critical agents of their present. The congregation of these artists around programmatic texts reflects a tendency to rely on the restructuring of reality through the reorganisation of artwork and, in some cases, the adoption of scientific and technological procedures. The reconfiguration of contemporary scenes was one of Marinetti's priorities. It was stated explicitly in *The Futurist Reconstruction of the Universe*, a manifesto by Giacomo Balla and Fortunato Depero published on 11 March 1915. This text summarises the role of the movement and is a synthesis of the Futurist intention no longer to simply describe the world, but to transform it through creativity. Balla and Depero conceived this manifesto as a strategic handbook for those who wished to take part in the Futurist revolution. From the first line, they expressed their common intention 'to realise this total fusion in order to reconstruct the universe making it more joyful, in other words by a complete re-creation' (Balla and Depero 1915: n.p.). The main difference from other theoretical texts was that this manifesto rejected a politicised stance, proposing a restructuring of the universe through a vital optimism instead of a violent warmongering attitude.

For Maurizio Scudiero and Enrico Crispolti, *The Futurist Reconstruction of the Universe* was a milestone between the first and second phases of Futurism; they argue that this text represents a considerable evolution from Boccioni's pictorialism to Balla and Depero's totalising vision. However, I should like to argue that the rift between the two phases of the movement did not occur with the publication of this manifesto, which only underscored the main Futurist principles, extending them to other disciplines. It opened a range of creative possibilities that, as noted by Crispolti, includes: science and politics; architecture, decoration and botany; painting and sculpture; 'tactilism'; fashion, graphic arts and set design; culinary arts; words-in-freedom; *tavole parolibere*; typographic imagination, free poetry and 'aeropoetry'; prose and drama; synthetic, variety and total theatre; dance; photography and film; advertising and mass communication (Crispolti 1986). Giacomo Balla and Fortunato Depero's project was thus conceived on a global scale, involving a range of disciplines, united by a desire to create a total reality. In contrast to

the fin de siècle's resistance to change, Futurists assumed their important historic role of trying to unveil the future of a new era based on technological development. These artists approached this task as a continuous experimental process focused on finding both the specific potential of the emerging new media and their possible interrelations.

Exploring the medium: first examples of interdisciplinarity

In the first half of the twentieth century numerous treatises on the limits of the arts were published. Some intellectuals started to ask whether the beauty of an artwork lay in the harmony of each of its parts, instead of in its origins. In contrast, others were against the interrelationship between artistic genres. Baudelaire and the Symbolists had been the first to explore synesthetic possibilities in poetry as the result of the relations among the senses. Avant-garde artists focused on the exploration of innovative hybridisation processes based on some of Richard Wagner's principles. Futurism in its turn undertook experiments in the relations between artistic forms, which would be very influential in the cultural practices of successive decades.

The concept of 'simultaneity' became a fundamental pillar of the Futurist cultural revolution. From the beginning, Marinetti incorporated into art the weight, sound and smell of objects. In *The Painting of Sounds, Noises and Smells*, published in 1913, Carrà referred to some of the main ideas announced in the *Technical Manifesto of Futurist Painting* (1910): 'We Futurist painters maintain that sounds noises and smells are incorporated in the expression of lines, volumes and colours just as lines, volumes and colours are incorporated in the architecture of a musical work. Our canvases will therefore express the plastic equivalents of the sounds noises and smells found in theatres, music-halls, cinemas, brothels, railway stations, ports, garages, hospitals, workshops, etc., etc.' (Boccioni et al. 1910: n.p.). The acceleration of urban rhythms prompted a dynamic perspective: everything was in movement and in a continuous process of change. Therefore, one of the reasons that led Futurists to defend interdisciplinary fusion was their willingness to assimilate the elements of modern life into their works.

These artists tried to translate the sensations produced by the modernist experience through the creative world. In the *Technical Manifesto of Futurist Literature* (1912), Marinetti stated: 'It is through very vast analogies that this orchestral style, at once polychromatic, polyphonic, and polymorphic, can embrace the life of matter'. He believed that 'the vaster the connections an image encompasses, the longer it will keep its stupefying power' (Marinetti 1912a: n.p.). In that way, he tried to fuse together opposing elements, feelings and disciplines by the use of analogy as a cognitive process.

As part of their polyexpressiveness, the contribution of the Ginanni-Corradini brothers (who during their Futurist period were known as Arnaldo Ginna and Bruno Corra) turns out to be essential. Their experiments reveal a deep interest in transgressing disciplinary boundaries to produce original works, so that today they can be considered pioneers of multimedia art. Indeed, they were the architects of an innovative project characterised by hybridisation and the incorporation of technology as the ultimate expression of the *macchinolatra* and *modernolatra* aesthetic. *Arte dell'avvenire* is one of their main texts, published in 1910 by Mazzini Printers in Ravenna and edited the following year by the Library L. Beltrami Editrice Internazionale in Bologna. Ginna and Corra believed that the parallelism between the arts should be explored in order to strengthen each art form: 'The essence of art is just one; there are several ways of expression ... there is a parallelism among all arts, an absolute correspondence between forms' (Ginna and Corra 1910). They focused their research and their interdisciplinary experiments on this aim, producing the first examples of abstract art, *musica cromatica* or *cinepittura*. They created a chromatic organ at the same time that Aleksander Nikolaewicz Skriabin conducted his experiments. Whereas the Russian composer used music to achieve chromatic combinations, the Italians started from colour to find musical correspondences. Around 1910 Ginna and Corra explained their theory: 'For two months each studied on his own without communicating his results – afterwards we presented, discussed and amalgamated our observations' (Corra 1912). In spite of difficulties, they concluded that it was necessary to translate the musical scales into the visual sphere in order to create a music of colours. They applied and exploited the laws of parallelism between the arts which had already been established. First of all, they felt the obvious need for a subdivision of the solar spectrum, even an artificial and arbitrary one, into four chromatic gradations at equal distances. In this way they managed to translate the seven colours into four octaves. The result of this research was a chromatic organ made up of twenty-eight coloured electric light bulbs, corresponding to twenty-eight keys. Owing to several technical difficulties, Ginna and Corra admitted that the result was not satisfactory: with only twenty-eight shades it was not possible to obtain clear gradations and the sources of light were not strong enough; if they used powerful bulbs, the excessive heat faded the colours after a few days. In spite of those disadvantages, the confluence of sound, light, colour and movement generated new reflections about analogical processes. Mario Verdone argues that films such as *Fantasia* would not have existed without the earlier experimentations of the Futurists (Verdone 1952: 39).

The brothers turned their thoughts to cinematography, and it seemed to them that 'this medium, slightly modified, would give excellent results, since its light potency was the strongest one could desire' (Corra 1912).

As early as 1907 Ginna had started to explore cinematic techniques: his early experiments included actually scratching and painting the film stock itself, a process that some years later would become a hallmark of Norman McLaren's animations. Between 1910 and 1912 the Ginanni-Corradini brothers carried out their synesthetic research with abstract painting films, even before official Futurism accepted this new medium. Being ahead of their time, they offered the first examples of visual symphonies in cinema. Their shorts, unfortunately now lost, included: *Accordo di colore, Studio di effetti tra quattro colori, Canto di primavera* (inspired by Mendelsshon), *Les fleurs* (by Mallarmé), *L'arcobaleno, Musica della danza*. This last film is mentioned in *Musica cromatica*, written in 1912, which is considered to be the first essay about abstract cinema. Corra explained that in *Musica della danza,* 'the predominant colours [are] carmine, violet and yellow, which are continually united, separated and hurled upwards in an agile pirouetting of spinning tops' (Corra 1912). According to Giovanni Lista, these films tried to add a spiritualist and esoteric dimension to new dynamic and coloured graphical compositions (Lista 2001: 24). Ginna and Corra, who were particularly concerned about interdisciplinary relations, were enthusiastic about the possibilities of film. For this reason, in 1916 Filippo Tommaso Marinetti entrusted Arnaldo Ginna with the filming of *Vita futurista*, the first and most important Futurist film. Together with his brother and some other colleagues, he also wrote the first Futurist cinema manifesto. It was a decisive text that claimed that the main role of this new medium was to carry out the 'Futurist reconstruction of the universe'.

Cinema as metamedium

As a result of Symbolist experiences, at the beginning of the twentieth century a large number of poets and painters turned their attention to the film industry. In their search for a total language, according to Giovanni Lista, the 'first experimental film theorists and movie-makers have been Wagnerian' (Lista 1987). André Gaudreault considers that intermedia relations established at the beginning of film history are essential to an understanding of how this medium reached its autonomy (Gaudreault 2004: 48–9). Futurists, together with members of subsequent avant-garde movements, believed that new technologies would allow a new synthetic art. For this reason, cinema was considered the perfect example of *macchinolatria* and the first metamedium of the new era: as a result of modern advances it should be able to unite different disciplines into a unique total language. Gianpiero Brunetta suggests that cinema became the magic key for expressing contemporary complexity, providing new perspectives in cultural studies, unattainable until that moment (Brunetta 2004: 71).

As Ricciotto Canudo has pointed out, Futurists maintained that cinema was not the simple sum of several arts, but their merger into one art, the seventh. Christian Metz supports this approach, noting that cinema emerged from pre-existing modes of expression and its distinguishing characteristic is its attempt to become the main interdisciplinary nexus (Metz 1972: 97–8). Before other avant-garde movements, Futurism announced its enthusiasm for cinematography with the publication of *The Futurist Cinema* (1916). Futurists were against all cinematographic productions that, remaining profoundly *passéist*, did not explore the immense artistic possibilities of cinema. Lacking a past and thus a tradition, the medium of cinema had the freedom to become the ideal instrument of a new art. Instead of copying the stage, the Futurist cinema should follow the evolution of painting, becoming an autonomous art, anti-aesthetic, deforming, impressionistic, synthetic, dynamic, free-wording. Futurists defined cinema as the expressive medium most adapted to the complex sensibility of the Futurist artist. Its main virtue was to create a polyexpressive symphony: 'The most varied elements will enter into the Futurist film as expressive means: from the slice of life to the streak of colour, from the conventional line to words-in-freedom, from chromatic and plastic music to the music of objects. In other words it will be painting, architecture, sculpture, words-in-freedom, music of colours, lines, and forms, a jumble of objects and reality thrown together at random' (Marinetti et al. 1916).

The Futurist cinema was designed to serve as the ideal metamedium to achieve a total artwork. According to Antonio Bisaccia, cinema was conceived as a '*musicolibera, imagoverbale*, indefinitive, polyexpressive and uncontrollable strength' (Bisaccia 2002: 39). This schizophrenic perspective was the essence of the medium's specificity as, cinema portrayed an accelerated reality. Futurists believed that it 'will sharpen, develop the sensibility, will quicken the creative imagination, will give the intelligence a prodigious sense of simultaneity and omnipresence' (Marinetti et al. 1916).

Instead of documentary filming, Marinetti and his colleagues were interested in 'a joyful deformation of the universe, an alogical, fleeting synthesis of life in the world' (Marinetti et al. 1916). In order to decompose and recompose the universe according to their whims, they used editing techniques and special effects. In *Vita futurista* (1916) split screens were used to illustrate the differences between Futurist and *passéist* lifestyles; the use of concave and convex mirrors to distort actors' silhouettes; and manual painting of the film stock. In other words, they used technical tools to reinforce their reconstructionist project.

Futurists did not limit their research to the visual sphere, they extended the Futurist cinematographic revolution to all disciplines. Futurist cinema was designed to co-operate in the general renewal and revitalisation of old

media. Cosetta Saba (2006: 125) argues that polyexpressivity was not a method or technique but a new expressive medium, a new art form that found in cinema its best ally.

Futurist-cinematographic revolution

Futurists, who were aware of their pioneering role, tried to put cinematographic techniques into practice. Mario Verdone (1967: 39) suggests that montage was the best gift the twentieth century gave to the art world. As a result of industrialisation, it was an essential contribution to the renewal of literature, poetry, painting and theatre. Futurists explored new models to represent reality that went beyond linear logic. Montage sequences combined numerous short shots with special optical effects, assembling different components and obtaining original condensations of space, time and information. This procedure was often used in Marinetti's creations, such as in the idea of a 'mechanical man of interchangeable parts', a utopian precursor of the aesthetics of the cyborg, created as a synthesis of organic and synthetic parts. The influence of montage is also evident in literary innovations, especially in the 'raging need to free words, releasing them from the prison of the Latin period'. Marinetti believed it was necessary to present images with a maximum of disorder, and to develop analogical techniques. Once adjectives, adverbs and conjunctive phrases had been suppressed, punctuation would naturally disappear in the continuity of a living style, without pauses of commas and periods. Wanda Strauven attributes these innovations to the influence of cinematographic techniques; in fact, the advances made in poetry are quite similar to those of experimental films. Marinetti suggested that '[p]oetry must be an uninterrupted succession of fresh images or it is nothing but anaemia and chlorosis' (Marinetti 1912a).

The use of onomatopoeia was a fundamental contribution to sound montage. In *Geometric and Mechanical Splendour and the Numerical Sensibility* (1914), Marinetti distinguished between several kinds of onomatopoeias: 'Direct, imitative, elementary, realistic onomatopoeia' to imitate real sounds; 'indirect, complex, and analogical onomatopoeia' that created a relationship between sensations of weight, heat, colour, smell and noise; and 'abstract onomatopoeia', capable of expressing the most complex and mysterious motions of our sensibility (Marinetti 1914). The brevity of the onomatopoeias permitted the most skilful combination of different rhythms, showing more abstractly the dynamism of a society in continuous evolution. The Futurist leader loved to express chaotic reality through the creation of neologisms, innovative images and onomatopoeic resonances. He also encouraged free associations between juxtaposed elements; in

Battaglia Peso + Odore we find several examples: 'benzoino tabacco incenso anice villaggio rovine bruciato ambra gelsomino case sventramenti abbandono giara-di-terracotta TUMBTUMB violette ombrie pozzi asinello asina cadavere sfracellamento sesso esibizione' (Marinetti 1968: 60). It is the result of 'thought's uninterrupted dynamism', an idea that Strauven links to Eisenstein's cinema.

Marinettian montage is also characterised by analogical techniques, both *in praesentia* (juxtaposition of two images, such as 'woman-gazelle') and *in absentia* ('gazelle'). Later avant-garde movements such as Surrealism or Dadaism used the first option brilliantly in masterpieces such as René Clair's *Entr'acte* (1924) and Luis Buñuel's *Un chien andalou* (1929). It is more difficult to find sequence shots of the second kind, which are much more abstract.

Another important contribution was 'intuitive montage', based on stream of consciousness, sometimes apparently illogical. One of the most representative examples is *Cinematografo cerebrale*, written by Edmondo De Amicis in 1907, which anticipated later experimental cinematographic experiences. The writer presented his work as a 'visualization and literary montage' that narrates a reverie appealing to oneiric logic. *L'ellisse e la spirale* (1915) is another example of written cinema. The author of this novel, Paolo Buzzi, explained that thanks to 'film + words-in-freedom', cinematographic logic was transposed into the literary sphere. Although the work did not match expectations, there were some interesting details, such as the incorporation of cinematographic techniques, or the insertion of formulae and mathematical signs. In *Risposte alle obiezioni*, a text written three months after the *Technical Manifesto of Futurist Literature* had been published, Marinetti explained that he aspired to an ideal poetry, composed only of second terms of analogical structures, which result in the expression of an untrammelled imagination and words-in-freedom, the abolition of syntax and the Latin sentence (Marinetti 1912b). Mario Verdone (1977: 23) stresses the presence of visual dynamism and a cinematographic tendency in Futurist literature. He observes that in 1905 Gian Piero Lucini claimed that he had written cinematographic verses as early as 1897. The poet Libero Altomare and the writer Francesco Flora included cinematographic references in *Mida il nuovo satiro*.

As John Welle writes: 'In 1914, *Odiernismo*, an anti-Futurist bi-weekly periodical, began publication at Rome. Its subtitle, *Quindicinale Antifuturista Letterario Cinematografico* [Anti-Futurist Literary Cinematographic Bi-Weekly], reminds us once again of the importance of film and literary interactions in Italy' (Welle 2000: 291). This publication launched a 'campaign for cinema literature' that was preceded by important essays

such as Anton Giulio Bragaglia's *Futurist photodynamism*, which provides the theoretical base for his explorations of painting, photography and film.

Literary Futurism was deeply influenced by cinematographic sensibility, as we observe in *Gioco pericoloso* by Aldo Palazzeschi or *Berlino* by Vasari. The Futurist poetic system can also be considered from a visual perspective since the word was not only a linguistic sign but also an iconic and dynamic element. In 1919 the journalist Piero Gobetti (1919: 39) wrote that cinematography 'had everything that Marinetti wanted for poetry'. The main mistake Marinetti made was to use cinematography to revitalise literature instead of exploring experimental cinema in depth.

Conclusion: the Futurist legacy

The aim of the Futurists was not only to renovate old media but also to incorporate new technologies into art. Their experimentation and research consisted in identifying the specific qualities of each medium. A new beauty was born from the chaos of the contradictory sensibilities that Futurists translated into an innovative linguistic universe. They substituted old narrative and aesthetic models for a metamedia system based on multiple interrelations between old and new forms of expression. In this process, the Futurist desire to adapt collective imaginary to a new era dominated by machines was essential. Mario Costa, who has studied in depth the strategies adopted by avant-garde movements to adapt art to technological evolution, concludes: 'The use of chemical and electro-magnetic energy in photography, film and phonograph has deeply modified artwork's conception and art and artist's status' (Costa 1999: 42). Futurists tried to re-establish the balance by the incorporation of new media into art. As Costa (1999: 42) maintains: 'Art history is Media history, the manifestation of the specific possibilities of each medium and its reciprocal capacity of influence and reaction'.

The innovative richness of avant-garde discourse consists in its capacity to project its goals into the future. Futurist reflections about cinema's role turned out to be essential in the evolution of this medium over many decades. Even today Futurist manifestos act as an important reference for an understanding of the influence of new media and digital technologies in our societies. As Marinetti predicted, this essential confluence of art and technology comes the closest ever to the total artwork. Peter Weibel, one of the most respected experts in media art and digital culture, explains that the impact of the media is global and that '[t]he media paradigm embraces all of the arts ... This is the post-media condition of the world of the media in the practice of the arts today' (Weibel 2006: 99). In fact, the remix culture has led to extraordinarily significant innovations in each of

the media and art that come from technical innovations. All of the artistic disciplines have been transformed by media, and Futurist cinema was one of the first steps in the formulation of the post-media paradigm. Today, new technological media are producing multidisciplinary hybridisations, which are polyexpressive works in Futurist terms, and that in the future will probably exceed Futurist expectactions.

In 1916 Marinetti and his colleagues proposed in *The Futurist Cinema* manifesto an interesting formula: 'Painting + sculpture + plastic dynamism + words in freedom + intonarumori + architecture + synthetic theatre = Futurist cinema' (Marinetti et al. 1916). This definition was formulated from a multimedia perspective in order to mix distinctive media-specific worlds. It is striking that almost one century later Lev Manovich, a pioneer in the theory of digital media, used a similar equation to define digital film as 'live action material + painting + image processing + composing + 2-D computer animation + 3-D computer animation' (Manovich 1995).

The binary code of the computer, together with algorithmic rules and programs, gives rise to new intermedia combinations and favours interactive processes. Numerical representation gives access to each element separately, allowing the automation of a large number of tasks and the opportunity to modify the final result, offering several versions. Cultural computerisation entails a transcodification of all cultural expressions, integrated into a universal, self-contained medium. Therefore, the primary Futurist intuition about the art and communication of the future has become a reality with digital technology.

Marinetti's effort drove him to imagine a future dominated by mass media and technology. His intuitions turn out to be decisive for an understanding of our present. We should remember that a few years after the foundation of the Futurist movement Carlo Carrà challenged all those who criticised the movement's impudence to wait thirty years. We are celebrating the first centenary of the publication of the Futurist Manifesto, and the great majority of their proposals remain indisputable reference points for communicative processes.

References

Abruzzese, A. et al. (1979). *Cinema e industria culturale dalle origini agli anni '30* (Rome: Bulzoni).

Adorno, T. W. (1970). *Aesthetische Theorie* (Frankfurt: Suhrkamp).

Balla, G. and F. Depero (1915). *Ricostruzione futurista dell'universo* (Milan: Direzione del Movimento Futurista).

Bisaccia, A. (2002). *Punctum fluens. Comunicazione estetica e movimento tra cinema e arte nelle avanguardie storiche* (Rome: Meltemi).

Boccioni, U. et al. (1910). *Manifesto tecnico dei pittori futuristi* (Milan: Direzione del Movimento Futurista).

Brunetta, G. P. (2004). *Gli intellettuali italiani e il cinema* (Milan: Bruno Mondadori).

Corra, B. (1912). *Musica cromatica* (Bologna: Beltrami).

Costa, M. (1999). *L'estetica dei media. Avanguardie e tecnologia* (Rome: Castelvecchi).

Crispolti, E. (1986). *Storia e critica del futurismo* (Rome: Laterza).

Gaudreault, A. (2004). *Cinema delle origini o della 'cinematografia attrazione'* (Milan: Il Castoro).

Ginna, A. and B. Corra (1910). *L'arte dell'avvenire* (Ravenna: Mazzini).

Gobetti, P. (1919). 'Il futurismo e la meccanica di F. T. Marinetti', *Energie Nuove*, 6 (15–31 January), 39.

Lambiase, S. and G. B. Nazzaro (eds) (1978). *Marinetti e i futuristi. Marinetti nei colloqui e nei ricordi dei futuristi italiani* (Milan: Aldo Garzanti Editore).

Lista, G. (1987). 'Ginna e il cinema futurista', *Il Lettore di Provincia*, 69, 20.

Lista, G. (2001). *Cinema e fotografia futurista* (Milan: Skira).

Manovich, L. (1995). 'What Is Digital Cinema?', www.manovich.net/TEXT/digital-cinema.html. Accessed 17 October 2013.

Marinetti, F. T. (1912a). *Manifesto tecnico della letteratura futurista* (Milan: Direzione del Movimento Futurista).

Marinetti, F. T. (1912b). *I poeti futuristi* (Milan: Edizioni futuriste di *Poesia*).

Marinetti, F. T. (1914). *Lo splendore geometrico e meccanico e la sensibilità numerica* (Milan: Direzione del Movimento Futurista).

Marinetti, F. T. et al. (1916). 'Cinematografia futurista', *L'Italia Futurista*, 10 (15 November).

Marinetti, F. T. (1968). *Teoria e invenzione futurista*, ed. L. De Maria (Verona: Arnaldo Mondadori).

Metz, C. (1972). *Semiologia del cinema* (Milan: Garzanti).

Saba, C. G. (2006). *Tecnologie e avanguardia in Italia dal Futurismo alla Net.art* (Bologna: CLUEB).

Verdone, M. (1952). *Gli intellettuali e il cinema* (Rome: Bianco e Nero).

Verdone, M. (ed.) (1967). *Ginna e Corra: cinema e letteratura del futurismo* (Rome: Edizioni Bianco e Nero).

Verdone, M. (1977). *Le avanguardie storiche del cinema* (Turin: Società Editrice Internazionale).

Wagner, R. (1993). *The Art-work of the Future and Other Works* (Lincoln and London: University of Nebraska Press).

Weibel, P. (2006). *The Post-media condition. Condición postmedia* (Madrid: Centro Cultural Conde Duque).

Welle, J. P. (2000). 'Early Italian Cinema Literature 1907–1920', *Film History*, 12, 3.

A Very Beautiful Day After Tomorrow: Luca Buvoli and the legacy of Futurism

Elisa Sai

As with every anniversary, the centenary of the publication of the Futurist manifesto has stimulated a discussion about the significance and impact of Futurism on its contemporary and later Italian and European culture. In art, it has occasioned a great opportunity to see and appreciate a whole range of works that are not normally available to the public. However, the study and interpretation of Futurist art have always been characterised by vibrant debate and polemic. Futurism's transitional role between tradition and avant-garde, the originality of the movement and its controversial political associations have all inspired strong feelings. The extremely varied and multimedia nature of Futurism lent the movement to a huge range of interpretations and associations. Over the last seventy years, while critics and academics were questioning the value and significance of Futurist art and disputing the controversial Futurist ideology, artists have been looking back and freely borrowing from Futurism as a source of inspiration. Artists engaged with Futurist aesthetics, ideologies and objects in a variety of approaches, and in different historical and artistic contexts.

An exhibition held in Italy from September 2007 to February 2008 entitled *Il futuro del Futurismo* (Di Pietrantonio and Rodeschini 2007) explored the possible different influences that Futurism had on later art including recent works by Damien Hirst, Vito Acconci, Michelangelo Pistoletto and Gilbert & George. The wide range of works and artists that the exhibition included in a discourse on the legacy of Futurism is extraordinary. In Milan, the last room of the exhibition *Futurismo 1909–2009* was entitled *The Legacy of Futurism* and included works of postwar Italian artists such as Lucio Fontana, Alberto Burri, Piero Dorazio and Mario Schifano (Lista and Masoero 2009). In her study of the reappraisal of the Baroque by some contemporary artists, Mieke Bal suggests that the artistic engagement with an earlier period can expose contemporary concerns and concurrently

provide a more informed interpretation of the past artistic production (Bal 1999). An investigation of the reassessments of Futurism in more recent artistic contexts might reveal contemporary anxieties with reference to Futurist aesthetics and ideology, and infuse new impetus in the interpretation of Futurist art often paralysed in a sterile scholarly orthodoxy. Bal states:

> By endorsing the present as a historical moment in the act of interpretation itself, one can make much more of the object under scrutiny. One can learn from it, enable it to speak and to speak back, as a full interlocutor in debates about knowledge, meaning, aesthetics and what matters about these in today's world. (Bal 1999: 18)

Exploring contemporary artistic attitudes towards Futurism might constructively contribute in identifying stereotypes, misconceptions and prejudice in conventional interpretations. Benjamin Buchloh, in his study on artistic appropriation, provides an interesting perspective:

> The aesthetic practice and appropriation may result from an authentic desire to question the historical validity of a local, contemporary code by linking it to a different set of codes, such as previous styles, heterogeneous iconic sources, or to different modes of production and reception. (Buchloh 2000: 348)

In the context of contemporary artistic reappraisals of Futurism, the artist Luca Buvoli represents an interesting case study. In his retrospective journey across Futurism the artist attempts to cast a contemporary view on a past modernist movement. Buvoli's engagement with Futurism constitutes an exciting form of interpretation; a new chapter in the historiography of Futurism, alternative to more traditional forms of analysis. While for many artists who have previously engaged with Futurism, the movement constituted a source of inspiration and celebration, Buvoli's work is neither a perpetuation nor an appropriation. More correctly it can be defined as an actualisation and recontextualisation of Futurism. Instead of proposing a homage to Marinetti's movement, Buvoli envisages a 'Futurism without optimism, an attempt to question the authoritarian and threatening side of our fascination with the future, velocity and power'.[1] For many years the controversial political associations of Futurism have probably constituted the most problematic and widely discussed aspect of the movement, an issue often omitted by the artists. Yet, Buvoli acknowledges the unsettled political debate and invites the viewer to ponder on the issues of control, communication and the fine line that separates art and propaganda in order 'to explore the thin line separating idealism and delusion and the parallels with demagogic strategies used today by media-driven societies' (Poggi and Buvoli 2009: 56–9). Buvoli's international recognition occurred in 2007

when, at the Venice Biennale, he created a multimedia project entitled *A Very Beautiful Day After Tomorrow* [Un Bellissimo Dopodomani], the climax of *Meta-Futurism,* a long-term project initiated by the artist in 2003. In order to provide an exhaustive analysis of the artist's backwards journey towards Futurism it becomes necessary to include an analysis of works that predate the Biennale project such as *Flying. Practical Training for Beginners and Intermediates* (2000) and *Not-a-Superhero* (1998).

Questioned about his approach to Futurism, Buvoli affirmed that he addressed the movement backwards. His journey commences in our time meditating on issues of power and control in contemporary society and progresses by exploring the suggestion of his juvenile fascination with flight and the idea of the hero. By merging these instances with the echo of traumatic historical events seen through the memories of his family and in particular his father, a pilot in the Second World War and later detained in a deportation camp, the artist attempts to extend this personal memory to a collective memory and translates a verbal and narrative account into the visual sphere. Though Buvoli himself recognises the influential effects of the Futurist visual sources in his cultural and artistic formation, it would be inaccurate to confine his artistic inspiration exclusively within that period. Buvoli is a contemporary artist who is deeply embedded in current artistic discourses and his work needs also to be examined in relation to contemporary art practice. For instance, the section of his production pertaining to an engagement with Futurism could be inscribed in contemporary practices of rereading and deconstructing modernism.

After his training at the Academy of Fine Art in Venice, Buvoli moved to America where he has been working for the past twenty years. With reference to his work in New York, and in a recent interview, Buvoli claimed that he wanted to react to the frame and the rigid and geometrised line of the anatomical drawing he was teaching as an assistant professor in Italy in favour of a flexible line that could perform its own story.[2] This represented Buvoli's departure, both artistically and psychologically, from what he defines as the limiting structuralist vision of the body. In describing the process of emancipation of the line he uses the term 'deskilling'. This word has a particular significance in the terminology of art criticism. The origin of this term goes back to Marx and the escalating unskilled labour force in factories, the decline of craft skill and its replacement with technological means. As Judith Rodenbeck explains, the term has been widely employed in a variety of contexts; for example 'in 1981 the Conceptual artist Ian Burn used the word deskilling to describe the way in which avant-garde artists of the early 1960s divested themselves of the obligations of physical production and invested more in conception and presentation' (Rodenbeck 2007: 84–91). It has been used to discuss artists such as Marcel Duchamp

and Andy Warhol and has often been employed to negatively suggest the decreasing of the artist's physical intervention in the process of creation. A recent book by John Roberts addresses the dialectic between deskilling and reskilling, looking positively at the possibility offered to the continuous exchange between these two processes in contemporary art (Roberts 2007). Buvoli indicates the beginning of his own process of re-skilling when in 2003 he turned his attention to Futurism. He states: 'I had to return to the drawing I was doing twenty years earlier, studying, copying, and thinking about the rigid fields of opposition. I had to discipline myself and face syntaxes, in this case the Futurist syntax, which I had forgotten'.[3] If, as Buvoli claims, *Meta-Futurism* mainly addresses issues of communication and control in art and society, the process of reskilling undertaken by the artist introduces a further layer of analysis. In *Meta-Futurism*, the study of Futurist syntaxes, combinations of colours, formal solutions, codes, terminology, fonts, the reintroduction of a frame and structure which is physically imposed in the posters and intentionally realised by the artist in the videos are all part of Buvoli's auto discipline and reskilling. The artist returned to his academic training of twenty years earlier, but also to the historical and cultural frame in which the Futurist works were produced. The control and manipulation to which the message is subjected finds a counterpart and confirmation in the process of creation itself. The artist looked back in time, something that Marinetti would not have done in 1909 when the rejection of the past was a keystone in his politics of rupture. Nevertheless tradition was happily embraced by the late Futurists in the 1930s when they showed admiration not only for their own past which was constituted by the artists Sant'Elia and Boccioni but also to the very tradition of Italian Art. In *Meta-Futurism* the reskilling process that the artist claimed to have undertaken also coincided with the extensive use of digital animation although always mixed and superimposed by Buvoli's own drawings and hand-sketched material. Despite his previous resistance to this form of animation, the artist felt legitimated to use it in his project on Futurism. Steve Dixon in 'Futurism e-visited' reports a comment by Giovanni Lista who states: 'Futurism is above all a philosophy of becoming, that is expressed by an activism exalting history as progress and celebrating life as the constant evolution of being ... a Futurist of today would be a fan of computer-generated images' (Dixon 2003).

Soon after moving to America in 1992, Buvoli completed a series of multimedia comic-book narratives that include *Not-a-Superhero* and *Wherever You Are Not* (1992). *Not-a-Superhero* is a comic-book figure, a hero who has lost his power and invulnerability. The work is in essence fragile and elusive like the action figures that represent the several characters of this fragmented narrative. Buvoli presents his anti-hero in line

with a new general period of decadence and deterioration in the symbolism of the figure of the hero. The anti-hero's continuous motion represents his attempt to survive the perverse *Dr. Logos*, which is emblematic of the power of rationality and Cartesian logic. Through his unconventional approach to comic tradition Buvoli creates his ironical and compelling stories using hand-drawn animation 'mimicking the mass-produced format and scope of Marvel and DC and replacing it with my scratchy collages and sculptures made of urban debris' (Grosz 2007). This transformation of the hero into its opposite is at the base of Buvoli's poetic of deconstruction carried out with the disassembling of the narrative and formal elements that we will see become central to his work on Futurism. Barry Schwabsky in *The Accidental Superhero* states:

> Yet in contrast to the Futurists' manically optimistic understanding of the idea of movement, Buvoli's work is saturated with the sense of movement as a problem, a symptom of imperfection. Being perfect and therefore static, while becoming – and movement – reflects a fundamental lack. (Schwabsky 1999: 24–7)

If the movement epitomises the perfect status quo for the Futurist, in Buvoli's work motion is interpreted both as the only faculty left to the super-hero and, equally, as a chronic and inescapable condition. Despite being now an anti-hero, the superpower of flight is still granted to the disconnected protagonist of this story. *Not-a-Superhero* does not specifically refer to Futurism; however the idea of heroism in relation to flight find a compelling counterpart in the Futurist aesthetic.

In *Flying. Practical Training for Beginners and Intermediates* completed between 2000 and 2002 Buvoli focuses on the role of a fictional character, Professor MaS, who instructs the utopian project of unassisted human flight. The description of the project states:

> The Professor demonstrates a series of movements which, when performed correctly, allow one to fly without the aid of any mechanical devices. The seriousness of the professor's presentation allows the viewer to momentarily defer judgments about the absurdity of the enterprise and become caught up in the hopes and aspirations represented by the Professor's quest.[4]

This work reveals the artist's interest in the theme of flying that will constitute a vital part of Buvoli's Futurist re-elaboration. The diagrams included in *Flying. Practical Training for Beginners* allude to the structural representation of the body but with the utopian aim of liberating it from the constriction of the terrestrial gravity. The structure is not imposed by any pre-existing theory but is the free elaboration of the artist who proposes his own geometry.

In the Biennale project, Buvoli translates some of the themes previously explored in his work into a comprehensive and contemporary reading of Futurism. The installation was a versatile production composed of animated videos, computer-generated and digital images, drawings, murals, sculpture and posters. The words *A Very Beautiful Day After Tomorrow*, adopted by Buvoli as a title, were originally addressed by Marinetti to his daughter in 1944 as a sort of a prophecy on the future during a tragic time in his personal life and in Italian history. Buvoli attempts to deflate the rhetoric behind Marinetti's positive statement and, at the same time, to underline the uncertainty and disillusion hidden behind those words. Buvoli's 500 square metre installation is divided into four phases that correspond to different parts of the exhibition space. *Anachroheroism*, presented in the first room, is so described by the artist:

> The euphoria of flight is as spectacular as the danger. The project's initial phase explores aesthetic as well as political aspects of aeronautics. Dynamic vector lines and an idealised, mechanised flying human shape surround the viewer upon entering the Arsenale, while handmade propaganda posters and mosaics rise along the walls.[5]

By naming the first phase Buvoli attempts to contradict Marinetti's unjustified optimism for the future. The title, *Anachroheroism*, indicates the disillusioned artist's view of the myth of the hero and its outmoded and superseded condition. The theme of flight, which incorporated the idea of heroism, violence and war, is presented in its potential tragic effects. At the same time, Buvoli flirts with the fascination and seduction of danger in the captivating use of colours and fonts and the general overwhelming atmosphere created in the room. The artist plays with the power of suggestion in the scenographic grandiosity of the scene epitomised by the gigantic sculpture of a flying human body hanging from the ceiling. It is clearly a reference to his previous works in which this figure appeared and it incorporates the concept of the machine body proposed by Marinetti since the publication of the founding manifesto in 1909. The sculpture occupies a strategic position in the exhibition space and openly acknowledges flight as the main theme of this work. For the Futurists, the aviator was the hero that could overcome the traditional terrestrial border and experience the newly discovered aerial dimension. In particular in the 1930s and subsequently in the publication of the *Manifesto of Aeropittura*, the figure of the aviator became the subject of idealisation in several Futurist works. In her discussion of Buvoli's sculpture Christine Poggi states:

> Within the Futurist imaginary, this dream of flight assumed the form of a desire to fuse man and airplane, flesh and metal, in the creation of an anti-human type, impervious to sentiment and capable of withstanding the

shocks occasioned by speed. Buvoli's aviator/airplane, which he calls Vector, refers to these dreams of transcendence, power and immortality although in a distinctly less heroic manner. (Poggi 2007 n.p.)

The sculpture is a human being in his flight enterprise without the machine. It could be the man who has already internalised the machine and acquired its power. Alternatively, it could be the body that has succeeded in liberating itself from its dependence on the mechanical tool and is now unconstrained. Buvoli does not to state his intention clearly. This impressive sculpture at the entrance is a disquieting shape of a genderless human being that controls the scene with its overwhelming presence. In this section, Buvoli is concerned with the impact of flight on the terrestrial space rather the idealisation of flight's enterprise. The spectator feels under surveillance by a depersonified presence who oversees and dominates the space. The room becomes the theatre where the dialectic dichotomy vision/control is unfolded. In the First World War aviation was mainly deployed with duty for reconnaissance operations and control of the territory while during the Second World War the terrifying aspect of flight and the possible destructive power of an elevated position and vision were fully exposed. In the other Buvoli's videos,[6] the continued interchange and transformation of the human being into the machine and vice versa remains unresolved. When in *Flying. Practical Training* the professor outlines his flying method, the creation of the imperishable and mechanical Futurist man seems to be attempted. However, the work does not suggest a mechanical empowerment of the body, instead the latter finds the necessary strength to accomplish the enterprise in his very human nature. Paradoxically, it represents a recognition of the intrinsic power of the human body. The fluctuating relationship between body and machine proposed by Buvoli finds correspondence in the later Futurist poetics. As Poggi explains, Marinetti thought that 'the inner consciousness of the Futurist superman, would be emptied of all that was private, sentimental and nostalgic. Psychology was a dirty thing and a dirty word' (Poggi 2009: 151). However, later in time, psychology and the soul of the Futurist man were scrutinised in art. In the painting *Il Cuore del pilota* by Mino delle Site,[7] the main theme becomes the feeling and psychology of the aviator. In *La spiritualita' dell'aviatore* by Fillia the pilot is not represented as a powerful hero any more but the delicate atmosphere of the painting is more directed towards the introspective investigation of the man/aviator.[8] Even the sexuality of the aviator is explored in a context in which the woman is not demonised but is delicately portrayed as the companion of the man/pilot in *L'amante dell'aviatore* by Regina.[9]

In the first room at the Biennale, on the two side walls, Buvoli creates a selection of what he calls 'propaganda posters'. The choice of poster is not

casual. In reference to the Italian aviation posters between 1910 and 1943, Maurizio Scudiero states:

> Over time, the poster was to prove itself to be an almost inexhaustible source of inspiration for artists and graphic designers. For its part, the poster constituted a powerful tool for spreading awareness of this new means of transport and at the same time, was a useful ally in giving flesh to a myth of modernity, an aerial mysticism for a new era of conquests and discoveries. (2002: 7)

As Buvoli suggests, in the posters the colours are fading and the language is hesitant and fragmented, the letters are collapsing, the colours spill over and inundate the borders.[10] The posters have lost the power to excite the mind and heart of the spectator. Buvoli's works alter the traditional function and physicality of the posters as they are not placed parallel to the wall but they often vertically emerge to occupy the spectatorial space. Through the displacement of the medium's physicality, they abandon their traditional flat format and are granted a three-dimensional nature. The artist is not preoccupied with hiding the creation process: the posters are not firmly fixed on the wall and the frame is often either missing or broken where the only supports are often constituted by rudimentary drawing pins. Buvoli does not only deploy the poster to convey a message but he also questions the message by challenging the medium.

In the following phase, *Entanglement of Modernist Myths*, the evil omen of the first phase is completely realised. The subtle critique and deconstruction culminate in the second room where everything is collapsing. The sculptures, which Buvoli calls 'vectors', are deconstructed in this room. All is left of these vectors are debris and fragments hanging from the ceiling. They are imprisoned and no longer capable of symbolising flight any more. As the artist explains, 'the flight trails of the initial Vectors – large lines and beams made of resin – soar upward and weave between a large resin marquee spelling out the project title before becoming entangled and falling to the floor'.[11]

The same atmosphere of disintegration permeates also one of the videos that Christine Poggi describes very effectively when she says:

> Buvoli's video presents the viewer with a montage of contemporary interviews and historical film footage of Fascist era, crowds hailing Mussolini and a newspaper burning, hand-drawn and animated scenes (including one of Marinetti dropping Futurist manifestos from the Clock Tower in Venice), a 1927 parade for aviator Charles Lindbergh, views of a 2005 aeronautical show, flags held by American soldiers marching in 'Operation Welcome Home' in 2006, Italian crowds at the World Soccer Final, and menacing smoke rings produced by bombs used in a re-enactment of WWII operations. As the video nears its conclusion, it seems to encounter resistance: the sound track slows

so that the refrain of the patriotic song becomes garbled, while the whirling propellers wind down. The final echoes of the song convey a sense of spatial and temporal distance. (Poggi 2007: n.p.)

At the beginning of the video the artist plays with the suggestion of an Italian popular song but as the sound is gradually distorted the disquiet in the spectator increases. Disillusion is all that is left of the fascination with flying and its potentiality. The words that randomly appear on the screen carry historical, cultural or biographical references and associations. In this phase, by combining contemporary images and archival footage, Buvoli draws parallels between past and contemporary events, collective myths and rites. The sense of rupture and alienation that permeates this video is disclosed in the dissociation between the words and the sound and the incongruity between the visual and sound elements of the video. The video finishes with the disintegration of forms and the fall of the hero when flight is finally arrested.

Both in his sculptural works and videos the artist intends to provide an alternative to the obsession with speed inherent in the Futurist aesthetic. For the exhibitions *Futurism 100* in London (Estorick Collection, 12 January–14 April 2009) and *Instant Before Incident* in New York (Susan Inglett Gallery, 14 February 2009–21 March 2009) Buvoli created a mural painting and sculptural works in reference to Marinetti's well-known car crash. In 1908, during his first drive, Marinetti lost control of his Fiat and the excitement and feeling resulting from that experience contributed to the development of the first Futurist manifesto. The mural is created in the language of comics and the painted motion sequence resembles the very style of Futurism. Buvoli claims: 'I have adopted several tactics to represent movement while attempting to slow it down, the car is condensed as a trope of representation of velocity; it is stretched, squashed and extended like a cartoon character, yet it is constituted by delay' (Poggi and Buvoli 2009: 59). By deferring the event, the artist concentrates on the instant before the collision. The suspended time is either an attempt to prolong the moment of ecstasy in which Marinetti was experiencing the power of velocity or the endless waiting for the inevitable tragic event. Paul Virilio, often mentioned by Buvoli as one of his cultural references, states:

> Accidents have always fascinated me. It is the intellectual scapegoat of the technological; accident is diagnostic of technology. To invent the train is to invent derailment; to invent the ship is to invent the shipwreck. The ship that sinks says much more about technology of the ship that floats. Today the question of the accident arises with new technologies, like the image of the stock market crash on Wall Street. (Der Derian 1998: 20)

Inherent in the nature of technology is the occurrence of an inevitable event

describable as accident and having devastating consequences. It could be argued that the contemporary technological world is living the instant before this accident where a discourse on suspended time emphasises the precarious nature of society. Recent studies have compared the apocalyptic atmosphere of the 1930s with the omen of an imminent disaster diffused in contemporary culture. However, this perspective was totally extraneous to the Futurist ideology in that period when they embraced an utter positivist and utopian attitude towards technology and future. While Futurism celebrated movement and flight in their positive and optimistic aspects, it becomes clearer why Buvoli refers to his work as a Futurism without optimism.

Buvoli's preoccupation with time and slowness also pervades the video *Velocity Zero* in which the process of 'deceleration' is already perceivable in the oxymoron that constitutes the title. In elaborating this video Buvoli worked in strict collaboration with language pathologists while he was filming people with aphasia loudly reading the Manifesto. The project's description says: 'Their slowed speech – transformed into fragmented animated sequences – mirrors the readers' attempts to fluently capture the text. Their moving struggle deflates the Manifesto's praise of speed and aggression and continues Buvoli's reading of Futurism from a post-utopian perspective'.[12]

The video attempts to destroy the rhetoric and violence of Marinetti's text. The slow pace of the speakers and their hesitation in the pronunciation contribute to create a feeling of frustration, anxiety and discomfort. By losing its speed the text reveals its absurdity. There is a breaking in temporality between the words that are pronounced in the video and the text that appears on the screen. The temporal and spatial fragmentation finds its visual correspondence in the dotted and scattered line added by the artist in his attempt to portray the speakers. Their corporeality is not completely obliterated, and the continuous appearance and disappearance of these ghostly and fragmented bodies reinforces the discomfort and uneasiness produced by the sound. *Velocity Zero* represents Buvoli's constant preoccupation and renegotiation between the notions of text, spoken word and corporeality. Performing declamation of text was common practice in the Futurist poetic. *Serate Futuriste* were animated events held in theatres where, among other activities that often included fights and exchange of insults, various Futurist texts were publicly recited. Buvoli proposes a similar experience with an inverted effect: the resistance of the text to be declaimed resembles our resistance to embrace the message. The notion of control and communication that accompanies the entire project is subtly present in the way the speakers need to control and discipline their performance and body to convey a message. In some of the earlier versions of the video Buvoli fully showed the faces of the speakers. However, the visual impact was too strong as

the distortion of the mouth and the patient's physical struggle to pronounce the words would have distracted attention from the whole experience. The artist decided then to superimpose his hand drawings to mitigate the effect. Although at first sight *Velocity Zero* may appear a very simple work, the artist made many infinitesimal decisions in reference to the background sound, the angle of the camera and the treatment of the text. The artist experimented with different background sound ranging from music to just the laboured breathing of the speakers in their effort of pronunciation. The angle of the camera was adapted to make the virtual space of the speakers more effective. In particular, the camera angle deployed in *Velocity Zero* has been associated with the traditional perspective from which Mussolini was always filmed in the propaganda footage to convey the suggestion of an imposing and overpowering presence. Because of the relevance of the textual reference, the artist carefully selected the typeface for the text of the manifesto that appears at the bottom of the screen. He opted for a hybrid between the print type used in first publication of the Futurist manifesto in English and the type deployed in the first publication of the manifesto in the French newspaper *Le Figaro*. The risk of transforming the text into a form of poetry, if perceived in its abstractness, was a major preoccupation for the artist. If the sound had become too detached from the meaning, the project could have turned into a form of concrete poetry, and aestheticising the performance would have prevented the deflation of the text's violence. The artist states:

> Paradoxically, one of the ideas I had in the process of realising this work was that I could ask the speakers to read not only the Futurist manifesto but also *Parole in Libertà*. And at the beginning I actually spent days with them reading other documents. One of the problems was that they were already too close at this assembling of Futurist syntaxes. The proximity between visual concrete poetry and the reading would have deleted my attempt, my desire to dismantle the violence itself.[13]

The video has been subjected to a heavy digitisation but at the same time the hand drawing of the artist reintroduced the human presence. In the exhibition's brochure, Pietropaolo points out how by 'favouring hand-drawing over each frame, the artist celebrates slowness through process' (Pietropaolo 2009). In her January 2009 interview, Buvoli adds a further level of interpretation in reference to the entire operation:

> The slowing down of language and the difficulty of communication are also employed to symbolically counter the ideology of power and violence that informs our society. Referencing both propaganda and advertising, the format of the manifesto allows ... for a timely critique of the ideologies of control and authority that permeate our everyday life in a media-saturated culture.

In Buvoli's work, the dialectic relationship and the juxtaposition between spoken and written word reaches the climax in *Velocity Zero*. Text and language were significant media in the Futurist effort to divulge their theories, probably comparable to the communicative power of their art. They produced an incredible amount of documents and manifestos both in the first and later period of their artistic activity. In his videos Buvoli usually inserts words that materialise on the screen to create lines of communication with other parts of the work and indeed with different works. In *Adapting One's Sense to High Altitude Flight* some of the apparently random words that appear on the video refer to the experience of Buvoli's father in a deportation camp. Another form of text is evident in the subtitles often inserted in the videos such as the manifesto in *Velocity Zero* or the patriotic song in *A Very Beautiful Day After Tomorrow*. Because of the importance of texts in his work, Buvoli wants the spectators not only to have an impression or suggestion from the sound but to fully understand all the implications of the text that he is reproducing. Raphael Rubinstein interprets it as an imaginative application of Lacan's 'signifying chain' (Rubinstein 2004: 152–4):

> For Lacan, the unconscious is structured like a string of words in which meaning is constantly deferred from one term to the next. Buvoli effects a similar deferral with his list of terms that glancingly touch on religion, physics, technology and ideology. Their meaning is ultimately in the very movement, the interconnection of roles and concepts. (2004: 153)

The language acquires a particular significance and meaning in the part of the Biennale project entitled *How Can This Thing Be Explained?*. In the artist's website the project is described as:

> two-channels video that compiles selected interviews the artist made with two of Marinetti's daughters and with Futurist scholars in both Italy and the United States to examine the problematic Futurist attitude towards violence as well as their conflicted views on the role of women.[14]

At first, the whole idea of openly acknowledging the controversial Futurist ideology could be interpreted as a slippage in the venture of rereading the movement through a visual and artistic transcription. The risk in presenting such an explicit message could have been to prevent the spectator from filtering and translating all these suggestions into a personal account. The allusions, suggestions, visual impressions, emotional correspondences and intellectual references in Buvoli's reading of Futurism are the strength of the project. The overt acknowledgment on the part of the artist of the political controversies surrounding Futurism could represent his conformity to received conventions of interpreting this period. Nevertheless, the

significance of language and words in the whole project has now become clear. In the case of this particular video, the speakers are not instructed to recite any predefined text and the artist did not have prior knowledge of the message, which was entirely within the speaker's discretion. Though the artist does not intend to interfere with the credibility of the comments, the visual manipulation operated in the videos can be speculatively interpreted as an attempt to provide a parallel and alternative artistic version of the academic message while questioning the legitimacy and authority of scientific method and logical thinking. In *Flying. Practical Training for Beginners* the very scientific tone and manner of Professor MaS who attempts to teach his improbable technique for unassisted human flight almost induce us to ignore the absurdity of the message. Scientific legitimacy was also extremely important for the Futurists. A series of articles titled 'Scientific Demonstration of Futurism' appeared in *Futurismo* in 1934 and other pseudoscientific theories in relation to flying were also regularly published in the Futurist periodicals (Ginna 1933: 5; Micheloni 1934: 8). Through his intervention on the visual sphere, Buvoli seems to question the scientific and rational approach as a means of understanding. At the same time Buvoli is captivated by the possibilities offered by a scientific approach:

> I'm fascinated by the rigorous, systematic approach to the discipline that science embraces. I engage in a constant dialogue an approach based on the empirical method but at the same time I play with the empirical approach to knowledge itself, the desire and the pleasure to expand knowledge.[15]

If in *Velocity Zero* the speakers were unable to pronounce the words, in this video there is not the physical inability but the incapacity of providing a definitive answer. It finishes with a question, an open end: *How Can This Thing Be Explained?* and nothing would seem more appropriate for a project that aims to expose the dialectical and contradicting nature of the Futurist movement.

Buvoli's work explores Futurism through the medium of art rather than deploying traditional forms of investigation. Although the artist claims to not be interested in openly engaging in any political and social critique, he uses Futurism as an occasion to explore issues of power of communication and media control in both past and contemporary Italian society, in his cultural and personal background and American society, and his everyday life reality. *Meta-Futurism* proposes a comprehensive investigation of Futurist aesthetics, succeeding where reception and traditional forms of analysis have often proved insufficient. The project engages with the spectator from a conceptual as well as from a perceptual perspective. Buvoli flirts with the potential fascination and seduction of Futurist aesthetics and strategies but by deconstructing codes, practices and methods the

artist succeeds in deflating the violence and destroys the rhetoric. Futurism borrowed from different cultural and artistic sources and, similarly, Buvoli absorbs, combines and freely transforms motifs drawn from contemporary art theory, popular culture, personal and collective memory, philosophy, technology, communication theory, historical occurrences and scientific method. The complexity of Futurism is exposed and actualised in a constant renegotiation between the past and the present.

Notes

1 *A Very Beautiful Day After Tomorrow. A Project for the 52nd International Venice Biennale 2007. Project Description.* www.lucabuvoli.com/html/biennale/Biennale.html. Accessed 25 January 2010.
2 Luca Buvoli, Interview with Elisa Sai, London, January 2009.
3 Luca Buvoli, Interview with Elisa Sai, London, January 2009.
4 MIT Visual Centre, *Luca Buvoli: Flying – Practical Training for Beginners*, 2000. http://listart.mit.edu/node/279. Accessed 25 January 2010.
5 *Project Description.* http://www.lucabuvoli.com/html/biennale/Biennale. html. Accessed 25 January 2010.
6 *Adapting One's Senses to High Altitude Flying* (2003); *A Very Beautiful Day After Tomorrow* (2007).
7 Mino delle Site, *Il cuore del pilota* (1933), Private Collection.
8 Fillia, *La spiritualita' dell'aviatore (*1929), Collezione Onorevole Pietro Campilli, Roma.
9 Regina, *L'amante dell'aviatore* (1935), Private Collection.
10 Project Description, www.lucabuvoli.com/html/biennale/Biennale.html. Accessed 25 January 2010.
11 Project Description, www.lucabuvoli.com/html/biennale/Biennale.html. Accessed 25 January 2010.
12 Project Description, www.lucabuvoli.com/html/biennale/Biennale.html. Accessed 25 January 2010.
13 Luca Buvoli, Interview with Elisa Sai, London, January 2009.
14 Project Description, www.lucabuvoli.com/html/biennale/Biennale.html. Accessed 25 January 2010.
15 Buvoli, Interview with Elisa Sai, London, January 2009.

References

A Very Beautiful Day After Tomorrow. A Project for the 52nd International Venice Biennale 2007. Project Description. www.lucabuvoli.com/html/biennale/Biennale.html. Accessed 25 January 2010.

Bal, M. (1999). *Quoting Caravaggio: Contemporary Art, Preposterous History* (Chicago: Chicago University Press).

Buchloh, B. (2000). *Neo-Avantgarde and Culture Industry: Essays on European and American Art from 1955 to 1975* (Cambridge, MA: MIT Press).

Der Derian, J. (ed.) (1998). *The Virilio Reader* (Oxford: Blackwell).

Di Pietrantonio, G. and M. C. Rodeschini (2007). *Il futuro del Futurismo* (Milan: Electa).

Dixon, S. (2003). 'Futurism E-visited', http://people.brunel.ac.uk/bst/3no2/Papers/Steve%20Dixon.htm.

Evans, D. (2009). *Appropriation* (Cambridge, MA: MIT Press).

Ginna, A. (1933). 'Scienza futurista. Investigazioni sulle tre dimensioni', *Futurismo* (29 January), 5.

Grosz, D. (2007). 'Luca Buvoli Is Not a Superhero', *Artinfo.com* (August). www.artinfo.com/news/story/25496/luca-buvoli-is-not-a-superhero/?page=1. Accessed 25 January 2010.

Lista, G. and A. Masoero (2009). *Futurismo 1909–2009: Velocita+Arte+Azione* (Milan: Skira).

Micheloni, R. (1934). 'Dimostrazione scientifica del Futurismo'. *Futurismo* (15 March), 8; (1 April), 5; (15 April), 5; (15 May), 5; (1 June), 2; (15 June), 5.

MIT Visual Centre. 2000. *Luca Buvoli: Flying – Practical Training for Beginners* http://listart.mit.edu/node/279. Accessed 25 January 2010.

Pietropaolo, F. (2009). 'Slow It Down to the Limit: Futurism at Velocity Aero'. Brochure of the exhibition *Velocity Zero* (London: Estorick Collection of Modern Italian Art).

Poggi, C. (2007). *Luca Buvoli. A Very Beautiful Day After Tomorrow (Un Bellissimo Dopodomani),* ICA Ramp Projects, University of Pennsylvania (20 January–25 March). www.lucabuvoli.com/ramp_buvoli_final–1.pdf. Accessed 25 January 2010.

Poggi, C. (2009). *Inventing Futurism. The Art and Politics of Artificial Optimism* (Princeton and Oxford: Princeton University Press).

Poggi, C. and L. Buvoli (2009). 'A Very Beautiful Day After Tomorrow', *Modern Painters,* 21, 56–9.

Roberts, J. (2007). *The Intangibilities of Form. Skill and Deskilling After the Readymade* (London: Verso).

Rodenbeck, J. (2007). 'Hands Off', *Modern Painters* (22 October). www.artinfo.com/news/story/25864/hands-off/?page=1. Accessed 25 January 2010.

Rubinstein, R. (2004). 'Watching the Sky', *Art in America*, 92:10, 152–4.

Schwabsky, B. (1999). 'The Accidental Superhero', *World Art*, 20, 24–7.

Scudiero, M. (2002). 'Epic Resonances, Dynamic Impulses and the Needs of Propaganda: The Aviation Poster 1910–1943', in M. Scudiero, M. Cirulli and R. Cremoncini (eds), *Planespotting. Italian Aviation Posters 1910–1943* (New York: Publicity & Print Press), pp. 7–10.

Index

Note: Literary and artistic works can be found under author or artist's name. 'n.' after a page reference indicates the number of a note on that page. Page numbers in *italic* refer to illustrations.